HOLLYWOOD AESTHETIC

HOLLYWOOD AESTHETIC

Pleasure in American Cinema

Todd Berliner

OXFORD
UNIVERSITY PRESS

OXFORD

UNIVERSITY PRESS

Oxford University Press is a department of the University of Oxford. It furthers
the University's objective of excellence in research, scholarship, and education
by publishing worldwide. Oxford is a registered trade mark of Oxford University
Press in the UK and certain other countries.

Published in the United States of America by Oxford University Press
198 Madison Avenue, New York, NY 10016, United States of America.

Library of Congress Cataloging-in-Publication Data
Names: Berliner, Todd, 1964- author.
Title: Hollywood aesthetic : pleasure in American cinema / Todd Berliner.
Description: New York : Oxford University Press, 2016. | Includes
bibliographical references and index.
Identifiers: LCCN 2016035635 (print) | LCCN 2016050463 (ebook) |
ISBN 9780190658748 (cloth : alk. paper) | ISBN 9780190658755 (pbk. : alk. paper) |
ISBN 9780190658762 (updf) | ISBN 9780190658779 (epub)
Subjects: LCSH: Motion pictures—Aesthetics. | Motion pictures—United
States—History—20th century.
Classification: LCC PN1995 .B3655 2016 (print) | LCC PN1995 (ebook) | DDC 791.4301—dc23
LC record available at https://lccn.loc.gov/2016035635

1 3 5 7 9 8 6 4 2

Paperback printed by Sheridan Books, Inc., United States of America
Hardback printed by Bridgeport National Bindery, Inc., United States of America

For my parents, who introduced me to Katharine Hepburn, Walter Huston, Mae West, Howard Hawks, Frankenstein's Monster, Akira Kurosawa, Cary Grant, and literally, when I was eight years old, to Edward G. Robinson at the Hillcrest Country Club. Plus, they loved me.

Contents

PART 4. IDEOLOGY

PART 5. GENRE

Preface: The Test of Time

An aesthetic analyst of Hollywood cinema faces the tricky issue of selecting the appropriate films to study. The biggest box office earners? Ordinary films? Canonical films? How does one determine the right scope?

This project opts for a broad range of films, studying both typical and extraordinary aesthetic achievements. Typical films closely follow standard practices of the classical Hollywood paradigm. But we should not confuse "typical" with "dull." Typical films help us understand some of mainstream cinema's time-honored methods for producing aesthetic pleasure, as well as providing a benchmark against which we can evaluate filmmakers' formal deviation and experimentation. The extraordinary films studied in this project test the limits of the classical paradigm, introducing novel or unusually complex aesthetic properties that augment Hollywood's standard repertoire of filmmaking practices. Although classical art forms tend toward uniformity, they also prize originality. Novel and complex properties in Hollywood films add variety to the filmgoing experience and sometimes expand the parameters of classical practice. Janet Staiger notes that innovations in Hollywood cinema replace "prior norms of excellence," as filmmakers, in an effort to differentiate their films, establish "alternative standards for the field."[1] Indeed, some of the films studied here, although extraordinary at the time of their release, no longer seem so eccentric because of changing norms.

Although I have selected an array of films to study, I focus my most enthusiastic analyses on works that have demonstrated popularity and interest among cinephiles—Hollywood film fans, film commentators and scholars, and passionate film viewers generally. We might instead have concentrated on Hollywood's biggest earners at the box office, and we will do some of that, but focusing primarily on blockbusters would not

accomplish the goals of this study. Ticket sales indicate what people wanted to see, not necessarily what they enjoyed or how much they enjoyed it. People see a film for reasons other than its potential to deliver aesthetic pleasure. To understand Hollywood's capacity as an art form, I think it most productive to concentrate on films that have engaged audiences intensely, over a long period, for reasons inhering in the films themselves. I therefore devote the majority of my most in-depth analyses to films that have satisfied what philosopher Anthony Savile and others have called "the test of time."

If we are to take the potential to deliver pleasure as a measure of an artwork's value, some aestheticians argue, then that potential should tend to endure. Many artworks offer pleasure at first, but we do not afford them much value because our pleasure does not persist and, upon repeated exposure to the work, may even turn into aversion. We consume and discard some artworks swiftly, while others, according to philosopher Jerrold Levinson, show an "enduring potential for gratification."

> Pleasure that testifies to artistic value must go beyond a single encounter, must be experienceable by others, and at other times: it cannot be merely fly-by-night or flash-in-the-pan. Pleasure in art and artistic value are connected only when a demonstrable *propensity* to give pleasure, inhering in the artwork, is present.[2]

Indeed, with some works, Levinson notes, our satisfaction "may deepen and extend itself on successive encounters."[3] These artworks give pleasure again and again and to many people. More artistically valuable works, the argument goes, tend to survive.

Mere survival, we must acknowledge, does not sufficiently determine an artwork's value. To pass "the test of time," a work must survive "for its own sake"—for the aesthetic attention paid to it.[4] Savile argues,

> when we know that a work of art has not securely passed time's test, then in the absence of any special explanation of why it has not done so, such as having been lost or having been available only to a very restricted group of people, we have some good ground for thinking that it is unlikely to be as worthy of our attention as those works which do have the stamp of time's approval.[5]

In short, if an artwork's survival results from factors relevant to its aesthetic appreciation, then survival over time can attest to the work's value.

How much time are we talking about? A length would be impossible to quantify, but the work should survive an *impressively long time*, as compared to the survival time of similar works. Given that Hollywood has been making movies for only a century and that few people watch a Hollywood movie even a year after its theatrical release, we can say

that a Hollywood film that persists in earning significant aesthetic attention after, say, two decades has withstood the test.

Although this study analyzes some flash-in-the-pan Hollywood films, I assume, following Savile, that such films are not as worthy of our attention as ones that have withstood the test of time. Canonical films, films that have shown long-term popularity, enduring cult films, and other Hollywood films have shown a demonstrable *propensity* to give pleasure. I think we can take the appeal of such films for granted, and it is up to me to demonstrate that audiences value them for their aesthetic rewards. We could, then, phrase this book's central question as follows: What is it about the Hollywood movies that people enjoy that makes people enjoy them?

In the course of this book, I analyze a range of films in an effort to reverse engineer their aesthetic design. I no doubt have ignored important areas, but I have attempted a comprehensive appraisal of Hollywood's aesthetic capacity. In the course of the book, for instance, we examine many mainstream films that have earned aesthetic appreciation from both fans and critics, including *City Lights* (1931), *Frankenstein* (1931), *Love Me Tonight* (1932), *Top Hat* (1935), *His Girl Friday* (1940), *Double Indemnity* (1944), *Leave Her to Heaven* (1945), *The Big Sleep* (1946), *Red River* (1948), *The Asphalt Jungle* (1950), *Invasion of the Body Snatchers* (1956), *The Graduate* (1967), *Jaws* (1975), *Goodfellas* (1990), and *Unforgiven* (1992). But I hope also to show that even ordinary popular films, such as *Speedy* (1928), *Marianne* (1929), *Tarzan and His Mate* (1934), *The Big Broadcast of 1938* (1938), *No Time for Sergeants* (1958), *Lover Come Back* (1961), *Urban Cowboy* (1980), *Rocky III* (1982), and *Stranger than Fiction* (2006), as well as New Hollywood action blockbusters, such as *Die Hard* (1988), *Independence Day* (1996), and *The Dark Knight* (2008), offer aesthetic pleasures for mass audiences. We furthermore study some curious outliers and celebrated Hollywood experiments—such as *Citizen Kane* (1941), *The Searchers* (1956), *The Killing* (1956), *Touch of Evil* (1958), *Vertigo* (1958), *Bugsy Malone* (1976), *Raging Bull* (1980), *The Last Temptation of Christ* (1988), *Brazil* (1985), *Everyone Says I Love You* (1996), and *Starship Troopers* (1997)—films that alienated a mass audience but that appeal to cinephiles or cult audiences. And we examine aesthetic properties in *Casablanca* (1942), *North by Northwest* (1959), *The Godfather* (1972), *Star Wars* (1977), and other films that seem to have found the optimal area for maximizing long-term popular attraction. I hope to show that these and many other Hollywood movies engage audiences, of one form or another, by satisfying people's aesthetic desires.

Acknowledgments

Malcolm Turvey, Mariana Johnson, Patrick Keating, and Stephen Prince each read the entire manuscript when I should have been embarrassed to show it to them. They saw both the forest and the trees, and I am grateful. J. Carlos Kase gave me insightful criticism of chapters 7 and 9. Philip Furia generously shared with me his knowledge of the songs of Hollywood. Murray Smith and Andrew Escobedo argued aesthetic theory with me. My editor, Norman Hirschy, gave me his diligence and support.

The University of North Carolina at Wilmington (UNCW) afforded me a research reassignment, summer research initiative, travel grants, and other grants in support of this project. The Film Studies Department at UNCW supported and encouraged me, in particular Nandana Bose, Chip Hackler, Dave Monahan, Ana Olenina, Tim Palmer, Sue Richardson, Andre Silva, and Shannon Silva, each of whom responded to selections from the book. The members of the Society for Cognitive Studies of the Moving Image encountered various pieces of my research, offering constructive, if sometimes humbling, feedback. The Weymouth Center for the Arts and Humanities provided several staggeringly productive writers-in-residencies.

Portions of this book have been published previously in Todd Berliner and Philip Furia, "The Sounds of Silence: Songs in Hollywood Films since the 1960s," *Style* 36, no. 1 (2002): 19-35; Todd Berliner, "Visual Absurdity in *Raging Bull*" in *Martin Scorsese's "Raging Bull": A Cambridge Film Handbook*, edited by Kevin Hayes (New York: Copyright © 2005 Cambridge University Press), 41–68; and Todd Berliner, "Hollywood Storytelling and Aesthetic Pleasure" in *Psychocinematics: Exploring Cognition at the Movies*, edited by A. P. Shimamura (New York: Oxford University Press, 2013), 195–213; all reprinted with permission.

Samuel, Jesse, and I together watched many of the movies studied in this book and discussed them. When one has perfect children, perfect moments happen all the time.

Finally, I get to say how wonderful my wife is. My most loyal friend, she is also my biggest champion and most scrupulous reader. I shudder to think what a mess this book would have been, and I would be, without her. Her name is Dana Sachs.

About the Companion Website

www.oup.com/us/hollywoodaesthetic

Oxford has created a website to accompany *Hollywood Aesthetic: Pleasure in American Cinema*. The site includes video clips from some of the films analyzed in the book. When readers see the symbol ▶, they are encouraged to consult the website; some e-readers can reach the videos directly by clicking on the symbol, depending on device and connection.

Introduction

The very name Hollywood has colored the thought of this age. It has given to the world a new synonym for happiness because of all its products happiness is the one in which Hollywood—the motion-picture Hollywood—chiefly interests itself.

—Carl Milliken, President of the Motion Picture Producers
and Distributors Association, 1928[1]

ENTERTAINMENT CINEMA

People seek out Hollywood cinema primarily for entertainment. Abundant empirical evidence supports that conclusion, and the American film industry banks on it.[2] Entertainment industry analyst Harold L. Vogel explains the economic value of entertainment products:

> Although life is full of constraints and disciplines, responsibilities and chores, and a host of things disagreeable, entertainment, in contrast, encompasses activities that people enjoy and look forward to doing, hearing, or seeing. This is the basis of the demand for — or the consumption of — entertainment products and services . . . Entertainment — the cause — is thus obversely defined through its effect: a satisfied and happy psychological state.[3]

We seek entertainment not for any practical purpose, need, or investment but for its own sake, for the happiness it affords us. The purpose of entertainment is entertainment. We seek out some films to teach us or edify us, but Hollywood gives us entertainment cinema.

Some scholars draw a distinction between entertainment and art, but I hope to dem-
onstrate that entertainment cinema is an art form that affords viewers aesthetic pleasure.
Aesthetic pleasure does not come from high art alone; mass art offers it too. Hollywood
cinema offers pleasures other than aesthetic ones: a social activity, fantasy, ogling at stars,
a respite from the heat outdoors, sexual excitement, a distraction from worries, commu-
nion with the past, and many others. In studying the appeal of Hollywood cinema, such
factors deserve consideration, but this book ignores them. Instead, I hope to demonstrate
that Hollywood movies, even routine Hollywood movies, attract viewers primarily by
offering them aesthetic pleasure. So, when people say, "I loved that movie," I think they
mean mostly, "That movie gave me a lot of aesthetic pleasure." But whether or not readers
believe, as I do, that aesthetic pleasure constitutes the chief appeal of Hollywood films,
I gather everyone would agree that aesthetic pleasure makes *some* contribution. This book
endeavors to explain that contribution.

Film scholars have long regarded entertainment cinema either as unworthy of serious
aesthetic study or else as an object of suspicion. Rutsky and Wyatt described this disci-
plinary tendency as they encountered it in 1990:

> Film theory has generally given a very limited consideration to fun and to films that
> are fun. . . . [S]uch films have been condemned as "products" that hide their sup-
> port of the dominant ideology behind the veneer of "entertainment" or "spectacle."
> Perhaps even more often, however, films that are seen as "merely fun" have been
> ignored as uninteresting or unworthy of analysis. . . . Moreover, it has been difficult
> for film theory to explain the pleasure of these films except in the broadest of brush-
> strokes (in essence, the arguments almost always fall back on the notion of "reassur-
> ing" pleasures).[4]

By "reassuring pleasures," the authors mean that the pleasures result from a film's ten-
dency to confirm the audience's belief in dominant ideology.[5] The authors note that the
mere fact of a film's popularity, for many film scholars, demonstrates its complicity with
dominant ideology. An entertaining film, according to this line of thinking, attracts mass
audiences because it is a trivial diversion from reality, a soothing amusement that rein-
forces bourgeois beliefs and values.

Other scholars have attributed the Hollywood film industry's widespread appeal to
its "commercial aesthetic,"[6] its accessibility,[7] the international hegemony of the major
studios,[8] marketing synergies,[9] or certain inherently appealing or marketable features,
such as "high concepts"[10] or stars.[11] Such accounts help explain why people may sit
through movies they find only diverting or recommend a movie that they describe as "not
bad." But the existing accounts do not adequately explain the intensity of the pleasure

people derive from Hollywood movies, an intensity that dates to the inception of the Hollywood film industry in the teens of the twentieth century. People do not merely experience Hollywood movies in a mildly pleasant way. Many people are passionate about Hollywood movies, their engagement active and exhilarated. Much of that engagement, I want to show in this book, results from the aesthetic pleasures afforded by individual films. Hollywood makes the most widely successful pleasure-giving artworks the world has ever known. More than any other historical mode of art, Hollywood has systematized the delivery of aesthetic pleasure, packaging and selling it on a massive scale. The American film industry operates under the assumption that pleasurable aesthetic experiences, among very large populations, translate into box office.

The existing accounts of Hollywood do not adequately explain the appeal of one Hollywood film over another. Many film scholars assume that moviegoers are essentially passive about their entertainment, spending their time and money on films that reinforce dominant ideology or that have the biggest stars, the largest promotional campaigns, or the most "buzz."[12] Comolli and Narboni argue that Hollywood tells the public what to want and then gives it to them.[13] Richard Dyer says that "show business . . . actually defines" what people want.[14] Laura Mulvey, in her influential ideological account of the pleasures of cinema, argues that mainstream cinema "positions" spectators as male voyeurs fetishizing and objectifying the female figure.[15] In the film scholarship normally grouped as Screen Theory, the cinema "produces" the spectator, who passively accepts the "subject position" constructed by the cinematic apparatus.[16]

Many film historians and cultural studies scholars view the Hollywood spectator as only slightly less passive than the spectator the Screen Theorists suppose. Some characterize the spectator as the chump of Hollywood's marketing machine, "good consumers" exposing themselves unthinkingly to Hollywood's devious manipulations. Barbara Klinger argues that the entertainment industry creates a "fascinated spectator," who, inundated with "mass media gossip," becomes "the good viewer solicited by the commercial apparatus."[17] Justin Wyatt attributes the success of many post-studio-era hits to Hollywood's reliance on "high concept," which includes easily marketed storylines, incessantly repeated poster imagery, saturation with trailers and promotional videos, and "pre-sold" factors, such as stars, musical soundtracks, or popular source material.[18] Theodor Adorno views mass media audiences as "powerless" in the face of a centralized "culture industry," which forces conformity to "that which exists anyway" and leads ineluctably toward "dependence and servitude."[19] Jon Lewis ends his textbook on American cinema history by noting Hollywood's capacity to mastermind the entertainment purchased by unwitting audiences: "If there is to be an end of cinema, we can be sure it will be an event the Hollywood studios have planned for and are now engineering. . . . [I]t's not like there will be nothing for us to pay for and watch in the future. The likes of Time Warner and

Disney will see to that."[20] All such accounts of Hollywood spectatorship view filmgoers largely as victims of ideology, mass media, and Hollywood formula, not advocates for their own entertainment.

But Hollywood studios cannot simply engineer what people enjoy. Hollywood chases public taste at least as much as it shapes it. If filmgoers were really so passive and indiscriminate, then one would expect most Hollywood movies to make money in theatrical release, since the same forces that shape and promote profitable films also shape and promote unprofitable ones. But most Hollywood movies fail at the box office, despite a production's effort to appeal to the same audience that sees profitable films, and despite that a film might have the same bourgeois ideology, star power, presold factors, and marketing synergies supporting it. The accounts of Hollywood cinema that presume a passive spectator cannot explain the commercial failure of *Lost Horizon* (1937), *Cleopatra* (1963), *The Fall of the Roman Empire* (1964), *Howard the Duck* (1986), *The Bonfire of the Vanities* (1990), *Waterworld* (1995), *The Avengers* (1998), *Battlefield Earth* (2000), *Catwoman* (2004), *King Kong* (2005), *Knight and Day* (2010), *John Carter* (2012), and countless other flops that have enjoyed the same industrial advantages as those that benefited the box office hits.

I do not mean to equate box office performance with aesthetic value. Aesthetic analysis cannot explain the commercial success of movies that seem almost universally scorned—*The Trial of Billy Jack* (1974), for instance. To account for a film's commercial success, we would have to examine nonaesthetic factors, such as cultural beliefs, marketing, product tie-ins, and the economics of presold properties. But quality must factor *somehow* in a film's reception. When a Hollywood movie fails at the box office, even when it exploits the industry's time-tested formulas for commercial success, it often means that the movie is no good. A persuasive account of the appeal of Hollywood cinema must explain why people enjoy watching some movies and not others.

This book's aesthetic approach to Hollywood cinema assumes a mentally active and engaged spectator, one who performs cognitive work. The fact that people typically find Hollywood movies fairly easy to watch does not mean that spectators are inactive or disengaged. An inactive or disengaged spectator, I presume, is bored. It also assumes that, to understand what makes individual Hollywood movies valuable to people, we must analyze artistic properties and spectators' moment-to-moment experiences of them.

Although we will study both ordinary and extraordinary aesthetic achievements, we should judge Hollywood by its best works—by its demonstrated *capacity* as an art form. If the Hollywood film industry succeeds in delivering aesthetic pleasure both routinely and, at times, in an outstanding way, then we should ultimately regard Hollywood cinema as an artistic achievement, not merely a commercial success. Most operas are mediocre, too, and we judge Shakespeare by his outstanding plays, not *Timon of Athens* and *The Life and*

Death of King John. Fans of Hollywood cinema can generally name dozens or hundreds of movies that have offered them exhilarating, memorable, even life-changing experiences. People develop their own film libraries of Hollywood movies and watch them numerous times over. They seek out Hollywood movies not just routinely but with excitement and appetite and think about movies they have enjoyed with affection and enthusiasm. Hollywood's reassuring ideologies, accessibility, commercial aesthetic, industrial dominance, and marketing strategies hardly account for such passionate engagement with artworks *for their own sake.* To fully understand that type of engagement, we must study the ways in which Hollywood films excite aesthetic pleasure.

Toward that end, this project sets out to explain: (1) the intrinsic properties characteristic of Hollywood cinema that induce aesthetic pleasure; (2) the cognitive and affective processes, sparked by Hollywood movies, that become engaged during aesthetic pleasure; and (3) the exhilarated aesthetic experiences afforded by an array of persistently entertaining Hollywood movies. Wherever we are in this study, we will always be working on one or more of those three tasks.

WHAT IS AESTHETIC PLEASURE?

I do not propose to address any philosophical controversies in aesthetics, which are legion. Instead, I want to take a pluralistic approach to defining aesthetic pleasure so as not to constrain our study too tightly to a single definition.

Aesthetic properties in artworks, aestheticians agree, are intrinsic and observable, involving the moment-to-moment direct experience of a work during the course of its unfolding and immediately afterward. Unlike some other types of engagement with artworks—historical, economic, social, etc.—aesthetic engagement requires perception of an artwork's sensory properties, which, in the case of cinema, include shots, lighting, performances, sound devices, plot devices, and so on, in other words, any cinematic property that we take in through our eyes and ears. "Lovers of beauty," philosopher Nick Zangwill writes, "are indeed lovers of sights and sounds."[21]

Aesthetic pleasures are not merely sensory, however. Sensory pleasures are passively borne, induced by stimuli, such as ice cream, that excite our faculties of sight, hearing, smell, taste, or touch. As I discuss in chapter 5, Hollywood offers sensory stimulation through attractive faces and bodies, spectacular scenery, and other devices designed primarily to appeal to our desire for visual or auditory arousal; however, such experiences are not always aesthetic. For an artwork's sensory properties to lead to aesthetic pleasure, the perceiver must not only feel localized sensations but also engage with the work through some form of mentation. When one enjoys a Hollywood car chase aesthetically, for example, one does not just experience the arousal that comes from observing high-speed turns

and crashes; one might also apprehend the relationships and dependencies between the sensory properties of the chase and other components of the movie, such as its plot, themes, characterizations, meaning, or overall design. Unlike sensory pleasure, aesthetic pleasure involves *thought* of the artwork's character, content, or structure.

Philosophers have proposed various other earmarks of aesthetic experience, including, for instance, that it involves some evaluation, reflection, contemplation, or sensitive discrimination of the object.[22] Hence, the observation, "The lighting is high contrast," for many aestheticians, would not constitute an aesthetic observation, whereas "The high-contrast lighting is mysterious" would, because it demonstrates taste or perceptiveness and expresses an appraisal of the work. In this aesthetic study, we will engage with cinema's sensory properties so as to judge whether the films are beautiful, ugly, interesting, dull, suspenseful, funny, pleasing, or exhilarating, or whether they exhibit other properties that require a human sensibility to appreciate.[23] And we shall use the broad term *appreciation* for all such engagement.

To summarize, for the purposes of this study, we define aesthetic pleasure as *a pleasure of the mind, dependent on an artwork's sensory properties, involving appreciation of the work's character, content, or structure.*[24] We furthermore conceive of pleasure itself as a broad category that includes any intrinsically rewarding emotional experience (which might involve fear, sadness, anxiety, etc.). Our working definition of aesthetic pleasure must remain broad so that we may address all of the pleasures of Hollywood cinema that discerning readers would regard as aesthetic.

WHAT IS HOLLYWOOD CINEMA?

Geographically, Hollywood signifies a district in central Los Angeles in which some motion picture companies established facilities for making movies in the teens of the twentieth century. Hollywood also signifies a filmmaking process, known as "studio filmmaking." Hollywood furthermore denotes an industrial model: Hollywood movies, some say, are those produced, financed and distributed by major studios, rather than by independent companies, which make "indies." For an aesthetic study of Hollywood, such definitions are useless.

The industrial distinction between Hollywood and independent cinema cannot help us understand Hollywood aesthetics. After the collapse of the studio system in the 1950s, independent production companies blossomed. Since then, independent companies have sought to address product shortages in the film industry by producing and distributing films that would previously have come under the purview of the studios. For instance, the action science-fiction film *Terminator 2: Judgment Day* (1991), produced by Carolco and distributed by TriStar Pictures, was financed and distributed outside of

the Hollywood studio system. Technically, it's an indie. But only a stickler would insist that *Terminator 2* is not a Hollywood movie. Even during the height of the studio system, independent companies produced numerous films—such as *Way Down East* (1920, United Artists), *A Star is Born* (1937, Selznick International Pictures), *It's a Wonderful Life* (1946, Liberty Films), and *Red River* (1948, Monterey Productions)—that, from an aesthetic standpoint, we could not distinguish from studio films.

I want instead to define Hollywood cinema by a set of formal practices and by its target audience. Whether a film was produced, financed, or distributed by a major studio or an independent company, whether a foreign production company supplied funding, whether it was shot in Hollywood or somewhere else, we shall call it a Hollywood film if it comes, in some way, out of the American film industry, if it has been designed to appeal to mass audiences, and if it obeys narrative and stylistic practices typical of studio filmmaking.

That level of generality enables us to study historical trends in Hollywood filmmaking, while also examining Hollywood as a group style that has remained, in some fundamental ways, unchanged for a century. Richard Maltby argues that "Hollywood's essential business has remained the same: entertaining its audience, producing the maximum pleasure for the maximum number for the maximum profit. The continuity of its economic purpose enables us to make generalizations about Hollywood over a period spanning nearly a century."[25] The American commercial film industry's persistent effort to entertain huge audiences has caused it to adopt a set of stable practices intended to appeal to spectators broadly and cross-culturally.[26] We will study those practices as a group style and also trace some of their historical development and variation.

A POETICS OF HOLLYWOOD CINEMA

"Art being a thing of the mind, it follows that any scientific study of art will be psychology. It may be other things as well, but psychology it will always be."

—Max J. Friedländer, art historian and curator[27]

This book examines the aesthetic properties of Hollywood films and the effect of such properties on spectator experience. For support, it draws primarily on two fields: film history and the modern science of experimental psychology.

A trove of historical research pertaining to the production, exhibition, and reception of Hollywood movies can assist the aesthetic researcher in understanding audiences' experiences of individual films and of Hollywood cinema generally. Movie reviews, box-office statistics, technical advancements, contemporaneous essays, trade journal articles, production histories, marketing information, awards and nominations, fan websites, and

biographical studies all provide historical evidence of a film's reception, as well as the context of its production and initial exhibition, which can help guide, complicate, and advance aesthetic analyses. Changes in the industry create new constraints on the form, function, and audience of Hollywood cinema, and this project situates aesthetic analyses within the context of film history, film reception, and developments in film and distribution technology.

Although primarily an "analytical poetics," which aims to study aesthetic properties across a range of works, this book also performs what Aleksandr Veselovskii called an "historical poetics," which seeks to trace the course of development of artistic forms.[28] Hence, we shall, when relevant, try to understand how Hollywood films assumed certain forms during the period of their production. In short, although this book addresses features of Hollywood cinema that have remained consistent over decades—emphasizing enduring principles that comprise Hollywood's group style—several of the analyses also explain how historical contingencies have shaped film reception and film form.

The other supportive field is psychology. Some readers may find it strange that a book on cinema so frequently references empirical literature in psychology. This project's object of study is Hollywood cinema, but Hollywood movies create aesthetic pleasure when they interact with a mind. A projected film image is not an aesthetic object unless someone experiences it or, at least, someone has designed it for that purpose. So, to accomplish our goals, we must understand both the intrinsic properties of Hollywood movies and the mental processes they excite. This interaction constitutes an empirical psychological event—an actual experience—and experimental psychologists have studied the event and related ones for many decades.

Scholars in the humanities sometimes object to using empirical research to understand the arts, which some believe are not suited to empirical testing. They believe that art criticism, like art itself, should be interpretive and intuitive, more sensitive to artistic values and unconstrained by the limitations and biases of science.[29] They oppose a "scientistic" approach to the arts that they regard as overly deferential to scientific methods and that, according to D. N. Rodowick, "becomes a de facto epistemological dismissal of the humanities."[30]

I have two objections to this position.

First, the empirical methods employed by scientists, although limited to what researchers can currently study empirically, supply some of our most reliable knowledge. The reliability of the scientific method accounts for why, when the situation poses dangers and the stakes are high (flying airplanes, building skyscrapers, performing heart surgery, and treating psychosis), we depend on empirically demonstrated results, not our intuitions. Scientifically obtained knowledge about human psychology can increase our understanding of art. Because the scientific method depends on random sampling,

repeat testing, falsifiability, and predictive capability, it can offer us fairly dependable information about human perception, cognition, and emotion. At the very least, it can help us understand whether a theory of aesthetic experience corresponds to the current understanding of the human mind.

Second, the social sciences could fill a library floor with scientific studies of the perception, cognition, and aesthetic appreciation of cinema and the other arts, and it would be irresponsible to proceed as though such research does not exist. As humanities scholars, we should be willing to accept feedback from empirical researchers in order to deepen and adjust our understanding of film aesthetics in light of scientific discoveries. Hence, this project draws on empirical research in the areas of emotion, arousal, insight, humor, hedonic psychology, aesthetic psychology, interest, processing fluency, coping, and expertise, and it evaluates theoretical claims about aesthetic experience in light of that work. Because empirical literature in psychology tends to deal with average responses, it has particular relevance to our understanding of Hollywood cinema; mass art forms, by definition, appeal to your average consumer.

In short, this project's use of empirical literature in psychology does not dismiss other approaches (The project takes mostly non-scientific approaches; it is not a science book). Nor does it excessively valorize science. The empirical literature merely adds to our base of knowledge.

PARTS AND CHAPTERS

The book's argument separates into five parts.

Part 1, "Hollywood Classicism and Deviation" (chapters 1 and 2), explains Hollywood's general principles for creating aesthetic pleasure for mass audiences. Chapter 1 explains the ways in which Hollywood balances easy understanding and cognitive challenge. Chapter 2 illustrates that balance with analyses of *His Girl Friday* (1940) and *Double Indemnity* (1944).

Each of the remaining four parts addresses a fundamental component of Hollywood's aesthetic design: narrative, style, ideology, and genre. Each part begins with a theoretical essay on the aesthetic pleasures afforded by one component, including supportive research in film history and experimental psychology, followed by one or two chapters that illustrate the essay's more complex points with exemplary case studies. These studies also demonstrate the usefulness of the proposed theories for understanding aesthetic pleasures afforded by film cycles and genres, individual films, moments in films, and film techniques.

Telling stories is Hollywood's primary formal concern, and Part 2, "Narrative" (chapters 3 and 4), examines the aesthetic pleasures of Hollywood cinema's approach to

storytelling. Chapter 3 examines the cognitive processes at work when a film cues specta-
tors to construct a film's story in their minds, and it explains the ways in which Hollywood
movies both ease and complicate the spectator's process of story construction. Illustrated
with examples from screwball comedies, twist films, and mysteries, the chapter offers a
new theory of Hollywood storytelling aesthetics—namely, that film viewers take plea-
sure when Hollywood narratives stimulate moments of free association, insight, and
incongruity-resolution. The chapter also explains some individual differences in viewer
preferences for more- or less-challenging narratives. Chapter 4 illustrates the theory
through an extended analysis of an unusual narrative pattern in *Red River* (1948), which
at times violates Hollywood's cardinal rules regarding narrative unity, probability, causal-
ity, and story logic. Disunity in this classical Hollywood narrative excites viewers' creative
problem-solving processes.

Although fundamentally a narrative cinema, Hollywood employs film technique—
cinematography, music, editing, costumes, special effects, and other stylistic devices—
to enhance the pleasures of the filmgoing experience. Part 3, "Style" (chapters 5 and 6),
examines the aesthetics of Hollywood's stylistic systems and the strategies of various
films operating within those systems. Chapter 5 examines the ways in which Hollywood
film style both supports a film's storytelling function and offers aesthetic pleasures inde-
pendent of storytelling. It also examines instances in which Hollywood film style seems
in competition with story, with genre, or with itself for control of a film's mood and mean-
ing. Chapter 6 offers an extended analysis of complex stylistic tendencies in *Raging Bull's*
(1980) cinematography, editing, and sound devices. *Raging Bull's* style is at times so dis-
unified that the film often seems on the verge of falling apart stylistically.

Much in this book might be controversial, but I suspect that Part 4, "Ideology," which
offers a new approach to ideological film analysis, might be the most tendentious. Part 4
(chapters 7, 8, and 9) sets out to show that Hollywood movies promote particular beliefs
and values not to advance an ideological agenda, as previous scholars have argued, but
rather to maximize aesthetic pleasure. In chapter 7, we examine the ways in which a film's
ideological properties—inasmuch as Hollywood embeds such properties in the artistic
design of its films—contribute to aesthetic pleasure when they intensify, or when they
complicate, viewers' cognitive and affective responses to a film's plot. The chapter also
offers this book's most complete account of the ways in which Hollywood movies cre-
ate pleasure by guiding viewers' emotional experiences. Chapter 8 demonstrates how
ideological constraints in studio-era Hollywood helped shape the aesthetic properties
of Hollywood crime films during the period of the Production Code Administration.
Chapter 9 examines the ways in which an unconventional use of genre devices in *Starship
Troopers* (1997) leads to ideological complexities that pose challenges for spectators try-
ing to make sense of the film's form and meaning. Together, chapters 8 and 9 illustrate the

aesthetic value (and, in the case of *Starship Troopers*, the commercial risks) of Hollywood films that thwart efforts to master their ideological properties.

Hollywood makes quintessential genre films, and any complete account of Hollywood aesthetics must explain the pleasures afforded by genre filmmaking. Part 5 (chapters 10, 11, and 12) examines the Hollywood genre system. Chapter 10 studies how genre eases viewers' grasp of narrative information, offering the pleasure of returning, as experts, to familiar characters, settings, and scenarios. The chapter also explains the ways in which genres develop novel and complex properties that counter a culture's growing genre expertise. Chapters 11 and 12 examine the aesthetic value of novelty and complexity, respectively, in a genre's evolution. Chapter 11 studies how one convention of the Hollywood musical—that characters spontaneously burst into song without realistic motivation—emerged, evolved, and disappeared, as well as the ways in which New Hollywood filmmakers transformed it, exposed it, and reclaimed it in ways that added novelty to spectators' aesthetic experiences. Chapter 12 examines filmmakers' experimentation with the conventions of the western, focusing on efforts to complicate the figure of the western hero.

Since readers of this book might not share the same disciplinary knowledge, I have also included a glossary at the end that defines some common jargon in psychology, aesthetics, filmmaking, and film studies.

By analyzing Hollywood cinema in the areas of narrative, style, ideology, and genre, this book attempts a comprehensive appraisal of Hollywood cinema's capacity to provide aesthetic pleasure. It endeavors to explain how Hollywood creates, for vast numbers of people, some of their most exhilarating experiences of art.

PART
1

HOLLYWOOD CLASSICISM AND DEVIATION

We must ultimately be able to account for the most basic fact of aesthetic experience, the fact that delight lies somewhere between boredom and confusion. If monotony makes it difficult to attend, a surfeit of novelty will overload the system and cause us to give up: we are not tempted to analyse the crazy pavement.

—E. H. Gombrich[1]

The Hollywood Aesthetic

When I build something, I often take it to the very edge of its collapse, and that's a very beautiful balance.

— Artist Andy Goldsworthy, from *Rivers and Tides: Andy Goldsworthy Working with Time* (2001)

HOLLYWOOD CINEMA OFFERS VIEWERS CERTAIN PREDICTABLE PSYCHO-logical experiences, which, at a general level, include processing fluency, cognitive challenge, emotional intensity and variety, imagination, and arousal. Such experiences are rewarding to an individual seeking understanding, emotional engagement, cognitive play, and psychological stimulation. The arts are well suited to satisfy these goals, and Hollywood cinema, as the chapters of this book will demonstrate, caters to them in ways that maximize aesthetic pleasure for mass audiences.

Two of these psychological experiences—processing fluency and cognitive challenge—run counter to each other because the first one reflects the easiness of an artwork and the second its difficulty. Every work of art must balance the extent to which it fosters one and the other. This chapter will explain the balance that Hollywood strikes.

CLASSICISM AND DEVIATION

In their aesthetic construction, Hollywood films counterweigh two tendencies. The first we will call, for convenience, Hollywood's "classical" tendency, which stretches toward unity and uniformity. Art commentators normally regard an art form as classical when it (1) changes relatively little and respects tradition; (2) obeys artistic norms, follows

standard practices, and discourages overly idiosyncratic expression; and (3) emphasizes certain aesthetic properties, including unity, decorum, mimesis, craftsmanship, and control.[2] Although relatively unified and uniform, classical artworks are not all easy to understand; Beethoven composed classical symphonies that demand a lot from listeners, particularly novice listeners. However, when a classical art form, such as Hollywood cinema, is also a mass art form, then artists can exploit classical practices to make their works accessible to mass audiences. Mass audiences tend to enjoy especially uniform and unified artworks that are easily understood.

Noël Carroll attributes the wide appeal of mass art to its accessibility. For Carroll, the mass artwork's effort to appeal to common factors among huge populations

> is not a failing, but rather a design consideration, given the function of mass art. For it is the point of mass art to engage mass audiences, and that mandates an inclination toward structures that will be readily accessible—virtually on contact and with little effort—to audiences with widely differing backgrounds.[3]

Psychologists use the term *processing fluency* to denote the ease with which the perceiver assimilates information.[4] For Leder, et. al., processing fluency in the arts involves perceiving an object, integrating it into memory, classifying it, and cognitively mastering and evaluating it.[5] The process can occur more easily than it sounds, and researchers have shown that properties that ease processing also increase pleasure. Numerous studies have found, for instance, that people prefer prototypical, average, and easily identified objects because of the efficiency, speed, and ease of processing.[6] Studies of the "mere exposure effect" have found that people prefer familiar objects (drawings, photographs, words, even nonsense words).[7] Hollywood relies on processing fluency to attract audiences seeking easy and familiar aesthetic experiences.

The propensity of mass art to create accessible entertainment, however, cannot fully account for the aesthetic value of Hollywood cinema. It if did, then mass audiences would always prefer easy artworks over more difficult ones. We could not, then, account for the enduring attraction of relatively challenging Hollywood films, such as *The Big Sleep* (1946) and *The Godfather, Part II* (1974). In fact, contrary to empirical studies that demonstrate that people prefer fluently processed works, several other studies have shown that people prefer works that contain moderate amounts of novelty, complexity, incongruity, dissonance, and ambiguity.[8] In maximizing aesthetic pleasure for mass audiences, Hollywood balances its classical tendency against a tendency to make artworks challenging. We might call this aspect of Hollywood cinema its "deviant" tendency, since it turns films away from classical norms of unity and uniformity.

In their review of the empirical literature on aesthetics, psychologists Thomas Armstrong and Brian Detweiler-Bedell distinguish the "calm pleasure" of processing fluency from the "exhilarated pleasure" of what they term "beauty": "Beauty is the exhilarating feeling that something complex, perhaps to the point of being profound, might yield to understanding."[9] Novel and complex objects, they argue, arouse heated mental activity—attentiveness, alertness, excitedness—and require more effortful processing as the perceiver investigates the object with the hope of understanding it. The prospect of achieving mastery over a challenging object, they argue, increases positive emotions, such as cheerfulness and exhilaration.[10] In addition to making a lot of fluently processed movies, the Hollywood film industry also makes moderately difficult ones that tend to appeal to cinephiles, experienced filmgoers, and filmgoers seeking more challenging aesthetic experiences.

Both kinds of artworks, the authors propose, create pleasure by satisfying a perceiver's epistemic goal: either to maintain knowledge or to expand it. The distinction between these goals helps us understand two discrete pleasures afforded by the arts. A fluently processed object, they argue, enables the spectator to avoid novelty and complexity in order to enjoy the "calm pleasure" of immediate understanding. A challenging object, by contrast, enables the spectator to approach novelty and complexity in order to enjoy the "exhilarated pleasure" of potential understanding.[11] As mass artworks, Hollywood movies must remain accessible to vast numbers of people, but to arouse the exhilarated pleasure of potential understanding they must also pose challenges to mastery. The balance of these competing tendencies accounts for the stability of Hollywood films, even Hollywood experiments such as *Citizen Kane* (1941), *Vertigo* (1958), *2001: A Space Odyssey* (1968), *Nashville* (1975), and *Raging Bull* (1980). Such films risk various forms of disharmony, but they still feel anchored to a familiar, reliable structure.

Together these two tendencies—the first, common in mass art forms, toward accessibility and the second, common among many enduring artworks, toward cognitive challenge—form a healthy tension within Hollywood's most aesthetically valuable productions. Both tendencies contribute to aesthetic pleasure, albeit of a different sort. The first tendency enables processing fluency: It relies on formulaic structures and easily mastered artistic devices, marrying Hollywood cinema to a set of time-tested aesthetic properties (unity, clarity, etc.) that make the films pleasing to mass audiences. The second tendency creates cognitive challenge: It stimulates audiences with more demanding aesthetic properties (disunity, ambiguity, etc.) that can lead spectators to a more elated response.

To understand how Hollywood generates these two sorts of pleasures, let us separately examine the formal properties characteristic of Hollywood's classical and deviant tendencies.

HOLLYWOOD'S CLASSICAL TENDENCY:
UNIFORMITY AND UNITY

The uniformity and unity of Hollywood cinema has already gained much scholarly atten-
tion and received its most definitive treatment in *The Classical Hollywood Cinema: Film
Style & Mode of Production to 1960* by David Bordwell, Janet Staiger, and Kristin
Thompson. We should rehearse some of the authors' main findings.

In establishing the uniformity of Hollywood cinema's formal design, Bordwell stud-
ied, on the one hand, how Hollywood sees itself (as represented in trade journals, techni-
cal manuals, memoirs, publicity handouts, and other internally generated literature) and,
on the other hand, the formal properties of a large sample of typical Hollywood films of
the studio era. In all, he found that the system functioned historically as a set of norms
that established "preferred practices" and set "limits upon invention"[12] The Hollywood
paradigm created a set of "bounded alternatives" that individual filmmakers could draw
upon and even experiment with, provided they did not violate the paradigm altogether.[13]

Staiger notes that "standardization" made Hollywood production fast, simple, and
profitable, establishing "norms of excellence" and enabling the mass production of expen-
sive entertainment products that were technically complicated to manufacture. "The
industry encouraged innovations, but they had to support or at least not interfere with
the controlling standard. Thus, the standard set up boundaries for variation."[14] Several
industrial mechanisms, she notes, established normative practices and quickly dissemi-
nated them throughout the industry, "ranging from stylistic practices (disseminated by
advertising, writers' and cinematographers' groups, how-to books, trade papers, and crit-
ics), to technology (the professional engineers' society, cinematographers' clubs, projec-
tionists' union), to business, production, and exhibition practices (trade associations and
trade papers)."[15] By the late teens of the twentieth century, the industry could rapidly
disseminate prevailing standards of what we now term "classical filmmaking." "The indus-
trial discourse," Staiger writes, "explains why the production practices of Hollywood have
been so uniform through the years and provides the background for a group style" that
has remained remarkably stable since the early twentieth century.[16]

Bordwell argues that the Hollywood group style prizes unity as "a basic attribute of
film form."[17] Following Beardsley, we shall regard unity as a function of two factors: *com-
pleteness* ("it has all that it needs") and *coherence* ("it all fits together").[18]

Hollywood storytelling demonstrates *completeness* in that it typically reveals the infor-
mation a spectator needs to know in order to understand the plot as it unfolds. A period of
exposition at the beginning of a film communicates to the audience relevant background
information about the characters, their world, and the impending struggle. Characters
exhibit traits and behaviors that are consistent across the film. Stories end decisively with

a clear resolution of the problem, at which point the spectator generally experiences closure and an impression of absolute truth, reinforcing narrative completeness.[19]

Stylistic norms also enhance completeness. Scenes typically begin with a long view that establishes the scene's locale, its temporal relationship to earlier scenes, the relevant characters, their spatial positions, and their mental states. As a scene progresses, Hollywood films cut up the established space into closer views, using setting, lighting, music, composition, and camera movement to highlight the thoughts and actions of the characters as they form goals, struggle, and make decisions.[20] Together, stylistic norms enhance completeness by giving spectators the impression that the film has not withheld anything necessary to properly understand the story as it unfolds.

Hollywood cinema is *coherent* both in the figurative sense of "logical and consistent" and in the literal sense of "stuck together" (i.e., separate devices in a movie seem bound to one another). Story events connect tightly and logically, unlike the more loosely connected events in European and Asian art films. Separate stylistic devices serve some of the same functions (e.g., to focus audience attention) or share some of the same properties (e.g., romantic music accompanies a romantic scene). The mere repetition of narrative and stylistic devices in a Hollywood film enhances coherence by encouraging spectators to connect separate elements of a film's form. Hollywood movies often repeat scenarios (scenes of latrine inspection in *No Time for Sergeants* [1958]), visual devices (split-screen telephone conversations in *Pillow Talk* [1959]), sound devices (the musical motif associated with the shark in *Jaws* [1975]), or lines of dialogue (puns in *Airplane!* [1980]). Stylistic and narrative repetitions create patterns of coherence, uniting scenes, characters, sounds, and visuals and connecting a film's different parts. The logic, consistency, connectedness, and repetition of artistic devices in Hollywood cinema give the impression that a film's separate pieces work together to form a coherent whole.

The principles of uniformity and unity restrain the choices available to Hollywood filmmakers in the areas of narrative, style, ideology, and genre. Later sections of this book will separately explain the ways in which Hollywood movies tend toward uniformity and unity in each area; however, in general, we can summarize the tendencies as follows:

- *Narrative*: Hollywood cinema makes storytelling devices easy to grasp, ensuring that events and their causal connections remain clear and unified.
- *Style*: Stylistic devices reinforce causal connections, establish continuous time and space, follow uniform patterning, and enhance the clarity and expressiveness of a film's mood and meaning.
- *Ideology*: A Hollywood film typically presents a coherent worldview that enables spectators to easily evaluate situations and that guides them toward intense emotions.

• *Genre*: The genre system features conventional topoi that make it easier to identify, evaluate, and categorize narrative information and that offer spectators the pleasure of returning, as experts, to familiar characters, settings, and scenarios.

Together, Hollywood cinema's narrative, stylistic, ideological, and genre properties provide layers of unity and uniformity that make the films feel complete and coherent.

HOLLYWOOD'S DEVIANT TENDENCY: NOVELTY AND COMPLEXITY

Total unity is boring. A musical composition made up of one interminable note demonstrates complete unity, but it would not generate enough variation to create pleasure. Even minimalist music contains *some* variation. Bordwell says that "Hollywood itself has stressed differentiation as a correlative to standardization" because the industry values novelty as well as uniformity.[21] Staiger notes the economic value of product differentiation and the efforts of American film companies, beginning around 1910, to stress differentiation in film advertising: "The words 'novelty' and 'innovation' became so common as to be clichés."[22] Product differentiation, she says, offered grounds for "competition and repeated consumption" of Hollywood films, encouraging innovation and variation in production practices.[23] Indeed, the industry cultivated and rewarded "innovative workers," such as John Ford, Cecil B. De Mille, and Gregg Toland, who pushed the boundaries of standard practice, because innovation increased box office returns by differentiating one film from another.[24]

Artworks add variety to our aesthetic experience by incorporating novel or complex properties, which stimulate cognitive activity by violating patterns, arousing the senses, and straining or thwarting the perceiver's efforts to unify the artwork. *Novelty* refers to unfamiliar, unusual, or idiosyncratic properties in an aesthetic object; its correlative is uniformity. Beardsley defines *complexity* as a factor of "the number of parts, and of differences between them, to be found within the aesthetic object."[25] He sees complexity as a correlative to unity, since similarities increase unity whereas differences increase complexity.[26] Both novelty and complexity impede perceivers' efforts to process an artwork, although they do so in different ways: Novelty disrupts expectations, whereas complexity confronts the perceiver with diverse information. Both novelty and complexity make our experience of artworks dynamic, activating our attention and focus and making cognition more vigorous and varied.

While Hollywood's classical tendency leads to a high degree of uniformity and unity in the areas of narrative, style, ideology, and genre, its deviant tendency enables a moderate amount of novelty and complexity in each area. Novelty and complexity expand

the aesthetic options available to Hollywood filmmakers and, thereby, the potential for product differentiation and box office return. Subsequent parts of this book will independently examine the aesthetic pleasures afforded by deviations in each area, but let us begin the discussion here by describing, in abstract terms, the ways in which Hollywood cinema incorporates novel and complex properties:

- *Narrative*: Hollywood films may alter their story logic, violate narrative patterning, or thwart the plot's coherence or completeness.
- *Style*: A film's style may function independently of narrative, or it may diversify or temporarily breach classical principles, and stylistic devices may compete with the narrative, with the genre, or with each other for control of a film's mood and meaning.
- *Ideology*: A film's ideology may contradict itself or other aspects of the narration, complicating viewers' beliefs, values, and emotions.
- *Genre*: Film genres, despite popular thinking, do not endlessly replay the same scenarios; genres evolve, adding novel topoi or complicating existing ones as viewers develop genre expertise and grow overly familiar with prevailing conventions.

Novelty and complexity in Hollywood narrative, style, ideology, and genre stimulate spectator cognition and lead spectators toward the exhilaration of expanding and reshaping their knowledge.

Many philosophers view the pleasure of art and aesthetics as a *pleasure of cognitive activity*. Kant's conception of beauty involves "the free play of the cognitive powers."[27] Levinson says that the pleasure of art is "typically a pleasure in *doing* something— listening, viewing, attending, organizing, projecting, conjecturing, imagining, speculating, hypothesizing, and so on."[28] According to this line of thinking, artworks typically offer pleasure by giving our minds work to do. Dewey emphasizes the cognitive challenges that aesthetic experience demands as the perceiver attempts to understand an artwork by resolving disparate properties: "That which distinguishes an experience as esthetic is conversion of resistance and tensions, of excitations that in themselves are temptations to diversions, into a movement toward an inclusive and fulfilling close."[29] Similarly, Beardsley commends art's capacity to create exhilaration through cognitive challenge. He argues that one symptom of aesthetic pleasure is

a sense of actively exercising constructive powers of the mind, of being challenged by a variety of potentially conflicting stimuli to try to make them cohere; a keyed-up state amounting to exhilaration in seeing connections between percepts and between

meanings, a sense (which may be illusory) of achieved intelligibility. For short: *active discovery*.[30]

Beardsley locates aesthetic pleasure in the perceiver's effort to understand an artwork. "Active discovery" leads to the "exhilaration" of seeing connections, real or imagined, among the object's features and of attaining, or attempting to attain, mastery of the artwork.

To value Hollywood cinema for its propensity to create cognitive challenges runs contrary to much film scholarship. Many film scholars, I noted in the introduction, view Hollywood cinema as exceedingly accessible and obvious, and many regard the Hollywood viewer as essentially passive. I believe a more moderate position better explains Hollywood's approach to creating aesthetic pleasure: Hollywood seeks an aesthetically productive balance between immediate understanding and cognitive challenge so as to both please mass audiences and sustain their interest.

Novelty and Complexity in *Speedy* and *City Lights*

Speedy (1928), starring Harold Lloyd, and Charlie Chaplin's *City Lights* (1931) illustrate the type of moderate novelty and complexity that Hollywood cinema readily accommodates without upsetting the uniformity and unity of classical filmmaking.

These two popular comedies, made during the transitional period between silent and sound cinema, featured comedians who had enjoyed enormous commercial success during the 1920s. Chaplin had been making a feature film every two or three years, while Lloyd was starring in one or two features a year, making Lloyd's movies more profitable than Chaplin's as a whole, although Lloyd's films have not received as much aesthetic attention since their initial release. Mostly remembered for his classic *Safety Last* (1923), Lloyd made seventeen other lesser known features, including *Speedy*, as well as almost two hundred shorts. I hope to demonstrate that *City Lights*, by complicating its ending only slightly more than a typical comedy of the period, creates increased aesthetic interest; the ending has certainly received more aesthetic attention in film scholarship than anything in Lloyd's work. Both films are accessible and pleasing, both fundamentally classical in structure, but the ending of *City Lights* puts somewhat more emphasis on deviation from the norm.

In *Speedy*, Lloyd plays Harold "Speedy" Swift, a ne'er-do-well who loses a series of jobs because of his fanatical interest in baseball. Seeking to marry his girlfriend, Jane, he must wait until her grandfather, Pop Dillon, the owner of New York's last horse-drawn trolley, has settled a dispute with the unscrupulous owner of a street-car company trying to ruin Pop's business. As is typical of the period's comedies, the protagonist saves the day

in a race against the clock, achieves personal success, and, in the process, wins the heart and marriage consent of his love interest.

The filmmakers delay the inevitable ending and add interest to the storytelling by inserting comic routines and plot diversions that, without transgressing classical Hollywood unity, vary the plot and style of the film. For instance, we witness Harold performing a series of dexterous gags as a soda jerk and an episode in which Harold, now a cab driver, meets the real Babe Ruth, who invites him to a baseball game. At one point, Harold and Jane visit Coney Island, affording the cinematographer an opportunity to film on a flying carnival airplane, Tilt-A-Whirl, Steeplechase, and various other moving rides in the famous amusement park, moments of spectacle within the classical plotting.

Although each situation adds novelty and diversity to the storytelling, each one also integrates into the film's larger storyline. The soda-jerk gags show Speedy's physical dexterity, which proves advantageous during an extended climax when he must defend the trolley against hired thugs trying to steal it. The Babe Ruth episode draws on Speedy's established interest in baseball and also provides an occasion for another employer to fire him. The Coney Island visit, where the lovers enjoy the day after Speedy's latest job loss, convinces Speedy that he wants to marry Jane. The episodes in no way thwart classical practice, but they add interest to the storytelling by providing opportunities for spectacle, humor, plot diversity, and stylistic variation. The mental work sparked by these diversions is minimal but not negligible. The movie may be easy to watch, but it still requires spectators to *do* something: project future events, integrate present events with previous plot elements and character traits, and process novel visual information. Like any routine Hollywood comedy, however, *Speedy* never offers so much cognitive challenge that it jeopardizes spectators' immediate understanding. For typical viewers, the film remains understandable on contact.

City Lights takes a few more risks. By only moderately enhancing novelty and complexity at its ending, the film creates enough cognitive challenge to give it lasting interest, all the while remaining within the bounds of classical practice. In the film's last scene, the Little Tramp, after his imprisonment for theft, meets up with the formerly blind flower girl who has mistaken him for a generous millionaire. His theft, we learn, has paid for an operation repairing the girl's eyesight, and she has been searching for him ever since. The movie has forecasted the moment when she will finally recognize that he is just a tramp, not the millionaire he has been posing as all along.

The final scene unites with earlier scenes in the film by completing the narration's causal chain of events. The scene depicts the moment the flower girl finally grasps the Tramp's real status, answering the audience's most pressing narrative questions: When will she find out, how will she find out, and how will she react? The scene also repeats narrative and stylistic devices used earlier. For instance, as before, the girl and the Tramp

exchange a flower and a coin, and—as in an earlier scene in which the Tramp stared through a window at a statue of a nude—here we see him again staring through a window at an attractive woman. The repeated devices help to connect the last scene narratively and stylistically to others in the film.

The film's ending, however, also comes off as strangely incomplete, uncomfortable, and ambiguous, not quite the conclusive reunion the film had been forecasting. When the flower girl, who has now gained her sight and opened a thriving flower shop, recognizes the Tramp by feeling his hand, we see what could be disappointment or pity in her face (or both) and an astonishing mixture of embarrassment and glee in his (video 1.1 ▶). The two characters, moreover, having lost their former rapport, seem to be experiencing the reunion in an uncomfortably mismatched way. Throughout the scene, the Tramp seems unaware of her disillusion and barely aware of anything about her, other than the fact that she can finally see. The characters are mismatched in other ways too. Formerly dejected and needy, she has grown confident and successful, whereas he has lost his bravado and looks now like a real tramp, rather than the cartoonish one of prior scenes. It is difficult to understand how the two of them will either remain together or separate. All in all, the ending shows some surprising narrative complexity and novelty, especially compared to the endings of other comedies of the period.

City Lights also demonstrates *stylistic* complexity and novelty in that the final scene's stylistic devices do not signal closure as thoroughly as one expects from the ends of Hollywood comedies of the period. The final title card, "The End," offers definitive closure, but other devices resist it. The film's last line, "Yes, I can see now," sounds more like the middle of a conversation than the closing line of a movie. The final shot does not depict a kiss (as in Chaplin's *The Gold Rush* [1925]), nor a closing door (*The Kid* [1921]), nor the Tramp waddling away from the camera (*The Circus* [1928], *Modern Times* [1936]). In the final shot of *City Lights*, a medium close-up of the Tramp's face, Chaplin stares fixedly at his co-star, delicately covering his smile with his knuckles (figure 1.1). Moreover, the last shot of the Tramp seems too short (four seconds) and fades too quickly, more like a transitional shot to a new scene than the closing shot of the movie. Finally, the scene's musical devices seem off track. Rather than reaching the coda during the final fade-out, the music reprises during the last shot, over the ending title card, and, for another twenty-five seconds, over a black frame, where it finally crescendos and ends (see video 1.1 ▶). Hence, the film does not reach full stylistic closure until more than half a minute after the last diegetic shot. Consequently, even as the plot is ending, the film's stylistic devices make it feel as though the scene is still playing on.

Admittedly, the end of *City Lights* does not demonstrate the narrative novelty and complexity of a movie by John Cassavetes or Lars von Trier, nor the stylistic novelty and complexity of Soviet Montage cinema or the French New Wave. *City Lights* is a mass

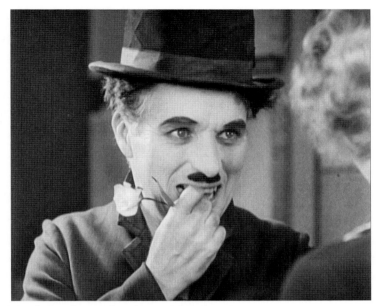

FIGURE 1.1 *The last diegetic shot of* City Lights *(1931).*

artwork, accessible to large audiences across cultures and time periods. But the ending does come off as unexpectedly dissimilar to the rest of the film, as well as to the endings of more typical Hollywood comedies of the period, such as *Speedy*. Consequently, *City Lights*, at its conclusion, poses a brief, moderate challenge to spectators, who must harmonize the ending of the film with expectations generated by earlier scenes and prior cinema experience.

FINDING THE BALANCE

We have seen that Hollywood films display both a tendency toward unity and uniformity and a correlative tendency toward novelty and complexity. But we do not yet understand how filmmakers working within the Hollywood tradition make movies both accessible and aesthetically appealing for mass audiences. How does Hollywood produce movies novel and complex enough to generate pleasure and interest but not so challenging that they overwhelm a mass audience's ability to cope?

To begin to answer that question, we must understand the relationship between pleasure, interest, and coping potential. Hence, we need to look more closely at the studies that indicate that people prefer art objects with moderate amounts of novelty, complexity, incongruity, ambiguity, and other properties that challenge spectators' cognition. The studies, many conducted by D. E. Berlyne and his colleagues, show a repeated, predictable relationship between such properties and hedonic value (usually indicated by ratings

FIGURE 1.2 *A graph of the Wundt Curve, representing the relation between arousal and "hedonic value."*

of "Pleasingness"). The graph of that relationship seems invariably to create an inverted-U figure, a pattern known as the Wundt Curve, named after Wilhelm Wundt, the pioneering nineteenth-century psychologist who observed it. Figure 1.2 shows Berlyne's representation of the Wundt curve, the X-axis indicating the "arousal potential" of a given feature (a measure of the feature's intensity) and the Y-axis indicating hedonic value.[31] The inverted-U findings indicate that subjects prefer challenging properties—novelty, complexity, etc.—in increasing intensity until some maximal level, at which point subjects start to become overwhelmed, and their pleasure diminishes and eventually turns to displeasure.

Berlyne's inverted-U findings support Gombrich's claim that "delight" from aesthetic experience "lies somewhere between boredom and confusion."[32] The findings, which, studies have shown, pertain to music, literature, movies, pictures, and other arts, are so prevalent that they have come to seem inevitable, irrespective of the properties tested for or the population studied.[33] Indeed, Berlyne's generic measures of preference do not tell us much about the value of individual artworks and take no account of subjective differences in responses to art (individual tastes, experiences, or judgments). Hence, the findings are, in some ways, trivial: We do not need hundreds of studies to tell us that most people are pleased by neither boredom nor confusion. The studies point to large-scale trends that are, by nature, generalizations—average reactions that indicate what appeals to the greatest number of people.

The very generality of the findings, however, attests to their pertinence to Hollywood cinema, a financially risky art form that must, to remain commercially viable, offer immediate pleasure to huge audiences. The Hollywood film industry tends to disregard idiosyncratic responses to art. Instead, Hollywood designs movies to appeal to very large

sectors of the world population. Recall Richard Maltby's description of Hollywood's business model: "the maximum pleasure for the maximum number for the maximum profit."[34] The Berlyne studies indicate that optimal hedonic value, among large samples, lies not at either end of the arousal scale but in the middle. Avant-garde filmmakers tend to work near the edges of the Wundt curve, but Hollywood cinema, because it targets a mass audience, seeks that optimal middle.

To my knowledge, no empirical studies have tested the relative arousal potential of various feature films, but we can speculate. *The Adventures of Elmo in Grouchland* (1999), *Sofia the First: Once Upon a Princess* (2012), and other films geared to toddlers, I gather, have little arousal potential outside of very young audiences and would, for typical adults, likely fall to the left end of the Wundt curve. By contrast, the films of baroque directors— such as Orson Welles, Federico Fellini, and Terry Gilliam—would likely fall toward the right end of the curve because of their visual intensity. Shane Carruth's *Primer* (2004), a cult favorite, would likely fall to the right end as well because of the plot's high degree of complexity and ambiguity. Indeed, we can define a *cult film* as a movie that mass audiences cannot cope with and that exhilarates those audiences that can.

Gaspar Noé's films, such as *Irréversible* (2002) and *Enter the Void* (2009), regularly elicit a negative hedonic response. Noé's extremely violent scenes and vertiginous use of strobe lights, spinning cameras, and pulsating sounds practically assault the spectator and are liable to overwhelm a mass audience. Noé belongs to the so-called New French Extremity, a movement that includes Bruno Dumont, Catherine Breillat, and other French directors whose films often toggle between minimalist scenes and scenes of such intensity that spectators might feel baffled, disgusted, and even physically ill. Dumont's *Twentynine Palms* (2003), for example, interrupts moments of minimalism (deliberate pacing, sparse dialogue and action, placid images of landscapes) with moments of aggressive sexuality and shocking, grotesque violence. A film like *Twentynine Palms* operates too much at the extreme ends of the arousal scale to appeal to vast numbers of spectators. Although some Hollywood films, such as *Rear Window* (1954), *Badlands* (1973), and *Drive* (2011), combine minimalism with intensity (albeit with far less severity than the New French Extremists), Hollywood tends to avoid the extremes and typically seeks arousal levels just before the point at which hedonic value starts to diminish among mass audiences.

Hedonic value, however, does not provide a full picture of aesthetic pleasure. When an artwork exhilarates us aesthetically, we typically do not call the work just "pleasing." Unpleasant artworks also offer aesthetic rewards, particularly when they arouse our *interest*. Interest is a "knowledge emotion" (like curiosity, confusion, and surprise), associated with thinking and comprehending.[35] Aesthetic pleasure can encompass Pleasingness (hedonic value) and Interestingness (epistemic value). Interesting works of art are often

more exhilarating than merely pleasant ones because they challenge us and excite thought, offering epistemic value as well as (or in place of) hedonic value.

When Berlyne and other researchers asked subjects to rate their "interest" in art objects, varying the same aesthetic properties, the data showed a different pattern. Whereas ratings of Pleasingness followed the curvilinear quadratic pattern of the Wundt curve, ratings of Interestingness followed a more linear path, as indicated in figure 1.3. Interestingness, Berlyne and other researchers found, increases until an object's aesthetic properties reach very high levels of intensity. Hence, after a certain level of intensity, an object grows less pleasing and increasingly interesting. Carruth and Noé, we might say, make interesting movies, not pleasing ones, since the intensity of their artistic devices moves far past the optimal middle of hedonic value.

Whereas avant-garde filmmakers, such as Chris Marker, Stan Brakhage, or Fernand Léger, often seek to be more interesting than pleasing (and sometimes seek to be displeasing), Hollywood filmmakers generally aim for *moderate Interestingness and maximum Pleasingness*. The films that result tend to be easily understood and immediately pleasant for a mass audience. Indeed, Hollywood's business model, which emphasizes opening weekends and brisk rentals, values quick Pleasingness over long-term interest. Because the Hollywood film industry, an expensive mass art form, encourages risk reduction more than risk taking, Hollywood films typically play it safe and often lack sufficient novelty, complexity, or other challenging properties to generate much lasting interest.

Occasionally, however, Hollywood films venture beyond the optimal middle of hedonic value into areas in which Interestingness increases and Pleasingness tapers off. By turning up the volume on their novelty and complexity, some Hollywood films arouse our knowledge emotions and challenge our ability to master their aesthetic properties. Such films engage us upon repeat viewings; we might return to them year after year. Some

FIGURE 1.3 *A graph representing the relation between arousal and "epistemic value."*

aesthetically exhilarating Hollywood films, I propose, risk displeasing audiences for the sake of sustaining interest.

In Hollywood, such riskiness is financially viable only as long as millions of spectators still feel they can cope with a film's aesthetic challenges. In fact, some illuminating empirical research lends support to the notion that a Hollywood film can add value to an aesthetic experience by intensifying its novel and complex properties, provided the film does not prevent the prospect of mastery for mass audiences—provided, that is, that average spectators do not feel so overwhelmed by the film that they give up the search for understanding it.

A variety of empirical studies have demonstrated a predictable relationship between (1) spectator interest, (2) an object's novelty and complexity, and (3) spectators' coping potential. Paul Silvia, for example, has shown that subjects find objects interesting when they appraise the objects, on the one hand, as complex and novel and, on the other, as comprehensible.[36] Silvia ran a series of experiments using polygons, abstract poetry, and pictures, which fell along a scale of novelty and complexity. He measured the coping potential of subjects with either a self-report scale or by manipulating the amount of information he gave subjects to help them understand the objects. Finally, he measured subjects' interest in the objects by either self-reports or behavioral expression (i.e., time spent viewing). Silvia found a robust correlation between interest in complex and novel artworks and the ability of subjects to cope with them. "Appraisals of novelty–complexity and of coping potential," Silvia concludes, "predicted interest regardless of whether the appraisals were measured or manipulated, whether interest was measured with self-report scales or behavioral measures, or whether the interesting things were randomly generated polygons, abstract poetry, or visual art."[37] Other psychologists have found similar correlations between coping potential and aesthetic evaluation. Millis, for instance, found that subjects enjoyed abstract paintings more when given titles that increased their understanding.[38] Art experts, researchers have frequently demonstrated, prefer more complex, unpredictable, and difficult-to-process artworks than do novices.[39] Novices can become overwhelmed by such works, whereas experts cope with them more easily.[40]

In short, *people prefer artworks that are challenging in accordance with their own coping potential.* Hence, a film that fails to sufficiently challenge a spectator (because it is too simple or familiar) may offer mild pleasure, but it is unlikely to generate or sustain much interest. By the same token, a film that overtaxes the average spectator's coping potential will not appeal to a mass audience, although it may appeal to film experts or other spectators with a greater-than-average ability to cope.

We can now formulate two theses about the aesthetics of Hollywood cinema that should sustain us for the remainder of this project. The first thesis concerns Hollywood's

general approach to creating aesthetic pleasure, and the second pertains to the subset of Hollywood films that withstand the "test of time" and that tend to appeal to cinephiles:

1. Hollywood cinema targets an area, between boredom and confusion, that is optimally pleasing for mass audiences. It seeks to offer enough cognitive challenge to sustain aesthetic interest but not so much that it would jeopardize a film's hedonic value or cause average spectators to give up the search for understanding.

2. Many of the Hollywood films that offer exhilarating aesthetic experiences beyond a single encounter and over extended periods operate near the boundaries of classicism, veering into areas of novelty and complexity that more typical Hollywood films avoid; however, they do so without sacrificing a mass audience's ability to cope with the challenge. Less immediately pleasing, more persistently interesting than typical Hollywood cinema, such films take risks, and exhilarated pleasure results when they seem on the verge of overburdening or displeasing spectators in some bold and extraordinary way.

I must briefly qualify my hypotheses.

First, the boundaries of classicism change over time. The incomplete and uncomfortable ending of *City Lights* seems more bold in the context of comedies of the early thirties than it does when compared to, say, the endings of *The Graduate* (1967), *Annie Hall* (1977), or other Hollywood comedies of the late sixties and seventies. By the same token, an "average spectator" of one era may be quite different from that of another. A routine Hollywood filmgoer in the mid-thirties had a lot of experience with backstage musicals, whereas today's routine filmgoer has a lot of experience with superhero movies. Consequently, we must examine aesthetic experience within a film's historical context.

Second, we must recognize that many persistently popular Hollywood films—*Gone with the Wind* (1939), *Singin' in the Rain* (1952), and *Pretty Woman* (1990), to name a few—seem no more challenging or audacious than the typical film. Hollywood specializes in creating exhilarating experiences and succeeds not only through cognitive challenge but in other ways as well (chapter 7, for instance, discusses the ways in which Hollywood intensifies viewers' emotions).

Still, a great many Hollywood films show an enduring potential to engage spectators by resisting mastery and straining Hollywood norms. We see that potential in *Psycho*, in the almost comically ridiculous image of Norman Bates dressed as his mother and in his oddly contorted face as Sam Loomis wrestles a knife from his hands (figures 1.4 and 1.5). We see it in the discordant ideologies promoted by *Fort Apache* (1948), which seems to both admire and critique authoritarian leadership. We see it in our conflicted response to Michael Corleone in *The Godfather* (1972), who accomplishes what we want (defeating

FIGURE 1.4

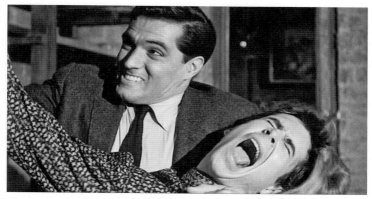

FIGURE 1.5

FIGURES 1.4 AND 1.5 *Norman Bates's ridiculous dress and facial expression at the climax of* Psycho *(1960).*

the Corleones's enemies) by becoming the criminal we admire him for *not* being at the beginning of the movie. We see it in the unsympathetic heroes of *The Searchers* (1956) and *The French Connection* (1971) or the sympathetic anti-heroes of *You Only Live Once* (1937), *Angels with Dirty Faces* (1938), *Detour* (1945), and *A Clockwork Orange* (1971); in the curious mixture of romance, beauty, gore, and outrage as a Texas Ranger and his posse riddle Bonnie and Clyde with machine-gun bullets in *Bonnie and Clyde* (1967); in the fascinating combination of ugliness and humanity in the circus performers in *Freaks* (1932); in the intricate narrative complexities of *Grand Hotel* (1932), *The Big Sleep* (1946), and *The Killing* (1956); in the baroque visuals of *Sunrise* (1927), *Touch of Evil* (1958), *The Elephant Man* (1980), and *Brazil* (1985); in the incongruously light-hearted zither music that scores *The Third Man* (1949); in the genre deviation of *Vertigo* (1958), *Chinatown* (1974), and *Unforgiven* (1992); in the disturbing humor of *The King*

of Comedy (1983); and in the bizarre, yet oddly sensible, romance between a teenager and an almost eighty-year-old woman in *Harold and Maude* (1971).

Although they put stress on the classical model of filmmaking, such films do not venture so far beyond strict classicism that they sacrifice the model's stability, reliability, or hedonic value. In the context of mainstream American cinema, however, they show surprising brinksmanship. Sculptor Andy Goldsworthy describes the "very beautiful balance" that comes from taking an artwork "to the very edge of its collapse."[41] Literary critic Stephen Booth describes great artworks as daredevils. "They flirt with disasters," Booth says, "and, at the same time, they let you know they are married forever to particular, reliable order and purpose."[42] Steadied by the uniformity and unity of the classical Hollywood paradigm, these bold, sometimes audacious, films seem at the same time formally stable and also on the edge of some collapse, and that's a very beautiful balance.

<p style="text-align:center">• • •</p>

Film history offers no paradigmatic examples of Hollywood's classical and deviant tendencies. No film can illustrate the variety of ways in which Hollywood filmmakers have adapted the classical paradigm. The brief examples above supply a sampling of novelties and complexities from Hollywood history, but they also leave the impression that, in Hollywood, deviation from strict classicism consists of one-off moments, bizarre hiccups of irregularity. To understand the ways in which talented Hollywood filmmakers systematically integrate novel and complex artistic devices without violating the classical paradigm, we must analyze devices that operate throughout a film. The next chapter offers extended case studies that illustrate a productive balance between Hollywood classicism and deviation. While no films perfectly embody that balance, the films studied in chapter 2—*His Girl Friday* (1940) and *Double Indemnity* (1944)—are shapely examples.

Classicism and Deviation in *His Girl Friday* and *Double Indemnity*

B Y WAY OF INTRODUCTION TO THE FOUR REMAINING PARTS OF THIS
book, this chapter will illustrate a balance between Hollywood classicism and devi-
ation in each of the areas of narrative, style, ideology, and genre. Parts 2, 3, 4, and 5 of
the book will explain the distinct contribution of each area to the aesthetic pleasures of
Hollywood cinema; however, before we begin that process, I must illustrate the previous
chapter's main points about Hollywood cinema's moderate complexity and novelty. So
let's examine the ways in which two beloved Hollywood movies of the studio era—*His
Girl Friday* (1940) and *Double Indemnity* (1944)—complicate formal patterning and dis-
rupt audience expectations, even as they obey classical Hollywood's formal imperatives.

NARRATIVE, STYLE, AND IDEOLOGY IN *HIS GIRL FRIDAY*

At the beginning of the screwball comedy, *His Girl Friday*, ace newspaper reporter Hildy
Johnson (Rosalind Russell) visits her ex-boss and ex-husband Walter Burns (Cary Grant)
to tell him that she is marrying insurance salesman Bruce Baldwin (Ralph Bellamy) and
moving to Albany to live as a suburban housewife. In an effort to prevent the marriage
and lure her back to the news business, Burns convinces her to write one last story about
a fired bookkeeper, Earl Williams (John Qualen), scheduled for execution the following
day for shooting a black police officer. The story mostly concerns Walter's underhanded
efforts to prevent Hildy from leaving with Bruce, and Hildy's efforts to thwart Walter.

Several of the film's artistic devices complicate the action or seem out of keeping with
the film's essential comic purpose. None of the devices transcends classical Hollywood

practice; however, their unusual variety and density make the storytelling uncommonly busy and multifarious and make understanding *His Girl Friday* somewhat more challenging than understanding other screwballs of the era.

Let's examine the film in the areas of narrative, style, and ideology.

Narrative in *His Girl Friday*

Marilyn Fabe has noted that "*His Girl Friday* has all the features of the classical Hollywood narrative film," including dual plotlines (a love story between Walter and Hildy and a career story involving the Williams hanging), deadlines (Hildy's impending marriage to Bruce, her train to Albany, and Williams's dawn execution), and clearly delineated protagonists with well-defined goals (Hildy and Walter seeking to thwart each other).[1] *His Girl Friday*, however, shows uncommon narrative density for a Hollywood movie. The number of elements in the narrative, the variety of elements, and the rapid pace at which the film presents them keep spectators cognitively excited, enabling them to watch the movie numerous times and still pick out pieces missed on previous viewings.

Although classical in structure, the plot includes gratuitous details, incidental to the story's causal progress, that add complexity to the narration. If we attend carefully, for instance, we might see the reporter known as "Stairway Sam" in the background of a shot, peeking up the skirts of women ascending the stairs outside the pressroom window (figure 2.1). We might also get the in-jokes about the actors playing the roles of Walter and

FIGURE 2.1 His Girl Friday *(1941). In the background of the shot, "Stairway Sam" looks up the skirts of women as they ascend the stairs behind the pressroom window. My arrows point to Stairway Sam's ogling, which the framing refuses to emphasize.*

Bruce: Walter says that Bruce looks like the actor Ralph Bellamy and elsewhere makes a passing reference to "Archie Leach," Cary Grant's real name. The film's overlapping dialogue packs in lines and makes narration dense and dynamic. Numerous narrative details threaten to distract viewers from the main plotline and make story comprehension more challenging.

To demonstrate the ways in which the film's rapid-fire dialogue in particular contributes to its narrative complexity, consider the scene toward the end, one of the busiest in the movie, in which Bruce interrupts Hildy and Walter as they furiously work on the Williams story. Bruce has just been released from jail, framed by Walter, who has also, unbeknownst to Bruce, stolen Bruce's wallet and filled it with counterfeit money. As Hildy types the story, Walter talks on the phone with his city editor, Duffy, trying to rearrange the front page to make room for an Earl Williams exclusive.

In the following transcript of the scene, I have cut parts to make it shorter and cleaner for readers, but the principal narrative information and most of the details of the dialogue remain. Video 2.1 ⊙ offers a brief portion of the two-and-a-half-minute scene.

HILDY: [*typing throughout*] Ah, hello, Bruce.

WALTER: [*To Duffy on the phone*] How's that? No, no, never mind the Chinese earthquake, for Heaven's sake.

BRUCE: Hildy, I just want to ask you one quest—

HILDY: Bruce, how'd you get out of jail?

BRUCE: Not through any help of yours.

WALTER: [*To Bruce*] Now listen, Buddy. You can't come in here, we're busy.

BRUCE: [*To Walter*] I'm not talking to you. [*To Hildy*] I had to wire Albany for a hundred dollars so I could get out on bail.

WALTER: [*To Duffy*] Look, I don't care if there's a *million* dead.

BRUCE: I don't know what they're going to think up there in Albany. They had to send the money to the police station.

WALTER: [*To Hildy*] Oh, for Pete's sake, Hildy, come on, we're waiting for that story.

HILDY: [*distracted*] We'll explain everything to them, Bruce.

BRUCE: Where's Mother? She said she's coming up here.

HILDY: She left.

WALTER: No, I can't hear you, Duffy.

BRUCE: Where'd she go?

HILDY: Out someplace.

WALTER: No, no, junk the Polish Corridor!

BRUCE: Hildy, tell me where my mother was going!

HILDY: Eh, she couldn't say.

WALTER: *[To Duffy]* Never mind that, this is more important.

BRUCE: Did she get the money from you?

HILDY: No, no, she left in a hurry.

BRUCE: I'll take that money, Hildy.

HILDY: All right, Bruce, right there in my purse.

BRUCE: I've decided I can handle things around here, and I'll take that certified check too.

HILDY: I'll give it to you, Bruce, here. Here's the tickets and you'll find your money in the wallet.

BRUCE: My wallet? This *is* my wallet. Say, there's something funny going on. *[Walter grabs Bruce's money and inspects it]* Hey, what are you doing?

WALTER: Just wanted to look at it.

BRUCE: Hildy, I'm taking—. Hildy, Hildy, I'm taking the nine o'clock train.

HILDY: *[distracted, still typing]* Sure, sure.

BRUCE: Did you hear what I said? I said, I'm taking the nine o'clock tr—

HILDY: *[with Bruce]* the nine o'clock tr—. Oh, Bruce, I put it in *here*!

WALTER: Hey, let her alone, will you, buddy?

HILDY: Will you do me a favor, Bruce, please?

BRUCE: I want you to answer me, just answer one question. You don't want to come with me, do you?

HILDY: *[To Walter, grabbing a sheet of paper she's typed]* I need that.

BRUCE: Answer me, Hildy. You don't, do you?

WALTER: *[To Duffy]* No. *[Bruce looks at Walter.]* Take all those Miss America pictures off page six.

BRUCE: Hildy, tell me, please tell me the truth. You never loved me, Hildy.

WALTER: Ah, wait a minute. *[Pointing at Bruce]* Now look here, my good man!

BRUCE: You shut up, Burns!

HILDY: How can I do anything with this racket going on?

BRUCE: *[To Walter, angrily]* You're doing all this to her, I know that. She wanted to get away from you and everything you stand for, but you were too smart. You caught her and changed her mind.

WALTER: *[To Duffy]* Take Hitler and stick him on the funny page! *[To Bruce]* Now let me ask you, Mr. What-Ever-Your-Name-Is—

BRUCE: *[To Hildy]* Will you give up everything for a man like him?

HILDY: No, I am not, but Bruce can't you see that something's happened. Wait, I'll tell you everything—

WALTER: Tell him? You'll tell him nothing! He's a spy, you fool.

BRUCE: I am *not* a spy.

HILDY: Ridiculous.

BRUCE: Come on, Hildy, you're coming with me right now.

HILDY: Gimme just a second. Can't you, don't you see this is the biggest thing in my *life*!

WALTER: Be quiet, Hildy.

BRUCE: I see. I'll keep. I'm like something in the icebox, aren't I?

WALTER: *[To Bruce]* Yeah.

BRUCE: You just don't love me.

HILDY: Oh no, now that isn't true. Just because you won't listen you say I don't love you. Now, you know that isn't the point at all.

BRUCE: The point is you never intended to be decent and live like a human being.

WALTER: *[To Duffy]* What's that?

HILDY: All right, all right if that's the way you want to think.

WALTER: *[Annoyed at their conversation]* Sebastian, jumpin' — I'm trying to concentrate!

BRUCE: You're just like him and all the rest.

HILDY: Sure, sure, that's what I am.

WALTER: *[To Duffy]* What? What? No, no, leave the rooster story alone. That's human interest. Did you get a hold of Butch O'Connor yet?

HILDY: If you had any sympathy or understanding, you'd understand what I'm trying to do here.

BRUCE: I understand, all right. I understand—

HILDY: Wait, wait, just a minute. There's only one question I want to know.

BRUCE: *[eagerly]* What?

HILDY: Walter.

WALTER: What?

HILDY: The mayor's first wife? What was her name?

WALTER: You mean the one with the wart on her?

HILDY: Right.

WALTER: Fanny. *[To Duffy]* What'd you say, Duffy?

BRUCE: Ah, Hildy, I don't think you ever loved me at all. . . . If you change your mind, I'm on the nine o'clock train. *[He walks out.]*

HILDY: *[Quickly, still typing]* If you want me, you've got take me as I am, instead of trying to change me into something else. I'm no suburban bridge player. I'm a newspaperman.

Several features in the dialogue contribute to the scene's narrative complexity. First, the dialogue packs in key story information. The scene conveys that Bruce has gotten out of jail, how he got out, and his concern that Hildy does not love him and never intended to marry him. More important, we see Hildy's indifference to her impending marriage to Bruce in the face of a breaking story ("Don't you see this is the biggest thing in my life!"). Indeed, the scene, in all likelihood, leads audiences to conclude finally that Hildy belongs working for a newspaper and not stuck with Bruce in the Albany suburbs. Her line, delivered rapidly, "I'm no suburban bridge player. I'm a newspaperman," summarizes that conclusion and reveals her own awareness too.

Meanwhile, the writers have also peppered the dialogue with incidental details that impede efforts to process key story information and that add humor and busyness to the scene. Indeed, such incidental dialogue often overwhelms the main narrative or competes with it for prominence: Hildy accidentally typing Bruce's words into her report ("Oh, Bruce, I put it in here!"); her random query about the mayor's first wife's name; unfinished and unanswered lines; and Bruce's discovery that Hildy has his wallet. Throughout the scene, Walter's lines add an abundance of comic business: lines to Duffy about news less momentous than the Williams story, such as the Chinese earthquake ("I don't care if there's a million dead") and World War II ("Take Hitler and stick him on the funny page!"); his interest in keeping "the rooster story"; his curiosity about the counterfeit money ("Just wanted to look at it"); an incidental remark about a wart on the mayor's wife; and his suggestion that Bruce is a spy, a charge that, for some reason, Bruce feels he must answer. Indeed, for the sake of brevity and clarity, I deleted from my transcript many of Walter's most incidental lines to Duffy ("What?" "What'd'ya say?" "Yeah," etc.) that provide a din of background noise to Bruce and Hildy's argument and also threaten to distract spectators from the thread of their conversation.

Finally, note how much of the action occurs simultaneously. The characters cut each other off mid-sentence, the actors speak over each other's lines, and they deliver their lines with such rapidity that the scene sometimes seems as though it might descend into unintelligibility. Furthermore, among the four characters featured—Bruce, Hildy, Walter, and Duffy—the scene contains paired conversations between Walter and Hildy, Walter and Duffy, Walter and Bruce, and Bruce and Hildy. Another pairing, between Hildy and her typewriter, adds further complication by focusing her attention on her work and distracting her from her conversation with Bruce. Moreover, since Duffy never appears in the scene but remains on the other end of a phone line, we must infer half of the conversation between Walter and him. The paired conversations toggle and overlap with such speed that at one point Bruce gets confused about who is speaking to whom: When Bruce asks Hildy whether she wants to come with him on the train, and Walter shouts, "No," Bruce, perplexed, turns to Walter. It takes a moment before he realizes that Walter

is talking to Duffy, not answering Bruce's question. The moment provides the scene's one pause in conversation, albeit only for a second.

Taken together, the simultaneous actions among different pairings of characters, the rapid-fire and overlapping dialogue, the confusions and ellipses, and the abundance of both key and incidental narrative information combine to make the scene narratively dense and complex, dropping obstacles between the narrative's causal progress and our efforts to follow it.

Style in *His Girl Friday*

Commentators often regard Hawks as an exemplar of Hollywood's classical style of film-making. Peter Wollen praises Hawks's "no-nonsense style—no flashbacks, no screwed-up camera angles, no unnecessary camera movements, no unnecessary close-ups, nothing to annoy the audience."[2] Richard Maltby says that Hawks "maximizes the normative representation of space."[3] Fabe notes *His Girl Friday*'s "invisible editing."[4] Indeed, *His Girl Friday* observes all of classical Hollywood's stylistic practices, which, as we saw in the previous chapter, emphasize uniformity and unity.

Still, the film's style does not remain uniform throughout and occasionally detracts from, rather than furthering, the transmission of narrative information and the overall comic mood. For instance, although the framing of the shot in figure 2.1 refuses to emphasize Stairway Sam's voyeuristic behavior, his presence in that shot and the shot's deep focus threaten to distract viewers from key plot information and onto peripheral comic business. The film might instead have cut to Stairway Sam, rather than sticking him in the back of the frame, toggling our attention to and away from him in a controlled way. As it is, if we attend to Stairway Sam, then we are not fully attending to *His Girl Friday*'s main plot.

Some imagery seems downright strange for this film, such as the dreary sketch of a face pinned on the wall of the pressroom (figure 2.2) and haunting images of the Williams gallows (figure 2.3), images inserted into chiefly lighthearted scenes. Most disturbing of all is the shot of Molly Malone after she leaps several flights from a pressroom window (figure 2.4). What must an audience do to integrate into their experience of the film the dismal image of Molly, face down, lying perfectly still on the pavement? The film's style and mood sometimes change dynamically. Maria DiBattista notes that the shot of "the searchlights that scan the prison after Earl Williams's jailbreak seems almost stock footage from one of the crime melodramas of which Hawks was a master."[5] The shot of Earl Williams in his prison cage supplies perhaps the most stylistically dissimilar image to the rest of the film (figure 2.5). That shot's high, angular framing, expressionist shadows, and bare, gloomy setting contrast with the film's mostly high-key-lighting scheme, more like

FIGURE 2.2 *My arrow points to a dreary* **FIGURE 2.3** *A shot of the gallows.*
sketch of a face pinned to the wall of the pressroom.

FIGURE 2.4 *Molly Malone lying still, face* **FIGURE 2.5** *Earl Williams in his cell.*
down, after she jumps out of a window.

FIGURES 2.2–2.5 His Girl Friday *(1941) at times includes grim, low-key, expressionist imagery*
that conflicts with the film's generally high-key style and farcical tone.

a shot from film noir than screwball. Indeed, if one saw only the frames represented in
figures 2.2–2.5, one would have a skewed sense of the film's overall visual style.

Ideology in *His Girl Friday*

Thomas Schatz considers *His Girl Friday* "dark" and "subversive."[6] Fabe calls it "darker,
richer, more subversive and interesting" than the typical Hollywood comedy.[7] The film
indeed displays unusual ideological complexity, advancing conflicted moral values and
values at odds with its comic purpose. Fabe, for instance, points to a "truly unpleasant
scene" between the reporters and Molly, which Fabe regards as "oddly out of harmony
with the film's zany atmosphere." In it, Fabe says, "the newspaper men taunt Molly sav-
agely for having compassion for Earl Williams, who is to be hanged the next day. When
the sound of the gallows being built ominously resonates through the newsroom, one of

the reporters says cruelly, 'They're fixing up a major pain in the neck for your boyfriend.'"[8] Indeed, the film demonstrates a persistent moral coldness that never abates, despite the comic tone. We witness such coldness in the discussions of the murdered policeman, the ineptness and corruption of government officials (who try to execute Williams, despite a governor's reprieve, to benefit their reelection campaigns), the officials' cynical courting of the "black vote," the background of social discontent and the Great Depression, the exploitativeness of the reporters, and their cruel treatment of Molly, driving her to leap from the pressroom window in a desperate effort to distract the reporters from Williams hiding in a desk.

At the heart of the career plot is Williams's senseless murder of a black policeman, spurred by the loss of his job and his susceptibility to communist rhetoric. Most morally disconcerting of all, none of the characters, other than Molly, seems to take seriously the impending execution of the befuddled Williams. The reporters hope to speed along the execution for the sake of their deadlines, and, purely to spite Walter, Hildy tears up a story she wrote that could potentially save the condemned man. Film scholar Lee Russell sums up the film's comedy: "Hawks's fun is grim."[9]

Such serious ideological issues could form the basis of a social problem film. *Ace in the Hole* (1951), for instance, deals seriously with some of the same issues that *His Girl Friday* treats comically. We might say that *His Girl Friday* is characteristic of a certain *kind* of comedy, a black comedy, which pokes fun at serious matters in a way that feels taboo. But I don't think we categorize *His Girl Friday* as a black comedy. If we did, it might be easier to digest the film's playful attitude toward serious matters because that's the kind of attitude black comedies take toward serious matters. Instead, *His Girl Friday* treats such matters as mere background noise or comic impediments to the protagonists' goals. As such, they add a moral edge to *His Girl Friday* that cuts at the film's cheery tone.

The film encourages spectators to hold conflicted values. Morally, it probably seems right for Hildy to end up with Bruce, who behaves virtuously and tenderly and truly loves her, rather than with Walter, who is vicious, thieving, gleefully amoral, and altogether undeserving of her. Indeed, it remains unclear whether Walter is using the Earl Williams story to get back together with Hildy or using his relationship with Hildy to get her to come back to the paper. For these reasons, I suspect our allegiances remain with Hildy in her dealings with Walter as he tries, in various crafty and crooked ways, to prevent her upcoming marriage to Bruce. Although I gather spectators want Hildy to outwit Walter in each individual battle between them, I also suspect that they prefer that she end up with Walter ultimately, rather than her dull insurance salesman fiancée. So film scholar Tom Powers has it mixed up when he writes about Hildy, "The audience is made to root for her, particularly since the alternative is marriage to her sickeningly sweet fiancé, Bruce."[10] Powers tries to make the film ideologically coherent, but the screenwriters have

constructed the scenario so that to root for Hildy, as she tries to outwit Walter, *is* to root for her to marry her sickeningly sweet fiancé, as well as to give up her rightful career as a newspaper reporter. Obviously the most talented reporter of the lot, Hildy belongs in a newsroom. But because the film has tied Hildy's career plot to the remarriage plot, she must remarry her cad of an ex-husband to remain a career woman.

Moreover, despite Walter's moral unsuitability, Walter and Hildy's similar wit, clipped speech, brisk manner, and mutual enjoyment make them seem destined for one another. Even their antagonism comes across as romantic banter and compatible combat, a passionate duel between intellectual equals. Although the movie takes pains to portray Bruce as adoring and supportive of Hildy—a fact that makes her rejection of him more difficult to adjust to than if the film had portrayed Bruce as domineering or judgmental—he seems the wrong man for *her*.

Indeed, *His Girl Friday* is designed morally so that, no matter how the story unfolds, spectators could not feel wholly satisfied. At the end of the movie, Walter appears for the first time to behave virtuously when he encourages Hildy to get on the train to Albany with Bruce. Despite Hildy's apparent victory and Walter's seeming moral transformation, it is disappointing to think that Hildy might go off with Bruce to the suburbs after all; Hildy breaks into tears at the prospect. But when, a moment later, we discover that Walter has just tricked her, it is again disappointing: Now, although Hildy will return to the newspaper business where she belongs, Walter's trick indicates that he remains just as much a scoundrel as ever. "What do you think I was, a chump?" he asks her. The final seconds of the movie, in which they agree to remarry and honeymoon in Niagara Falls, reinforces the impression of Walter as a reprobate when he suggests that during their honeymoon they cover a labor strike in Albany and wonders whether Bruce might put them up. He also makes Hildy carry her own unwieldy suitcase, hat, and coat as he gleefully heads out of the pressroom empty-handed. The cheerful here-we-go-again music signals the happy ending but cannot quite erase the moral irritations of the film's final moments. Walter hasn't improved at all.

His Girl Friday admits narrative, stylistic, and ideological devices that add complexity to the narration without violating the classical Hollywood paradigm. Although more ballsy than other screwball comedies of the period, the film is still fairly typical of the genre, which is known for its quick pace, unconventional humor, and occasional ideological bite. The screwball genre provides a stable frame that allows the film to risk moderate complexity in other areas.

Double Indemnity works the other way around. Although narratively, stylistically, and ideologically conventional for the period, the film does not fall so neatly within the parameters of the Hollywood crime genre of the 1940s. In many ways, *Double Indemnity* seems out of harmony with the film's hard-boiled predecessors. In the last section of this

chapter, I want to show how *Double Indemnity*'s characterizations and casting deviate from the film's genre identity.

GENRE IN *DOUBLE INDEMNITY*

Critics and filmgoers have loved *Double Indemnity* since its release in 1944. Written by Billy Wilder and Raymond Chandler (based on James M. Cain's 1935 novel) and directed by Wilder, the film became a hit and earned a trove of positive reviews and seven Oscar nominations, including nominations for Best Picture, Best Director, and Best Screenplay. Still one of the most enduring and popular studio-era crime films, *Double Indemnity* demonstrates the ways in which Hollywood filmmakers combine classical genre use with genre deviation in order to add novelty and complexity to the storytelling.

To understand the film's genre deviation, we need to consider it in light of crime films released around the same time.

Double Indemnity rode the crime-movie wave of the 1940s, which included such films as *High Sierra* (1941), *The Maltese Falcon* (1941), *Suspicion* (1941), *This Gun for Hire* (1942), *Journey into Fear* (1943), *Shadow of a Doubt* (1943), *Laura* (1944), *Murder, My Sweet* (1944) and hundreds of less notable movies. The films in this series, often known as film noir, rarely ranked among Hollywood's top grossers, but by the time of *Double Indemnity* they pervaded Hollywood cinema, particularly as B movies and programmers (a category of moderately priced features between the expensive As and low-budget Bs). By 1944, these crime films had already established a firm set of genre expectations. Often featuring working-class characters, the films typically combined social realism, the wit and attitude of hard-boiled detective fiction, and the visual stylization of German expressionism. Influenced by *Citizen Kane*, many of the films included complex flashbacks, a detective-film structure, compositional tension, deep focus cinematography, odd angles, low-key lighting, and chiaroscuro.

We see these very elements throughout *Double Indemnity*. The opening, for instance, is classic film noir. The credits feature the silhouette of a man on crutches walking ominously toward the camera, his figure looming larger and larger in the frame (figure 2.6). The first diegetic shots show a car speeding recklessly through dark city streets, running stop lights and barely avoiding crashes, anxious and fast-paced music in the soundtrack. The first shots of our main character depict him dressed in a long coat, his facial features obscured by his hat, the camera placement, and low-key lighting. When he speaks, he is obviously in pain. Such properties make it easy to identify the film's genre.

Fans of crime cinema and hard-boiled detective fiction of the twenties, thirties, and forties would find the film's plot patterning familiar. The film features "the time-honored flash-back device," to quote the *Herald-Tribune*, which had become so common

FIGURE 2.6 *The opening credits of* Double Indemnity *(1944) use conventional stylistic devices that signal the film's genre.*

by 1944 that *Los Angeles Times* critic Philip K. Scheur wrote about the film, "I am sick of flash-back narration and I can't forgive it here."[11] Our protagonist, insurance salesman Walter Neff, behaves like a typical noir lead. Neff narrates his story from its beginning, leading up to the moment that, bleeding from a gunshot wound, he drives to his office, when the flashback narration meets up with the present day. Neff's voice-over, moreover, adopts the witty, literary style characteristic of the genre, filled with descriptive metaphors, such as "I knew I had hold of a red-hot poker, and the time to drop it was before it burned my hand off" and "How could I know that murder can sometimes smell like honeysuckle?" In keeping with the crime-film style of the day, Wilder and Chandler added the flashback conceit and metaphoric dialogue, both absent from Cain's novel. The story, too, follows genre conventions. An alluring, dangerous woman, Phyllis Dietrichson, ensnares our protagonist in a criminal enterprise. The story features murder plots (including a wife killing her husband and lovers killing each other), a criminal investigation, extended suspense sequences, and deadly, obsessive sexual desire, all conventional narrative elements in crime films of this period. The story ends, as it must in this type of film, with the death or arrest of our anti-hero and his temptress.

These and numerous other genre properties identify *Double Indemnity* as, in many ways, a typical crime film of the studio era. But *Double Indemnity* is not typical, nor does it strictly follow the standard practices of the genre. The film includes enough genre deviation to challenge crime film fans, increasing the novelty of the film experience and impeding efforts to easily master its genre properties. Let's look at some of these off-genre properties, beginning with our protagonist.

Walter Neff is a cool, smooth-talking, hard-boiled insurance salesman. Insurance salesman? Neff acts like the detectives of *The Maltese Falcon, Laura*, and *Murder, My Sweet*—one man alone, a proletarian tough guy with a comeback for every insult—but he sells car and life insurance. Furthermore, he does not come off quite as suave as the character seems to think he does. Every time he strikes a match with a flick of his thumbnail, he looks like someone trying to act tough, someone impersonating a tough guy from the movies.

Neff, moreover, is played not by an actor known for his ruggedness or crime-film pedigree—such as Humphrey Bogart or John Garfield—but by Fred MacMurray. Wilder himself called it "odd casting."[12] Although one of Hollywood's highest paid actors at the time, MacMurray is not masculine or sexually attractive, like Garfield, not even interesting looking, like Bogart. The actor has a boyish, oblong face, perfect teeth, and an easy smile that often moves from a wide grin to a more child-like smile when he presses his lips together. Although critics generally praised MacMurray's acting, some remarked on the fact that the character "is somewhat different from his usually light roles,"[13] and the *New York Times* called the performance "a bit too ingenuous."[14] Walter acts like a tough guy, but, played by MacMurray, he really seems like an insurance salesman.

Now, after many years, it's hard to imagine anyone else in the role of Neff, but Hawks originally wanted manly George Raft, who turned him down.[15] According to Richard Schickel, after Wilder ran through Paramount's entire roster of rugged actors, "he had an inspiration. Why not a soft guy—a soft guy pretending to be tough?"[16] The executives at Paramount considered Wilder crazy for casting MacMurray, an actor known for light comedies. MacMurray had played decent, genial leading men in such films as *The Gilded Lily* (1935), *Too Many Husbands* (1940), and *No Time for Love* (1943). He initially turned down the role of Neff because he feared the part was "too heavy to handle."[17] According to MacMurray, Wilder pestered him daily "at home, in the studio commissary, in his dressing room, on the sidewalk."[18] He finally agreed to take the part but only because he thought Paramount would never let him do it.[19] Ultimately, the casting choice differentiated *Double Indemnity* from other crime films of the period.

Sometimes the character's lines, like his match striking, seem to be trying too hard to impress. "I wonder if a little rum would get this up on its feet," Walter says to Phyllis about the iced tea she has given him. His first lines in the movie are to an elevator operator, who is asking Walter about working late. "Late enough," Walter says, "Let's ride." A tough guy can get away with saying "Let's ride" to a cabbie but not to an elevator operator. Some of the character's lines come off as downright weird: "I used to peddle vacuum cleaners—not much money but you learn a lot about life." I have been mulling over the logic of that line for many years now. The character also has a strange habit of telling bad jokes.

"No pigeons around, I hope," he says to Phyllis, when she describes her sun bathing. An early exchange between them goes as follows:

> PHYLLIS: Neff is the name, isn't it?
> WALTER: Yeah. Two *F*s, like in Philadelphia. You know the story.
> PHYLLIS: What story?
> WALTER: The Philadelphia Story.

The joke doesn't even make sense. Twice, Walter says "I love you" to his supervisor, Barton Keyes, played by Edward G. Robinson. It is an endearing but awkward line for one male character in a 1940s crime drama to say to another, particularly a coworker, and difficult to deliver with the appropriate mixture of sincerity and irony. Smiling wryly, MacMurray does pretty well with it, considering how clumsy the line is.

Barbara Stanwyck's Phyllis Dietrichson better suits the 1940s crime film, although the character does not display the glamour and knock-out beauty of femme fatales played by Rita Hayworth and Ava Gardner. She's tawdrier. *New York Times* and *Variety* both remarked on her physical unattractiveness.[20] Phyllis wears an anklet and her wardrobe looks cheap. She appears first dressed only in a towel; later we see her still buttoning her dress when she walks downstairs. She applies lipstick while talking to Neff. None of these actions seems particularly fetching; in fact, they come across a bit crass. When she visits Neff in his apartment, you can see her bra straps through her blouse.

Let's examine some of the dialogue in the scene in Neff's apartment, which deviates from genre convention. Once the two kiss, the scene becomes overtly romantic, shot in soft focus, the characters whispering their lines:

> WALTER: I'm crazy about you, baby.
> PHYLLIS: I'm crazy about you, Walter.
> WALTER: That perfume on your hair. What's the name of it?
> PHYLLIS: I don't know. I bought it in Ensenada.

Phyllis's "I don't know. I bought it in Ensenada," which she delivers in the same breathy voice as "I'm crazy about you, Walter," seems incongruous with the sexually charged mood of the scene. Surely, writers as brilliant as Wilder and Chandler could have come up with a suggestive name for that perfume (how about "Dangerous Desire"?). Instead, they have her say a line that seems peculiarly designed to undermine the scene's generic romantic signals.

Double Indemnity never deviates so much from crime-film convention as to alienate spectators or threaten their ability to identify the film's genre. But it adds enough novelty

to the crime-film form to make the movie seem fresh and interesting, even today, and to challenge spectators' efforts to master its design.

· · ·

I hope that my analyses of *His Girl Friday* and *Double Indemnity* have demonstrated the ways in which these two films systematically, and with some degree of boldness, integrate complex and novel artistic devices into their classical framework. But to understand the aesthetics of Hollywood cinema, we still have several large tasks to accomplish. We must examine Hollywood's standard artistic practices in the areas of narrative, style, ideology, and genre; the aesthetic properties characteristic of each area; and each area's distinct contribution to the aesthetic pleasures afforded by Hollywood cinema. Furthermore, we must try to understand what distinguishes the Hollywood films that succeed in sparking aesthetic engagement over decades. We begin that examination in Part 2 by studying Hollywood's most fundamental formal concern: telling a story.

PART
2

NARRATIVE

Nothing in the world is as dull as logic.

—Alfred Hitchcock[1]

Hollywood Storytelling

W<small>E MIGHT ASSUME THAT PEOPLE ENJOY NARRATIVE CINEMA BECAUSE</small> they like watching good stories. But a good story hardly accounts for the pleasures of narrative. *The Maltese Falcon* (1931) with Ricardo Cortez has a story practically identical to that of the 1941 remake with Humphrey Bogart, yet few movie fans have even heard of the first movie, whereas the remake—which tells the same story in a different way—ranks among Hollywood's most celebrated productions. The pleasures of narrative come not just from good stories but from good storytelling.

Storytelling—or, more technically, "narration"—is the process by which an artwork selects, arranges, and renders narrative information in a way that stimulates audiences to perform cognitive activities.[2] Narration arouses what we could describe as a guided act of imagination in which the audience mentally constructs a story based on plot cues from the work of art.

To understand the process of storytelling, we should draw a common distinction between "plot" and "story" (what the Russian formalists called "syuzhet" and "fabula"). Whereas "plot" denotes the artwork's presentation of narrative events, "story" denotes *all* narrative events, including events presented in the plot as well as events we infer. We construct the story by mentally linking the events of the plot. So, if the plot has presented narrative events out of chronological order, then, to construct a coherent story, we rearrange the events chronologically in our mind. If the plot has left out key story information, we attempt to fill it in. In short, *narration* is the process by which an artwork's *plot* stimulates the perceiver to mentally construct the *story*. We should regard the pleasures of storytelling as aesthetic inasmuch as they result from the perception of the artwork's sensory properties (the plot), they demand thought (story construction), and they involve

appreciation of the artwork's character, content, or structure. The aesthetic pleasure of storytelling derives from the cognitive activities that narration stimulates, the result not of watching stories but of constructing them in our mind.

Hollywood cinema generally makes the spectator's process of story construction fairly easy. Most aesthetic commentary about Hollywood storytelling has focused on its unity because narrative unity enables spectators to readily connect plot events. Narrative unity stimulates the calm pleasures associated with easy understanding, making Hollywood cinema accessible and immediately pleasing for mass audiences.[3] Easy understanding, however, does not fully account for the intensity of the aesthetic pleasure people sometimes derive from Hollywood storytelling. Cognitive challenge, we saw in chapter 1, can lead us toward more exhilarated aesthetic pleasure. In Hollywood storytelling, that challenge comes from disunities in the narration that make it more difficult for a spectator to construct a coherent story. Narrative disunity makes storytelling more demanding, as well as more stimulating and interesting. So, for a full account of the aesthetic pleasure of Hollywood storytelling, we must account for the pleasures afforded by both narrative unity and narrative disunity.

TOWARD NARRATIVE UNITY

A unified narrative develops according to an internally consistent story logic, the work's narrative properties connected and interrelated to form a seemingly organic whole. The principle of unity in art dates to Plato and Aristotle and has governed much criticism of the arts, particularly in the appreciation of art forms, such as Hollywood cinema, that follow classical storytelling principles. A disunified narrative, by contrast, contains gaps, ambiguities, improbabilities, incongruities, or other impediments to coherent story construction. We expect disunity in avant-garde narratives, such as surrealist films, but when it comes to Hollywood, we generally expect to find narrative unity.

David Bordwell has argued that by 1917 the American film industry had already adopted a firm set of practices to promote narrative unity, practices that persist in contemporary American cinema.[4] Indeed, many film commentators regard unity as a chief organizing principle of mainstream filmmaking.[5] V. F. Perkins says that a film's credibility "depends on the inner consistency of the created world . . . [which] must obey its own logic. There is no pretext, whether it be Significance, Effect or the Happy Ending, sufficient to justify a betrayal of the given order."[6] Advice from Hollywood screenwriting manuals invariably accords with Perkins's observations on the importance of unity. "Everything in the story should contribute to its structural unity," Lewis Herman writes, an admonition echoed in manuals dating back to 1917.[7]

Unity makes Hollywood storytelling easy to understand. Hollywood narration creates clear linkages between plot events by means of *causality*, the principle that one event brings about another. A classical story connects events not arbitrarily (x *and* y), nor chronologically (x *then* y), but *causally* (x *therefore* y). Causality makes narrative connections tight and logical. According to Seymour Chatman, causally linked events are "hinges" in a narrative structure and "cannot be deleted without destroying the narrative logic."[8] One Hollywood screenwriting manual says flatly, "There should be nothing [in a screenplay] which is not clearly caused by what precedes and nothing which is not clearly the cause of what follows."[9]

Indeed, causality organizes virtually every aspect of a film's plot. Even disaster films, designed to exploit audience's attraction to the spectacle of stars and destruction, tightly fasten their causal links. An electrical short, shoddy workmanship, and cost-cutting, revealed at the beginning of *The Towering Inferno* (1974), set in motion the fire that ultimately consumes the building. By the same token, Hollywood comedies, which enjoy considerable license for narrative illogic, routinely link scenes by means of cause-and-effect. At the end of *No Time for Sergeants* (1958), draftees Will Stockdale and Ben Whitledge finally get themselves transferred to the infantry, an aspiration established in their first scenes together. We call Hollywood narratives "linear" because each event leads to another in a sequential progression toward closure, when the cause-effect sequence completes its course.

Noël Carroll attributes Hollywood's "easily graspable clarity," in part, to a question-and-answer structure that he calls the "erotetic model of narrative."[10] Carroll argues that later events in Hollywood movies answer questions posed by earlier events. For instance, an early scene in *Make Way for Tomorrow* (1937) shows two aging parents informing their adult children that they have run out of money and are losing their home. The scene poses the question, "Where will the parents live?" The answer comes later in the scene: The children decide, reluctantly, to share the burden of housing them by splitting them up. The family's apprehensions about the decision pose other questions, "How will the children and parents react to the arrangements?" Later scenes answer those questions by depicting the children's difficulties adjusting, their resentments toward their parents, and the parents' disappointment in their children. By the end of the film, when the narration has answered all of our questions, we feel we have learned everything important about the story.

Bordwell has identified other components of Hollywood narration that enhance narrative unity. He notes that Hollywood movies almost invariably contain two interconnected plots, one involving heterosexual romance and the other something else (work, war, etc.). Hollywood's dual plot structure promotes narrative parallels and encourages spectators to make linkages between disparate plot elements, particularly at the moment

of climax, when the two interdependent plotlines frequently resolve at the same moment through the same set of character actions.[11] Both plotlines may end successfully, both may end unsuccessfully, or one may end successfully and the other unsuccessfully, but the plotlines will typically resolve interdependently. In *Groundhog Day* (1993), for instance, both plotlines resolve successfully and simultaneously when Phil escapes an eternity of Groundhog Days by behaving like the man that Rita would fall in love with. In *I Am a Fugitive from a Chain Gang* (1932), failure in one plotline means failure in the other. James Allen attempts to break free of his past (in which he escaped from a chain gang, after a wrongful conviction for robbery) and marry his beloved Helen. In the end, however, Allen lives as a criminal on the run and must never see Helen again. In other movies, success in one plotline means failure in the other: In *The Maltese Falcon* (1941), Sam Spade's success at solving a murder mystery means sending the woman he loves to jail; in *Batman Begins* (2005), Bruce Wayne can remain Batman only if he forgoes a romantic relationship with Rachel Dawes; and, in *Dinner for Shmucks* (2010), Tim earns back the love of his girlfriend through a moral victory that causes him to fail in the corporate world. In all of these scenarios, spectators can readily unite the two plotlines because the films have created causal linkages between them.

Other components of Hollywood narration contribute further to narrative unity and easy understanding. A goal-oriented protagonist, struggling to overcome obstacles, motivates narrative progress and reinforces causal connections between scenes. Deadlines and definitive resolutions contain the narrative by finishing it off. "The ending becomes the culmination of the spectator's absorption," Bordwell says, "as all the causal gaps get filled."[12] Bordwell notes that Hollywood movies clearly demarcate scenes according to Aristotle's unities: unity of time (scenes have a continuous duration), space (a definable locale), and action (a distinct cause-effect phase).[13] Together, the foregoing principles of classical Hollywood narration make it relatively easy for the spectator to connect a movie's disparate plot elements.

Bordwell accounts for spectator *comprehension* of Hollywood narration, but how do we explain spectator *enjoyment*?

The unity of classical narration enables Hollywood spectators to conjoin different segments of a movie into a pleasing whole. Hollywood plots tend to avoid ambiguity, weak causal connections, narrative detours, and plot information extraneous to the story's causal progress, excluding the noise that makes ordinary experience so much more distracting and stressful. Consequently, our understanding of the story pops into view without much effort or confusion. To quote Beardsley, the plot "has all that it needs" and "it all fits together."[14] According to Carroll, "Movie actions evince visible order and identity to a degree not found in everyday experience. This quality of uncluttered clarity gratifies the mind's quest for order."[15] When endings link with beginnings

by means of a distinct, unbroken causal chain, the spectator feels the satisfaction that comes from drawing a straight line of connections between plot segments. Indeed, the Hollywood plot has been streamlined to facilitate straightforward momentum, story-lines delineated and distractions minimized. Finally, the question-answer model of nar-ration, according to Carroll, has "an extraordinary degree of neatness and intellectually appealing compactness."[16] In the end, the film rewards our investment in the fate of the characters with an all-or-nothing conclusion that satisfies our desire for complete understanding.

Causality, erotetic narration, and an overall commitment to narrative clarity make the spectator's process of constructing a coherent story relatively undemanding. The notion that spectators' engagement with a Hollywood movie results from its "easily graspable clarity" finds support from empirical studies demonstrating that easy understanding cor-relates with positive aesthetic evaluation. According to the Processing Fluency Theory of aesthetic pleasure, advanced by psychologist Rolf Reber and his colleagues, properties that ease our understanding of an artwork also increase our pleasure in it.[17] When classi-cal Hollywood narration eases understanding, the studies predict, then movies become spontaneously pleasing.

THE LIMITATIONS OF CLARITY, ACCESSIBILITY, AND THE PROCESSING FLUENCY THEORY

Clarity alone does not explain the power of mainstream movies. If it did, then spectators would find all Hollywood movies intensely engaging since all of them follow a question-and-answer storytelling model and make narrative events clear and easily connected. Clarity may explain the "widespread engagement" of Hollywood cinema, but it does not adequately explain the intensity of that engagement or viewer preference for one Hollywood movie over another.

In Carroll's account, we should expect spectators to respond most intensely to those movies that have the clearest plot connections and the most accessible plot patterning. His theory, therefore, cannot explain why mass spectators do not engage more intensely with extremely clear and accessible films, such as *Blue's Big Musical Movie* (2000) and other films marketed to toddlers. Nor can his theory explain the power of relatively challenging Hollywood narratives, such as *The Big Sleep* (1946), *The Killing* (1956), *2001: A Space Odyssey* (1968), *The Godfather, Part II* (1974), *Nashville* (1975), *Blade Runner* (1982), *The Matrix* (1999), *Kill Bill* (2003 and 2004), and *Inception* (2010). Although wedded to classical storytelling principles, such films challenge efforts to construct a coherent story. The films do not pose as many challenges as *Diary of a Country Priest* (1951), nor have they earned the box office of *Titanic* (1997), but they demonstrate less "easily graspable

clarity" than typical Hollywood movies, yet masses of people have found them intensely engaging.

Clarity accounts for the mass accessibility and inherent pleasingness of Hollywood storytelling but not the appreciation and elation people feel when watching Hollywood movies they love. In short, unity and processing fluency tell only half of the story. Intense engagement, I propose, results when Hollywood movies *strike the right balance* between easy understanding and cognitive challenge. Sometimes audiences, even mass audiences, want something less pleasant and more interesting.

Hence, although we have, from film studies, a theory of unity in Hollywood storytelling and, from experimental psychology, empirical studies that testify to the pleasure of narrative unity, we do not yet have a theory that accounts for the aesthetic pleasure afforded by disunity in Hollywood storytelling. We need, in other words, a more complete theory of the aesthetics of classical Hollywood narration, one that also accounts for the pleasures afforded by gaps, complexities, discontinuities, novelties, inconsistencies, incongruities, and other elements that make Hollywood narratives more disunified, dynamic, and difficult to process. In this chapter, I present such a theory and support it with empirical research, particularly in the areas of insight and incongruity-resolution. The theory sets out to explain the ways in which Hollywood movies generate exhilarating aesthetic experiences by combining the classical model of storytelling with strategic breaches of narrative unity and story logic.[18]

TOWARD NARRATIVE DISUNITY

We should think of narrative unity and disunity not as all-or-nothing aesthetic properties but as a continuum. All Hollywood movies, not matter how unified, contain some measure of disunity, if only through the narrative gap that results when movies delay story resolution. The unity-disunity continuum, moreover, does not inhere entirely in the work itself since it is determined, in part, by the subjective experience of individual spectators. Spectators experience a lot of narrative unity when they easily conjoin plot elements within the artwork. Spectators experience a lot of narrative disunity when they struggle or fail to make plot elements cohere.

Citizen Kane offers a notorious example of narrative disunity. On his deathbed, publishing magnate Charles Foster Kane utters his last word, "Rosebud," initiating a search by the reporter, Thompson, to answer the film's central mystery, What does "Rosebud" mean? Astute filmgoers, however, notice that no one could have overheard Kane utter his final word because he said it while alone in his bedroom. The violation of story logic,

inasmuch as spectators notice it, creates an aesthetic defect potentially so damaging that, when a journalist asked Orson Welles about it, Welles reportedly considered the problem and said finally, "Don't you ever tell anyone of this."[19]

Because of the threat narrative disunity poses to the credence, causality, and reliability of Hollywood narration, commentators since at least the 1920s have regularly admonished screenwriters to avoid illogical or implausible events.[20] "Writers should be picky regarding logic and credibility," one screenwriting handbook says, "otherwise, the story will be riddled with gaps, improbabilities, illogic, and similar dents in believability."[21] Narratologist Marie-Laure Ryan regards faulty logic either as an aesthetic deficiency or, at best, as an excusable "trade-off" for an otherwise worthwhile narrative situation. Plots with faulty logic, Ryan says, "make the sophisticated reader groan."[22]

I propose, however, that disunities in a narrative, even logic violations, add aesthetic value to Hollywood narration, provided story resolution seems tangible or somehow within reach. Spectators need not actually resolve a disunity, but as long as they feel *capable* of resolving it, then narrative disunity will tend to exhilarate aesthetic experience. Provided spectators remain motivated to continue the search for understanding, then greater plot disunity will likely invigorate spectators' cognitive activity: the more plot disunity, the more effort required to construct a coherent story. Indeed, artworks that merely *present* stories—without stimulating us to *construct* stories—give our minds too little to do. Disunity makes story construction more athletic, increasing the potential for exhilaration in our aesthetic response.

Film scholars and authors of screenwriting manuals have not fully recognized the role that disunity plays in enhancing the aesthetic pleasure of Hollywood narration. Bordwell goes the farthest toward explaining the aesthetics of disunity when he discusses narrative devices that complicate the Hollywood viewer's experience. "Retardation devices," he says, "can introduce objects of immediate attention as well as delay satisfaction of overall expectation."[23] Retardation devices cue spectators to predict events that will fill-in narrative gaps. Hollywood plots might also supply "masses of material" and misleading material that complicate the viewer's ability to construct a coherent story.[24] Furthermore, the plot's rapid rhythm, Bordwell notes, impedes reflection and boredom. Finally, the variety of scenarios presented in a typical Hollywood movie prevents narration from becoming monotonous.[25] These devices ensure that a Hollywood movie has more than one note— that within its highly unified format, the plot creates sufficient delay, momentum, and diversity to maintain spectator interest.

But still we do not understand the aesthetics of disunity in Hollywood narration. How does narrative disunity exhilarate our aesthetic response? What thinking processes are engaged and what makes them pleasurable? When does disunity detract from aesthetic

pleasure and when does it add aesthetic value to Hollywood narration? I want to answer these questions by explicating two hypotheses:

1. Narrative disunity can motivate us to engage in free association and creative think-ing in order to resolve disparate plot information.
2. Provided resolution remains tangible (even through fuzzy reasoning), narrative disunity within a classical Hollywood framework adds variety to the filmgoing experience; stimulates imagination, curiosity, and creative problem-solving; and liberates our thinking from the burdens and limitations of good sense.

My two hypotheses challenge the commonsense assumption that aesthetically successful Hollywood narratives exhibit a relatively high level of unity and obey strict story logic. I hope to demonstrate that many aesthetically successful Hollywood narratives exhibit a relatively high level of *dis*unity or flat out *violate* story logic. Skilled Hollywood sto-rytellers, as we shall see, can use the seeming flaw in an otherwise unified narrative to a film's aesthetic advantage. As long as spectators retain confidence in the stability of a film's narrative foundation, then disunity in Hollywood narration will lead spectators toward *exhilarated pleasure*.

DISUNITY, ABDUCTION, AND INSIGHT

To understand the aesthetic pleasure of disunity in Hollywood narration, we must under-stand the mental processes at work when encountering information that seems some-how surprising, inexplicable, or out of place. This encounter can stimulate a "fuzzy" type of reasoning that logicians and philosophers of science call "abduction," or what Peter Lipton has called "inference to the best explanation."[26] Abductive reasoning involves pon-dering evidence or problems and conjecturing a provisional explanation for them. With abduction, someone observes a surprising fact (e.g., My car door has a huge scratch) and then creatively infers a plausible cause (That juvenile delinquent next door must have keyed it). Abduction accounts for how people form hypotheses about the world based on hunches, and philosophers of science, such as Charles Peirce, have employed the concept of abduction to explain how creative scientific discoveries take place.[27]

Logicians regard abductive reasoning as "fuzzy" because, unlike other types of rea-soning, it tends to lead to inexact or unreliable conclusions. *Deduction*, by contrast, denotes precise or "crisp" reasoning. With deduction, conclusions necessarily follow from general principles, as in the famous syllogism: (1) All men are mortal, (2) Socrates is a man, (3) therefore, Socrates is mortal. *Induction* is the process of inferring probable causes through testing and scrutiny. Detectives work inductively when they gather clues,

and scientists work inductively when they test hypotheses. Abduction, by contrast, is just a guess.

Unlike its more reliable counterparts, abductive reasoning can easily lead to false inferences and logical fallacies, such as *post hoc ergo propter hoc* ("after this, therefore because of this"). After Hurricane Katrina, several commentators—from minister Pat Robertson to minister Louis Farrakhan to Al-Qaeda to New Orleans mayor Ray Nagin—concluded that the hurricane came after, and therefore resulted from, *Roe v. Wade*, racism in America, America's tolerance of homosexuality, or various other national sins. Although abduction might lead to false conclusions, it also enables someone to make creative connections unavailable through more strict sorts of reasoning. Making connections through abduction does not demand rigor or scrutiny. The process enlists our imaginations most of all: It relies on our ability to form new concepts, uninhibited by practical constraints.

Cognitive psychologists use the term *insight* to describe the "a-ha" moment when someone suddenly understands something. With insight, a creative solution suddenly comes into consciousness as we understand relationships among elements in a new way or break free of unwarranted assumptions.[28] Researchers have reproduced insight experimentally. In a classic study, Maier placed subjects in a room with several objects and asked them to tie together two pieces of string hanging from the ceiling.[29] The strings, however, fell too far apart to hold at the same time. The solution came to those who thought to tie an object to one string in order to create a pendulum motion. Most people failed to see the solution, unless the experimenter prompted them by "accidentally" brushing against one of the strings while leaving the room.

Although the underlying cognitive mechanisms of insight remain mysterious, research suggests that solutions to "insight problems" (like the string problem) occur instantaneously, rather than incrementally, and that insight relies on unconscious thinking processes unlike those required to solve "non-insight problems" (like algebra).[30] For instance, people can generally predict how they will solve an algebra problem and how long it will take, but they have no idea how or when they will solve an insight problem.[31] The answer just comes to them all of a sudden. More like free association than crisp reasoning or intellectual scrutiny, insight demands imagination. Abundant scientific evidence supports the existence of this moment of sudden apprehension, and further evidence testifies to the pleasures—joy, satisfaction, and other positive emotions—that attend it.[32] Indeed, although my two hypotheses concerning the pleasures of narrative disunity may run contrary to common sense, my point about insight is extremely intuitive. We have all enjoyed the moment when disconnected information suddenly fits.

So let's note the key features of insight: It involves unconscious problem-solving, it requires cognitive effort, it can be prompted, it relies on imagination, it happens unconsciously and instantaneously, it is prone to error, and it creates pleasure. Such features

make insight an important area for understanding how people deal with disunities in narratives, since insight enables us all of sudden to connect narrative information that does not easily fit together or that may not fit together logically at all. Studying moments in which storytelling induces insight can furthermore help us understand some of the aesthetic pleasures of narrative.

Given our understanding of disunity, abduction, and insight, I suggest that the process of making sense of a narrative disunity follows three stages:

1. The narration cues the perceiver to form a hypothesis about a story.
2. The narration surprises the perceiver by presenting plot information that the hypothesis cannot explain.
3. Using abductive reasoning, the perceiver tries to improvise a new hypothesis that connects plot information and restores consistency to a set of beliefs.

Stage three marks the thrilling moment of insight when we break free of our current beliefs, and suddenly the improbable, the inconsistent, the inexplicable, or the unimaginable seems inevitably right.

But what makes insight pleasurable? The most illuminating scholarship on that question comes from humor and laughter studies, which offer the most comprehensive body of research— and perhaps the only empirical research—on the aesthetic pleasures of narrative disunity. Let's examine some of that research.

INCONGRUITY-RESOLUTION, PLEASURE, AND FREE PLAY

Most scholars of humor and laughter ascribe to some version of Incongruity Theory. The theory dates to Aristotle's *Rhetoric*, but Kant, Beattie, Schopenhauer, and others further developed it. The theory holds that humor results when someone suddenly recognizes a pattern violation. Laughter, as humor researcher John Morreall describes it, is a "reaction to something that is unexpected, illogical, or inappropriate in some other way."[33]

Psychologists James M. Jones, Thomas Shultz, and Jerry Suls elaborated Incongruity Theory and refined it. Their Incongruity-Resolution Theory proposes that humor arises when the perceiver meets with an incongruity and feels motivated to resolve it.[34] The perceiver laughs upon the sudden apprehension of a solution to a humorous kind of "insight problem."[35] Consider the Woody Allen joke, cited by Suls, in which a group of prisoners escape, "twelve of them chained together at the ankle, getting by the guards posing as an immense charm bracelet." When listening to the joke—as with almost all jokes that we would regard as narratives—our minds follow the three-stages

that mark any encounter with narrative disunity. However, with jokes, according to Incongruity-Resolution Theory, the disunity is so intense as to create a pattern violation or *incongruity*.

1. The narration cues the perceiver to form a hypothesis about a story. *The prisoners will find a way to escape the chain gang.*
2. The narration surprises the perceiver by presenting information incongruous with the hypothesis. *Posing as jewelry could never succeed because the prisoners are obviously too big.*
3. Using abductive reasoning, the perceiver tries to improvise a new hypothesis that connects narrative information, resolves the incongruity, and restores consistency to a set of beliefs. *Prisoners chained at the ankle, on second thought, have an appearance oddly similar to a very large charm bracelet, so their ruse could conceivably work.*

Although we do not really, rationally believe that such a ruse could work, the joke enables a fuzzy kind of resolution the moment we find a connection within the incongruous information.

Piles of ethnographic and controlled psychological studies support Incongruity-Resolution Theory, many of them conducted by Shultz and his colleagues in the 1970s. As one example, Shultz and Horibe found that children considered verbal jokes funniest when the jokes had both an incongruity and a resolution. For example, the joke, "Why did the cookie cry? Because its mother had been a wafer so long," offers "resolution" because a phonetic similarity between "a wafer" and "away for" enables the listener to find a connection between incongruous story elements (cookies and absences). By contrast, children found jokes less funny when the jokes had an incongruity and no resolution ("Why did the cookie cry? Because its mother was a wafer") or a resolution and no incongruity ("Why did the cookie cry? Because he was left in the oven too long"). Shultz also identified incongruity and resolution properties in the large majority of Chinese jokes, riddles from non-literate cultures, and Japanese riddles and folk tales.[36]

Note that resolution does not require logic or even a meaningful explanation. Indeed, "resolution" seems the wrong word sometimes because, with some humor, nothing is solved. One humor theorist tried to correct the misnomer by labeling the connection between disparate elements an "appropriate relationship" rather than a "resolution."[37] The "wafer joke," for instance, hinges on the perception of a non-meaningful similarity, the result of a homophonic coincidence, not any logical relation between wafers and being away. The joke results from *making a connection* or *seeing an appropriate relationship* between disparate things ("a wafer"/"away for," chain gangs/charm bracelets). Humor encourages us to entertain playful connections between incongruous story elements,

freed from the limitations of crisp logic and close scrutiny. Humor offers our minds a vacation from logic and scrutiny, replacing them with free play.[38]

The illogic we find in much humor testifies to one of the key attractions of aesthetic experience in general: its low stakes. When experiencing works of art, we use the same cognitive capacities that we use to interact with the everyday environment; however, with the arts, we employ them for playful, rather than practical, purposes.[39] Art enables us to enjoy *risk-free cognition*, liberated from the practical consequences of everyday experience. Because of its low stakes, the arts enable patterns of thinking that the real world normally discourages and regards as dysfunctional.

Imagination is the key cognitive process associated with aesthetic experience. Because of our capacity for imagination, the arts enable experiences (sometimes intensely emotional or intellectual experiences) unencumbered by the practical consequences that make ordinary life so much more inhibiting and mentally taxing. Of course, we use imagination to navigate everyday life as well. However, unlike imaginative thinking in an aesthetic context, imaginative thinking in everyday life poses risks, since logic and practical constraints do not rule our imaginations. Consequently, we do not use much imagination when we drive our cars, protect the safety of our children, or pay our utility bills, and we rely on the assumption that most other people—airplane pilots, nuclear engineers, car mechanics, doctors, lawyers, tax auditors, and grocery store managers—rely more on scrutiny and logical thinking than on imagination in their work.

With artworks, such concerns disappear. The arts remove the burdens and limitations of good sense and instead encourage guessing, free association, and creative insight—mental activities that, when unchecked by scrutiny and reason, might in the real world lead to impractical assessments, false inferences, incomplete knowledge, or unrealistic beliefs. Liberated from the risks associated with casual, illogical thought, we feel free to think in ways that high-stakes reality inhibits. Under the security of the artistic context, we are let loose for cognitive play.

Beyond Mirth: Incongruity-Resolution and Narrative Pleasure

I introduce Incongruity-Resolution Theory here because it helps us to understand how our minds respond to and enjoy the disunities we encounter in Hollywood narratives. Although it may seem strange to think of jokes as equivalent to extended narratives, we engage in the same cognitive processes when we recognize a pattern violation in either one. Indeed, most jokes *are* narratives. If a narrative, as many narratologists define the term, is merely a chain of events in a cause-effect relationship,[40] then the brief joke, "A skeleton walks into a bar and orders a beer and a mop," is as much a narrative as

The Brothers Karamazov. A disunity, whether in a joke or in an extended sequence of events, motivates the same abductive search for connections. And if we find a connection, we experience the same thrill of insight.

Finding a connection may result in mirth and laughter or merely the delight of connecting inconsistent plot information. "We enjoy incongruity in other ways than by being amused," Morreall observes.[41] Recall that the standard tropes of both humorous and non-humorous literature—rhyme, metaphor, metonymy, paradox, puns, oxymoron, irony—all encourage us to find a connection between inconsistent things. Whether we consider disunities prompted by jokes, word play, or extended narratives, the process of searching for resolutions has the same potential to inspire insights and playful mental associations, freed from the burdens of logic, scrutiny, and good sense.

Whodunits, Mismatched Partners, and *Urban Cowboy*

Hollywood narratives often inspire viewers to make connections between inconsistent plot information. A Hollywood whodunit, for example, typically reveals the *least* likely character as the murderer, the one we never considered (hence, "the butler did it"), surprising us and also enabling us to see an intriguing correctness and inevitability in events that previously seemed unimaginable. When, at the end of *Murder on the Orient Express* (1974), we learn that all of Hercule Poirot's suspects committed the murder together, it seems at first incongruous, because it violates expectation and whodunit tradition, and perfectly correct, because Poirot had, in typical fashion, already demonstrated that each suspect had a motive.

Screwball comedies often bring together mismatched characters: a rich heiress and a working man (*It Happened One Night* [1934], *Holiday* [1938]), a stuffy intellectual and a sexy vamp (*Ball of Fire* [1941]), a stuffy intellectual working man and a ditsy rich heiress (*Bringing Up Baby* [1938]). The mismatch creates a disunity in the narrative (Those two could never be right for one another) and violates our expectations about suitable couples. However, the mismatch also enables us to find oddly appropriate connections between potentially incongruous plot information. Encouraged by the conventions of the screwball genre, viewers hypothesize a story logic that enables them to conceive of the match as appropriate. Indeed, part of the interest and delight of such films comes from witnessing the inevitable union of characters who seem so wrong for one another. One can imagine an incongruity so pointed as to prevent resolution—say, a screwball romance between Joseph Goebbels and Gertrude Stein. However, romances with highly inappropriate partners—*Harold and Maude* (1971) and *Minnie and Moskowitz* (1971), for example—although they strain reason and probability, enable imaginative insights that more unified narratives do not.

Harold and Maude and *Minnie and Moskowitz* are unusual films, but more typical Hollywood romances also inspire our abductive reasoning processes. The utterly ordinary *Lover Come Back* (1961) creates such animosity between the competing advertising executives played by Doris Day and Rock Hudson that their union at the end of the film seems at once inexorable and preposterous. He misuses her, callously deceives her, steals her ideas, tries to trick her into having sex with him, humiliates her publicly, and treats her with downright contempt, yet we spend the entire movie imagining how these two will end up married. Indeed, the filmmakers seem to have made the couple's union as improbable as possible in order somehow to hamper its inevitability. The logic by which they unite is infantile: After accidentally eating some alcoholic candies, they marry in a drunken stupor, have sex, and get an annulment; nine months later he convinces her to marry him again as she's heading into the delivery room. *Lover Come Back*, barely remembered now, was the third highest grossing movie of 1961, and I suspect its brief popularity depended in part on its ability to resolve a scenario that logic, scrutiny, and the practicalities of the real world would tell us is irresolvable.

An early scene in the brief eighties hit, *Urban Cowboy* (1980), offers another routine example of abduction and insight. Bud (John Travolta) slaps Sissy (Debra Winger) shortly after their first kiss. "You hit me," Sissy says angry. "You're not supposed to hit girls." They argue in the parking lot and end up fighting in a watery ditch, setting in motion the film's first major conflict: These two characters have a budding romance, but they don't know each other well, and he seems volatile and aggressive. We likely hypothesize a storyline in which the two fight one another and finally end up together at the end of the film. But the scene does not go in the way we predict. After they enter his pickup, drenched, angry, unable to speak, he says abruptly, "Do you want to get married?" A close-up of her face cuts suddenly to a scene in which they pose for photographs, having just wed. In a surprising few seconds, the narration causes us to improvise a new hypothesis that explains the events we have just seen: The fighting couple was flirting in some dysfunctional way, heading toward union, not away from it. Though unexpected, it's an utterly conventional series of cuts. We have seen this sort of surprise many times in Hollywood cinema. Yet it cannot help but spark our processes of abduction and insight, as the narration causes us to break free of our current beliefs and imagine a new direction for the story.

DISUNITY, IMAGINATION, AND COGNITIVE PLAY

Research suggests that pleasure in humor correlates positively with the degree of disunity, provided some form of resolution remains tangible. Jones found that one group's rating of the funniness of cartoons correlated directly with another group's rating of the cartoons' degree of incongruity.[42] Deckers and Buttram, Hoppe, and McGhee each found

an "inverted-U" relationship between incongruity and humor, such that humor increased relative to the degree of incongruity and then began to decline.[43] This research suggests that the greater the strain on our ability to resolve disunified information—so long as the strain does not overburden our efforts at resolution—the greater we enjoy it. Indeed, as we saw in chapter 1, researchers have found that people prefer artworks that offer greater difficulty, provided the objects do not overwhelm their ability to cope.[44] Greater levels of disunity warrant more imagination and effort, and the result can be exhilarating, as we try to unite properties that resist resolution but that nonetheless offer the prospect of resolution.

Psychologists Armstrong and Detweiler-Bedell argue that an encounter with a disunified object excites a free play of ideas, as we break free of current beliefs and reach for new understanding:

> Instead of protecting one's knowledge against the threat of inconsistency, one welcomes novelty for its promise of yielding to understanding. . . . In ordinary cognition, a person smothers uncertainty with a familiar concept to avoid confusion. During free play, a person contemplates a novel stimulus, while holding prior understandings at bay, to expand his or her knowledge structures.[45]

The effort to understand a disunified object exercises our cognitive agility and creative problem-solving capacities. If logic and practical reasoning cannot help us understand an object (logic and practical reasoning cannot help us get the "wafer" joke, for instance), then imagination and free association might. A disunified object can prompt us to perform, with lackadaisical logic, feats of imaginative thinking.

But do all of these encounters with disunity—in jokes, whodunits, and Hollywood romances—amount to the same thing? We would not call the disunities in whodunits and screwball comedies violations of story logic. Indeed, those genres motivate certain conventional kinds of disunity. Still, from the viewpoint of a perceiver attempting to understand a disunified narrative, all such encounters excite the same cognitive activity. Whether experiencing jokes, whodunits, screwball comedies, *Urban Cowboy*, or any other narrative, aesthetic pleasure intensifies, I propose, whenever someone discovers a connection that repairs a breach in the plot pattern.

It seems relatively easy to find unity in the mismatched romantic partners of screwball comedies, but some disunities—such as the one in *Citizen Kane*—once perceived, seem utterly irresolvable. An irresolvable disunity will readily damage a classical narrative, just as Ryan suggests. The failure of *Citizen Kane* to offer a potential resolution to its narrative inconsistency accounts for why critics regard it as a flaw. But suppose *Citizen Kane* had enabled in viewers an "a-ha" moment of insight? Suppose, for instance, that Raymond's

flashback had shown the butler at Kane's bedside at the moment of death, inviting us to suddenly hypothesize that Kane's loneliness had distorted the initial depiction of his death scene? In that case, the inconsistency could have been a source of aesthetic pleasure, rather than an aesthetic defect.

Twist Films, Mysteries, and Convoluted Narratives

As a counterexample to *Kane*, consider *The Sixth Sense* (1999), which, toward the end, creates a momentary, but radical, disunity when it reveals that a primary character has, in fact, been a ghost for most of the movie. The revelation creates a brief rupture in story logic, until we repair the rupture with a new concept that restores coherence to the story. Judging from reviews, blogs, and commentary about the movie on the Internet Movie Database, the moment of insight, when we reimagine the story through the lens of our new hypothesis, creates tremendous excitement, so much that writer-director M. Night Shyamalan made this type of twist his artistic signature.

With twist films, spectators reimagine an extended storyline in light of an incongruous revelation. Hollywood has been making twist films since the studio era (*Woman in the Window* [1944], *Stage Fright* [1950], *Witness for the Prosecution* [1957], *Psycho* [1960], *What Ever Happened to Baby Jane?* [1962], *Planet of the Apes* [1968]), and they have grown increasingly popular and complex since the 1990s (*The Usual Suspects* [1995], *The Game* [1997], *Fight Club* [1999], *A Beautiful Mind* [2001], *The Others* [2001], *The Prestige* [2006], *Shutter Island* [2010]). Twist films offer paradigmatic examples of the pleasures of incongruity-resolution in Hollywood narration because they work just like jokes.

Incongruity constitutes one form of narrative disunity in Hollywood storytelling. Another is a narrative gap—a break in the cause-effect chain that makes it more challenging for spectators to construct a coherent story. Mystery films help us understand the pleasures afforded by narrative gaps. Such films create curiosity and interest by withholding crucial causal information, prompting spectators to try to repair the break imaginatively. For instance, *And Then There Were None* (1945) withholds from us the knowledge that one of the apparent murder victims faked his death. We eliminate him from our list of suspects yet have difficulty forming a coherent story because the remaining suspects also seem innocent. Narrative gaps establish an atmosphere of mystery and create intriguing puzzles for spectators to solve. The gaps motivate a search for understanding, and plot cues guide the search. Mystery films manipulate our abductive reasoning processes as we entertain a variety of guesses in an attempt to restore coherence to the story.

The process of abduction creates pleasure only as long as we retain confidence in the possibility of story coherence. The search for meaning hinges on the assumption that meaning exists. Once we give up that assumption, the search stops. Hence, the existence

of meaning matters less than the assumption of its existence. Under normal circumstances, Hollywood mystery films fill in all of their major narrative gaps, but sometimes they don't and they don't have to. Indeed, the most certain way to sustain an audience's search for meaning is to make meaning impossible to find. The notorious example from classical Hollywood comes from *The Big Sleep* (1946), with its perhaps irresolvable puzzle of double-crosses, cover-ups, and murders. The film deliberately forsakes narrative logic, David Thomson says, "so that 'fun' could be pursued."[46] Director Howard Hawks said about the story, "I never figured out what was going on. . . . After that got by, I said, 'I'm never going to worry about being logical again.' "[47]

The Big Sleep, like many enduring Hollywood mysteries, contains an uncommonly gappy narrative for a Hollywood film. We also encounter narrative gaps in *Vertigo*, a wildly implausible story involving a husband's convoluted efforts to cover up the murder of his wife. Indeed, one of *Vertigo*'s scenes makes no sense in retrospect. After Scottie (James Stewart) watches Madeleine (Kim Novak) enter the lobby of the McKittrick Hotel and appear in the window of one of the rooms, the manager in the lobby insists that Madeleine hasn't come into the hotel that day. Together Scottie and the manager inspect the room, from which Madeleine has apparently vanished. The mystery adds a puzzling strangeness to Madeleine's behavior that accords with the film's mood and themes at that point, prompting spectators to imagine potential resolutions somewhere in the realm of the supernatural. Although a supernatural explanation ultimately makes no sense when the film switches from a ghost story to a crime story, it functions provisionally to sustain the search for meaning. Ultimately, *Vertigo* never clarifies the scene or the mechanics of the ruse, even after the film has explained its other gaps and mysteries. Movies such as *The Big Sleep* and *Vertigo*—as well as, more recently, *Mulholland Drive* (2001), *The Double* (2013), and *Enemy* (2013)—invite us to use abductive reasoning in order to make sense of a narrative that logic and close scrutiny would not help us understand and might even prevent us from understanding.

Convoluted narratives offer another common form of disunity, particularly in recent cinema. Films such as *Reservoir Dogs* (1992), *Memento* (2000), *Eternal Sunshine of the Spotless Mind* (2004), *Primer* (2004), *The Prestige* (2006), *Duplicity* (2009), *Triangle* (2009), *Source Code* (2011), *Looper* (2012), *Cloud Atlas* (2012), and *Coherence* (2013) have together formed a popular trend. (Chapter 10 examines some possible causes of the recent trend in convoluted narratives.) A handful of studio-era films explored similar narrational devices. *The Killing* (1956), for instance, not only puts scenes out of chronological order, but the film also includes plot convolutions that only increase the difficulty of understanding the story. At one point, the lead caperist, Johnny (Sterling Hayden), puts a gun in a guitar case, transfers the gun to a flower box, puts the flower box in a bus-station locker, and puts the key to the locker in the mailbox of another caperist, Mike

(Joe Sawyer), who picks up the key and uses it to retrieve the gun, which he puts in another locker at the race track where the heist will take place and where Johnny, after staging a distraction, picks it up again. The convolutions complicate the caper and inhibit viewers from questioning why Johnny didn't simply give Mike the gun (or the key) sometime before. In fact, the movie never explains why Johnny must arrange for Mike to obtain the gun at all, if Johnny will only pick it up again himself later on at the track.

Although scholars often regard Hollywood as an "excessively obvious" cinema,[48] movies such as *The Big Sleep*, *Vertigo*, and *The Killing* make comprehension difficult when their disunities jeopardize, or flat out violate, story logic. Such films create interest with plots that might not withstand logical scrutiny. Would these narratives offer more aesthetic pleasure if they ultimately made better sense? I think they would not. If *The Big Sleep*, *Vertigo*, and *The Killing* resolved all of their gaps and mysteries, they would surrender some of the qualities that make the films persistently interesting: Once a plot makes perfect sense, it immediately sacrifices the atmosphere of mystery and labyrinthine complexity so central to mystery films and convoluted narratives. As Hitchcock himself said, "Nothing in the world is as dull as logic."[49] Mystery and narrative complexity sustain our interest in such films, as well as our sense that their stories contain difficult problems that demand attention and thought.

Confronted with a mass of plot information that context says must make sense, spectators likely have a persistent feeling that more remains to be understood than their minds can readily grasp. For Armstrong and Detweiler-Bedell, that feeling defines "exhilarated pleasure," which results, they say, from the prospect of "understanding particularly challenging stimuli when the potential to realize such understanding . . . is tangible but distant."[50] The astonishing popularity of writer-director David Lynch—and his persistent ability to raise substantial budgets for projects with deeply indeterminate narratives—testifies to the aesthetic value and commercial value of films that keep understanding "tangible but distant." Even after Lynch's narratives have concluded, they linger because some of their plot elements do not obey story logic and remain mere potentials for understanding. Some spectators find Lynch's films too disunified, but for spectators engaged by them—that is, spectators willing to persist in the search for understanding, despite violations of story logic—Lynch's films offer exhilarated pleasure.

Based on my descriptions of narrative disunity in *The Big Sleep*, *Vertigo*, and *The Killing*, one might think that I long for a Hollywood cinema more like *Un Chien Andalou* (1929) than *Stagecoach* (1939). Hollywood, however, can only flirt with disunity. Because Hollywood cinema is stabilized by a classical foundation that reassures spectators of their ability to cope, the films can exhibit an occasional indeterminacy without alienating a mass audience. *Un Chien Andalou* forgoes that foundation, and, as a consequence, typical viewers are liable to conclude that the story will never make sense. *The Big Sleep*, *Vertigo*,

and *The Killing*, by contrast, likely retain an audience's trust in their underlying coherence. A classical foundation stabilizes these films and sustains the search for understanding.

I still have not entirely figured out the story of *The Big Sleep*, but, each time I watch the movie and contemplate it afterward, I persist in the secret mad hope that this time I will. My search for story coherence endures because of the mere prospect of understanding. If that prospect is ever permanently ruined, then *The Big Sleep* would become, for me, an aesthetically damaged narrative. But as long as story logic remains "tangible but distant," then my guessing will continue. The film's atmosphere of mystery and complexity will persist as long as reason does not clear things up and ruin the mood.

CONCLUSION: INDIVIDUAL DIFFERENCES, PROCESSING CAPACITY, AND THE PLEASURES OF STORYTELLING

According to the theory of storytelling aesthetics presented here, storytelling creates pleasure by cuing viewers to mentally resolve disparate plot information. Hollywood generally makes resolution fairly easy by using time-tested storytelling principles, especially principles of clarity and causality, that ease mental activity and satisfy the viewer's desire for immediate understanding. Easy resolution makes Hollywood movies spontaneously pleasing for average spectators. Some Hollywood movies, however, exhilarate our aesthetic experience by making plot resolution more difficult. Aesthetic pleasure exhilarates when cognitive activity is athletic and resolution distant but still tangible. Using abductive reasoning, viewers engaged by such films seek to unify plot information, repair gaps and inconsistencies, or sort out convolutions. As long as a movie does not put so much strain on our cognitive resources that we give up the search for understanding, then our aesthetic pleasure will likely intensify with the degree of difficulty at resolution.

This theory helps explain why different people enjoy narratives with different levels of novelty, complexity, improbability, ambiguity, inconsistency, incongruity, or other factors that increase the strenuousness of the story construction process. Some viewers seem willing or able to resolve narrative elements that other viewers regard as too difficult or impossible to resolve. Empirical researchers have shown, for instance, that people who possess more experience with art prefer more complex, unpredictable, and difficult-to-process artworks.[51] To achieve intense levels of mental activity, experts require more challenging art that offers more resistance to understanding.

My theory of storytelling aesthetics also helps us understand why we might feel in the mood sometimes for a David Lynch movie and at other times for a simple romantic comedy. Even film experts sometimes seek entertainment from undemanding art, dependent largely on their brain's *processing capacity* at the time. Processing capacity determines the maximum amount of information that we can process within a

cognitive system (such as working memory). One study found that subjects preferred to listen to more simple music if the experiment limited their available processing capacity by engaging their attention in other ways.[52] The researchers gave subjects one of several mandatory tasks that demanded attention. Easier tasks allowed for greater "spare capacity." They then offered subjects a choice of listening simultaneously to either a simple or a complex melody. The study found that "the greater the spare capacity (the smaller the likelihood of an overload), the greater the proportion of complex-melody choices, given that the two types of melodies were initially liked about equally."[53] When people devote cognitive resources to a task, they have fewer resources to devote to art. This finding may help explain the resistance of Americans to foreign-language films, because reading subtitles adds nothing to a film's aesthetic enjoyment and instead threatens to reduce enjoyment by dividing attention and adding to one's cognitive load.

So when we say, "I'm in the mood for something light," I think we mean, "My brain does not have the processing capacity right now to enjoy strenuous entertainment." Context (the other activities in our brain) helps determine the kind of art we prefer at the moment. When we feel mentally fatigued, when the environment distracts us, or when thoughts or worries consume us, then we have fewer cognitive resources to devote to art, and more easily processed artworks become more attractive.

Finally, my theory helps explain why a good story does not automatically translate into aesthetic pleasure. The aesthetic pleasures of narrative rely on good story*telling*— the process by which an artwork cues the spectator to construct a story in her mind. By complicating the spectator's story construction processes, Hollywood narration can intensify that pleasure. Consider how much less pleasurable *Memento* would be if it told its story in chronological order. A chronological *Memento*, which one can find on DVD, eliminates the challenge of constructing a coherent story out of non-chronological segments. The chronological *Memento*, which tells the same story as *Memento*, is a much duller movie.

Talented Hollywood filmmakers find inventive ways to challenge spectators' story construction processes: incongruous representations of characters in *The Searchers* (1956) and *Chinatown* (1974), highly improbable events in *North by Northwest* (1959) and *Magnolia* (1999), divergent plotlines in *Grand Hotel* (1932) and *Nashville* (1975), causal gaps in *The Big Sleep* and *2001: A Space Odyssey* (1968), stories told in non-chronological pieces in *Citizen Kane* and *Pulp Fiction* (1994), and thwarted narrative expectations in *Mildred Pierce* (1945) and *Psycho* (1960). Such films challenge our ability to construct coherent stories out of disunified plots. But as long as the films have not made the process too onerous for us—as long as story resolution remains tangible and

we persist in the search for understanding—then the films have enabled in us exhilarating moments of imagination, insight, and free play.

<p style="text-align:center">· · ·</p>

This chapter presents a broad theory of Hollywood storytelling aesthetics, and I have selected examples (mostly from screwballs, whodunits, twist films, and mysteries) that illustrate in the clearest way the aesthetic value of narrative disunity and the processes of abduction, insight, and incongruity-resolution. But can my theory explain aesthetic pleasures afforded by Hollywood films in other, more narratively straightforward genres? And how might Hollywood filmmakers exploit the aesthetic benefits of narrative disunity not for twists, revelations, convolutions, and moments of mystery but regularly, and in a sustained way, to create cognitive play?

The following chapter analyzes the classical Hollywood western, *Red River* (1948), a film that periodically breaches its own narrative logic. Most of the time, *Red River* exhibits clarity, causality, linearity, Aristotle's unities, and all of the other classical canons that stabilize Hollywood narration and make it easily graspable. At other times, however, the film's plot devices seem out of harmony with narrative logic and impede the efforts of viewers to construct a coherent story. I hope that my analysis of the film will further illustrate my model of storytelling aesthetics and also demonstrate the model's usefulness in explaining how individual Hollywood narratives excite aesthetic pleasure.

Finding the Fit

Shifting Story Logic in *Red River*

A play should have barely been rescued from the mess it might just as easily have been.

—Tony Kushner[1]

THE PREVIOUS CHAPTER LEAVES US WITH THE FOLLOWING QUESTION: Does narrative disunity offer aesthetic pleasure only for an instant or can filmmakers sustain the pleasures of abduction, insight, and incongruity-resolution throughout a film in order to enliven and diversify the spectator's aesthetic experience of an extended narrative?

In this chapter, I want to analyze a series of narrative disunities in the 1948 Howard Hawks western, *Red River*, a film that repeatedly violates Hollywood screenwriting's cardinal rules regarding narrative unity, probability, causality, and story logic. I hope that my analysis will not only illustrate the aesthetic pleasures of sustained narrative disunity but also offer further evidence for the most controversial point from the previous chapter: that, as long as we feel we can make sense of inconsistent plot information, even through spurious logic, then narrative disunity will add aesthetic value to classical storytelling and pleasure to our aesthetic experience. My analysis of *Red River* will, I hope, illustrate the justness of that unintuitive idea.

PLANTING WITHOUT PAYOFF

Red River displays an unusual plot pattern for a classical Hollywood western: The narration often predicts events that never materialize, as though scriptwriter Borden Chase began, and ultimately abandoned, several storylines but neglected to delete them from his script. The love story between Thomas Dunson (John Wayne) and Fen (Colleen Gray) illustrates this pattern. *Red River* kills off Fen after only one scene, but because the narration reveals her death indirectly (when Dunson sees that the Indian he has killed is wearing the bracelet Dunson gave Fen), the movie might be indicating that, despite appearances, she is not really dead. She seemed such a strong character—and Gray plays her with such verve, sensuousness, and charisma—that it is hard to believe the character has only one scene and that the film would not have rendered her death more definitively and dramatically. Moreover, since Dunson and Fen's love scene reveals their plan for her to join him in the future, Fen's return later in the film would offer a fitting opportunity to unify the narrative. Still, we never see her again.

The movie squanders numerous other possibilities for narrative unity. An early scene between Dunson and a Mexican gunman suggests that *Red River* will center, at least for a time, on Dunson's efforts to defend his land against land baron Don Diego, but no other scene raises the issue. Similarly, after a playful quick draw between Dunson and Matt Garth (Montgomery Clift), Groot (Walter Brennan) hollers that Matt is "just a little bit faster" than Dunson, foreshadowing a gunfight between the two cowboys that never takes place. Moreover, we repeatedly hear about Indians and border gangs threatening Dunson's herd on the cattle drive, yet neither attack occurs.

A gunfight between Matt and Cherry Valance (John Ireland) seems not merely probable but virtually certain. The movie introduces Valance as a headstrong gunslinger, a villainous counterpart to Matt. Wearing a forbidding black shirt and a loose bandana, Cherry stares Matt down and coolly leans forward in his horse, a snarl in his lip, insolently challenging Matt and Dunson when they object to an inspection of their herd (figure 4.1). When Matt and Cherry together start shooting a tin can in the following scene, Groot says they are "sizing each other up for the future," and, as though the foreshadowing were not already overt enough, he says, "Them two is gonna tangle for certain, and when they do it ain't gonna be pretty" (video 4.1 ▶). Screenwriting manuals call this kind of dialogue a "plant," which prepares spectators for a "payoff" later in the film. Astonishingly, however, the promised "tangle for certain" never happens; the plant has no payoff.

"Planting and payoff" is a common storytelling device, regularly discussed in screenwriting manuals because it reinforces narrative unity. "Planting and payoff are based in causality," one manual says, "strengthening of overall dramatic unity by creating specific connections between disparate sections of the plot."[2] A plant creates a narrative gap that

FIGURE 4.1 *Cherry Valance (John Ireland) sneers at Matthew Garth (Montgomery Clift) in* Red River *(1948).*

prompts spectators to hypothesize story events that will fill in the gap with a fitting payoff. Because *Red River* neglects to fill in some persistent gaps—establishing an environment for events that the narration never realizes—the plot seems to drift off course. Although Robin Wood considers *Red River* "by no means the rambling and episodic work it may appear to the casual observer," his conclusion admits the feeling of narrative drift that I am pointing to.[3] Screenwriting guru Syd Field warns his readers precisely of this drifting. When plants are "left hanging and unresolved," he says, the story line "seems to wander around in search of itself. . . . Things that are set up have to be paid off."[4]

At least one of the film's false predictions was intentional. In a recorded interview in 1972, Peter Bogdanovich asked Hawks about the rivalry between Matt and Cherry, "Were you going to pay it off and then change your mind?" "No, no," Hawks replied. "I just thought [the rivalry] was good to hang over. . . . The usual picture would have [paid it off], and I thought, 'Well, why do it?' "[5] Other narrative detours resulted, it seems, from the film's piecemeal scriptwriting process.[6] Chase based the script on his serialized story, "The Chisholm Trail," which, though itself somewhat rambling, pays off some of the plants that the film leaves hanging. His draft script includes attacks by both Indians and border gangs, as well as a more logical conclusion to the Dunson-Matt conflict. Although Hawks altered events in Chase's original script, he apparently maintained some of Chase's plants. This type of fragmented scriptwriting process, a common practice in Hollywood, can result in orphan storylines such as those found throughout *Red River*.

Still, before principal photography, writers have typically cleaned up the script. In fact, if we believe the screenwriting manuals, *Red River* represents shoddy screenwriting;

the script is kind of a mess. By regularly planting without paying off, the narration fails to conjoin scenes and leaves storylines incomplete. Surrealist filmmakers, such as Luis Buñuel and David Lynch, regularly pursue similar narrative strategies, but, in a classical Hollywood narrative, most people would regard this type of disunity as an aesthetic defect.

As Tony Kushner says about good playwriting, however, *Red River* seems to have "barely been rescued from the mess it might just as easily have been." Indeed, the film has a highly regarded screenplay and earned Chase a nomination from both the Motion Pictures Association of America and the Screenwriter's Guild. In the disorder of the screenwriting process, the filmmakers hit upon an aesthetically productive narrative pattern unavailable to classical narratives with a more linear causal progress: As *Red River* abandons several storylines, it makes use of the existing plants by depicting scenes that contain subtle echoes of the events the movie forecasted. In this way, the narration, like a joke, establishes both an incongruity (something out of harmony with story logic) and an unexpected, but still fitting, resolution (a connection that suddenly makes the incongruous element feel appropriate).

I want to demonstrate that the movie follows the joke pattern that I spelled out in the previous chapter:

1. The narration cues the perceiver to form a hypothesis about the story.
2. The narration surprises the perceiver by presenting information incongruous with the hypothesis.
3. Using abductive reasoning, the perceiver tries to improvise a new hypothesis that connects narrative information, resolves the incongruity, and restores consistency to a set of beliefs.

Red River plays out this pattern in a variety of scenarios. The narration inspires a series of insights in which spectators find fuzzy connections in the film's plot. Those connections, once found, enable a playful, creative, unexpected story resolution—more like free association than logical reasoning.

FUZZY CONNECTIONS

Red River enables viewers to create plot connections by depicting scenes *reminiscent* of the forecasted scenes, exploiting viewer expectations for story events without directly fulfilling narrative promises. For instance, Fen never reappears, but the film introduces Tess Millay (Joanne Dru), who looks a lot like Fen and who behaves with the same energetic, contrarian brass in her scenes with Matt that we saw in Fen's interaction with Dunson.

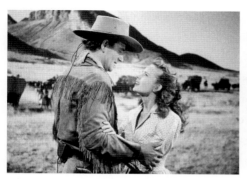

FIGURE 4.2 *Thomas Dunson (John Wayne) and Fen (Colleen Gray).*

FIGURE 4.3 *Matthew Garth (Montgomery Clift) and Tess Millay (Joanne Dru).*

FIGURES 4.2 AND 4.3 Red River *(1948). Physical similarities between Fen and Tess Millay create a connection between the two characters and may confuse the two in the minds of spectators. They wear the same style of dress—light, patterned, button-down front with a V-neck collar. They have similarly dark, thin, elongated eyebrows. Makeup and lighting highlight their cheekbones. They both have long, wavy hair, pulled back behind the ears.*

Film scholar Suzanne Liandrat-Guigues says that the script's substitution of one romance plot for the other "permits a certain sliding of the Fen-Tom couple towards the Tess-Matt couple as well as superimposing one on the other."[7] Robin Wood and Varun Begley separately remarked on the women's similar roles in the story.[8] We should also note the characters' physical similarities, particularly their cheekbones, hairstyles, clothing, and eyebrows (figures 4.2 and 4.3). Their similarities have led many of my students to remark that upon meeting Tess they initially thought she was Dunson's girlfriend from the first scene, a confusion encouraged by the fact that Dunson is absent when we meet Tess, that over an hour has passed since we have seen Fen, that neither actress Colleen Gray nor Joanne Dru are particularly well known (and were not in 1948), and that Fen's story seemed oddly unfinished. The film did not resolve the ambiguity, students have told me, until Dunson finally meets Tess, twelve minutes after her introduction in the film.

We have here the structure of a very subtle joke. Based on earlier events, we expect, perhaps, that we might re-meet Fen (hypothesis), we meet a woman who might have been Fen and isn't (incongruity), but we can connect the two women because they look and behave so similarly (resolution). I have made some assumptions here about spectators' hypotheses and resolutions, and the details may prove different for different spectators, but consider how unfinished the Dunson-Fen love story remains and how many connections to that story the introduction of Tess enables (character behavior, character appearance, a new romantic pairing). And if readers do not find my own anecdotal class experience persuasive, consider how many critics have remarked on the connections between the women, as well as the connections between their relationships with

Dunson and Garth. Plenty of evidence suggests that the narration encourages an oblique resolution (what Liandrat-Guigues calls "sliding" and "superimposing") between the two storylines.

Resolution, here, is not logical. The Tess-Matt story does not literally resolve the Dunson-Fen story. It's just a fuzzy connection between Fen and Tess based on how they look and behave. The connection hinges not on any logical outcome to the Fen storyline but rather on the perception of a non-meaningful similarity—an echo, a déjà vu—independent of causality and story logic. It is the same type of playful, felicitous connection at work in the "wafer joke," which hinges on a fuzzy connection between words based on how they sound. Like the "a wafer"/"away for" echo, the Fen/Tess echo encourages us to connect incongruous plot elements through a creative insight, freed from the limitations of crisp logic and close scrutiny. The similarities between Fen and Tess and the prospect of resolution enable abductive reasoning to resolve story information that crisp logic could not.

Red River's narration fills other gaps in a similarly oblique fashion, enabling a series of fuzzy connections between disparate plot events. Dunson must defend his property not against Don Diego, as expected, but against Matt. Someone does take Dunson's cattle from him, just as the plot predicted, but not the expected border gangs or Indians. Matt takes them. Indians appear in the film, but they attack a band of actors and prostitutes, not Dunson's crew. Border gangs never appear, despite the characters' worries, but the crew stumbles upon a man attacked by them. Most lopsided of all, Matt and Cherry never face each other in a gunfight, despite Groot's confident prediction. Instead, Dunson shoots Cherry in a brief gunfight, and Matt fights Dunson.

The fight between Matt and Dunson, however, does not pay off the forecasted gunfight between them. Rather, the two men engage in a climactic fistfight after Dunson shoots at Matt in an effort to provoke Matt to draw his gun. Commentators have described the film's ending as implausible, and Chase objected to it too.[9] In Chase's original serialized story, Matt shoots Dunson in a standoff and kills him, a more fitting payoff to Groot's observation that Matt is "just a little bit faster" (although Groot's line never appears in Chase's original story). Indeed, close critical scrutiny cannot reconcile the ending's narrative logic. Liandrat-Guigues says the ending makes "fun of the conventions of narrative verisimilitude," and John Belton says it "totally disregards plot expectations."[10] Wood considers the ending magnificent but also says that it violates "the rules of the traditional Western."[11] These commentators consider the film's climax a violation of unity, probability, and story logic because the story swerves toward a conclusion incongruous with the one the narration seemed to be preparing.

Sometimes spectators require only casual resolutions to plot events. The aesthetic context removes the burden of having to make perfect sense, enabling free associations

and creative insights that high-stakes reality normally inhibits. Indeed, *Red River* shows just how promiscuous we can be when it comes to story logic. We might take just about any story logic that comes to mind, provided the narration guides our thinking in a fertile direction and that some resolution, however specious, remains available.

For a clear example of casual abductive reasoning, consider the climactic scene in which Matt finally strikes back at Dunson after stoically taking a beating from him. The scene relies on the assumption that audiences do not pay rigorous attention to story logic. When Matt punches Dunson in the face for the first time, Groot excitedly describes the fight in terms that only vaguely relate to the story we have been watching: "For 14 years I been scared, but it's going to be all right!" a line that assumes that, for the first time, Matt is standing up to Dunson. But Matt had already stood up to Dunson, so Groot's comment about being scared for 14 years does not cohere with previous plot events. In fact, just about all Matt does throughout the movie is stand up to Dunson—in an early scene with Don Diego's man when Matt, as a boy, refuses Dunson's order to stand aside; in a scene in which Matt prevents Dunson from whipping and killing Bunk Kenneally; in a scene in which he prevents Dunson from hanging the deserters on the crew; and, most blatantly, when Matt takes Dunson's herd. Still, Groot's line offers the audience a spontaneous conceptual frame for understanding the climactic fight, an impromptu frame established on the spot. Groot's line helps shift our thinking to whatever vaguely plausible story logic we can infer.

At each narrative detour in *Red River*, the movie squanders an opportunity to fulfill a narrative promise and replaces abandoned storylines with ones reminiscent of, but incongruous with, the ones predicted. The narration upsets expectations about how the story would turn out, but we "get" the story—in the same way we "get" a joke—if we can form a new hypothesis that enables plot events to cohere. We can, for instance, resolve the early antagonism and later camaraderie between Cherry and Matt if we can reconceive of the tin-can-shooting scene as a sign of growing friendship, and not, as Groot encourages us to see it at the time, as "sizing each other up for the future." And although Groot's line, "For 14 years I been scared, but it's going to be all right," prompts a sudden shift in spectators' conception of the story, the line also feels appropriate because it resonates with some earlier plot information (Matt's vow not to let Dunson take his gun, Matt's mutiny, and Dunson's promise to include Matt on his cattle brand once Matt earned it).

We could describe this mental process as free association, even though plot cues (lines of dialogue, plot repetitions, etc.) in fact govern the process. The sudden shifts in narrative direction prompt spectators to *find the fit*—the best fit they can find, no matter how tenuous, unexpected, or illogical—between plot events that do not coordinate in a firm, foreseeable, or rational way. A mind making such precarious connections is in a state

of insight, reordering a disorderly narrative and using imagination to correct a story that refuses to settle down and behave.

Finding a connection between incongruous information—a connection predicated less on scrutiny and logic than on abductive guesses and creative insights—liberates the mind from the restrictions and burdens of good sense. "Part of the delight we feel in this use of our imagination is the feeling of liberation it brings," humor theorist John Morreall says about encounters with incongruity. "Instead of following well-worn mental paths of attention and thought, we switch to new paths, notice things we didn't notice before, and countenance possibilities, and even absurdities, as easily as actualities."[12] For Morreall, the aesthetic value of incongruity rests in the "drive to seek variety in our cognitive input."[13] Because spectators grow acclimated to conventional plot patterning, its effect fades and can grow tiresome. Plot incongruities prevent a narrative from becoming too orderly and predictable, reducing the numbing effects of genre, strict causality, and narrative unity.

In this respect, the disunities in *Red River* are a version of the turns and reversals that pepper good storytelling generally. All Hollywood plot patterning to some extent prompts spectators to imagine alternative outcomes, and Hollywood movies often lure spectators into false inferences. But we can distinguish *Red River* by the *subtlety* of the film's narrative design, the *variety* of scenarios that serve that design, and the *impertinence* of the depicted events to the causal momentum of the story. The design is subtle because, unlike a film with a surprising twist (such as *Psycho* [1960]) or an obvious change in a character's goals (such as Rick's change of heart in *Casablanca* [1942]), *Red River* does not flaunt its shifts in narrative direction, shifts that I gather most spectators never consciously recognize because the narration does not draw spectators' attention to their own false predictions. The scenarios are various because they play out in diverse ways within several storylines (Dunson defending his land and cattle, the film's two love stories, Matt's relationships with Dunson and Cherry, the predicted attacks of border gangs and Indians). And the events are impertinent because they fail to respect story logic and seem counterproductive to the film's narrative direction. Yet such subtle, various, and impertinent plot devices deliver a more dynamic experience than the one advertised by *Red River*'s sturdy classical western veneer.

CONCLUSION

The narrative detours in *Red River* challenge our ability to straighten out the story and make it linear. Since the rules of linearity and story logic seem not always to apply in this film, we must use our imaginations to repair the gaps and connect plot events that the narration has disconnected or linked tenuously. From my description of its plot patterning, one might think that I consider *Red River* an experiment in non-causal Hollywood

narration. But the film mostly obeys classical storytelling principles: goal-oriented protagonists attempting to overcome obstacles, character-centered causality, a definitive climax, deadlines, and all of the other classical canons that make Hollywood narration coherent and reliable. Unlike the era's foreign art films—such as *Open City* (1945), *The Red Shoes* (1948), or *Late Spring* (1949)—*Red River* commits only intermittent and surreptitious infractions of classical narrative norms. With the stability afforded by classical narration, it can risk some trivial story logic violations and still remain anchored to classical cinema's structure and purpose.

I could be wrong, of course, about the aesthetic pleasures of *Red River*'s narrative patterning. The film clearly offers aesthetic rewards, and it clearly exhibits narrative disunity, but we cannot say for certain that its disunity contributes to its aesthetic value. Perhaps other qualities explain that value entirely (interesting characters, a good story, appealing actors, etc.). Indeed, its disunities might detract from its aesthetic value. Many critics have attacked the film's ending, for instance, and Hawks found it necessary to defend it.[14] My analysis shows, however, that the film's narration prompts spectators to form various hypotheses about the direction of the story, that the narration presents information incongruous with spectator hypotheses, and that spectators must creatively improvise new hypotheses to resolve the incongruous information. And, as we saw in the previous chapter, considerable research, including numerous controlled empirical studies, has shown that this very process—incongruity, insight, and resolution—creates pleasure. So while we should not regard my conclusions as definitive, some strong evidence supports them. Classical narration, we know, prizes unity. But people value classical narratives, I propose, in part for the imaginative mental activity that their disunities inspire.

Aesthetically valuable narrative disunities differ in a crucial way from the "plot holes" that critics complain about in movies they don't like: Plot holes offer no prospect of resolution. Viewers who do not like the ending of *Red River*, for instance, find it implausible and abrupt; they don't believe Matt and Dunson's behavior and cannot see how to make the ending fit with earlier scenes. By contrast, viewers such as Robin Wood consider the ending "magnificent."[15] Wood somehow *finds the fit*. For him and others, the narration contains enough disunity to excite their abductive reasoning processes but not too much to ruin the prospect of resolution. Studying this balance in classical Hollywood narration helps us to understand the talent required to tell a story well, since the middle ground between too much and too little disunity must be hard for storytellers to locate. I think we will often find that talented Hollywood storytellers are somewhat reckless when it comes to story logic: They allow our imaginations to make sense of stories that logic and scrutiny would tell us are nonsense.

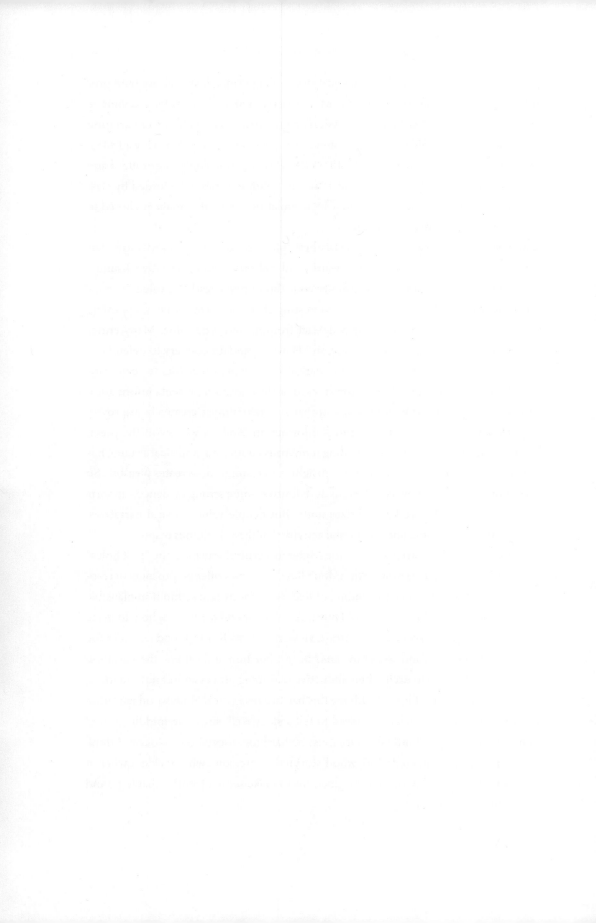

3

STYLE

The enemy of art is the absence of limitations.

—Orson Welles[1]

Hollywood Style

WHEN DIRECTOR WILLIAM FRIEDKIN WAS EDITING *THE EXORCIST* (1973), one dull scene was giving him trouble. In it, Ellen Burstyn's character walks down an autumn street in Georgetown while a group of laughing children in Halloween costumes run past her. "It was beautiful," Friedkin said, "but I felt everything stopped here." In the Warner Bros. music library, Friedkin found a haunting minimalist piece, entitled "Tubular Bells," that had a nursery-rhyme quality that he liked. "The only thing that could save [the scene] would be this weird sound coupled with the nursery-rhyme motif that would be vaguely disturbing" (video 5.1 ▶).[2] A stylistic ornament to a lifeless scene, the music gave audiences something interesting on which to focus their attention while the plot lingered. The music appeared only briefly in *The Exorcist*, but it enlivened the scene and became intimately tied to the identity of the film.

Part 2 on the aesthetics of Hollywood narrative cannot account for the pleasures afforded by music in the Halloween scene in *The Exorcist*, nor the pleasures of a film's cinematography, editing technique, settings, costumes, casting, or various other aspects of Hollywood cinema that we normally group under the umbrella of "style." We tackle that topic here in Part 3 as we investigate the aesthetic pleasures of Hollywood's stylistic norms, as well as the pleasures afforded by a handful of noteworthy stylistic deviations.

We will begin by examining style's two primary aesthetic functions in Hollywood cinema: to enhance the *clarity* and the *expressiveness* of Hollywood storytelling. But style also serves aesthetic functions independent of storytelling, so we will also examine two functions of Hollywood style separate from its storytelling function, namely *decoration* and *stylistic harmony*. Finally, we must recognize that a film's style may also compete with story, with genre, or even with itself for control of a film's mood and meaning, and the

last part of this chapter will address the aesthetic value of various forms of *stylistic dissonance* in Hollywood cinema. Although individual stylistic devices typically serve several functions at once (Hollywood is an aesthetically economical cinema), each of these five functions—clarity, expressiveness, decoration, harmony, and dissonance—offers a different form of aesthetic pleasure.

We must begin, however, with a definition. What is style?

Style denotes any distinctive manner in which a work is created or presented.[3] We observe style in art by noting patterns of techniques resulting from choices made by artists. In cinema, style denotes the distinctive and patterned use of the devices of the cinematic medium (shots, sets, lighting, colors, performance, etc.).[4] We can use the term to describe the behavior of filmmakers or the attributes of films themselves. And we can employ the concept of style to understand the patterned techniques of a single film or filmmaker (individual style) or a collection of films by many filmmakers (group or general style). Even Hollywood movies, which use style primarily for telling stories, do not objectively record plot material; they are filmed in styles. Gombrich notes that an artist "cannot transcribe what he sees; he can only translate it into the terms of his medium."[5] Style determines the manner and texture of the translation, fundamentally shaping our experience of artworks.

David Bordwell calls Hollywood cinema itself a "group style" because the films share so many stylistic properties, and the films work within a system that has remained remarkably stable across decades. Filmmakers working in mainstream American cinema must conform to the group style, subordinating individual styles to it. We should not, however, view the Hollywood group style merely as a hindrance to individual expression. Classicism, in all of the arts, has enabled artists to explore and express their creative talents because of the stability and reliability of classical models. Composer and philosopher Leonard Meyer writes that "Mozart could compose with astonishing facility partly because the set of constraints he inherited (and which he partly modified), the so-called Classic style, was specially coherent, stable, and well established. As a result Mozart had to make relatively few deliberate choices among alternatives."[6] Similarly, without the constraints of the serial novel, we would not have the many works of Dickens or Dumas. The strict constraints of English Renaissance theater gave us the plays of Jonson, Marlowe, and Shakespeare. Hollywood's classical style limits artistic choices, but—as the quotation from Orson Welles at the top of Part 3 testifies—the limitations also ease and encourage the creative process.

Hollywood encourages creativity because the industry prizes originality. Originality generally comes in the form of new stories, but sometimes it results from individual and group variations within the general Hollywood style. Films such as *Sunrise* (1927), *Grand Hotel* (1932), *Citizen Kane* (1941), *2001: A Space Odyssey* (1968), *Annie Hall* (1977),

Brazil (1985), *Pulp Fiction* (1994), and *Fantastic Mr. Fox* (2009) employ individual styles that differentiate them from other Hollywood films. Directors Orson Welles, Sam Fuller, Alfred Hitchcock, Stanley Kubrick, Woody Allen, Martin Scorsese, Robert Altman, Terry Gilliam, Baz Luhrmann, and Wes Anderson have pursued distinctly individual styles, even when they have worked in Hollywood.

Most group variations within Hollywood cinema fall into either periods or genres. Bordwell has noted for instance that, since the 1960s, Hollywood has systematically adopted an "intensified" version of the classical continuity established during the studio era, featuring shorter shot lengths, wide-ranging camera movement, a lot of movement within the mise-en-scène, percussive bursts of images, and dynamic uses of sound.[7] Psychologist James Cutting and his colleagues have demonstrated empirically that between 1935 and 2010 shot lengths have decreased, films have displayed increasingly more motion, and film images have gotten progressively darker.[8] Genre motivates much of the group variations within the Hollywood style: low key lighting in crime and horror films, outbursts of song in the musical, spectacular effects in the science fiction genre, etc. Still, Hollywood filmmakers must express individual styles and group variations within the parameters of the general Hollywood style. In this chapter, we examine the aesthetic pleasures enabled by those parameters.

STYLE AND STORYTELLING

In Hollywood cinema, style and narrative typically work harmoniously to achieve coordinated effects. Classical narration, Bordwell argues, treats film technique as a vehicle for transmitting story information.[9] Style, at this level of functioning, serves the purely instrumental role of bearing the artwork's narrative meaning.

In theory, filmmakers have an infinite number ways to film a scene. In a Hollywood movie, however, certain ways of filming are more probable than others, and the film's plot primarily determines the stylistic techniques used.[10] Take as an example editing devices. The three most common transitions are cuts, dissolves, and fades. But filmmakers have not used the devices interchangeably; plot patterning biases the stylistic choice. Hence, filmmakers typically use cuts in the course of continuous action (during the middle of a scene), whereas they more likely use fades and dissolves between scenes. It is permissible to use a fade or dissolve within a scene but less probable. Moreover, whereas a dissolve more often marks a transition between scenes that depict plot information that occurs close in story time, filmmakers typically use fades to indicate a longer passage of story time. The patterned use of stylistic devices means that spectators minimally experienced in the medium can easily grasp a device's function within its narrative context.[11]

Bordwell, V. F. Perkins, and other researchers have established the unity of style and narrative in Hollywood cinema, but we must still account for the aesthetic pleasures afforded by that unity. Hollywood film style creates pleasure by enhancing the *clarity* and *expressiveness* of Hollywood storytelling. We should discuss clarity and expressiveness separately because they offer distinct aesthetic pleasures and, since they inhere within all Hollywood productions, they deserve focused attention.

Clarity

If we can't get artistry and clarity, let's forget the artistry.

—David O. Selznick, memo on the cinematography

he wanted for *Gone with the Wind* (1939).[12]

In figure 5.1, a still frame from *The Bad and the Beautiful* (1952), note the way in which lighting, framing, focus, prop placement, and actorial position guide viewer attention toward Lana Turner's face and telephone conversation. The spectator has no doubt as to the main subject of the shot because the film's stylistic devices work in concert to clarify the intended focus of the plot at that moment.

As the quotation above from producer-executive David O. Selznick testifies, Hollywood sets out to tell stories clearly, even if it means sacrificing other aesthetic values. Mainstream cinema has developed a set of stylistic devices that ease our understanding of story information by making spatial and temporal relations clear and narrative

FIGURE 5.1 The Bad and the Beautiful *(1952). Framing, lighting, focus, prop placement, and blocking work together to center spectator attention.*

information accessible, legible, and salient. Matching techniques, the 180-degree system, and analytical editing help ensure that screen direction remains consistent, that the film renders space and time in a continuous and unambiguous way, and that viewers observe a largely seamless flow of images. An establishing shot during the exposition phase of a scene provides the spectator with a mental model of overall scene space and establishes, usually within the scene's opening seconds, the relevant characters, their mental states, the location of the scene, and its temporal relation to other scenes. Reestablishing shots reorient the spectator after character movement. Variable framing, anticipatory framing, and shot/reverse-shot patterning ensure that the camera remains in an ideal position for recording narrative information, that the information remains organized and clear, and that spectators stay focused on the moment-to-moment progress of the plot. Lighting techniques (such as three-point lighting), frontality (the practice of turning actors three-quarters toward the camera), selective focus, and the practice of placing the most important subject matter toward the center of the frame emphasize the primary figure of story interest. The star system and typecasting make character identities familiar and wed the identities of performers to those of their customary roles. Dialogue is spoken, recorded, mixed, and reproduced (or, in the case of silent cinema, depicted) for maximum clarity.

Hollywood firmly established these stylistic devices, admittedly a partial list, in the 1910s, and they endure in Hollywood cinema today. The consistency and systematic use of these and other devices across films and across time periods ensure that a typical Hollywood film remains clear at each moment and that the spectator, as Bordwell says, "will almost never be at a loss to grasp a stylistic feature."[13]

The clarity of sound and the visual image ensures that spectators quickly, accurately, and easily perceive and identify the sensory properties of a Hollywood film. Selznick's concern about the clarity of the cinematography in *Gone with the Wind*, and Hollywood's emphasis on perceptual clarity in general, have a strong basis in perceptual psychology. In fact, empirical psychologists who study perception could have written a manual for Hollywood cinematography practices. Such practices conform to those properties that psychologists have found increase *perceptual fluency*, which denotes the "ease of identifying the physical identity of the stimulus."[14] Hollywood movies ensure that figures of narrative importance stand out from their backgrounds with high contrast.[15] Hollywood cinematographers tend to balance frames fairly symmetrically.[16] And Hollywood uses lighting, color, and other devices to enhance the clarity of objects.[17] Researchers have found that each of these practices, and other common Hollywood stylistic practices, contribute to perceptual fluency and that "the more fluently the perceiver can process an object, the more positive is his or her aesthetic response."[18]

Noël Carroll attributes the "power" of mainstream movies to their "easily graspable clarity," and two of his points pertain to the clarity of Hollywood film style.[19]

First, Carroll notes that movies rely on pictorial representations and therefore require little work or training. Unlike literature and other art forms that rely on symbol systems requiring independent mastery, movies are image-based and therefore "rely on a biological capability that is nurtured in humans as they learn to identify the objects and events in their environment."[20] Abundant evidence supports the contention that we learn to recognize an object in a picture as soon as we can recognize the object the picture refers to in the world. People have difficulty learning to read, because reading demands mastery of arbitrary symbols, but they easily learn to watch movies because objects in pictures resemble their referents.

Hollywood style typically exploits the ease with which spectators recognize pictorial representations by depicting key visual information with utmost denotative clarity. Cinematography practices make objects in the frame easy to identify by fostering clear and unobstructed views of the narrative action. For instance, incidental objects in the mise-en-scène rarely obstruct narratively important visual information, and selective focus directs attention and renders plot information clearly. Lighting technique and picture resolution further enhance the image's legibility: Frontal lighting illuminates important story information, and backlighting separates foreground from background and enhances the illusion of volume (Note how figure-ground contrast and backlighting increase the illusion of volume in figures 5.7 and 5.8). Hollywood has promoted the development of high-resolution lenses and film stocks (and now digital cameras) to make objects and characters maximally crisp and clear.

Hollywood staging techniques, moreover, make it easy to identify visual information. Actor frontality maximizes recognition and enables spectators to infer characters' mental states. In fact, empirical studies suggest that three-quarter views of faces, such as those commonly used in Hollywood staging, promote better recognition than do profiles or direct frontality (see figures 5.4 and 5.8).[21] The Hollywood frame typically displays an organized and immediately graspable array of mise-en-scène elements. Director Robert Zemeckis said about staging,

> the most important thing is to make sure the audience is looking where you want them to look. You have to make sure they clearly understand the story point that is taking place, and that they grasp all of the pertinent information while sort of ignoring everything that's not important. Short of force-feeding the issue by blacking out everything else in the frame or providing blinking arrows, this is primarily accomplished through shot-composition and careful blocking.[22]

Hence, the speed, ease, and accuracy with which the spectator identifies objects in the Hollywood frame and understands their significance results not just from pictorial

recognition, as Carroll notes, but also from stylistic choices designed to make pictorial representations maximally clear. One need only watch some of the visually obscure movies of Stan Brakhage, Bruce Baillie, or Andy Warhol or some of the visually disorganized movies of John Cassavetes to understand that the "easily graspable clarity" of the Hollywood frame results from a specific system of stylistic practices, in addition to cinema's pictorial basis.

Carroll's second relevant point is that—unlike plays, which have fewer and weaker means for controlling spectator attention—movies employ *variable framing*. The viewer, therefore, "is generally in a position where he or she is attending to exactly what is significant in the action-array or spectacle on screen."[23] Variable framing includes the capacity for cutting, zooming, moving the camera, and altering the distance, height, and angle of framing, enabling filmmakers to point to narratively important visual information and bracket out incidental objects in the mise-en-scène. "Everything extraneous to the story at that point is deleted," Carroll says. "Nor does the spectator have to find the significant details; it is delivered to her."[24] Consequently, movies have far more control over our attention than the theater, where our eyes track the action more freely and where we must cope with on-stage distractions.

Hollywood movies, in particular, exert this control because of the degree to which they use variable framing to point to and bracket story information. Compare the concentrated framing of a typical Hollywood movie to the "all over" compositions in Jacques Tati's *Playtime* (1967), which feature an overabundance of visual information and refuse to direct the spectator's perception to one area of the frame over another (figure 5.2).

FIGURE 5.2 *Unlike mainstream movies,* Playtime *(1967) includes an overabundance of visual information and refuses to direct spectators' attention to one area of the frame.*

Jonathan Rosenbaum succinctly summarized *Playtime*'s visual style when he wrote, "The subject of a typical shot is *everything that appears on the screen*."[25] By contrast, mainstream movies, Carroll says, make it practically impossible *not* to attend to the filmmakers' visual selections.[26]

The clarity of mainstream cinema, Carroll argues, makes it accessible, and accessible artworks appeal to our cognitive drive for immediate understanding. The ease with which spectators perceive Hollywood movies, even at the sensory level, helps to make them, in terms of Reber's Processing Fluency Theory of aesthetics, inherently and spontaneously pleasing for mass audiences.

Expressiveness

In Hollywood cinema, style does more than deliver story information. It also increases the expressive power of a story by establishing mood, emphasizing the story's meaning, enlivening characterization, enhancing the narrative's emotional development, and intensifying the story's cognitive and affective impact.

Take, for example, the scene in *Frankenstein* (1931) in which a father carries his daughter's lifeless body through town. After the Monster kills the little girl, the father interrupts a festive outdoor celebration as other villagers carouse and dance. Story information alone emphasizes the intrusion of horror on the festivity, but the challenge for the filmmakers is to shoot the scene in a style that maximizes its expressiveness, both stressing the point of the scene and enhancing its emotional impact. The obvious solution would be to show the appearance of the father at the celebration and then cut to the villagers' reactions, a stylistic choice that would clearly and immediately express the shock of the event. The film could sustain that moment for 5 or 10 seconds, cutting to various astonished villagers to fully express the transition from festivity to horror. Cinematographer Arthur Edeson and director James Whale, however, use an even more expressive stylistic solution, one that both communicates shock and extends the instant of transition for almost a minute of screen time.

The filmmakers stage the event so that villagers see the dead girl not all at the same time but rather one after another. In two long takes, lasting a total of 48 seconds, the camera tracks sideways and backward with the distraught father as he carries his daughter's corpse through the celebration (video 5.2 ▶). The framing and deep focus of these shots enable spectators to witness again and again each moment when different villagers at the party first see the dead child, their expressions turning from merriment to gaping horror. Notice in figures 5.3 and 5.4, for instance, that all of the characters on the right side of the frame express shock on their faces, whereas the characters on the left side of the frame, who have not yet seen the father and the dead girl, are still

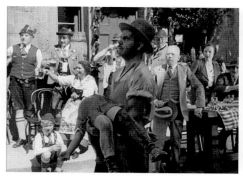

FIGURE 5.3 **FIGURE 5.4**

FIGURES 5.3 AND 5.4 Frankenstein *(1931). Two tracking shots follow a father carrying his dead child through a village celebration, enabling the film to repeatedly depict the moment in which villagers change their expression from merriment to horror. Note that characters on the right side of each frame express shock on their faces, whereas characters on the left side of the frame, who have not yet seen the dead girl, are still celebrating.*

celebrating; their faces, too, will soon turn to shock as the father and tracking camera pass them by.

The filmmakers have selected a staging and cinematography style that intensifies the emotional expressiveness of the moment by sequentially portraying, for dozens of characters, the instant of shock. This stylistic choice also enables the film to depict festivity and shock at the same time, rather than replacing one with the other, since at each moment during these two shots we see in the frame some villagers celebrating and others suddenly in dismay. Throughout the sequence, moreover, we hear some voices expressing shock ("Look, Maria!") and others whooping and cheering in celebration.

Talented filmmakers find creative techniques that enhance a scene's expressiveness while conforming to Hollywood's general stylistic parameters. During the restaurant scene in *The Godfather* (1972), for instance—when Michael returns armed from the bathroom, prepared to kill his two dinner companions, Sollozzo and Captain McCluskey—the filmmakers use several stylistic devices to express Michael's uncertainty, distraction, and growing anxiety. Withholding reverse-shots of the other men, the filmmakers train on Michael's agitated expression after he sits back down at the table, focusing our attention on Michael's mental state while at the same time imitating his inattention to the conversation with Sollozzo. Furthermore, Sollozzo's unsubtitled Italian has now grown less clear and more complex, making it harder to decipher, so that we are just as distracted from Sollozzo's words as Michael, whose mind is consumed with the impending murders. Finally, the sound of an approaching subway car outside the restaurant increases in volume—first clicking, then rumbling, then screeching loudly at the moment Michael

stands to shoot the two men—expressing Michael's mental state, as if by magic, through the sound of the world around him (video 5.3 ▶).

Like *The Godfather*'s restaurant scene, the crop-duster scene in *North by Northwest* (1959) exploits the acoustic principle that, when an object making a sound moves progressively closer, the sound volume and pitch increase. As the airplane attacking *North by Northwest*'s protagonist Dopplers toward and then past him, the sound of the engine creates an effect akin to a musical crescendo, echoing the rise and fall of his peril (video 5.4 ▶). Hence, the scene, which contains no music until the very end, metonymically coordinates the threat to our protagonist with the expressive sound of that threat: When the danger becomes greatest, the volume and pitch grow highest.

During some scenes in *Jaws* (1975), the filmmakers place the camera right at water level, waves lapping onto the camera lens, a vantage that would seem to put spectators' own bodies, from the chin down, in the ocean with a shark (figure 5.5 and video 5.5 ▶). This camera position became common for Hollywood filmmakers shooting scenes in which a character is struggling to escape a shark, appearing in *Jaws* sequels and used pervasively throughout the more recent shark film, *The Shallows* (2016).

Such techniques may seem obvious and inevitable, but they result from stylistic choices made by filmmakers. *The Godfather* might have subtitled Sollozzo's Italian or filmed the scene in a traditional shot-reverse-shot pattern. *North by Northwest* need not have made the audience's aural experience mimic that of the protagonist (the pitch and volume of the airplane engine might have remained constant, as though we sat in the cockpit), or the filmmakers might instead have used music, rather than Foley, to intensify the scene's expressiveness. And water level is but one of many available camera positions for filming a shark attack (*Jaws* uses many others). Hollywood sets strict parameters for filmmakers' stylistic choices, but those parameters create opportunities for expression, creativity, and play.

FIGURE 5.5 Jaws *(1975). Placing the camera at water level while a character is struggling to pull his feet out of the water would seem to put spectators' own bodies in the ocean with the shark.*

STYLE INDEPENDENT OF STORYTELLING

The previous sections on clarity and expressiveness outline the aesthetic pleasures afforded by the unity of style and narrative in Hollywood cinema. However, Hollywood movies feature stylistic devices that offer aesthetic pleasures in themselves, independent of film narration. Of course, at some point, it becomes impossible to separate almost any component of Hollywood film style from its narrative function; in Hollywood film-making, style and narrative inevitably intersect. But in attempting to isolate and evaluate Hollywood style, one can get pretty far before driving through an intersection. I want to isolate some stylistic properties of Hollywood cinema and evaluate the ways in which they serve two aesthetic functions independent of whatever storytelling purposes they might also fulfill. Those functions are *decoration* and *stylistic harmony*.

Decoration

> *We should permit our eyes once in a while to stray from the picture to the frame and to wonder at its function.*
>
> —E. H. Gombrich, *The Sense of Order: A Study in the Psychology of Decorative Art*[27]

Decoration contributes to an artwork's attractiveness without serving any necessary narrative, thematic, or structural function. Decoration (or ornamentation) refers to any independently attractive property that by itself makes a work more pleasing. Richard Maltby, echoing industry terminology, refers to many such properties as "production values."[28] Hollywood's "commercial aesthetic," he says, "is essentially opportunist in its economic motivation," creating the most attractive sets and costumes and obtaining the most lavish locations and appealing actors in its goal of giving the public what it wants.[29] Hollywood spends millions of dollars, often tens of millions, within each film's production budget just on decoration. Independent producer James Schamus complains, "The budget is the aesthetic."[30] Kristin Thompson sees decoration in formalist terms. "Excess," and she calls it, "retains a perceptual interest [for the spectator] beyond its function in the work."[31] Like ornamental patterns in baroque architecture, excess deflects attention from the object's narrative or substantive purpose. Excess enlivens an artwork by making it more vivid and stimulating our perception of details.

Decoration in Hollywood cinema gives the spectator something to explore outside the confines of narrative composition. "Our eyes are attracted," Gombrich says, "to points of maximal information content."[32] If a plot grows dull, as in the Halloween scene from *The Exorcist*, our perception is liable to shift to areas that offer greater possibilities for pleasure, such as the music. Decoration at such moments ensures that our eyes and ears have something appealing to perceive.

Inasmuch as we respond to decoration purely on a sensory level, many aesthetic theorists would not consider our response aesthetic. But an artwork's sensory properties can lead to aesthetic pleasure when our response involves appreciation of the work's character, content, or structure.

A scene from *Tarzan and His Mate* (1934), the second installment in MGM's *Tarzan* series, illustrates the way in which a film's sensory properties stimulate aesthetic pleasure when they cause us to appreciate the artwork itself. The film finds a narrative pretext for a three-minute sequence in which Tarzan and Jane swim together nude in a lake (figure 5.6). At first, the scene seems included to add sexual garnish to the movie, ideal bodies cavorting undressed in a pastoral setting. The scene serves no necessary compositional function, and, when regional censors forced MGM to remove the scene, plot coherence did not suffer. However, the filmmakers have also taken pains to film the scene in a way that is liable to elicit aesthetic appreciation (video 5.6 ⏵). Beautifully lit, the underwater cinematography adds light patterns across the swimmers' bodies that intermittently conceal and reveal their nakedness. The actors swim gracefully with dance-like choreography, illuminated bubbles sparkling from their noses, bubble sounds echoing in the soundtrack. The background, so black that it seems more like an abstract space than a lake, creates strong chiaroscuro and makes the actors look almost like painted figures. Such elements, in combination, make the scene ethereal and stylized, creating a series of memorable images in an otherwise forgettable movie.

Hollywood increases the decorative appeal of its films by featuring idealized versions of things that people find already attractive: idealized bodies, as in *Tarzan and His Mate*,

FIGURE 5.6 *In a scene cut from exhibition prints by regional censors, a sexualized and stylized underwater dance in* Tarzan and His Mate *(1934) adds to the film's decorative appeal.*

as well as attractive landscapes, clothing, faces, lavishly decorated homes, apartments with spectacular views, appealing speaking and singing voices, the sounds of nature and music, charismatic people, rich colors, babies, and so on. Indeed, the film industry has integrated this type of "window dressing," as we might call it, into the design of many Hollywood plots, which might feature lavish balls, international settings, expansive landscapes, scenes of seduction and nudity, scenes with music, etc.—plots designed in part for the purpose of displaying pictorial and aural decoration.

Genre motivates specific decorative properties: song and dance in the musical, desert vistas in the western, sexually alluring women in crime films. Hollywood publicity in the studio era referred to period dramas, adventure films, and swashbucklers as "costume pictures," identifying the films by their chief ornamental attraction. Plot and genre provide pretexts for fundamentally ornamental pleasures.

Ornaments are, by their nature, attractive in themselves, but Hollywood uses common stylistic devices to enhance and idealize their attractiveness. Patrick Keating has shown that Hollywood cinematographers during the studio era used lighting to glamorize stars. Hollywood conceived of glamour, Keating says, as "an ideal of perfection. . . . When women are lit according to this ideal, the lighting simply reinforces the already established ideals of feminine beauty."[33] Glamour lighting, which developed in the 1910s and continued pervasively through the 1930s, featured soft and direct frontal lighting, a lot of diffuse fill light, and backlighting that created a noticeable halo effect. As a result, the subject seemed to glow (see figures 5.7 and 5.8). In a 1934 essay, cinematographer Karl Struss at Paramount described the cinematographer's objective: "Our aim is to convey an impression, not alone of actuality, but of *perfected* actuality. Our aim is to show players and settings, not merely as they are, but as the audience would like to see them."[34] Cinematographers employed glamour lighting, particularly with female stars, in order to smooth skin, eliminate blemishes and lines, and soften edges and shadows.

Glamour lighting threatened what most directors of photography (DPs) considered cinematography's primary functions: storytelling, realism, and improving overall pictorial quality.[35] But they had to submit to studio bosses, such as Irving Thalberg and Harry Cohn, who insisted on it. Paramount DP Victor Milner complained in a 1930 essay, "Painting with Light": "No matter whether the action be taking place in a dungeon or a ball-room, the star must be kept beautiful, with never a suspicion of a shadow upon the famous face or form, and, regardless of the setting, a beautifying halo of back-lighting following her around the set."[36] Glamorous images created such attraction, studio executives felt, that glamour should trump other aesthetic values, such as realism, an appropriate mood, the clarity of the image, and even story logic.

Cinematographers sometimes developed individualized lighting schemes to bring out the most distinctive traits of specific actors, particularly female stars. They lit films,

FIGURE 5.7 **FIGURE 5.8**

FIGURES 5.7 AND 5.8 *Shots of Carole Lombard and William Powell from* My Man Godfrey *(1936) demonstrate typical glamour lighting for women and men in the 1930s. Cinematographer Ted Tetzlaff used soft frontal lighting on both figures, although on Powell he used sharper focus and a slightly harder key light, which was placed farther to the left of the camera. Consequently, whereas Lombard seems to shimmer, Powell's face has a somewhat harder surface and more distinct modeling. For both actors, fill light reduces shadows and backlight creates a halo effect.*

Tino Balio says, "to present the star's image to the best advantage."[37] Hence, William Daniels emphasized Greta Garbo's eyes and eyelashes (as did her makeup artists), and Lee Garmes highlighted Marlene Dietrich's cheekbones. Notice how the lighting and shadow on Lombard's face in figure 5.7 emphasize her low, prominent cheekbones and triangular jaw. Arthur Miller, a DP at Fox Studios, said about shooting Shirley Temple, "I always lit her so she had an aureole of golden hair. I used a lamp on Shirley that made her whole damn image world famous."[38] The contracts of some big female stars of the 1930s and 1940s, such as Garbo, stipulated which cinematographer would shoot them because the stars knew that certain cinematography techniques would hide their imperfections and enhance their most attractive features.

The vogue of very soft glamour lighting died out in the 1930s, but Hollywood has always sought to intensify and idealize its decorative properties so as to achieve something close to image and sound perfection. This decorative ideal results not just from lighting but also from makeup, step stools for short actors and toupees for balding ones, vocal dubbing, stunt doubles, body doubles, Foley work, optical printers, miniatures, analog and digital matte work, compositing, and other manipulations. Three-strip Technicolor processes rendered colors that looked hyper-real, creating rich, deeply saturated hues with distinct color contrast, glamourizing the entire world of a movie. These days, Hollywood uses digital manipulation to perfect settings or remove undesirable features. Digital graphics, for instance, embellished cinematography of New Zealand to create sumptuous environments in *The Lord of the Rings* trilogy (2001, 2002, and 2003). For movie versions of Broadway musicals, Hollywood has usually hired movie stars, rather

than talented Broadway singers, dubbing their voices when needed so as to Frankenstein together the perfect combination of stardom, performance, and singing talent. Opera singer Marni Nixon, for example, dubbed the singing voices of Deborah Kerr in *The King and I* (1956), Natalie Wood in *West Side Story* (1961), and Audrey Hepburn in *My Fair Lady* (1964) because the stars selected for the roles could not sing the parts well enough themselves. In pursuit of glamour, Hollywood filmmakers have sought to eliminate imperfections, intensify the attractiveness of already attractive elements, and idealize appearance and performance.

Glamour constitutes only one example of Hollywood's ornamental aesthetic. We see it also in the industry's propensity for spectacle, technological novelty, virtuosity, and stylish technique. Hollywood plots integrate car chases, casts of thousands, singing and dance numbers, elaborate crane movements, and special effects because these elements retain a perceptual interest in themselves, providing an additional attraction to scenes that would be less appealing without the decoration.

In *Stranger than Fiction* (2006), one of the film's many decoratively photographed scenes takes place inside an "articulated bus" (a two-section bus with an accordion pivot in the center). Our protagonist, Harold Crick (Will Ferrell) sits in the forward section while his love interest, Ana Pascal (Maggie Gyllenhaal), sits near him but in the rear section. The arrangement provides a pretext for camera and character movement in what could otherwise be a visually static scene of two seated characters conversing in a typical shot/reverse-shot arrangement (video 5.7 ▶). As the bus turns corners and the two sections pivot in different directions, the characters' eye lines and relative positions adapt continuously during the conversation. The camera, moreover, arcs diagonally around, toward, and away from the characters because the filmmakers usually shoot each character roughly from the vantage of the other character in the scene, who sits in a different section of the bus. The odd arrangement provides a realistic motivation for ornamental camera and character movement, an interesting visual effect that serves no obvious narrative function.

In the next chapter on *Raging Bull's* style, we will examine further the aesthetic value of stylistic technique, but, for one more key example of Hollywood ornamentation, let us look briefly at the industry's exploitation of technological novelty.

Throughout its history, Hollywood has added technological ornament to the film going experience, inaugurating sound in the mid-1920s, widescreen aspect ratios in the late 1920s and again (more pervasively) in the 1950s, three-strip Technicolor in the 1930s, stereophonic sound in the 1940s, 3-D at various times since the 1950s, Sensurround and digital animation in the 1970s, High Frame Rate 3D in the 2010s, and various other technological ornaments. Many films that featured these novelties early on drew conspicuous attention to the new technology. Scott Higgins has shown that early

three-strip Technicolor movies, such as *Becky Sharp* (1935), highlighted the splendor of the Technicolor system itself, often through garish display. But soon thereafter films such as *The Trail of the Lonesome Pine* (1936), *God's Country and the Woman* (1937) and *Dodge City* (1939) made the process more unobtrusive and better integrated with classical practices.[39]

The pattern is common: Technological novelties first introduced as spectacular ornamentation will, if they endure (as did sound, color, wide-screen aspect ratios, and digital graphics), eventually be integrated into classical storytelling in a less obtrusive way. In 1952, the independent production company Thomas-Todd introduced the three-projector, curved-screen spectacle, Cinerama, with the documentary, *This Is Cinerama*.[40] The format retained its technological novelty for a period and was used for several features in the 1950s, but the novelty wore out in the 1960s. By 1953, however, widescreen cinema in various formats had already replaced the 1.33:1 Academy Ratio as the standard for virtually all theatrical exhibition.

Art appeals to our desire for both order and stimulation by affording us easy adjustment and easy arousal. A sense of order, Gombrich argues, enables us to adapt to our environment, whereas irregular features stimulate our perception.[41] The mind craves stimulation so much that the absence of it can lead to hallucinations.[42] Decoration in Hollywood cinema—glamour, spectacle, stylish film technique, technological novelty—counteracts a movie's monotony and continuity, increasing its arousal potential but demanding little adjustment, attention, or thought.

Loosely fastened to a movie's narrative design, decoration adds pleasure and interest to a film without burdening us with essential information. Because decoration is, by definition, unnecessary to a Hollywood film's composition, it does not threaten the perceiver's ability to cope with the work. During a scene of pure ornament (such as a typical dance number in a Hollywood musical), we might leave for the concession stand without suffering the confusion that comes from missing compositionally necessary information. We need not perceive decoration for an artwork to make sense: We need not attend to the costumes in a costume picture, the technological novelties of a science fiction film, nor the glamorous appearance of a Hollywood starlet. Such properties are pure extravagances; whatever surplus pleasure we get from them is mere luxury. With decoration, we commit minimal cognitive resources and gain what pleasure we can.

Stylistic Harmony

Harmony is a factor of the similarity and concord of different artistic devices. In music, harmony offers consonance and dissonance in balance, a pleasing resolution of disparate sounds. Harmony works similarly in cinema, coordinating disparate cinematic devices in

a pleasing way. We have already discussed the harmonious relation between style and narrative in Hollywood cinema, but style can create its own harmonies through patterns of techniques. Noël Burch argues that "even though there may be structures that are 'perceptible only to those who have created them,' they nonetheless play an important role in the final aesthetic result."[43] Stylistic patterns offer the scenes in which they appear the same harmonies that rhyme and meter offer poetry: They provide extra-meaningful systems of coherence that unify the artwork and link its different parts.

Hollywood films regularly repeat stylistic techniques to add harmony to films. The opening of *Double Indemnity* (1944) includes several images of flames against a dark background (a welder with a blow torch, flares on a road, matches striking in the dark). *North by Northwest* features a recurring grid pattern, beginning with the opening credits and extending through several sequences, including the crop-duster scene. Further examples include scenes with flowers in *Frankenstein*, low- and high-angle shots of stairs in *Psycho* (1960), shots of doorways and other thresholds in *The Searchers* (1956), long tracking shots through Manhattan in *Manhattan* (1979), and scenes in *Touch of Evil* (1958) that feature a man and a woman riding in a convertible. The recurrent stylistic properties cooperate to give such films a patterned look—a style of presentation.

Hollywood filmmakers draw most stylistic patterns from Hollywood's standard repertoire of devices (shot/reverse shot, establishing shots, analytical editing, etc.), but even utterly conventional Hollywood films will sometimes repeat flourishes, provided they conform to classical norms. *Rocky III* (1982), for instance, repeatedly features shots of Mr. T. from either a high or a low angle, sometimes with a zoom in (figures 5.9 and 5.10). Other filmmakers repeat more idiosyncratic devices. Throughout *Taxi Driver* (1976), we see overhead shots of hands on desks and tables (figures 5.11–5.15). The unusual shots add little substance to the scenes in which they appear: They exist mainly for their own sake, without recourse to narrative composition. *Brazil* (1985) features cluttered settings,

FIGURE 5.9 **FIGURE 5.10**

FIGURES 5.9 AND 5.10 *Examples of high-angle and low-angle shots of Mr. T. from* Rocky III *(1982).*

FIGURE 5.11

FIGURE 5.12

FIGURE 5.13

FIGURE 5.14

FIGURE 5.15

FIGURES 5.11–5.15 *Shots of hands on desks and tables repeat throughout* Taxi Driver *(1976).*

distorting wide-angle lenses, exaggerated linear perspective, extreme high- and low-angle cinematography, surrealist imagery, and an incongruous combination of the very large and the very small (figures 5.16–5.21).

Stylistic patterning establishes correlations among a film's parts, providing systems of coherence and correspondence outside of narrative patterning. Film scoring offers the same sort of harmonies. While music in film serves an expressive function (stressing plot developments, anticipating future events, enhancing characterization, and intensifying a scene's emotional development), as well as a decorative function (as in *The Exorcist*), it also links various moments of a film through its mere repetitive presence. "Echoes and repetitions," literary critic Stephen Booth writes, "can make an artificial construct feel almost as inevitable . . . as an object in nature."[44] Stylistic patterning gives cinema a background consonance—behind the more prominent narrative patterning—that unifies

FIGURE 5.16

FIGURE 5.17

FIGURE 5.18

FIGURE 5.19

FIGURE 5.20

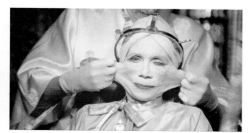

FIGURE 5.21

FIGURES 5.16–5.21 *Similar expressions of visual density, distortion, and incongruity in* Brazil *(1985).*

different parts of a film. Stylistic patterns give to narrative patterns what The Pips give to Gladys Knight: They contribute nothing essential to understand the composition, but they add structure and stability to the presentation and, if they disappeared, the work would suffer for their absence.

STYLISTIC DISSONANCE

In the previous sections of this chapter, we examined four aesthetic functions of Hollywood film style: clarity, expressiveness, decoration, and harmony. Of course, individual stylistic devices often serve several functions at once. Deep color saturation in a film scene may express emotion (reflecting a character's cheerful mood, for instance),

enhance clarity (helping to distinguish objects and separate foreground from back-ground), and provide decoration (enlivening the mise-en-scène with visual splendor). A glamour shot of a female star (decoration) may reinforce a male protagonist's attraction to her (narrative clarity and expressiveness) and repeat similar lighting designs from other scenes (harmony). Hollywood cinematographers, editors, art directors, sound designers, and the other creative contributors to a movie seek productive unions of various stylistic functions.

Sometimes, however, a film's stylistic functions stand in conflict with one another or with classical Hollywood's narrative and stylistic imperatives, such that compromise solutions would not work. In a 1930 article cited above, cinematographer Victor Milner complained that studios forced him and his colleagues to use stylistic devices counterpro-ductive to a film's storytelling needs. But a conflict between style and story does not nec-essarily result in aesthetic weaknesses. Because Hollywood permits a moderate amount of disunity in its stylistic patterning, we can find many stylistic dissonances in Hollywood films that, even in moderation, add challenge and interest to spectators' engagement. Although dissonance may be counterproductive to storytelling clarity, a unified mood, and formal harmony, it can be exceptionally productive in adding aesthetic interest to Hollywood's more stylistically bold films. In this final section of the chapter, we shall examine some of the ways in which style in a Hollywood film competes with story, with genre, or with itself in an aesthetically productive way.

Style versus Clarity: *Touch of Evil*

Style can arouse our cognitive activity when it impedes, rather than enhances, narrative clarity. Take as an example the scene in which police detective Hank Quinlan (Orson Welles) strangles 'Uncle' Joe Grande (Akim Tamiroff) in Welles's *Touch of Evil*. Here, stylistic devices hinder the clarity and communicativeness of the narration. The scene takes place in a seedy dark motel room at night, while the movie's female protagonist, Susan Vargas (Janet Leigh), lies drugged on the bed. The primary light in the room, the scene implies, comes from the slow strobing of a storefront sign outside the hotel room window (video 5.8 ▶). The conceit of the strobing light provides a realistic pretext for a number of unusual and stylistically interesting effects that challenge the spectator's ability to perceive events and construct a coherent story.

First, the scene stages much of the action in darkness, large portions of the frame com-pletely black, even when the source light strobes on (figure 5.22). The strobe effect, more-over, requires the spectator to "fill in" the actions of the characters, since we can see the actions legibly only during moments of illumination. This filling-in process—in which the spectator intermittently perceives, infers, and predicts character movement while light

FIGURE 5.22 *In the strangling scene from* Touch of Evil *(1958), the lighting scheme leaves much of the frame in darkness.*

rhythmically comes in and out—grows increasingly challenging as the scene progresses. While the scene moves closer to climax and Grande grows more frantic, the movements of the characters become more dynamic and unpredictable so that, between moments of illumination, character positions change more drastically. The spectator's filling-in process must therefore intensify to keep pace with increasing stylistic interference.

Cinematography and editing devices in the scene also make it difficult to see the action, impeding the spectator's ability to perceive and identify plot information easily and accurately. The filmmakers stage much of the action very close to the camera, at extreme angles, making it more difficult to comprehend what we are observing. The absence of long shots also prevents us from forming an overall model of character movement. Quick and unpredictable editing makes shot transitions disorienting since the subject of the frame often changes dynamically with each cut. The editing avoids standard continuity devices that would smooth the transitions from one shot to the next, forgoing graphic matches, eyeline matches, and matches on action that would orient us from shot to shot and enable us to adjust more easily to transitions. Interspersed shots of Susan Vargas help to inform us of her condition, but they further impede efforts to construct a coherent picture of the struggle between Quinlan and Grande, the scene's primary interest.

Still, the style does not prevent viewers from understanding the story because narrative activity remains fairly simple: Quinlan strangles Grande while Susan Vargas lies insensible on the bed. Style puts some scene details beyond our grasp, but not so much that it impedes our ability to understand the action generally. Furthermore, although the style jeopardizes the clarity of the storytelling, it coordinates expressively with the scene's mood and subject matter, as well as with the lighting scheme of other scenes. The filmmakers have put stylistic furniture between us and our perceptual goals, but

the impediments do not thwart our progress; they just get in the way. In doing so, they enliven our story construction processes as we seek to make sense out of intermittently illegible plot information.

Touch of Evil offers a baroque example of an ordinary stylistic trend in crime movies from the 1940s and 1950s. Even the most routine movies of the film noir cycle employed low-key lighting devices that interfered with image clarity. Low-budget noirs—such as Phantom Lady (1944), Strange Illusion (1945), The Devil Thumbs a Ride (1947), Cry of the City (1948), Pickup (1951), The Hitch-Hiker (1953), and The Other Woman (1954)—used obscure lighting to set a dark mood, stylize the image, and add visual interest to films that had no budget for lavish sets or glamorous stars. Noir lighting offers a visual emblem of Hollywood's tendency to seek pleasurable compromises between easy processing and cognitive challenge. The lighting offers enough perceptual difficulty to create mystery and interest but not so much as to make the plots unclear or cause average spectators to abandon the search for understanding.

Style versus Genre: *Leave Her to Heaven*

A conflict between style and genre, although it can challenge our ability to identify and categorize an artwork, can add interest to our aesthetic experience. *Leave Her to Heaven* (1945) offers an illustrative example.

Director John Stahl shot the film in Technicolor, a style that seems ill suited to the story of a woman who, in the words of producer Darryl Zanuck, "deliberately kills her own unborn child, drowns the crippled brother of her husband and endeavors to send her own adopted sister to the electric chair. And yet despite all of this, there are certain things about her that you rather like."[45] In 1945, studios typically reserved Technicolor for costume pictures, musicals, epics, and romantic melodramas. They typically shot movies about murderous femme fatales in the low-key black-and-white film noir style of the day. The film, moreover, features clothing and sets designed to emphasize Technicolor's rich hues, including in most every scene colorful wallpaper, flowers, fruit, clothes, shoes, or flower-patterned fabrics.

Reviewing the film for *Time* magazine, James Agee complained about the dissonance: "the story's central idea might be plausible enough in a dramatically lighted black and white picture" but not in the "rich glare of Technicolor."[46] For Agee, Technicolor sets the wrong mood, evoking thoughts and emotions antipathetic to the film's premise. Yet *Leave Her to Heaven* became Fox's highest-grossing picture of the decade and remains of interest to critics in part because of its incongruous mixture of melodrama stylistics and noir subject matter, particularly in the colorful scene in which Gene Tierney's character,

Ellen, coldly allows her disabled brother-in-law to drown in a lake. Later in the film, a close-up of Ellen's satin sky-blue mules, radiant and pretty, signifies Ellen's intention to stage an accident that will abort her fetus (video 5.9 ⊙). Technicolor is not an outlandish choice, but it is an improbable one and, given audiences' psychological associations with the format, one that requires some mental adjustment.

Other stylistic choices also work against the film's morbid story, including Alfred Newman's melodramatic score; the casting of Cornel Wilde (known in 1945 mostly for romantic melodramas and swashbucklers) as the protagonist, Richard; and overdramatic dialogue delivered in breathy voices, the actors looking off into the distance ("Yet I know now, people you love don't really die"). Sometimes it seems as though different filmmakers are battling over the film's genre, style, and tone. Lines that begin sentimentally sometimes turn menacing, as when Ellen says to Richard, "Darling, will you marry me? And I'll never let you go—never, never, never" and "Oh darling, forgive me. I'm sorry. It's only because I love you so. I love you so I can't bear to share you with anybody." Other lines seem stylistically inappropriate to the dramatic moment. In response to his wife's confession that she deliberately killed his brother and unborn son, Richard says, "I'm leaving you, Ellen," as though she had confessed an affair with the gardener.

An early scene with Richard and Ellen on a train serves as an emblem for the dissonance between style and genre in the film. Genre cues mark the scene as the traditional "meet cute" of romantic comedy, but Gene Tierney's strange performance makes the scene discomforting and difficult to categorize. During the scene, in which the two characters meet for the first time, Ellen stares at Richard as he fumbles with cigarettes, burns his fingers, forces a smile, tries to read, and furtively glances back at her, visibly uncomfortable with the focused attention. Meanwhile Newman's jaunty score, romantic and jazzy, sets a tone appropriate to light romantic comedy. Richard's evident attraction to her and Tierney's deep red lipstick, long lashes, and stunning good looks further identify the scene as one in which two lead characters begin to fall for one another during semi-comic circumstances.

The dissonance in the scene comes from the intensity of Ellen's stare; she looks spellbound, entranced, not amused (figure 5.23). Not only does she stare at Richard for an uncomfortably long time, and with no evident reason, but she seems to look *through* him, not at him. He reacts, grows uncomfortable, and occasionally looks right at her, but her expression never changes, as though she's watching someone in a different world, as opposed to someone interacting with her in a train car. Despite generic cues suggesting "meet cute," the scene is creepy and Ellen is creepy. Her creepiness makes sense only in retrospect, however, after we learn what a psychopath she turns out to be. During the scene, the performance clashes with genre cues signifying comic romance.

FIGURE 5.23 Leave Her to Heaven *(1945). Actress Gene Tierney's discomforting stare during the train scene conflicts with the scene's other genre cues, which suggest romantic comedy.*

Leave Her to Heaven remains interesting, and offers an odd footnote in histories of American crime films of the period, because its style, alternately melodramatic and sinister, sometimes works against its genre identity.

Hollywood offers many other examples of dissonance between style and genre. The lighthearted zither music in Carol Reed's *The Third Man* (1949) has received much attention in film commentary in part because it seems ill suited to a story of black market profiteering and mass murder. Hitchcock liked to film suspense scenes using stylistically incongruous devices, such as staging *North by Northwest*'s centerpiece attempted-murder scene in a field of crops. Here, the brightness and wholesomeness of the setting work against the subject of the scene; a dark alley would have made better sense. Hitchcock's *Notorious* (1946) increases the suspense of a party scene with interspersed shots of champagne bottles on ice; champagne bottles normally carry associations far removed from danger. *The Birds* (1963) manages to create fear, horror, and suspense out of shots of birds grouping on a jungle gym. Style can make a work more interesting when it competes with a film's genre for control of the mood and meaning, challenging audiences to reconcile the work's inconsistent properties.

Style versus Style: *Goodfellas*

Some filmmakers delight in stylistic dissonance. Orson Welles cuts from moody expressionism to documentary realism in the first two segments of *Citizen Kane* (1941). The first generation of post–studio era filmmakers grew keen on contrasts in style. Consider

the incongruous mixture of classical music and brutality in *A Clockwork Orange* (1971), which, for instance, scores a fight scene with Rossini's overture to *The Thieving Magpie* (video 5.10 ▶). Or consider the mixture of humor and morbidity in *M*A*S*H* (1970) and *Harold and Maude* (1971). Or, for a more subtle and more recent example, view the opening scene of *Michael Clayton* (2007), in which the film's urgent sound devices challenge the more placid visual devices for control of the film's tone and pace (video 5.11 ▶).

The opening scene of Martin Scorsese's *Goodfellas* (1990) provides an emblem of stylistic dissonance in Hollywood cinema. The scene cycles through several distinct styles that alter audience expectations and signal disparate attitudes toward the story and characters.

The sequence, which lasts about two minutes, introduces the film's three lead characters: Henry (Ray Liotta), Jimmy (Robert De Niro), and Tommy (Joe Pesci). Riding in a car, they hear a thumping sound and decide to pull over. They open the trunk and see a bloody man with a battered face, a white sheet wrapped around him, crying out in pain. Tommy says, "He's still alive," and stabs the man in the stomach several times with a large knife. Jimmy then shoots the man five times, and Henry closes the trunk. That's the gist of the scene.

The plot itself is ambiguous because we do not know these characters, their relationship to one another, or what has put them in this astonishing situation, but changing stylistic techniques add to the ambiguity.

Before the scene begins, over the opening credits, we hear the sound of cars speeding by. The credit names move quickly across the screen, right to left, as though they were race cars. The first diegetic image shows the rear of a car swerving between lanes. For a moment, the swishing credits, the engine's revving sounds, and the car's movement imply that we have entered the movie in the middle of a car chase. The second diegetic shot, however, of the characters inside the car shows two of them asleep and Henry, the driver, struggling to keep his eyes open. This shot offers the first stylistic inconsistency, since the drowsy tone inside the car belies the previous impression of energy and bustle.

Once Henry pulls over to investigate the thumping sound, the style changes again, this time using traditional horror-film imagery to create a feeling that something treacherous lurks in the trunk of the car. The camera tracks in on the trunk, as though to emphasize the menace within it, and the sound of thumping continues. In other shots, we see our three protagonists standing back from the trunk, looking at one another fearfully, poised to defend themselves. Tommy swallows nervously, clutching a weapon in his coat pocket. The red glow of the car's brake lights, which gives the scene a red tint, and smoke issuing from the tailpipe further add to the atmosphere of horror and suspense.

The film thwarts expectations generated by the horror-genre stylistics, however, when Henry opens the trunk. Instead of a dangerous figure, we see a battered, bloody, helpless

body. Here, the film's style switches yet again, as our protagonists become the dangerous figures. When Tommy repeatedly stabs the man in the stomach, the Foley work creates the wet "chunk" sound of a knife piercing through flesh. The framing—a medium long shot that depicts Tommy's violent thrusts into the man's blood-soaked body—graphically highlights Tommy's brutality. When Jimmy shoots the man, the sound of his pistol reverberates boldly, and flashes of gunfire illuminate the frame. The actors' performances, moreover, which previously indicated worry and timidity, now suggest malevolence. Tommy grimaces like a brute, and Jimmy shoots the bloody man with calculated professionalism.

The scene then takes one final stylistic turn, the most incongruous of all, toward irony (video 5.12 ▶). As Henry moves to close the trunk, he says blithely in voiceover, "As far back as I can remember, I always wanted to be a gangster." Then, at the moment he slams the trunk, we hear the jazzy trumpet sounds that begin Tony Bennett's 1953 rendition of "Rags to Riches." The camera tracks in on Henry and freeze frames on his face. Together, Henry's line, the exuberant sound of horns, and the freeze frame create ironic distance from the gruesome events, and the movie's attitude shifts playfully and incongruously to something like camp.

In its opening two minutes, *Goodfellas* has quickly cycled through five separate styles in one scene: the energetic style of a car chase, the flat style of a drowsy car-ride scene, the ominous style of a horror film, the aggressive style of a crime film, and the ironic style of camp. Although the styles are pronounced, the movie transitions smoothly from one to the next (for instance, we expected to see something horrifying in the trunk of the car, and we do see something horrifying, although we see a *victim* of violence, not the aggressor that the film's stylistic cues had predicted). Nonetheless, as the plot unfolds, spectators must reconcile dissonant stylistic signals in order to make the scene cohere.

Casting against Type

We have studied dissonances in which one sensory component of a film (say, genre iconography) conflicts with another (say, cinematography devices). But sometimes dissonances in a film are more conceptual, as is the case when Hollywood films cast against type. We may not regard casting as a stylistic component of a film since, under most circumstances, casting does not create patterns of techniques. But casting contributes to film style by shaping the distinctive manner in which a movie is presented. Casting that violates an actor's familiar persona can create interesting dissonances between our concept of the actor, our concept of the role she is portraying, and our sensory experience of the performance itself (the actor's appearance, behavior, and voice).

Hollywood productions generally favor typecasting, which promotes formal unity and eases efforts to identify and understand characters. Typecasting puts actors in familiar roles—roles consistent with their on- and off-screen personas—and, as we saw in chapter 1, greater familiarity triggers liking ("the mere exposure effect"). However, film productions occasionally cast actors in roles inconsistent with their personas, and the performances that result often rank among Hollywood's most memorable and celebrated.

RKO studios cast Dick Powell, the high-voiced star of 1930s Warner Bros. musicals, as rugged private detective Philip Marlowe in *Murder, My Sweet* (1944), and Paramount did something similar the same year with Fred MacMurray in *Double Indemnity* (1944). Director Anthony Mann cast Jimmy Stewart—who had played, among other optimistic characters, the wholesome lead in *Mr. Smith Goes to Washington* (1939)—as a misanthropic loner in a series of 1950s westerns. Boyish Tony Curtis finally earned critical recognition for a part that—judging from his roles up to that point in adventure films and light comedies—would seem almost perfectly ill-suited to him: the devious press agent, Sidney Falco, in *Sweet Smell of Success* (1957). Debonair Cary Grant played an alleged killer in *Suspicion* (1946), comedian Robin Williams a psychopath in *Insomnia* (2002), jovial Steve Carell a disturbed murderer in *Foxcatcher* (2014), and clean-cut Shirley Jones a prostitute in *Elmer Gantry* (1960), for which she won an Oscar, as did sensual Susan Sarandon for playing a nun in *Dead Man Walking* (1995) and stunning Charlize Theron for playing an unattractive serial killer in *Monster* (2003) (figures 5.24 and 5.25).

Critic Roger Ebert wrote about Theron's performance as real-life prostitute and multiple murderer Aileen Wuornos, "What Charlize Theron achieves in Patty Jenkins's *Monster* isn't a performance but an embodiment. . . . This is one of the greatest performances in the history of the cinema."[47] Ebert calls Theron's performance an "embodiment" because

FIGURE 5.24 *Publicity photograph of Charlize Theron.*

FIGURE 5.25 *Charlize Theron in* Monster.

FIGURES 5.24 AND 5.25 *Charlize Theron cast against type as an unattractive murderer in* Monster *(2003).*

he knows that she is among Hollywood's most appealing actors, nothing like the character she plays in *Monster*. Here, one's concept of Theron conflicts with one's concept of the Wuornos character, as well as with one's sensory observations of her—her oily skin, bad teeth, workman's clothes, stiff behavior, and tense, frowning face. If the filmmakers had cast an actor better suited to the role, one who looked and behaved more like the real Aileen Wuornos, then the performance would not have earned such recognition. Theron's performance creates interest and aesthetic excitement in part because of the casting incongruity. Knowing the actor's real attractiveness and real appeal, we admire the performance all the more for superseding that reality.

Of course, against-type casting can be disastrous. Consider John Wayne as Genghis Khan in *The Conqueror* (1956) (figure 5.26). Wayne could not pull off the incongruity (unlike Theron, he could not supersede reality), and viewers seem to have found the distance between Wayne and Genghis Khan too far to bridge. However, as long as viewers can reconcile the discrepancy between the persona and the role—as long as the work can withstand the strain on its coherence—then aesthetic pleasure, including our appreciation of the performance itself, is liable to intensify with the discrepancy.[48]

· · ·

Stylistic harmony and *stylistic dissonance* exhibit both consonance and dissonance but in different proportions. Whereas stylistically harmonious artworks offer consonance and dissonance in balance, stylistically dissonant works seem out of balance. They resist resolution and easy understanding by making a film more difficult to perceive (*Touch of Evil*), categorize (*Leave Her to Heaven*), or comprehend (*Goodfellas*). Such films create interesting combinations of inconsistent properties. They remain pleasurable to a mass audience as long as they do not overburden an average spectators' ability to cope. Stylistically dissonant works cause us to adjust, as lithely as our minds will allow, to stylistic cues that harbor disparate attitudes and meanings. The process of challenge, adjustment, and reconciliation exercises our cognitive faculties as we attempt to grasp an unstable object and make it sit still.

FIGURE 5.26 *Failed against-type casting: John Wayne as Genghis Khan in* The Conqueror *(1956).*

CONCLUSION

Style serves five primary aesthetic functions in Hollywood cinema, some of which support Hollywood's storytelling function and some of which work independent of it or, even, against it.

- *Clarity* in Hollywood style enables processing fluency. It makes Hollywood narration accessible, immediately understandable, and spontaneously pleasing for mass audiences.
- *Expressiveness* enhances a film's cognitive and affective impact. It focuses our attention on key narrative details and emphasizes a narrative's emotional development.
- *Decoration* affords us easy adjustment and easy arousal. Decoration gives us something attractive to attend to without burdening us with information that might prove important to understanding the work.
- *Stylistic harmony* offers systems of coherence and correspondence outside of narrative patterning. Harmony creates background connections between different parts of a film.
- *Stylistic dissonance* offers the possibility of mastering a challenging object. Dissonance generates aesthetic interest by creating inconsistent objects—objects of curiosity.

Hollywood's primary formal concern is telling stories, and style in Hollywood cinema serves primarily as a storytelling instrument. But Hollywood also devotes a lot of stylistic resources, and considerable financial resources, to non-storytelling functions that enhance or supplement the aesthetic pleasures that Hollywood narrative has to offer.

· · ·

This chapter's brief examples of the functions of style in Hollywood cinema offer a broad account of various aesthetic pleasures afforded by Hollywood's classical stylistic systems, as well as pleasures afforded by some interesting variations within those systems. But to understand how a bold Hollywood stylist balances the conflicting demands of unity and disunity, harmony and dissonance, conformity and idiosyncrasy, perceptual fluency and challenge, we must study a film in detail. *Raging Bull* (1980), the subject of the next chapter, tests the limits of the classical Hollywood style. The film often skirts the edges of classicism, at times crossing over into avant-garde stylistic practice. It therefore offers an illustrative case study of the boundaries of Hollywood's stylistic paradigm and of the potential for exhilaration enabled by films that succeed in navigating near those boundaries.

Raging Bull's Stylistic Dissonance

RAGING BULL'S (1980) STYLE SEEMS OFTEN ON THE POINT OF FALLING to pieces. Consider the last fight scene, in which Sugar Ray Robinson incessantly pummels an exhausted Jake La Motta. The scene depicts images so ludicrous that it's a wonder viewers can make sense of it. One shot bizarrely shows a punch from the optical point of view of Robinson's glove as it approaches La Motta's face (figure 6.1). One of Robinson's blows causes liquid to spray out of La Motta's head, as though from a sprinkler, and splatter a crowd of onlookers with what looks like a bucket of blood (figure 6.2). At one point Robinson winds up for a punch in a ridiculously awkward stance, his arm and shoulder stretched in the air behind him, like a third-grader pretending to threaten another kid (figure 6.3). The shot appears even stranger because of slow motion cinematography and the curious emergence of smoke surrounding Robinson's body. Such bizarre and implausible imagery permeates the film's fight sequences, which are often so strange and complicated that they threaten efforts to understand what one is seeing.

As we have already seen, aesthetic evaluation of an artwork is strongly predicted by the artwork's novelty and complexity, on the one hand, and the spectator's ability to cope, on the other. This book argues that, when experiencing works of art, as we come closer to our own personal boundary line between coping and not coping, provided we do not cross it, we experience the exhilaration that comes from reaching for understanding. So far, we have analyzed Hollywood movies that venture near the boundary line for average spectators, often with some deal of boldness, but that generally stay in the safe region where novelty and complexity remain minimal or moderate and coping fairly easy. *Raging Bull*, by contrast, seems determined to linger around that line in ways that threaten the film's underlying reliability, harmony, and coherence. In the context of Hollywood

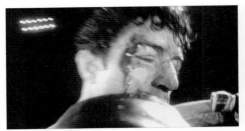

FIGURE 6.1 *A boxing glove's optical POV shot.*

FIGURE 6.2 *An absurd amount of blood splatters the crowd.*

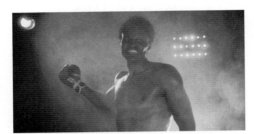

FIGURE 6.3 *Sugar Ray Robinson winds up in an awkward boxing stance.*

FIGURES 6.1–6.3 *Bizarre and implausible images from the last fight scene of* Raging Bull *(1980).*

cinema, *Raging Bull*'s style seems so disunified and idiosyncratic that one would expect the film to either vex viewers or thrill them. Judging from its mixed reception, both commercially and critically, the film seems to have done both.

Raging Bull failed to appeal to a mass audience in its theatrical run and received only a handful of good reviews from major critics at the time of its release. By the end of the 1980s, however, several polls of critics ranked it the best film of the decade. *Premiere* magazine's poll of twenty-three "film world notables" scored *Raging Bull* almost twice as highly (105 points) as the decade's second-highest scorer, *Wings of Desire* (1987) (59 points). Similar polls by *American Film* and *Time* also ranked *Raging Bull* the best film of the eighties. The discrepancy between the film's initial mixed reception and later acclaim suggests that *Raging Bull* requires repeated exposure (greater familiarity) in order to increase spectators' coping potential. In terms that I hope this book has already made familiar, *Raging Bull* alienates spectators who cannot cope with the film's challenges and exhilarates those who can. In this chapter, I set about demonstrating that *Raging Bull*'s stylistic dissonance, although potentially alienating, comprises one of the film's chief aesthetic attractions for those engaged by the film's style.

Before I do, however, I want to explain the care with which director Martin Scorsese constructed the film's eccentric design.

DESIGNING *RAGING BULL*

"I put everything I knew and felt into that film and I thought it would be the end of my career," Scorsese said. "It was what I call a kamikaze way of making movies: pour everything in, then forget all about it and go find another way of life."[1] To prepare the eight elaborate fight sequences, Scorsese and Michael Chapman, the director of photography, mapped out every camera angle, camera movement, and distance of framing, as well as every actor's movement and punch. Chapman said, "Each shot was drawn out in great detail, almost like Arthur Murray, those weird dance steps they used to draw on the floor. We did that."[2] Together, the fight scenes last about nineteen minutes of screen time in the 129-minute movie, but they took ten weeks to shoot in a film that shot for a total of sixteen weeks.

Scorsese and Chapman filmed each fight sequence in a different style. For instance, image-distorting techniques during the third fight convey an impression of heat: A heavy haze fills the frames; figures come in and out of focus; long lenses and slow motion cinematography make the movements of the characters look sluggish; and several shots display a desert-mirage effect, created by putting flames in front of the camera lens (figure 6.4). The sixth fight, which focuses on La Motta's eagerness to win Marcel Cerdan's middle-weight crown, leaves a completely different impression. This sequence has a more lyrical presentation—it is the only fight sequence set to opera music and without an announcer's commentary—and the quick depictions of the passing rounds make La Motta's victory seem swift and assured. By contrast, the last fight sequence, in which La Motta loses the crown, focuses on the punishment he receives during the bout and seems to go on interminably: Slow motion shots frame the blood and sweat falling off of La Motta's face; at times the action stops and all sounds drop out, except for the sound of the boxer's panting breath; and, for half a minute, discordant images of Robinson's ceaseless punching flash across the screen.

Post-production took six months, rather than the allotted seven weeks. According to editor Thelma Schoonmaker, producer Irwin Winkler said to her and Scorsese, " 'You can't mix this film *inch by inch*.' And Marty said, 'That's the way it's going to be done.' And it *was*."[3] Her first major narrative film, *Raging Bull* earned Schoonmaker an Oscar for editing. She attributed the victory to Scorsese's pre-production planning and the director's own editing talents: "I felt that *my* award was *his* because I know that I won it for the fight sequences, and the fight sequences are as brilliant as they are because of the way Marty thought them out. I helped him put it together, but it was not my editing skill that made that film look so good."[4]

The diligence with which Scorsese constructed every moment of *Raging Bull* and the critical recognition the film ultimately received, especially for its impressive

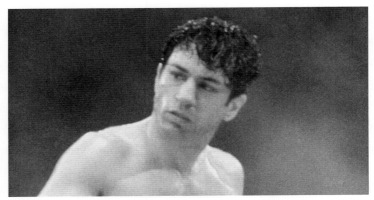

FIGURE 6.4 *During* Raging Bull*'s third fight sequence, a heavy haze fills the frame. The filmmakers put flames in front of the camera lens to distort the image.*

fight sequences, prompts this chapter's painstakingly close examination of the film's style. To understand what has led *Raging Bull* to earn such recognition, one needs to consider the film, as Scorsese and his colleagues did when they constructed it, "inch by inch."

Raging Bull proved grueling to plan, shoot, and edit partly because it violates the logic of Hollywood's cinematography and editing conventions, which offer filmmakers a ready-made, time-tested blueprint for keeping spatial relations coherent, for comfortably orienting spectators, and for maintaining a clear flow of narrative information. As we saw in the previous chapter, filmmakers working within Hollywood's classical style make few choices among alternatives. Because the film challenges Hollywood's stylistic practices, *Raging Bull* required a series of deliberate, time-consuming decisions. The film exhibits unusual stylistic complexity and novelty through the sheer number of stylistic devices, the differences between them, and their eccentricity. The film, however, also relies on, and feels stabilized by, classical conventions of narration, continuity, and realism, which prevent the film from falling into disarray. *Raging Bull's* unifying properties check its propensity for stylistic dissonance and hold together the film's separate pieces.

To understand the ways in which *Raging Bull's* style balances correlative tendencies toward harmony and dissonance, let's first look at two antithetical techniques the film uses to combine images: stylistic collisions and fluid transformations. Scorsese himself testified to this tension in his work when he said, "I'm torn between admiring things done in one shot, like Ophuls or Renoir, on the one hand, and the cutting of, say, Hitchcock and Eisenstein on the other."[5] At the end of the chapter, we will explore the film's precarious balance between harmony and dissonance by examining a truly illogical sequence of images. There, I hope to show that the film enables spectators to make sense of a sequence that reason says they should not be able to understand.

RAGING BULL AND COLLISION EDITING

Interspersed throughout *Raging Bull*, Scorsese employs a type of editing heralded by Soviet filmmaker Sergei Eisenstein during the period 1923 to 1930.[6] Instead of maintaining narrative and spatial continuity between shots, as in the American style of editing, Eisenstein constructed sequences in his early films out of a series of conflicting images, or what he called "visual counterpoints."[7] Editing, Eisenstein believed, should not be fluid but shocking. He based his theory of "montage" on the Hegelian dialectic that Marx employed in his theory of revolutionary change: Eisenstein believed that by combining two disparate images (the first a thesis, the second its antithesis), a film could create a new concept (synthesis) through the collision. To that end, he interspersed his early films with images that took spectators out of the immediately relevant narrative space in order to depict some area or figure that offered a metaphorical accentuation or contrast to the narrative action. In *October* (1927), for instance, Eisenstein inter-cuts images of Alexander Kerensky with those of a mechanical peacock to suggest, through the visual metaphor, the Russian leader's pompousness and posturing (video 6.1 ▶). At times his films show a character or action from various discordant angles, or the films drastically change the subject of the frame from one shot to the next. In his writings, Eisenstein argued that an incongruous combination of images more effectively conveys abstract ideas and creates more passionate audience responses ("*explodes* with increasing intensity"[8]) than the fluid "continuity editing" prominent in American cinema. For this reason, we can refer to Eisenstein's technique as "collision editing."

Raging Bull offers textbook illustrations of Eisenstein's editing method. Perhaps the most straightforward example of a single Eisensteinian cut is the transition from a scene between Jake and Vicki La Motta in their bedroom to a boxing scene between La Motta and Tony Janiro. In the bedroom scene, Jake questions a groggy Vicki about a comment she made about the young boxer:

> JAKE. Well, how come you said that thing about Janiro?
> VICKI. What'd I say?
> JAKE. You said he had a pretty face.
> VICKI. I never noticed his face.
> JAKE. Well, how come you said that then?

The pace is slow, the scene quiet—they speak softly, and we hear no ambient sounds or mood music—but our knowledge of Jake's propensity for jealous violence makes the moment tense and pregnant with seething rage. The low-key lighting, which casts heavy shadows across their faces, makes the mood even more ominous. As the scene ends, we see Jake brooding on her comments (figure 6.5).

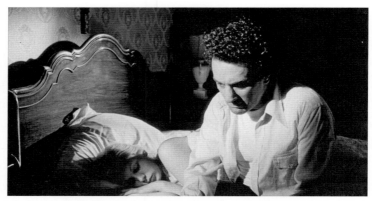

FIGURE 6.5 *A quiet, still shot of Jake brooding precedes a shocking transition to a loud, dynamic fight scene.*

Suddenly and shockingly, the film cuts to an extreme close-up of a boxer, presumably Janiro, getting punched twice in the face. The filmmakers have timed the cut with the first punch, and we hear loud pummeling and a raucous crowd. The film makes no effort to smooth the harsh transition from the bedroom to the ring: Instead, we move jarringly from a slow to a fast pace, from quiet to loudness, from stillness to movement, and from contained violence to expressed violence. As Eisenstein would have predicted, the two shots, when combined, create a concept present in neither shot individually: La Motta expresses his anger and jealousy in the boxing ring.

Scorsese pelts *Raging Bull*'s fight sequences with numerous visual collisions and cutaways similar to the one that joins the bedroom scene to the Janiro fight. During the scene of La Motta's fight with Jimmy Reeves, for instance, the film cuts from the action in the ring to a shot of two men (one of them a soldier) fighting in the stands. The juxtaposition of images suggests that the fighting in the ring fuels a broader interest in violence among boxing fans. The film furthers that idea when it intersperses shots of fans cheering the most brutal boxing activity, of photographers snapping shots of the boxer's blows, and of a riot among the fans after the fight.

The film's most intensely Eisensteinian sequence occurs in the last fight scene: the title match with Sugar Ray Robinson that results in La Motta's loss of the middle-weight crown. During the final moments of the bout, the filmmakers pack into 26 seconds of screen time a sequence of 35 discordant shots that break fundamental rules of continuity editing. The sequence conveys a subjective impression of La Motta's experience as Robinson pummels him incessantly.

Shots of Robinson's punches combine in a barrage of incongruous images. For instance, Robinson's right jab in one shot (figure 6.6) illogically hits La Motta with a left hook in the subsequent shot (figure 6.7), and, when the film cuts back to Robinson, his right punch continues to follow through (figure 6.8). Violating the 30-degree rule,

the film then jump cuts from the straight-on shot of Robinson (figure 6.8) to a low-angle shot of him (figure 6.9). (See video 6.2 ▶; video 6.3 ▶ shows the sequence in slow motion.) The sequence of 35 shots also contains nine violations of the 180-degree rule.

The transitions between different camera angles and framings, furthermore, do not follow conventional editing patterns. At times, the combination of shots seems almost random. The film moves unpredictably from one close-up to another, and each cut drastically alters the subject of the frame or the view of the action, rather than following the continuity convention of only slightly shifting the frame's center of interest (video 6.4 ▶; video 6.5 ▶ shows the sequence in slow motion.). The sequence also violates temporal and graphic continuity by portraying five successive shots of Robinson's gloves hitting La Motta's face, without any pause between punches, each shot from a different angle, two of them with the camera canted in opposite directions (figures 6.10 and 6.11). (See video 6.6 ▶; video 6.7 ▶ shows the sequence in slow motion.)

Although collision editing interferes with *Raging Bull*'s clarity and formal harmony, it enlivens the mental activity of spectators attempting to connect the images. By defying customary editing patterns and thwarting perceptual continuity, the film hinders spectators from easily identifying the objects on screen. The complex combinations of images

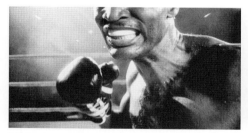

FIGURE 6.6

FIGURE 6.7

FIGURE 6.8

FIGURE 6.9

FIGURES 6.6–6.9 *Four consecutive shots from* Raging Bull *violate classical continuity. Robinson's right jab in figure 6.6 illogically hits La Motta with a left hook in figure 6.7, and the sequence jump cuts from figure 6.8 to figure 6.9.*

 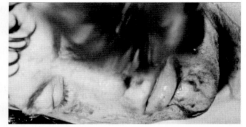

FIGURE 6.10 **FIGURE 6.11**

FIGURES 6.10 AND 6.11 *Two consecutive shots of La Motta with the camera canted in opposite directions.*

make *Raging Bull* more interesting and engaging for spectators seeking the exhilarated pleasure that comes from attempting to understand a perceptually challenging object.

The aesthetic pleasure afforded by the film's novel and complex editing devices, however, depends on the spectator's ability to cope with the challenges they pose. Whereas avant-garde filmmakers, such as Eisenstein, often make their films too challenging for average spectators, Scorsese increases the spectator's coping potential by periodically conforming his editing technique to classical Hollywood practice, enhancing the spectator's ability to identify objects and easing the process of reconciling disparate images. Consequently, despite the violations of classical continuity, *Raging Bull*'s last fight sequence does not feel as unconventional as a collision editing sequence in an Eisenstein film.

Eisenstein, for instance, often takes spectators out of the diegesis in order to create a symbolic connection between juxtaposed images, such as those of Kerensky and the peacock, a type of unmotivated cutaway forbidden in Hollywood's continuity system. Collision editing in *Raging Bull*, by contrast, follows continuity editing patterns more closely because it does not take the spectator out of the boxing arena. Moreover, the film routinely cuts from tight, disorienting close-ups back to long shots that reestablish the space and character positions. Finally, as Hitchcock did in the shower sequence in *Psycho* (1960), Scorsese uses the jarring editing technique to convey the protagonist's subjective experience of violence, thereby integrating the technique with the flow of narrative information: The rapid-fire and disorienting cuts convey La Motta's experience of the speed and impact of Robinson's blows.[9] Eisenstein uses collision editing to convey all sorts of ideas, whereas Scorsese, like Hollywood filmmakers generally, uses it to express violence, speed, and disorientation.

THE STEADICAM AND STYLISTIC VARIETY

Scorsese relishes seamless visual transformations just as much as Eisensteinian collisions, and he often garners recognition for his elegant tracking shots. The 92-second tracking

shot of La Motta as he enters the ring before winning the middle-weight crown from Marcel Cerdan rivals any of Scorsese's others in terms of its dramatic impact and dazzling display of virtuoso technique. For this extravagant shot, Scorsese and Chapman took advantage of the recently invented Steadicam camera stabilizing system. First used commercially by cinematographer Haskell Wexler in *Bound for Glory* (1976), the Steadicam enabled an operator to obtain smooth tracking shots using a handheld camera. It cut production costs by eliminating the need to lay tracks or use dollies or cranes and allowed operators to film more easily in cars, moving up and down stairs, and in other tricky situations that might shake the camera. Scorsese and Chapman also used the small, lightweight Arriflex 35 BL camera, which allowed them to create complex point-of-view shots and smooth tracking shots (without ballooning production costs), to quickly reorient the camera in the middle of a shot, and to use makeshift rigs to, Scorsese said, "get the cameras flying the way I wanted."[10]

In the long take before the Cerdan fight, Scorsese and Chapman use the Steadicam in ways that add to the sequence's decorative appeal. As we saw in the previous chapter, decoration offers "surplus pleasure": It stimulates our perception of details and counteracts an artwork's monotony without burdening spectators with essential information. The shot of La Motta approaching the fighting ring takes advantage of the decorative capabilities of the Steadicam and lightweight Arriflex BL. I want to focus in particular on the ways in which the shot exploits the rig's smoothness and ease of manipulation in order to seamlessly alter the cinematography style as the camera progresses toward the ring.

The shot begins in La Motta's dressing room where we see him warming up for the bout (figure 6.12). The medium shot is confined by the dressing-room walls, as well as by the presence of Jake's brother Joey and two trainers. The intimacy of the moment and the tightness of the frame align the spectator with La Motta's entourage, who watch him prepare for the most important fight of his career. As La Motta finishes donning his robe, the camera begins to track backward into the hallway outside the dressing room. During the reverse tracking shot, we see Joey in the front of the frame, La Motta in the middle, and glimpses of the two trainers behind (figure 6.13). The shot of La Motta and his entourage, as the camera winds through the corridors, is familiar from numerous documentary films—such as *Don't Look Back* (1967) and *Richard Pryor: Live in Concert* (1979)—featuring performers entering an arena, and, at this point in the shot, the film adopts the style of a performance documentary. The impression of documentary filmmaking strengthens when we start to see and hear fans cheering La Motta along, since with this type of shot we generally feel we have privileged access to the performer, traveling with him as he moves through a crowd of fans (figure 6.14).

Soon, however, the camera loses that privilege and adopts the restricted perspective of one of those fans. Tracking backward, the camera ducks into a corner, pans right with

FIGURE 6.12

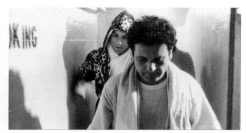

FIGURE 6.13

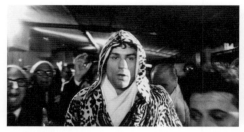

FIGURE 6.14

FIGURE 6.15

FIGURE 6.16

FIGURES 6.12–6.16 *During a long take, shot with a Steadicam, the camera assumes a series of "identities" marked by different cinematography styles: La Motta's entourage (figure 6.12), performance documentary (figures 6.13 and 6.14), boxing fan (figure 6.15), and omniscient viewer (figure 6.16).*

La Motta as he passes, and without pausing begins tracking forward behind him. We now watch the back of the fighter while he enters the crowded arena, moving farther away from us as other fans increasingly block our view of him (figure 6.15). As the shot tracks forward behind La Motta while he enters the arena, we see a huge, applauding crowd of spectators and an illuminated fight ring in the distance. Now we can barely see La Motta as he jogs to the left side of the ring and the camera moves to the right.

Finally, the Steadicam operator steps onto a crane, and the camera sweeps into the air, filming the cheering crowd and the fighter as he enters the ring (figure 6.16).[11] At this point, the camera assumes the perspective not of any character in the film but

rather of an omniscient viewer, looking down on the event. The expansive final frame (figure 6.16) is practically the visual opposite of the confined frame that began the sequence (figure 6.12), yet, because the filmmakers shot the entire sequence in a single take, we have moved here without any abrupt transitions. So, as the cinematography assumes various "identities"—La Motta's entourage, performance-documentary filmmaker, boxing fan, and omniscient viewer—the transformations among different cinematography styles remain fluid, and one could not demarcate the frames in which each change occurred.

The narrative information delivered in this long tracking shot could have been delivered in more efficient ways. Scorsese and Chapman might have constructed the same sequence of events out of stationary shots without damaging any causal connections in the story. Indeed, in terms of storytelling coherence, the sequence could be removed altogether, since we do not need to *see* La Motta enter the ring to know that he got there somehow. The shot decorates the movie without serving any necessary narrative, thematic, or structural function. Even the shot's primary expressive function—to emphasize the significance of the impending bout—is subordinate to its decorative function, since the expressiveness results largely from the shot's stylistic extravagance, an ornamental flourish heralding a momentous occasion.

The fluid tracking shot furthermore adds stylistic diversity to the movie. Indeed, the entire film integrates a range of styles, including television footage (figure 6.17), still photography (figure 6.18), and home-movie style color footage, which was spliced into each exhibition print by hand because it required different print stock (figure 6.19). The heavy stylization of the fight sequences, moreover, contrasts with the documentary-like realism of most sequences outside of the ring, which, aside from occasional slow-motion effects, employ mostly classical conventions of lighting, editing, and cinematography. The actors' performance styles create another dissonance. In *The Cabinet of Dr. Caligari* (1920) and *Metropolis* (1927), exaggerated and heavily sculpted performances combine with expressionist sets to create an overall style of graphic distortion. In *Raging Bull*, by contrast, the subtle and realist style of acting conflicts with the heavily stylized editing, cinematography, and mise-en-scène, so that the performances sometimes seem out of harmony with the expressionist environment, especially during fight sequences. Because the film harbors so many varied styles, *Raging Bull* demands more cognitive agility than typical Hollywood movies. Movies that vary their styles—such as *Citizen Kane* (1941) and *2001: A Space Odyssey* (1968)—seem unstable and difficult to master. Lacking formal symmetry and proportion, they demand greater cognitive effort since spectators must reconcile stylistic dissonances and adjust to changing stylistic cues.

FIGURE 6.17

FIGURE 6.18

FIGURE 6.19

FIGURES 6.17–6.19 *Disparate visual styles in* Raging Bull *include television footage (figure 6.17), still photography (figure 6.18), and super-8 mm color footage (figure 6.19).*

Still, by repeating devices, the film provides stylistic continuity from shot to shot and creates harmonies among different scenes. For example, black-and-white cinematography generates high-contrast images and dramatic shadows in sequences both inside and outside of the ring and gives much of *Raging Bull* the look of film noir and 1940s press photography, both of which, according to Chapman, influenced the film's visual style.[12] Moreover, although each fight sequence exhibits a distinct style, most sequences make use of slow-motion cinematography, extreme high- and low-angle shots, and moving cameras, as well as featuring smoke-filled arenas, heated discussions between La Motta and his crew in his corner, and photo-journalists incessantly snapping photographs. The film also feels stabilized by a narrative purpose that generally conforms to the principles of classical Hollywood narration, at least in the first hour and twenty minutes: Our protagonist has a clearly defined goal (to win the middle-weight championship) and must overcome obstacles (mobsters, a boxing scandal, weight problems, and arguments with his brother and wives) to achieve his goal in a definitive climax (the 1949 Cerdan fight). Consequently, although *Raging Bull* often risks stylistic incoherence, one generally experiences the film not as avant-garde experiment or salmagundi but as unified.

In the final section of this chapter, I want to show that *Raging Bull* takes its stylistic disunity up to the point of absurdity.

ON THE BRINK OF ABSURDITY: "LA MOTTA VS. SUGAR RAY ROBINSON, DETROIT 1943"

As I argued in chapter 3, our desire to master an artwork (to understand it and resolve its properties into some sort of coherent entity) hinges on our assumption that understanding is possible. We need not actually achieve mastery, as long as we believe that the work would yield to greater understanding the more we investigate it. Indeed, the moment we master a work of art is the very moment we stop investigating it. The more one investigates certain sequences of *Raging Bull*, however, the less sense they make. Even upon close scrutiny, the film remains elusive. *Raging Bull* sustains the search for understanding by offering the prospect of coherence while ensuring that coherence remains impossible to obtain.

The film's depiction of the first 1943 bout between La Motta and Robinson illustrates the extent to which *Raging Bull* risks stylistic and logical discontinuity. The entire bout takes 75 seconds of screen time, but three shots, which depict La Motta punching Robinson out of the boxing ring, show particular incoherence; they last five seconds (video 6.8 ⓟ; video 6.9 ⓟ shows the sequence in slow motion).

- Shot one (figure 6.20). A low-height long shot of La Motta driving Robinson from the right side of the ring to the left as the camera tracks left with them.
- Shot two (figures 6.21–6.23). A high-angle, over-the-shoulder shot as La Motta punches Robinson out of the ring (figure 6.21). The shot is in fast motion, and the camera tracks in from a long shot of Robinson to a medium shot, as the boxer falls to the floor beyond the ring (figure 6.22). The camera then tilts up to film a photo-journalist taking a flash photograph from ringside. The frame turns almost completely white, and, as the whiteness fades, we see the decaying flash of the photographer's camera (figure 6.23).
- Shot three (figure 6.24). A one-second freeze-frame representing a still photograph, brightly lit, taken from ringside. La Motta has just punched Robinson, who is in the midst of falling out of the ring.

This dense and rapid series of shots presents a lot of information that does not make sense. Let's begin with the most illogical shot in the sequence—shot three (figure 6.24), the brightly lit still frame of La Motta punching Robinson out of the ring. The shot implies that the photograph taken by the photo-journalist in shot two has been inserted back into the film's sequence of events. The picture, moreover, depicts Robinson in mid-air, even though the preceding shot showed the boxer already on the ground (figure 6.22). The sequence's most illogical idea, however, results from the perception that the photographer

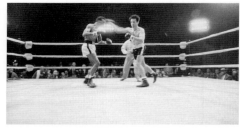

FIGURE 6.20 *Shot 1.*

FIGURE 6.21 *Shot 2a.*

FIGURE 6.22 *Shot 2b.*

FIGURE 6.23 *Shot 2c.*

FIGURE 6.24 *Shot 3.*

FIGURES 6.20–6.24 *Three consecutive shots from the scene "La Motta vs. Sugar Ray Robinson, Detroit 1943." The photograph depicted in Shot 3 (Figure 6.24) seems, illogically, to include the image of the photographer taking the photograph.*

represented in the left side of shot three (figure 6.24) is the same photographer depicted in shot two (figure 6.23)—the same photographer who presumably *took* shot three, the very shot in which he appears.

The conventions of continuity editing suggest that the photographer in the picture also took it. On the one hand, the eyeline match between shots two and three suggests that, when a shot of a photo-journalist taking a photograph (shot two) is followed by a shot of a photograph (shot three), then the photo-journalist must have taken that photograph. On the other hand, spatial relations within the shots tell us that the depicted

photographers are the same. The two shots follow a conventional shot/reverse shot pattern, although in this instance the editing pattern results in an absurd idea: The photograph somehow includes the image of the photographer taking the photograph.

I suspect that spectators, however, find enough coherence in the familiar editing pattern to orient them from shot to shot and prevent them from recognizing the absurdity *as* absurdity. The quick pace of the sequence encourages spectators to make whatever sense they can out of the barrage of images, and, as the plot moves rapidly forward, one need not bother figuring out the details of the various spatial impossibilities. Narrative momentum and our investment in our protagonist's efforts to win the bout provide a stable context capable of distracting us from the film's lapse in coherence. In short, the sequence makes sense because we *want* it to make sense and because narrative context insists that it must make sense.

Some of the scene's most bizarre moments combine images and sounds in an incongruous way. Whereas sounds of punches and cheering fans provide a degree of auditory realism, we also hear dissonant sounds that come across almost comically in the context of a boxing match: booming sounds (like a large animal thumping in the forest), a high-pitched screech that fades into the sounds of cheering fans, something that sounds to me like an animal screaming, and a sound that resembles the revving of a cartoon character winding up for a punch. Scorsese said about sound-effects editor Frank Warner, "He used rifle shots and melons breaking, but he wouldn't tell us what many of the effects were; he became very possessive and even burnt them afterwards so nobody else could use them."[13]

Although my characterization of *Raging Bull*'s style makes the film seem more like art cinema than Hollywood cinema, the film's stylistic disunities differ from similar elements in art films, such as visual distortions in *The Cabinet of Dr. Caligari*, temporal and spatial illogic in *October*, narrative nonsense in *Last Year at Marienbad* (1961), or the various absurdities of style and character in *Pierrot le Fou* (1965). Because art films work outside of classical tradition, often flaunting their violations of story logic and stylistic convention, we come to them with a different set of expectations. By contrast, spectators generally come to *Raging Bull* expecting a classical Hollywood film, and in many ways it is one. The film's classical Hollywood properties (a goal-oriented protagonist, cause-and-effect narration, continuity editing, realistic storytelling devices, conventional stylistic patterning, etc.) provide a solid foundation on which Scorsese can lay his stylistic eccentricities, preventing the film from separating into incoherent pieces. *Raging Bull* remains both engaging and elusive, even upon multiple viewings, because its stylistic disunity keeps the film a step removed from intelligibility. To understand the film, one must mentally correct it so that it depicts not what reason says it is depicting but rather what narrative context and Hollywood convention say it *must* be depicting. To understand *Raging Bull*, spectators must make the film into something reason says it is not: coherent and comprehensible.

PART
4

IDEOLOGY

This is the moment of moral ecstasy. The hero is so right *(that is, so wronged) that he can kill with impunity. And we are with him one hundred percent. The feeling of supreme righteousness in this instant is delicious and hardly to be distinguished from murderousness.*

—Jane Tomkins on the western hero[1]

Ideology, Emotion, and Aesthetic Pleasure

WE BEGIN WITH THIS CHAPTER'S CENTRAL QUESTION: HOW DOES ideology relate to aesthetic pleasure? We may not think of ideology as an aesthetic property of an artwork since we might discuss an artwork's ideology without ever considering the work's aesthetic design. But ideology can factor into aesthetic pleasure when it helps to concentrate—or complicate—our beliefs, values, and emotional responses to an artwork. When ideology connects intimately to an artwork's formal properties and contributes to our aesthetic experience, then it becomes part of a work's aesthetic design. In such cases, we can say that the artwork has an "ideological framework," consisting of design properties that contain, support, and advance the film's ideology.

Hollywood movies, at least during film viewing, guide our beliefs and values so that we might approve some events and deplore others, hope for some outcomes and dread others. The ideological framework of a film helps viewers evaluate the variety of situations presented. This framework may include both narrative devices (such as characters, dialogue, and situations) and stylistic devices (such as cinematography, performance, makeup, and lighting). In this chapter, we study the contribution of ideology, as it is embedded within Hollywood cinema's design properties, to pleasurable aesthetic experiences.

Before we undertake that task, however, we must first define what we mean by ideology.

In its modern meaning, ideology denotes a system of beliefs and values, typically moral values. Beyond that, however, theorists employ the term in different ways. Karl Marx and Friedrich Engels saw ideology as a type of thought that reflects the beliefs and values of the dominant social class, whose interests the subordinate classes mistake for

their own. Social institutions, they argued, advance the dominant ideology, creating an oppressed state of "false consciousness" among the lower classes.[2] Later cultural critics expanded the conception of ideology so that it characterizes not just class but also race, gender, sexual orientation, and other cultural categories. Louis Althusser defines ideology as a system of "representations (images, myths, ideas, or concepts, depending on the case) endowed with a historical existence and role within a given society."[3] Althusser sees ideology as a vast network of representational systems that permeate culture and restrict thought.[4] This wide-ranging conception of ideology has had a lasting imprint on ideological film scholarship, supporting the works of Slavoj Žižek, Colin McCabe, Mary Ann Doane, and countless others.

Noël Carroll, in discussing the relationship between ideology and mass art, helps distinguish between narrow and broad uses of the term, both of which we find in critical literature in the arts. In Carroll's narrow formulation, ideology always has a pejorative meaning. For a proposition to be ideological in the narrow sense, Carroll argues, (1) it must be false or otherwise epistemically flawed, and (2) it must favor some practice of social domination.[5] By contrast, ideology in the broad conception denotes any system of beliefs and values, in which case the term would equally characterize Gandhi's pacifism and Hitler's racism. Carl Plantinga calls the broad conception, "ideology as worldview."[6] The narrow, pejorative conception serves critics trying to expose pernicious ideological meanings within artworks. For an aesthetic study like this one, however, we need not consider whether an ideology is true, false, constructive, pernicious, or innocuous; we need only consider ideology's contribution to aesthetic pleasure.

Consider the supposition, inherent in some Hollywood police-detective movies, that effective police deal with criminals violently and without regard for due process. For a critic concerned with exposing Hollywood's pernicious values, such a proposition is surely ideological in Carroll's narrow, pejorative sense:

(1) *It is false or epistemically flawed*: In the real world, unlike in many police-detective movies, the justice system regularly prosecutes criminals effectively, and such films rarely draw our attention to the role of due process procedures in helping to ensure fairness in the system and protect suspects from arbitrary punishment.

(2) *It favors social domination*: The government secures power over its citizens if police need not trouble with the details of the Constitution and rule of law.

In the spirit of aesthetic specialization, however, we might respond, "Yes, that may be so, but let's not worry about that right now." Instead, we might focus on the ways in which the ideology of the police-detective genre guides us toward aesthetic pleasure.[7]

IDEOLOGICAL FILM ANALYSIS
AND AESTHETIC PLEASURE

Given that I am conceiving of ideology in the broadest way, why use a term with such a loaded history in film studies? Why not simply say "worldview"? I want to retain the term *ideology* because I shall argue here that the systems of beliefs and values that scholars widely regard as having a pernicious effect on spectators' moral responses to Hollywood cinema can sometimes have a positive effect on spectators' aesthetic responses.

Several scholars have argued that Hollywood, in offering "reassuring pleasures" to mass audiences, reinforces the status quo. However, by bounding over the apparently self-evident "pleasures" of Hollywood cinema in order to explain its ideological harms, scholars have skipped a few steps, as though labeling such pleasures "reassuring" accounts for their appeal.[8] The proposition that a film's complicity in dominant ideology leads to its popularity has become so established in film scholarship since the 1960s that proponents take it as a matter of course, without questioning the mechanism by which a film's ideology delivers pleasure. Film scholarship has yet to explain how a film's ideology contributes pleasure, reassuring or not, to spectators' aesthetic experience.

Inasmuch as ideological film scholars purport to explain the pleasures of cinema, many of the existing analyses share the same weakness: a problem accounting for the attraction of one Hollywood film over another. This weakness is most evident among scholars who view Hollywood cinema as *essentially* nefarious. Frederic Jameson tries to account for the "aesthetic gratification" of "mass culture" by examining the ways in which it engages social and political anxieties only to suppress them. He argues that mass culture, including films such as *The Godfather* (1972) and *Jaws* (1975), offers utopian resolutions and "an optical illusion of social harmony," which serves as a "fantasy bribe to the public about to be so manipulated."[9] Laura Mulvey, in her essay "Visual Pleasure and Narrative Cinema," argues that traditional narrative cinema inevitably causes the spectator to adopt the position of a male voyeur and fetishist, along with an attendant "ideology of representation" that includes male dominance, female passivity, and fear of castration.[10] Jameson and Mulvey each make an earnest effort to explain how the ideological structure of Hollywood narrative leads to "gratification" or "pleasure," but their theories do not explain why mass audiences obtain more gratification or pleasure from some Hollywood movies than from others, since all of them purportedly share the same fundamental principles in their ideological construction. A blockbuster like *The Godfather* or *Jaws* is no more of a "Utopian fantasy" than a flop like *Cleopatra* (1963) or *Howard the Duck* (1986).[11]

Several ideological film scholars argue that mainstream Hollywood films create pleasure by affirming the existing beliefs and values of the dominant culture. Robin Wood says that "the pleasure offered by the *Star Wars* films corresponds very closely to our basic

conditioning; it is extremely reactionary, as all mindless and automatic pleasure tends to be."[12] Douglas Kellner argues that ideology serves a "soothing" function in Hollywood genres: "In order to resonate to audience fears, fantasies, and experiences, the Hollywood genres had to deal with the central conflicts and problems in U.S. society, and had to offer soothing resolutions, assuring its audiences that all problems could be solved within existing institutions."[13] Jean-Louis Comolli and Jean Narboni assert that Hollywood could sell anything to the public, as long as it promoted dominant ideology: "'What the public wants' means 'what the dominant ideology wants.' The notion of the public and its tastes was created by the ideology to justify and perpetuate itself."[14] Comolli and Narboni believe that the mere presence of dominant ideology satisfies the mainstream public's entertainment demands.

Robert Ray purports to make "theoretical progress toward an understanding of cinematic popularity" by examining the fundamental role of some of America's most prominent myths—such as self-invention, American exceptionalism, and outlaw legends—in the appeal of Hollywood cinema.[15] Ray hopes he can forecast the mass appeal of individual films by examining the ideologies of commercial successes, but—like Jameson, Mulvey, and many other film analysts—he does not account for the countless *unpopular* Hollywood films that broker the same myths and fantasies as the popular ones. Ray argues that success in Hollywood depends on two things: ideology (what he describes as "the resolution of incompatible values") and an "invisible style." He says, for instance, that Orson Welles could not find work as a director in America because *Citizen Kane* (1941) dramatized "the irresolvable conflict between American myths of success . . . and of the simple life" and because *The Magnificent Ambersons* (1942) "demonstrated the stark incompatibility of nineteenth-century small-town values with those of the modern industrial age."[16] Ray's argument, however, ignores countless artistic decisions that went into making Welles's films, and he dismisses, with too little effort, generations of aesthetic and historical analyses of Welles's filmmaking career. If success in Hollywood can be boiled down to ideology and invisible style, then the studios have wasted a lot of money hiring talented directors, actors, cinematographers, editors, and costume and set designers when any capable technicians equipped with the right ideological tools could have done the job.

Jameson, Mulvey, Kellner, Ray, and Comolli and Narboni represent some of the more extreme positions, admitting little or no positive value in mainstream Hollywood cinema. Other ideology critics take a more tempered approach. Richard Dyer, like Jameson, points to Hollywood's utopian urge, but he sees in the musical genre a possibility (mostly unrealized) for historical engagement and transformation.[17] Consequently, his analyses show more appreciation of Hollywood cinema than Jameson's. Despite Robin Wood's disdain for Hollywood films like *Star Wars*, he sees in the horror genre "the struggle for

recognition of all that our civilisation *re*presses or *op*presses."[18] Barbara Klinger regards the melodramas of Douglas Sirk as a set of conflicting meanings that change with the historical context. Contrary to Comolli and Narboni, Klinger's historiographic analysis demonstrates that films "serve as sites of confluence for diverse cultural concerns during particular eras and through time. This potential diversity and changeability make it difficult for us to label individual films as reactionary or progressive."[19] Klinger does more than acknowledge that a film's appeal is contingent upon the beliefs and values of the culture viewing it; she shows how audiences within different historical contexts understand and appreciate Sirk's films in different ways.

Hollywood executives, occupationally attuned to current trends, take into account the historical variability of meaning and appreciation when they determine which films to finance. Indeed, we can find instances in Hollywood history when the economics of challenging, rather than sustaining, the status quo has led the industry to support politically progressive films with commercial potential, such as *I Am a Fugitive from a Chain Gang* (1932, Warner Bros.), *The Grapes of Wrath* (1940, Twentieth Century Fox), *Tobacco Road* (1941, Twentieth Century Fox), *Dr. Strangelove or: How I Learned to Stop Worrying and Love the Bomb* (1964, Columbia), *M*A*S*H* (1970, Twentieth Century Fox), *Coming Home* (1978, United Artists), *Reds* (1981, Paramount), *Wall Street* (1987, Twentieth Century Fox), *Malcolm X* (1992, Warner Bros.), *Bullworth* (1998, Twentieth Century Fox), and the documentaries of Michael Moore, including *Roger and Me* (1989, Warner Bros.), *Bowling for Columbine* (2002, United Artists), and *Capitalism: A Love Story* (2009, Paramount). In the early and middle 1970s, Hollywood exploited a popular anticapitalist trend in the culture with such films as *McCabe and Mrs. Miller* (1971, Warner Bros.), *The Godfather, Part II* (1974, Paramount), and *Chinatown* (1974, Paramount), a trend that drifted into the period's blockbusters, such as *The Towering Inferno* (Twentieth Century Fox), the highest grossing movie of 1974, and *Jaws* (Universal), the highest grossing movie of 1975. Janet Wasko states the obvious fact: "Above all, profit is the primary driving force and guiding principle for the industry."[20] And here we have the ideological weak spot in the capitalist system of film production: The studios would promote the revolution if they thought it would sell tickets.

I do not want to abandon the tradition of combining ideological film analysis with aesthetic criticism. I want instead to change the focus, if only briefly. Rather than view Hollywood as an instrument of ideology's oppressive goals, as many previous film scholars have done, I want to view ideology as an instrument of Hollywood's aesthetic goals. In doing so, I hope to fill in some missing steps in current ideological film scholarship by explaining the mechanisms by which a film's ideological properties contribute to its aesthetic appeal. Ultimately, I hope to demonstrate that the film industry promotes particular ideologies, and integrates them into the design properties of Hollywood films, in

order to precipitate entertainment—active enjoyment, not just "reassuring pleasures"—for mass audiences.

THE IDEOLOGY OF VIOLENCE IN THE ACTION GENRE

Hollywood cinema's typical treatment of violence demonstrates that Hollywood promotes beliefs and values not to advance an ideological agenda but rather to maximize aesthetic pleasure. One might think, from looking at action films, that the American film industry has designed its movies to promote an ideology of violence. But studios have no financial interest in promoting an ideology of violence. Rather, Hollywood movies have enlisted an ideology of violence in order to enable exciting action scenes.

When a film embeds exciting action within an ideological framework, then we are liable to evaluate the action in light of its relationship to other components of the movie, such as its plot, themes, characterizations, or overall moral structure. By guiding our evaluation of events, a film's ideological framework can turn a sensory experience into an aesthetic one, making a scene not just arousing but suspenseful, bold, unpredictable, infuriating, satisfying, or thrilling. An exciting action scene embedded within a narrative's ideological framework is primed to create aesthetic pleasure.

The real world rarely offers situations in which violent action proves the most appropriate, effective, and satisfying solution to a problem (real violence often causes more problems), but such situations pervade the action genre. Hollywood action films strategically construct scenarios in which violence emerges as the most efficient, rational, and moral response to narrative urgencies. If a police-detective movie, for instance, establishes the worldview that effective police deal with criminals violently and without concern for due process, then the violent, extra-constitutional actions of a Hollywood police detective will likely lead spectators to feel excitement, relief, celebration, hope, or other pleasurable emotions. In the worldview of a good many Hollywood police-detective films—*The Big Heat* (1953), *The Big Combo* (1955), *Madigan* (1967), *Dirty Harry* (1971), and many others—the Constitution does not just obstruct effective law enforcement; it also obstructs aesthetic pleasure.[21]

The ideological framework of *Die Hard* (1988) justifies a series of exciting action scenes. The film's narrative design fosters violent action, excluding the possibility of non-violent alternatives. In *Die Hard*, a band of criminals takes hostages in a Los Angeles skyscraper in order to obtain assets contained in the vault. Our protagonist, John McClane (Bruce Willis), a New York cop hiding in the building, thwarts their plans by shooting the criminals, engaging in fist fights, and blowing up portions of the skyscraper. McClane cannot arrest the criminals since they outnumber and outgun him, and the film portrays characters who try to appease the criminals as smug and naïve. In fact, the film has

constructed each scene in which our protagonist employs violence so as to leave no possibility that the Los Angeles police or FBI might help McClane control the criminals, that anyone could subdue the criminals with the mere threat of violence, that negotiation might diffuse the situation and save lives, or that McClane could help the hostages survive or escape without recourse to violence.

Having dispensed with the legal annoyances of due process and standard police procedure, *Die Hard* has strategically disarmed or excluded information (such as effective hostage negotiation strategies) that might challenge its ideological presuppositions and interfere with scenes of action. McClane, fighting overwhelming odds, reacts to a series of desperate situations in which violence alone, enacted by him alone, can solve an immediate problem: The criminals shoot at him or attack him, and he must urgently save himself or hostages by shooting back, fist-fighting, or blowing things up. As a result of the film's commitment to the proposition that effective police deal with criminals violently and without concern for due process, the narrative teems with exciting scenes in which our protagonist foils brutal criminals through a series of violent actions. In *Die Hard*'s conception of the world, violence is the right solution to an extraordinary number of problems.

For spectators engaged by the film, *Die Hard* offers a "delicious" moral justification for violence (as Jane Tomkins describes the feeling in the quotation that opens Part 4). Like Tomkins's western hero, McClane *must* retaliate in order to combat the criminals' atrocious behavior and prevent further atrocities. Not to retaliate would be wrong. The spectator can enjoy the excitement of violence and, at the same time, feel satisfied that violence is the most righteous solution to McClane's immediate problems. One's aesthetic response to the film (whether one considers the film dull, engaging, forgettable, ridiculous, satisfying, thrilling, etc.) hinges on one's moral evaluation of McClane's behavior within the context of the film's worldview. *Die Hard* has carefully constructed its scenarios so that "moral ecstasy," to use Tomkins's phrase, results when situations warrant our hero's violent behavior.

The action genre has mastered such scenarios. We see similar ones in *The Adventures of Robin Hood* (1938), *The Big Heat* (1953), *Goldfinger* (1964), *Dirty Harry* (1971), *Lethal Weapon* (1987), *Under Siege* (1992), and countless other action films. *Independence Day* (1996), in which space aliens set out to destroy the human race, takes pains to ensure that the aliens have left no possibility for peaceful coexistence. When the president of the United States proposes peace, an alien replies that humanity's only course is death. The reply likely excites action film fans, who would feel disappointed if, instead of scenes of violent action, the movie proceeded with scenes of peace negotiations between the president and the aliens. In the face of such hostile and irredeemable enemies and without any available alternatives, our protagonists must employ violence as the only rational recourse.

A typical Hollywood action film can lead spectators to formulate a worldview, however temporary, that helps them make sense of, justify, and find satisfaction in the violence performed by the film's protagonists. We can summarize the action genre's common ideology as follows: *Violence by good people is the best way to confront violence by bad people (or bad space aliens)*. Provided they are susceptible to the rhetoric of the action genre, spectators approve such uses of violence, even though they may deplore similar behavior in the real world. Although movies cannot always control our values (we might resist an artwork's worldview), movies often guide our values in the short term by constructing their plots so that we can easily evaluate story events by means of a particular ideological presupposition. The worldview of the action genre enables us to positively evaluate our protagonist's violent behavior, creating the potential for "moral ecstasy" and other exhilarating emotions.

The exhilaration felt when watching Hollywood action films differs from the exhilaration I have discussed previously in this book. Until now, we have examined the exhilarated pleasure of attempting to master a challenging aesthetic object. In the action genre, exhilaration comes from having our emotions, desires, and convictions heightened to such a degree that we yearn for release and grow elated at the prospect. Hollywood specializes in this type of experience and offers equivalent scenarios in all of its genres. Hollywood cinema guides us toward highly emotional experiences by concentrating our beliefs and values in a far more focused and prolonged way than ordinary reality normally does.

We can see from the foregoing discussion that the ideologies embedded in Hollywood films help shape spectators' emotional experiences by guiding spectators' evaluation of narrative situations. Hence, for a full account of Hollywood aesthetics, we must explain how Hollywood creates aesthetic pleasure by guiding spectator emotion. Emotion pertains to other aspects of Hollywood cinema than ideology, but ideology offers us an appropriate occasion for discussing emotion because some leading psychological theories posit that emotions result from a person's subjective evaluation of a situation. Hence, to understand the relationship between ideology, emotion, and aesthetics, we must take a detour through some theories of emotion.

CINEMA, EMOTION, AND AESTHETIC PLEASURE

Several film scholars, including Carl Plantinga, Ed Tan, Richard Maltby, Dirk Eitzen, and Patrick Keating, argue that Hollywood designs movies expressly to elicit emotion. Tan calls the feature film an "emotion machine."[22] Eitzen says Hollywood "gives the most emotional bang for the buck."[23] Keating advises us to look at Hollywood narrative as "as an emotional system designed to produce feelings of hope, fear, delight, and despair."[24] Maltby says that "audiences go to the movies to consume their own emotions."[25] Let's try

to understand how Hollywood movies stimulate emotion and how emotions contribute to aesthetic pleasure.

Emotion is a controversial area in psychology. At one end of the spectrum are "somatic theories" of emotion, which hold that situations trigger bottom-up, biologically prescribed, reflexive emotional responses, such as recoiling in shock upon seeing a character stabbed. At the other end are "appraisal theories," which posit that top-down cognitive processes mediate emotions, which result from a person's subjective evaluation of a situation.[26] Both models have supportive evidence, and I cannot hope to resolve their relative validity. I can, however, take a pluralistic view of the competing theories of emotion, particularly since Hollywood seems to rely on both reflexive (e.g., disgust felt upon viewing a grotesque object) and top-down (anger evoked by a character's unjust treatment) emotional responses. The two types of responses typically work harmoniously in Hollywood movies to create unified effects, but they can also work against each other. We will consider Hollywood's reliance on reflexive responses later in the chapter, but first let's examine how Hollywood guides our evaluation of events in ways that lead to emotional responses.

According to a top-down approach to emotions, when spectators respond emotionally to a situation presented in a film—when spectators care about how a plot unfolds—they evaluate the relevance of a depicted situation to their own concerns. Psychologists who study emotion call this process of evaluation "appraisal."

The Appraisal Theory of Emotions—advanced by Magda Arnold, Richard Lazarus, Nico Frijda, and others—helps explain how movies guide our emotional responses to situations. According to the theory, a person's appraisal of a situation, not the situation itself, leads to an emotional response. Since Appraisal Theory posits that the individual's emotional experience depends on a situation's personal significance, the theory helps explain why different people have different emotional responses to the same situation. Each emotion, the theory predicts, corresponds to an individual's subjective appraisal. For instance, *anger*, some psychologists suggest, results from an appraisal of a demeaning offense or injustice; *sadness*, a loss that cannot be undone; *anxiety*, an uncertain threat; *relief*, an improvement in a distressing condition; *frustration*, an obstruction to one's desires; and so on for every emotion. Movies create "emotional heat," to use Lazarus's phrase, when they cause us to appraise depicted situations as personally relevant.[27] When we believe that a situation affects our own concerns—for ourselves, for other people, or for fictional characters that concern us—then we feel that heat.

Appraisal Theory also helps explain the relationship between cinema, ideology, and emotion. Through their ideological framework, movies establish systems of beliefs and values that guide our appraisals of events (such as McClane's violent behavior). Such systems provide a set of evaluative criteria that lead us to understand, judge, and respond

emotionally to plot situations. We evaluate situations as positive or negative, depending on whether we appraise the situations as congruent or incongruent with our own concerns. A movie helps shape those concerns through its ideological framework.

Of course, we do not ourselves experience the situations experienced by the characters, and our emotional responses need not mimic theirs. But we can still feel emotional heat, provided the film has established strong sympathies or antipathies for characters.[28] Plantinga explains how our engagement with film characters affects our own emotional well-being (Following Roberts, Plantinga uses the word "construal" in the way others use "appraisal"[29]):

> When the viewer develops a concern that the goals of a character be met, this creates a desire for the attainment or maintenance of the character's desired state or the escape from or avoidance of an aversive state. In the case of sympathetic emotions, spectators typically align themselves with the character's concerns, and their construal of the situation is guided by this alignment.[30]

When we engage with a character, Plantinga argues, we evaluate situations in light of their effect on that character, and if our engagement is deep our emotions can be strong.[31]

According to Plantinga, even if we do not share the emotions of a sympathetic character, our emotions are often congruent in valence.[32] By the same token, our emotions often oppose those of unsympathetic characters. So, for example, an injustice enacted upon a sympathetic character may trigger anger in us (Luke's interminable imprisonment in *Cool Hand Luke* [1967]), whereas an injustice enacted upon an unsympathetic character may cause mirth (Lina Lamont's humiliation at the end of *Singin' in the Rain* [1952]). Irreparable loss experienced by a sympathetic character may cause us to feel sadness (Vito Corleone crying over Sonny's death in *The Godfather* [1972]), whereas irreparable loss experienced by an unsympathetic character might trigger relief and satisfaction (Hans Gruber falling to his death in *Die Hard*). And so on. Our sympathies and antipathies for characters help determine the relevance of a situation to our own concerns and hence the intensity, quality, and valence of our emotional experience.

According to most psychologists, emotions motivate us to change our interaction with the environment. For instance, anger, for many people, motivates attack. But we cannot attack film characters. Our inability to act within the diegesis, Tan argues, enables our entertainment:

> The experiencing of emotion from a safe distance is one of the prime pragmatic characteristics of film viewing. A terrifying situation is entertaining precisely because you can do no more than watch; if you were in a position to intervene, in order to protect

yourself and others, then you would feel responsible and would no longer be able to enjoy the fictional events on the screen.[33]

The implications of our inability to act within the diegesis extend further than Tan indicates. Although the fictional context relieves us from the burden of acting, it can also frustrate us by preventing action that might help us regulate our emotions. A lack of control over the situation confines us to our own emotional resources. We can try to cope with our emotions, we can withdraw from the fiction, but we cannot change the fictional environment, which proceeds ineluctably no matter what we do. Indeed, psychologists have found that so-called "negative" emotions (such as anxiety) motivate action more than "positive" emotions, which tend to suppress action.[34] When we feel intense negative emotion, the desire to act remains strong, and our own impotence impedes our capacity to cope with the situation.

Aesthetic Pleasure and "Collections" of Emotions

The constraints imposed by the fictional context leave us at the mercy of the narration. By drawing out situations that stimulate negative emotions, filmmakers exploit our inability to perform actions that would help us regulate our emotions. If, for instance, we see a criminal preparing to assault a sympathetic character, we may feel fear, anxiety, or anger. The film has stimulated emotions that motivate us to perform an action—perhaps to warn or to help the victim or attack the criminal—that the fictional context prevents us from performing. Our anger toward the criminal during a suspense scene may be compounded by our frustration that we can do nothing to stop him. The buildup of negative emotions may even strengthen the desire to act and create a feedback loop of increasing emotional intensity, until the narration resolves the problem and settles us down. The impotence of the film spectator in the grip of negative emotion leads us to say that audiences are "sitting on the edge of their seats." The phrase is not merely metaphoric. In highly suspenseful situations, film spectators want to act—to jump out of their seats and do something within the diegesis to help them regulate their emotions.

We should not assume, however, that a "negative" emotion necessarily results in a negative aesthetic experience. Indeed, I put "negative" in quotation marks because emotions that we might normally regard as aversive, such as fear and sadness, may offer emotional rewards in an aesthetic context or other atypical contexts. A filmgoer may enjoy suspense scenes not *despite* but *because of* the high level of anxiety they excite. Oscar Wilde made the point succinctly in *The Importance of Being Earnest*: "This suspense is terrible. I hope it will last."

Humans, it seems safe to say, are a deeply aesthetic species, locating aesthetic value in all sorts of unexpected places. Jerrold Levinson points to this human quality when he writes:

> Even were we to agree that an artwork is valuable, ultimately, only insofar as *experience* of it is in some way worthwhile, it does not follow that an artwork is valuable only insofar as experience of it or engagement with it is *pleasant*, or straightforwardly enjoyable. . . . Much art is disturbing, dizzying, despairing, disorienting—and is in fact valuable in virtue of that.[35]

Levinson reminds us that we should not equate aesthetic value with pleasant emotions. As every fan of the horror genre knows, unpleasant emotions can also contribute to a valuable aesthetic experience. We might in fact call a horror film "pleasurable," provided we recognize pleasure as a broad category of intrinsically rewarding emotional experiences.

Psychologists who test for aesthetic value, however, have normally regarded it as a function of pleasant feelings, using scales such as "pleasing-displeasing," "like-dislike," "positive-negative," "good-bad," and "pleasant-unpleasant." Psychologist Paul Silvia complains: "The psychology of aesthetic experience is eerily close to the psychology of how much novices say they like something."[36] Silvia and others have demonstrated that unpleasant emotions also contribute to valuable aesthetic experiences and that the qualities that make artworks interesting often differ from those that make artworks pleasing.[37] Yet, beyond a handful of studies, psychology has conducted little research on the aesthetics of so-called negative emotions.

Hence, we should view an aesthetic experience as valuable not according to the "positive" emotions it creates but rather according to the emotional rewards it offers and the behavior it reinforces. People become fans of the horror genre when they find horror films emotionally rewarding. "Negative" emotions, we can say, afford aesthetic value when they increase the likelihood that someone will seek out the same type of aesthetic experience again.[38]

Unlike aesthetic psychologists, Hollywood filmmakers regularly traffic in negative emotions—anger, horror, fear, disgust, contempt, embarrassment, confusion, frustration, sorrow—in order to intensify our experience and add urgency and importance to dramatic situations. Indeed, films that do not exploit the aesthetic value of negative emotions often lack intensity and appear cold or bland. Negative emotions are not by-products of a film's aesthetic value; rather, they help account for it. Many Hollywood movies generate emotional pain, yet people still find them entertaining. Indeed, emotion

can, by itself, entertain. Emotion creates variety in our experience, stimulates curiosity, arouses our senses, and mobilizes us. Silvia and Berg argue that emotions "make some events feel significant, urgent, and important."[39] Richard Lazarus, a leading psychologist of emotion, writes that our emotions

> provide *indispensable color* to our lives; we think of emotional experiences as hot, exciting, involving, or mobilizing, and distinguish them from experiences that are routine, cold, and detached. Life without emotion, even painful emotions, would be an exercise in monotony. Negative emotional experiences are aversive but when there is too little emotional color, we are bored and seek excitement.[40]

Spectators might find a Hollywood film such as *Schindler's List* (1993) aesthetically valuable in part because the movie elicits intense emotions, including negative emotions. That emotional color, I presume, helps to make the film far more popular than the countless documentaries about the Holocaust—such as *Shoah* (1985), Claude Lanzmann's anti-dramatic nine-hour interview documentary—that might contain more valid knowledge and a more nuanced assessment of the Holocaust than Spielberg's movie but which are not as emotionally "hot." Judging from the behavior it reinforces (evidenced by $321 million in worldwide box office grosses, in addition to television broadcasts, video rentals, school and other screenings), *Schindler's List* seems to offer mass spectators more emotional rewards than *Shoah*.

Richard Maltby argues that Hollywood filmmakers "organize movies so that spectators will produce their emotions in a sequence and pattern that [spectators] find satisfying."[41] Psychology offers some empirical support for Maltby's argument. Michael Kubovy, in his review of the experimental literature on "pleasures of the mind," finds that such pleasures are "collections" of emotions, both positive and negative, that unfold over time.[42] Indeed, some illustrative empirical evidence suggests that, at least for average spectators, pleasure derives not from the valence of our emotions (positive or negative) but rather from their intensity, provided spectators feel a favorable emotion at an episode's end. Psychologist Daniel Kahneman conducted a series of studies on this issue and found that two factors predicted subjects' retrospective evaluation of an episode: (1) the intensity of the peak emotion recorded during the episode (in the case of aversive episodes, the worst moment), and (2) a positive final emotion, recorded just before an episode ended.[43] In his review of this and other studies, Kubovy concludes that "some distributions of emotions over time are particularly pleasurable, such as episodes in which the peak emotion is strong and the final emotion positive."[44]

We can draw some tentative conclusions about Hollywood aesthetics from findings in psychology about emotions.

First, the finding that collections of emotions offer pleasure lends credence to the proposition that Hollywood designs movies to stimulate a variety of emotions that unfold over time.

Second, findings in psychology also help account for the prevalence in Hollywood cinema for scenes that elicit intense emotions, since intense emotions, either positive or negative, will likely contribute to spectators' positive evaluation of a movie.

Third, empirical research in psychology helps account for Hollywood's tendency to offer happy endings, since a positive evaluation of an episode, studies suggest, derives from the intensity of the peak emotion combined with a positive final emotion. Frijda notes that "one of the possible functions of a positive emotion like contentment is to suppress energy expenditure and behavior disruption by negative emotions."[45] Happy endings tend to satisfy our desire to act, relieve us of the disruption caused by negative emotion, and leave us content and stable. Indeed, Kahneman's finding that people prefer episodes with intense peak emotions and favorable final emotions sounds a lot like Hollywood formula.

Finally, the findings help explain why movies with unhappy endings often feel less complete than movies with happy endings, even when unhappy stories fully resolve (as in *Dr. Strangelove*). Unhappy endings tend to mobilize us and trigger a desire to change our relationship with our environment, whereas happy endings leave us more inert. Many political filmmakers, such as the Italian neorealists, have understood intuitively that contentment suppresses action. Sarah Kozloff argues that films with "the best chance of motivating people to change their behavior need endings that a) show the problem is unresolved and urgently demands social action; b) raise enough empathic anger or moral indignation in viewers to surmount the pressing concerns of our own lives and problems."[46] Political filmmakers, it would seem, should end their films unhappily if they want to motivate change after the final credits. Hollywood, to maximize pleasure, generally takes the opposite approach.

IDEOLOGICAL UNITY AND COMPLEXITY
IN HOLLYWOOD CINEMA

We can now relate what we have learned about ideology, emotion, and aesthetic pleasure to what we already understand about the aesthetics of Hollywood cinema. The remainder of this chapter examines the ways in which a Hollywood film's ideological framework either concentrates or complicates spectators' appraisals of depicted situations in order to intensify or diversify spectator beliefs, values, and emotions. Toward that end, I shall

argue two points. The first point concerns the ideologically *unified* Hollywood film and the second the ideologically *complicated* Hollywood film:

1. Typical Hollywood films concentrate their ideological properties in order to guide spectators toward a consistent worldview and coherent appraisals of depicted situations. These films create aesthetic pleasure by affording spectators immediate understanding and intense emotion.

2. Ideologically complicated Hollywood films disrupt appraisals and complicate spectators' beliefs, values, and emotions. More interesting than pleasing, these films encourage spectators to reshape their knowledge in an effort to resolve conflicting ideas.

My two points resonate with the typology advanced by Comolli and Narboni in their famous 1969 essay for *Cahiers du Cinéma*, "Cinema/Ideology/Criticism." The ideologically typical film corresponds rather roughly to Comolli and Narboni's type A, which comprises "those films which are imbued through and through with the dominant ideology in pure and unadulterated form."[47] The authors denigrate such films as "the unconscious instruments of the ideology which produces them."[48] They do not attempt to explain the pleasure of such films, except to say that they appeal to "public demand" and that public demand is itself "created by the ideology to justify and perpetuate itself."[49] Here, I hope to explain the mechanism by which ideologically typical films offer aesthetic pleasure to mass audiences.

My second type of film, which I call "ideologically complicated," corresponds, again roughly, to Comolli and Narboni's type E, consisting of "films which seem at first sight to belong firmly within the ideology and to be completely under its sway, but which turn out to be so only in an ambiguous manner. . . . The films we are talking about throw up obstacles in the way of the ideology, causing it to swerve and get off course."[50] The authors clearly admire this type of film for its ability to resist the "reactionary" ideologies that produce it. I hope to show that such films have aesthetic value too and that they can also appeal to a mass audience. Though less typical, the ideologically complicated Hollywood film is still prevalent, particularly in certain genres (such as the crime film). But my second point is complicated, so, while I will explain it in this chapter, chapters 8 and 9 elaborate on the point's complexities with some illustrative case studies.

The Ideologically Unified Film

In general, artworks organize their features to an extent that we rarely see in the real world, removing the distractions and complications that make ordinary experience muddled and messy. For Beardsley, "the concentration of the [aesthetic] experience can shut out all the

negative responses—the trivial distracting noises, organic disturbances, thoughts of unpaid bills and unwritten letters and the unpurged embarrassments—that so often clutter up our pleasures."[51] By blocking out the clutter that makes everyday life stressful and noisy, artworks marshal our attention "into free and unobstructed channels of experience."[52] Consequently, artworks offer us the pure emotional experiences that everyday reality rarely makes possible.

Carl Plantinga has described the ways in which Hollywood movies in particular concentrate their design features for the sake of ideological and emotional coherence. Plantinga regards Hollywood movies as "hypercoherent" because they "streamline reality, including in their narratives only what is needed to generate their desired effect."[53] Hollywood movies offer us the unity and definition that we rarely experience in ordinary life, appealing to viewers "not because they reflect experience, but because they idealize and exaggerate it."[54] For that reason, Plantinga calls Hollywood movies "*affectively prefocused*. Built into a movie is a particular way of seeing events and characters, a specific order and duration to those events—in short, a built-in gestalt or perspective."[55] Unlike the real world, Hollywood movies concentrate our experience in a highly efficient way and rarely interrupt an intense emotional experience with extraneous details or emotionally counterproductive information. In a Hollywood movie, a character's death scene is the wrong time for UPS to deliver a package.

When a Hollywood movie does include extraneous details, they tend to support and validate the film's worldview. A typical Hollywood movie unifies and intensifies our emotional experience by stuffing its ideological framework with supplementary information that makes ideologically good characters (characters that, within the worldview of the movie, represent correct beliefs and positive values) more appealing than their antagonists. Carroll notes that good characters in mass art tend to behave decently in a variety of ways:

> Whereas villains in mass fictions are apt to behave toward "social inferiors" quite brutishly (kicking the dog, tormenting the retarded, misleading children, etc.), the protagonists in mass art generally evince a democratic courtesy to such characters. . . . [T]his tendency toward egalitarianism . . . functions to make the moral and political positions that the characters represent . . . attractive.[56]

Hollywood concentrates narrative information in ways that intensify our emotional responses to characters and their worldviews. Typical Hollywood cinema is *ideologically redundant*, packing in superfluous information that reinforces a film's ideological position.

The framework that supports the ideology of a Hollywood film includes not just narrative devices but also stylistic devices, such as cinematography, performance, lighting, makeup, costume, and props. Like narrative devices, stylistic devices in typical films reinforce our appraisals of characters and situations and lead us toward a unified

emotional experience. However, stylistic devices work on us differently. Narrative devices in a Hollywood film connect *logically* to character to form a consistent batch of traits and behaviors. An ideologically vicious character, such as a Hollywood Nazi, might logically behave viciously in other ways too. Stylistic devices, by contrast, connect *magically* to character. Ideologically good characters in a Hollywood film should not, for any logical reason, look and sound more appealing than ideologically bad characters, but typically they do.

By using stylistic devices to elicit emotional responses to characters and situations, Hollywood may be exploiting the bottom-up, automatic quality of emotions. According to some psychologists, emotion is a biologically primitive response to sensory stimulation, an inherited reflex, hardwired into our brains. This theory of emotions, attributed to psychologists William James and Carl Lang, holds that a stimulus triggers activity in the autonomic nervous system that leads to an emotion, which is a consequence of sensing our own physiological change. The theory remains controversial, but inasmuch as emotional responses to art are fundamentally physiological, some aesthetic theorists would not regard the responses as aesthetic. Nonetheless, our physiological responses often work synergistically with more strictly aesthetic responses to enhance our emotional experience.

Let's examine some instances in which style works together with a film's ideology to elicit a unified emotional response.

Representatives of bad ideology in a Hollywood film are oftentimes cast, performed, or filmed in an unappealing way. *Pickup on South Street* (1953) films its communist villain with hard, low-key lighting, using a tight frame and a low angle, all of which distort facial features already distorted by the character's snarling and sweating (figure 7.1).

FIGURE 7.1 Pickup on South Street *(1953). Framing, lighting, makeup, and performance work together to make the film's representative of communism look repellent.*

Consequently, communism, in *Pickup on South Street*, seems not only a dangerous ideology but also a repulsive one. Similarly, Louise Fletcher's stiff, repellent performance of Nurse Ratched in *One Flew Over the Cuckoo's Nest* (1975) contrasts with Jack Nicholson's charming, dynamic performance of Randall P. McMurphy. In this way, the ideology advanced by the film—which one could summarize as *society's rigid institutions seek to destroy non-conformity and individualism*—is not only enacted in the narrative but also personified through character, casting, and performance, all of which cooperate to make the film's worldview *feel* right.

Stylistic devices in *Casablanca* (1942) help define the film's attitude toward Nazi Major Strasser (played by Conrad Veidt) and Czech Resistance leader Victor Laszlo (Paul Henreid). In figure 7.2, hard side-lighting on Veidt, with weak fill light, creates heavy modeling on his face and forehead, emphasizing lines, bags, and blemishes. By contrast, in figure 7.3, more diffuse and frontal lighting on Henreid softens his features, affording his face a glow that glamorizes the actor's good looks. Moreover, Veidt's military wardrobe and the "European" manner in which he holds his cigarette help characterize him as an exotic foreigner with a suspicious demeanor. Indeed, one can usually tell the difference between the good and the bad characters in an ideologically typical Hollywood movie just by looking at still frames because the film's stylistic devices make the good characters look appealing and the bad characters unappealing.

A typical Hollywood film tailors its stylistic devices so that the sensory preferences of the audience conform to the ideological presuppositions of the film. Although our emotional response to such devices may not be aesthetic in itself, inasmuch as it is reflexive and purely physiological, it supplements our thoughtful responses to characters and situations. Plantinga calls this coordination of style and subject matter "synesthetic affect" because elements from one mode (for example, romantic music or gauzy

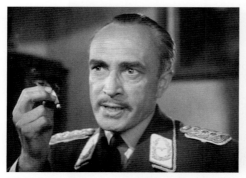

FIGURE 7.2 *Conrad Veidt as Major Strasser.* **FIGURE 7.3** *Paul Henreid as Victor Laszlo.*

FIGURES 7.2 AND 7.3 *Casting, costume, props, lighting, and performance in* Casablanca *(1942) reinforce the film's attitude toward each character's ideology.*

cinematography) feel as though they fit another mode (a love scene). This type of synesthetic coordination permeates even the most aesthetically banal Hollywood films. Frank Thring's effete performance of King Aella in *The Vikings* (1958) dooms the character to a cowardly death. During a cooking montage in the middle of *Leap Year* (2010), a jaunty instrumental works in tandem with Anna and Declan's playful behavior to signal their turn from hostility to affection. Hollywood filmmakers routinely synchronize different expressions of the same affect. One of the chief skills of a filmmaker, Plantinga says, is to combine different cinematic elements so that they work in tandem to coordinate a viewer's emotional response.[57]

The Ideologically Complicated Film

So far in this chapter, we have discussed Hollywood movies in which ideological, sensory, and aesthetic properties move in a unified direction toward concentrated cognitive and affective responses. However, some Hollywood films lack the ideological tidiness of the typical film. Here, individual properties are at odds with our expectations, with one another, or with the film as a whole. Such films generate interest through their disharmonies.

An ideologically good character may appear *in*decent or *un*attractive, and his antagonist may be appealing. Consider John Huston's grandfatherly performance as Noah Cross, *Chinatown's* (1974) figure of capitalist and incestuous depravity. Although the character has a repugnant worldview ("You see, Mr. Gittes, most people never have to face the fact that at the right time and the right place, they're capable of *anything*"), he typically appears genial and charming. In fact, in many ways he is more appealing than our hero, Jake Gittes (Jack Nicholson), who comes across periodically as smug, foolish, puerile, ugly, and obnoxious, even as he tries to expose corruption and restore justice to Los Angeles.

Because Hollywood enjoys charismatic villains, we see a dissonance between a character's charm and his repugnant worldview in a large variety of Hollywood films, including *The Public Enemy* (1931), *Shadow of a Doubt* (1943), *The Searchers* (1956), *A Clockwork Orange* (1971), *Badlands* (1974), *Wall Street* (1987), *The Silence of the Lambs* (1991), and *Inglorious Basterds* (2009). Orson Welles lends his wry charisma to his portrayal of Harry Lime, the colorful figure of unscrupulous postwar black-market profiteering in *The Third Man* (1949). Although the film discredits Lime's worldview, *The Third Man* also justifies it in a memorable monologue, reportedly written by Welles himself (video 7.1 ▶):

> Don't be so gloomy. After all, it's not that awful. Remember what the fellow said. In
> Italy for 30 years under the Borgias they had warfare, terror, murder, bloodshed. But

they produced Michelangelo, Leonardo da Vinci, and the Renaissance. In Switzerland they had brotherly love and they had 500 years of democracy and peace, and what did that produce? The cuckoo clock.

The speech's wit, historical perspective, and perverse logic make the worldview of Harry Lime seem, at the least, interesting.

The anarchist philosophy of the Joker from *The Dark Knight* (2008) has a similarly compelling logic, and the character's worldview, as well as his appearance, are liable to elicit conflicted emotions (video 7.2 ▶). "Upset the established order," the Joker says, "and everything becomes chaos. I'm an agent of chaos. Oh, and you know the thing about chaos? It's fair." The Joker has a point; chaos is fair. The character's philosophical integrity and incorruptibility make it difficult to reject his worldview in any easy way. His appearance too, like his ideology, is repugnant and interesting. He has large keloid scars extending from the corners of his mouth, he has an unpleasant habit of licking his lips when he speaks, and his Joker makeup looks as though he applied it some weeks earlier and not very well—all of which leaves the impression that the character is trying to both conceal and exaggerate his deformed face (figure 7.4). Actor Heath Ledger hunches his shoulders and gives the character's voice an odd nasal intonation more appropriate to a Hollywood computer nerd than a terrorist. The character's eccentric appearance, speech, and philosophy combine with Ledger's unusual performance to make the Joker's scenes more intriguing: The character seems complex enough to warrant contemplation.

A variety of films, from both the studio era and modern Hollywood, challenge audiences when their ideologies and their design features prevent us from evaluating characters in a coherent way. Our delight in Harry Lime and the Joker, for instance, and our interest in contemplating their beliefs, psychology, appearance, and behavior compete

FIGURE 7.4 *The Joker's pathetic, repellent, and intriguing appearance in* The Dark Knight *(2008).*

with our desire to see them defeated. Such films promote conflicted values and disorganize our emotional experience.

Making Ideology Strange

Mass artworks ordinarily feature commonplace beliefs and values ("Love is more important than money," "Success is the reward of hard work," "Family comes first," "Live life to the fullest," etc.) that maintain and reinforce an audience's existing knowledge. "Typically," Noël Carroll writes, "mass artworks do not function as the source of new beliefs about human conduct, but mobilize pre-existing ones."[58] Spectators more easily evaluate narrative information when they already hold the beliefs and values that a movie promotes. Our mere familiarity with common beliefs and values, even if we do not hold them ourselves, ensures that we immediately understand what a Hollywood film is telling us.

Some Hollywood films, however, use artistic devices to "defamiliarize" an ideology so that it seems somehow strange or different from its common presentation. The Russian formalists used the term *defamiliarization* to describe the ways in which artworks make us see the world in a new way, overcoming our habits of perception. Victor Shklovsky says that art recovers "the sensation of life," makes one feel things, makes "the stone *stony*."[59] Films that defamiliarize commonplace ideologies make common ideas and situations seem new.

The original *Invasion of the Body Snatchers* (1956) offers an illustrative case. Here, space aliens infiltrate an American suburb by killing and taking the shape of its inhabitants. Scholars have read the film as an allegory both of communism in American society[60] and of the McCarthyist overreaction to it,[61] an ambiguity so unresolvable that I suspect the film is not an allegory for anything at all. I think we can say confidently, however, that the film makes the American conception of normality look subtly and curiously strange. The film depicts behavior overly familiar to Americans—smiling when greeting someone, a superficial friendliness toward neighbors, a bland sweetness when talking to children, and other everyday scripts of human interaction—and makes the behavior appear vaguely sinister. Indeed, when characters who have previously behaved in a distinctive manner suddenly obey common norms of interaction, the change is immediately repellent, and we know that something has gone terribly wrong: Their normality tells us that aliens must have replaced them.

The subtlety of the strangeness results from the fact that the actors do not exaggerate their behavior, which is not hyper-normal; if we saw the same behavior in another movie of the period, it might seem benign. Sometimes stylistic cues, such as ominous music or an odd camera angle or lighting effect, make an otherwise innocuous moment seem sinister. Sometimes only the context has changed—our suspicion that someone's mother is not his mother, that an uncle is not an uncle. In one scene, we see what looks

like perfectly normal behavior of people milling about a town square in the morning—normal, that is, until our protagonist observes, "It's too early to be so busy." Here, a small contextual cue transforms seemingly benign behavior into an invasion of an alien species (video 7.3 ▶). *Invasion of the Body Snatchers* presupposes a common worldview (normal, friendly behavior is benign) and defamiliarizes that worldview by undermining it (normal, friendly behavior is malignant). As a consequence, we see normality in a new way. The movie makes normality strange.

The Last Temptation of Christ (1988) makes Christianity strange. The film took a common Christian idea—Jesus was both human and divine—and made it so unfamiliar that the film found itself at the center of what *Variety* called a "Holy War."[62] Director Martin Scorsese claimed that nothing in his movie contradicted the Gospels, but he presented Jesus's story so unconventionally that common Christian beliefs depicted in the film—raising the dead, healing the blind, the rite of transubstantiation—seemed peculiar and disturbing. Lazarus, raised from the dead, looks partially decayed. His flesh is rotting, the bones in his hands protrude, and he has trouble focusing his eyes and attention. Other characters show disgust at his smell. Aspects of Christian doctrine that modern Christianity has allegorized seem tangible in the film because of cinema's capacity to present events literally and viscerally.

The depiction of the Last Supper calls attention to the idea of cannibalism that centuries of Christian liturgy have veiled. In *Last Temptation*, when Jesus urges his disciples to eat his body and drink his blood, they look disconcerted. Jesus's request, so familiar to contemporary Western audiences, astonishes his disciples. And when a disciple pours some wine onto his fingers, it looks like real blood (video 7.4 ▶). By reifying events that Christian ritual has conditioned people to regard mostly in symbolic ways, *The Last Temptation of Christ* makes common Christian beliefs and values seem unfamiliar, even subversive.

CONCLUSION

We should regard ideology as a component of a film's aesthetic framework when ideology connects intimately to a film's design features. "Aesthetic appreciation of art," Levinson writes, "always acknowledges the vehicle of the work as essential, never focusing only on detachable meanings or effects."[63] In ideologically unified Hollywood films, such as *Die Hard, Independence Day, Pickup on South Street*, and *Casablanca*, narrative and stylistic devices work synergistically to concentrate our beliefs, values, and emotional responses, offering us a purer experience than we can find in most real-life situations. By contrast, ideologically complicated Hollywood films present their ideologies in a novel or ambiguous way, even though the ideological content itself may be common. Films such as

Chinatown, The Third Man, and *The Dark Knight* contain design features that upset our appraisals of events and characters and complicate our intellectual and emotional experiences. *Invasion of the Body Snatchers* and *The Last Temptation of Christ* seem inappropriate vehicles for the orthodoxies they presuppose because their narrative and stylistic devices make common beliefs and values seem strange.

As I argued in chapter 1, we can think of aesthetic pleasure as the satisfaction of a perceiver's epistemic goal—either to maintain knowledge or to expand it. This formulation helps us understand the relationship between ideology and aesthetics. Whereas the ideologically unified Hollywood film satisfies a desire for immediate understanding, the ideologically complicated Hollywood film satisfies a desire for deeper understanding. The complicated film exercises our cognitive powers and reshapes our knowledge, as we seek connections among inconsistent information in an effort to restore coherence to our beliefs, values, and emotions. Prompted by their unusual designs, spectators engaged by such films will try to process their dissonant properties in the hope that the works might yield to understanding.[64]

. . .

There is much more to say about the ideologically complicated Hollywood film, and the following two chapters explore the subject from two different vantages. Chapter 8 demonstrates how ideological constraints in studio-era Hollywood shaped the formal properties of an entire body of crime films, now commonly referred to as film noir. Chapter 9 moves in the opposite direction, examining the ways in which formal properties complicate a film's ideological meaning.

Crime Films during the Period of the Production Code Administration

Censorship is not the mutilation of the show. It is the show.

—Chris Marker, *Sans Soleil* (1983)

B ETWEEN THE 1930S AND THE 1950S, HOLLYWOOD FILMMAKERS WORK-
ing in the crime genre faced a tricky problem. They had to satisfy, on the one hand, regional censors and religious groups and, on the other, filmgoers interested in the salacious, violent, and morally controversial material featured in crime stories. In 1934, to protect the studios from censorship and controversy, the film industry established the Production Code Administration (PCA). The PCA provided prompt feedback, mostly at the script stage, about potentially objectionable material. Such material included seduction, sex, adultery, theft, shootings, and murder—the very subjects that made crime movies popular, the genre's raw material itself.

The Production Code offered moral directives to filmmakers and PCA administrators, and many Code provisions had overtly ideological directives: "Crimes against the law . . . shall never be presented in such a way as to throw sympathy with the crime as against the law and justice or to inspire others with a desire for imitation." "The sanctity of the institution of marriage and the home shall be upheld. Pictures shall not infer [*sic*] that low forms of sex relationship are the accepted or common thing." "Miscegenation is forbidden." "Obscenity in word, gesture, reference, song, joke, or by suggestion, is forbidden." "No film or episode may throw ridicule on any religious faith." If we define ideology as a system of beliefs and moral values, then we should regard the entire Code as an ideological treatise.

In 1952, the Supreme Court afforded movies First Amendment protection, making it increasingly difficult to enforce the Code. Furthermore, since the Supreme Court's decision in the 1948 Paramount anti-trust case had forced studios to divest their holdings of movie theaters, in the 1950s theaters began to show films without Code seals of approval, including independent films over which the studios had no control. Consequently, Code enforcement weakened throughout the 1950s, and in 1968 the industry finally replaced it with a film ratings system. At the height of the studio era, however, exhibiting a studio film required PCA approval.

It may seem strange to think of the Production Code Administration as an aesthetic contributor to a film. The PCA was run by moral regulators, not artists. But the PCA contributed to the aesthetic design of many thousands of films of the studio era, and sometimes its contributions added positive aesthetic value to the films it regulated. This chapter will attempt to explain the aesthetic contribution of the Production Code's ideological constraints on crime films made during the period of the PCA.

THE POETICS OF VIOLENCE

To satisfy the PCA and regional censors, studio-era filmmakers developed a complex system of stylistic and narrative devices that enabled crime films to smuggle in objectionable material, as long as the material remained sufficiently allusive or ambiguous. Everyone was in on the ruse, including the PCA, which sometimes suggested altering scenes in order to permit objectionable material in a less overt fashion. As many film commentators have noted, such contortions no doubt improved crime films of the 1940s and 1950s—a group now commonly referred to as film noir—enhancing such films through stylized imagery and storytelling. Largely because of its stylization, the noir cycle includes some of studio-era Hollywood's most beloved pictures and has become, according to Dennis Hopper, "every director's favorite genre."[1] Indeed, the moral and ideological limitations placed on the films enabled the noir style, particularly their distinctive presentation of violence. As Stephen Prince has noted, studio-era filmmakers devised a "substitutional poetics, whereby unacceptable types of violence could be depicted not directly, but through various kinds of image substitution."[2] Instead of depicting explicit violence, the films used shadows, obscured action, or off-screen action, or they presented images and sounds that stood in for the violent events or centered on more benign areas of the mise-en-scène.

In their depiction of violence, crime films of the PCA period show more subtlety and peculiarity than most crime films today; today's PG-13 movies can have far more explicit violence than any studio film made between the 1930s and 1950s. By prohibiting explicit violence, the Production Code sometimes caused filmmakers to shift a film's narration to something less visually shocking. In *Double Indemnity* (1944), Walter Neff strangles

Mr. Dietrichson from the backseat of a car, while Dietrichson's wife, Phyllis, sits next to her husband in the driver's seat (video 8.1 ▶). We hear the muffled sound of the man choking to death, but, instead of showing us the murder, the camera trains on Phyllis's surprisingly composed expression, the slightest sign of satisfaction on her face (figure 8.1). Here the Code prohibition, "Brutal killings are not to be presented in detail," offers an occasion to attend to character reaction, rather than to violence itself.

By substituting an inoffensive image, filmmakers might create a visual complement to violent action. In *Pickup on South Street* (1953), the film's communist villain shoots the endearing tie-seller/stool-pigeon Moe (Thelma Ritter) in her apartment. "Look Mister," Moe says, "I'm so tired, you'd be doing me a big favor if you'd blow my head off." In 1953, a film could not depict that sort of thing explicitly, so the camera pans from her forlorn face to a record album on the gramophone by her bed. Throughout the scene, the gramophone has been playing "Mam'Selle," a bittersweet ballad incongruous with the grilling the villain has been giving Moe. The film times the sound of the gunshot with the end of the song, and, afterward, the camera lingers for a moment on the gramophone, where the needle has begun to scratch and wobble in the way that needles do when a record album comes to an end (video 8.2 ▶). We can see here how the "poetics of violence," to use Prince's phrase, that developed during the studio era helped not only to avoid regulatory action but also to "expand the creative possibilities of expression in American cinema."[3] A needle scratching on a gramophone counterpoints the violence of the scene and also conveys sadness more profoundly than would the image of Moe getting her head blown off.

FIGURE 8.1 *In* Double Indemnity *(1944), the camera trains on Phyllis Dietrichson rather than on the murder of her husband occurring in the passenger seat next to her, satisfying the PCA directive that "Brutal killings are not to be presented in detail."*

IDEOLOGICAL COMPLEXITIES

The studio-era crime film, with its paradoxical interest in celebrating and condemning criminals, created ideological complexities that added richness to the filmgoing experience. James Naremore notes that PCA intervention sometimes created contradictions in Hollywood cinema's portrayal of controversial material because the activity of censorship often "manifests itself as a slight incoherence or displacement" in a film's narrative, "and from the point of view of aesthetics, it sometimes has salutary results." He argues that we can see in such displacements "many of the things that censorship was trying to repress."[4] Indeed, regional censorship and PCA regulation sometimes led to complex ideological contortions within crime films that sought to abide by Code provisions—"The sympathy of the audience should never be thrown to the side of the crime, wrong-doing, evil or sin"; evil should not be "made to appear attractive or alluring" or good "to appear unattractive"—even as the films exploited audience's delight and interest in crime and criminals.

The PCA, in an effort to impose moral order on the crime genre, at times made the genre morally incoherent. Thomas Schatz notes that, despite PCA restrictions on the portrayal of criminals, "the gangster-hero's position within the genre's narrative structure—i.e., as hero, as the organizing sensibility through whom we perceive the urban milieu—generated considerable sympathy for his behavior and attitude."[5] Representatives of the law in many studio-era crime films merely provide obstacles to the goals of our criminal protagonists and ideological cover for the filmmakers. *The Roaring Twenties* (1939) spends far more narrational attention, and star power, aligning spectators with the goals of the film's bootlegging, murderous gangsters (played by James Cagney and Humphrey Bogart) than with those of the G-men trying to jail them. *Pickup on South Street* (1953) pits a crooked underworld against a ring of communist spies whose inherent moral corruption contrasts with the crooks' potential redemption and industrious efforts to profit within moral limits. Such films, like many from the PCA era, construct scenarios that tacitly elicit sympathy for criminals while overtly denouncing their crimes.

Studio-era crime movies often worked hard in their concluding moments to deny the ambivalence with which they presented their criminal protagonists, and, at the end of such films, one can sometimes detect the filmmakers struggling to find an ideologically palatable resolution. *White Heat* (1949) seems to both revile and delight in gangster Cody Jarrett's (James Cagney) good-natured attitude toward crime and violence. Consider, for instance, the odd amusement of Jarrett's response to the complaints of another escaped convict—whom Jarrett has locked in the trunk of a car—that it's "stuffy": Jarrett, blithely eating a chicken leg, says, "Stuffy huh? I'll give you a little air," and fires several rounds into the trunk. A primary motivation for the murder, it seems, is Jarrett's desire to make a joke. And the line is indeed funny, just as the murder is indeed ruthless.

The presence of undercover cop Hank Fallon (Edmond O'Brien), who befriends Jarrett and infiltrates his gang, further complicates the film's attitude toward the criminal. The moment when Jarrett discovers Fallon's real identity creates sympathy for the gangster, who clearly liked Fallon, and Jarrett's hysterical reaction at the moment of discovery makes him look hurt by the betrayal. Laughing wildly, Jarrett says, "I treated him like a kid brother." In its last few scenes, however, *White Heat* avoids the potential moral ambiguity of a situation in which a cop earns the affection of a likable criminal: Fallon never shows remorse about befriending Jarrett, and he transitions back into the role of policeman immediately and unbothered. *White Heat* concludes on a note of complacent ideological resolution after Jarrett dies in a fiery blaze: "Cody Jarrett," Fallon says smugly, "finally made it to the top of the world, and it blew up right in his face."

Detour (1945) sustains some compelling ideological ambiguities by portraying its protagonist as barely responsible for his crimes. In *Detour*, Al Roberts (Tom Neal) hitchhikes from New York to Los Angeles to join up with his girl, landing a ride with a man who unexpectedly dies in his sleep while Roberts is driving. Afraid the police will accuse him of murder, Roberts assumes the driver's identity. He picks up a hitchhiker, Vera (Ann Savage), who recognizes the deception and threatens to turn him over to the police. Then, after inadvertently killing Vera, Roberts is forced to wander the country for fear, once again, of a murder charge. Because Roberts has so little control over his doomed circumstances, spectators' disapproval of him has more to do with the paranoia and imprudence of his behavior than its illegality. Consequently, his arrest in the final seconds of the film, an ending forced upon the filmmakers by the PCA, seems ideologically necessary for a 1940s crime movie, generically appropriate, but morally unwarranted.

We saw in the previous chapter that ideologically complicated Hollywood films disrupt our appraisals of events and characters, offering us more challenging, and potentially more rewarding, aesthetic experiences than typical, more unified Hollywood films. Crime filmmakers of the PCA era, in an effort to satisfy both PCA regulators and a filmgoing public fascinated by crime and criminals, devised complex narrative and stylistic contortions that generated ideological inconsistencies in the narration. Films noirs remain intriguing because of their inconsistencies. We may not in fact understand films noirs—their inconsistencies may prevent us from understanding them—but we may feel that we could and that, if we did, they would offer us deeper meaning.

COMPETING VOICES IN *THE ASPHALT JUNGLE*

The Asphalt Jungle (1950) offers an illustrative case study of the ways in which regional censorship and the PCA forced ideological contradictions upon filmmakers that added interesting dissonances to the storytelling. The film intensifies the crime genre's conflicted

attitude toward criminals and police about as thoroughly as any Hollywood film from the studio era, an attitude expressed in the paradoxical line of the film's lead criminal, Doc Riedenschneider (Sam Jaffe): "Experience has taught me never to trust a policeman. Just when you think he's all right, he turns legit."

The portrayals of corrupt Lt. Ditrich (Barry Kelley) and hard-nosed Commissioner Hardy (John McIntire) likely pose difficulty for anyone trying to consistently separate the good guys in this movie from the bad guys. Although we see corrupt police and hard-nosed commissioners in such films as *On Dangerous Ground* (1951), *The Big Heat* (1953), and *The Big Combo* (1955), *The Asphalt Jungle*'s attitude toward these two characters seems peculiarly unstable. In their first scene together, before we know of Ditrich's corruption, Commissioner Hardy looks like a thug, bawling out Ditrich for allowing a witness to back down. Intimidated by hooligan Dix Handley (Sterling Hayden), the witness, we have seen, feels too afraid to identify Handley in a lineup. "Lock up the witness!" Hardy shouts at Ditrich, "Scare him worse!" He then berates Ditrich for failing to close down the bookie joints in town ("Rip out the phones! Smash up the furniture!"). Hardy seems lawless and shrill and Ditrich looks pitiable, especially his child-like smile after the commissioner snidely gives him one last chance to make good on his responsibilities as a police officer. Ultimately, however, the film undermines spectators' first impression of these two characters when it later portrays Hardy as an honest crime-fighter and Ditrich as a brutal, self-serving cop on the take.

Our impression of Doc Riedenschneider undergoes a similar transformation. Before we meet Riedenschneider, Hardy describes him as "one of the most dangerous criminals alive." Immediately afterward, in Riedenschneider's first scene in the film, the cinematography supports Hardy's ominous characterization of the criminal. The framing self-consciously conceals Riedenschneider's face for a minute of screen time, surrounding the character with an air of mystery and danger (figure 8.2). When we finally see his face, it's tense, shot from a low angle, half-darkened by expressionist shadows (figure 8.3). Not long afterward, however, we come to think of Riedenschneider as an avuncular character, nonviolent, exceedingly kind and gracious. His menacing introduction in the film completely mischaracterized him. We can say the same for Dix Handley, presented in his first scenes as a brutal hooligan (figure 8.4), who ultimately emerges as our primary focus of sympathy.

Hence, the introductions of four main characters in the film—Dix, Hardy, Ditrich, and Riedenschneider—violate the common Hollywood practice of introducing characters in a way that reveals their typical attitude and behavior.[6] Our first impressions of a character prove the most emphatic and robust, and Hollywood movies generally exploit the "primacy effect," which holds that initial information has the most salient impact on our evaluation of something. Initial information, Bordwell says, provides a baseline against which we judge later information: "Once first impressions get erected, they are

FIGURE 8.2 The Asphalt Jungle *(1950) at first conceals the face of Doc Riedenschneider, adding mystery and danger to his introduction into the film.*

FIGURE 8.3 *Riedenschneider's face, when we finally see it, looks ominous because of a tense expression, the low angle, and expressionist shadowing.*

hard to knock down."[7] *The Asphalt Jungle* does not violate our first impressions to surprise us—the film neither emphasizes nor dramatizes the changes in its depiction of the characters—but rather in a way that makes the narration's attitude toward the characters feel unreliable and irregular. The film challenges audiences to dismantle their first impressions of four central characters in the story, establishing initial sympathies and antipathies that later events subtly undermine.

FIGURE 8.4 The Asphalt Jungle *introduces Dix Handley as a brutal hooligan in his first scenes.*

The film's attitude toward criminals and police often seems in conflict with itself, as though different authors were competing for control of the film's ideological meaning. In some ways, that description accurately characterizes *The Asphalt Jungle*'s production history. The film, we could say, had four authors: W. R. Burnett, who wrote the novel that inspired the film; Ben Maddow, who wrote the original screenplay; John Huston, who revised Maddow's screenplay and directed the film; and the PCA. The PCA had only a few objections to the film; however, some self-censorship seems to have affected its plot construction, a common inhibition for filmmakers during this period. Although studios and filmmakers sometimes included controversial material that tested the PCA's rigidity, they disliked rewriting or reshooting films already in production and generally avoided provoking PCA regulators. We can find records of PCA-suggested revisions, but for traces of self-censorship we normally need to inspect scripts and films themselves.

We can see such traces in Huston's script revisions and direction, which indicate the filmmaker's efforts to both satisfy and resist the moral restrictions forced upon films at that time. As James Naremore notes, Maddow's early script, like Burnett's novel, centered on Commissioner Hardy's efforts to clean up a corrupt city.[8] Maddow's script included a framing device in which Hardy addresses a group of reporters, explaining the importance of police to public safety. Huston removed the framing device in his revised script; however, perhaps to forestall PCA interference, he included a press-conference scene toward the end of the film that incorporates some of Maddow's original themes and dialogue. The resulting film is a ragbag of moral positions that challenge viewers' efforts to pinpoint *The Asphalt Jungle*'s ideology.

The press-conference scene, in which Commissioner Hardy explains the vital importance of a strong police force, creates the most ideological inconsistency of any scene in the movie. On the one hand, Hardy's speech to the reporters seems designed to stem accusations from the PCA that the film elicits too much sympathy for criminals. On the other hand, the scene also seems designed to make Hardy's speech wrong and unpalatable. Hardy says,

> It's not anything strange that there are corrupt officers in police departments. The dirt they're trying to clean up is bound to rub off on some of them, but not *all* of them, maybe one out of a hundred. The other ninety-nine are honest men trying to do an honest job. . . . [*Hardy clicks on a series of police radios announcing crimes in progress*]. We send police assistance to every one of those calls because they're not just code numbers on a radio beam; they're cries for help. People are being cheated, robbed, murdered, raped. And that goes on 24 hours a day, every day of the year. And that's not exceptional; that's *usual*. It's the same in every city of the modern world. But suppose we had *no* police force, good or bad? Suppose we had [*clicks off each radio in turn*] just silence. Nobody to listen. Nobody to answer. The battle's finished. The jungle wins. The predatory beasts take over. Think about it. . . . And we'll get the last one too. In some ways, he's the most dangerous of them all—a hardened killer, a hooligan, a man without human feeling or human mercy.

Hardy's speech delivers the film's most overt ideological message, but I want to single out three elements that undermine the logic and impact of the speech, which comes across as far more abrasive than a transcript of the monologue implies.

First, the speech is patently self-serving. We might support a neutral party's justification for a strong police force, but, when a policeman gives one, it sounds political. His scare tactics and eager effort to dismiss Lt. Ditrich's corruption—"Suppose we had no police force, good or bad? Suppose we had just silence"—sound rhetorical and threatening, especially since the difference between a good police force and a bad police force obviously matters.

Second, we have engaged with the criminals too intimately to accept Hardy's characterization of them as "predatory beasts," especially since, with Huston's revision, the speech comes at the end of the film, after we have developed strong sympathies for the beasts. Indeed, the film has taken pains to help us get to know each caperist individually, including their family lives, responsibilities, desires, and support of one another. At the end of his speech, Hardy refers to Dix, now the chief figure of our engagement, as "a man without human feeling or human mercy." But Hardy is wrong about Dix, who, we have seen, has both feeling and integrity, a fact that undermines the scene's

ideological advertisement for a strong police force fighting predatory beasts. We know Dix better than Hardy does and sympathize with the "hooligan's" goal of returning to his farm in Kentucky. And if Hardy's final words about Dix do not undercut his speech entirely, the dissolve from the press-conference scene to a scene with Dix—a bullet in his side, mumbling about horses as he desperately drives to the farm of his youth—certainly does. Moreover, the one truly virtuous character in the movie, Doll Conovan (Jean Hagen), sitting in the passenger seat, clearly adores him. Here, our knowledge of Dix and our sympathetic response to him contradict the film's overt ideological message.

Finally, actor John McIntire portrays Commissioner Hardy in the most sententious manner he can muster (video 8.3 ⏵). McIntire was a character actor, craggy but not by nature repellent. He could, in such roles as gun-dealer Joe Lamont in *Winchester 73* (1950), display a folksy, Will Rogers–like charm. In this film, however, he seems grim and conceited, particularly with lines such as, "Think about it," which he delivers with the superiority of a high school principal admonishing students to appreciate their teachers. When he stands, the actor sticks his hands in his hip pockets, looking self-important, particularly when filmed from a low angle. In close-up, the actor furrows his eyebrows and grimaces (figure 8.5). Taken together, the self-righteous rhetoric, the mischaracter-ization of our protagonists, and McIntire's smug, annoying portrayal of Commissioner Hardy make the speech both inaccurate and vaguely off-putting, all of which undermine its ideological message.

FIGURE 8.5 *Actor John McIntire grimaces smugly in the press conference scene in* The Asphalt Jungle.

CONCLUSION

Film noir illustrates the sometimes complex contribution of ideology to an artwork's aesthetic design. Ideology, the previous chapter argued, typically serves a unifying function in a Hollywood film, guiding spectators toward a consistent worldview, coherent appraisals of depicted situations, and intense emotional experiences. In film noir, ideology often complicates aesthetic design, disrupting our appraisals and leading us toward more ambiguous beliefs, values, and emotions. As mass artworks, Hollywood movies must remain accessible to mass audiences, but they can also challenge audiences to a moderate degree. Film noir remains aesthetically engaging because it poses challenges to mastery, operating near the boundaries of classicism without sacrificing classical Hollywood's accessibility.

The ideological restrictions of the Production Code posed creative problems that noir filmmakers solved through visual and narrative contortion. The filmmakers' solutions, in turn, created challenges for audiences, who had to decode and make sense of films that may not show complete clarity or coherence in their storytelling. Spectators had to imagine what film regulation forced filmmakers to conceal or represent obliquely. Did Waldo Lydecker have sex with Laura in *Laura* (1944)? Or is he homosexual? Is Joel Cairo in a sexual relationship with Kasper Gutman in *The Maltese Falcon* (1941)? What does it look like when Walter kills Mr. Dietrichson in *Double Indemnity* or when the communist shoots Mo in *Pickup on South Street*? What did Carmen Sternwood do to cause Geiger to blackmail her father in *The Big Sleep* (1946)? Films of the period left this sort of story information ambiguous or visually obscured, although the source books generally made the information more explicit. Movie audiences at the time understood that films could not deliver such information directly, and they expected films to encode salacious material. The constraints placed on ideologically objectionable content justified the unusual storytelling practices and led to subtle curiosities at the periphery of a story— nothing too disruptive of classical practice but still stylized, distorted, and ambiguous. To rephrase the quotation from Chris Marker at the top of this chapter, censorship did not mutilate film noir; it enabled it.

Spectators, moreover, had to reconcile ideological contradictions in works that had authors with conflicting objectives. Whereas filmmakers endeavored to make movies maximally entertaining, the PCA sought to remove or refashion objectionable material, whatever that material's entertainment value. This conflict made many crime films of the period more confusing and intriguing. As I argued in chapter 1, the effort to please audiences immediately and optimally often conflicts with the effort to make complex artworks that remain interesting over time. The PCA, it turns out, forced filmmakers to make crime movies more complicated and enduring.

I do not mean to sound nostalgic here. The weakening and ultimate elimination of the Code enabled filmmakers increasingly to exploit the aesthetic possibilities of explicit sex, violence, controversial content, and other material regulated during the period of the PCA. If the Code had persisted, we would not have the films of Sam Peckinpah, Stanley Kubrick, Martin Scorsese, Jane Campion, Ridley Scott, Spike Lee, Quentin Tarantino, Paul Thomas Anderson, Kathryn Bigelow, and many other excellent filmmakers. However, I think we can safely conclude that the conflict between filmmakers and PCA regulators sometimes resulted in works more persistently interesting than Hollywood filmmakers would have made otherwise. Without that conflict, we certainly would not have had the films noirs of the 1940s and 1950s.

We can also observe that, as a result of lifting almost all regulation of film content, that particular kind of film, and its attendant aesthetic possibilities, is no longer available. Christine Gledhill notes that "one way of looking at the plot of the typical *film noir* is to see it as a struggle between different voices for control over the telling of the story."[9] In trying to harmonize the voice of entertainment with the voice of ideological regulation, filmmakers created a unique cycle of films commonly praised for their stylishness and moral instability. And when one of those voices died out, the cycle died with it.

Genre and Ideology in *Starship Troopers*

I MAGINE A FILM THAT TOOK THE CAST OF BEVERLY HILLS, 90210, MEL-
ROSE *Place, Saved by the Bell,* and *Doogie Howser, M.D.*; depicted the characters' high
school romances, their fights with their parents, and their career anxieties; and then
ripped out their limbs and intestines with vicious insects the size of Mercedes trucks.
Wouldn't that be shocking? It shocked me.

Starship Troopers (1997) combines the conventions of television teen drama, the
science fiction war film, and a slew of other genres in such an unpredictable way that
it becomes nearly impossible to make sense of the film's worldview. In her pan in the
New York Times, Janet Maslin criticized the genre inconsistencies when she wrote that
the film "never gets over its 180-degree swivel from teen-age love story to murderous
destruction. But coherence does not appear to be a major concern."[1] Roger Ebert, in
another negative review, called it "the most violent kiddie movie ever made."[2] Since pre-
dictability constitutes the primary appeal of genre filmgoing, *Starship Troopers*'s mercu-
rial form likely contributed to its poor critical reception and limited its success in a mass
market. But those very qualities, I believe, have exhilarated spectators engaged by the
film's unusual design. *Starship Troopers* demonstrates the commercial risks, and the aes-
thetic excitement, of a Hollywood film whose formal properties muddle up its ideologi-
cal meaning.

I have argued throughout this study that, when experiencing works of art, as we move
closer to our own individual boundary line between coping and not coping, provided
we do not cross it, we experience the exhilaration that comes from reaching toward
greater understanding. For its intended mass audience, *Starship Troopers* seems to have
crossed that line. *Raging Bull* probably crossed it too, but with an estimated negative cost

of $18 million, *Raging Bull* need not appeal to nearly as many viewers to justify its commercial investment. *Starship Troopers*, which reportedly cost $100 million, had to appeal to a massive audience.

Starship Troopers's genre properties so complicate the film's ideology that spectators cannot comfortably identify the film's form and meaning. The film, I propose, alienates spectators who cannot cope with that ambiguity and exhilarates those who can. We shall begin our investigation by first exploring some of the commercial and aesthetic repercussions of the film's audacious genre deviation.

GENRE BENDING, AESTHETIC PLEASURE, AND BOX OFFICE

In *Hollywood Incoherent*, I noted that films sometimes use genre topoi to trick us, misleading us into expecting something true to form, all the while setting us up for something unconventional.[3] I called this practice "genre bending" because such films reshape genre conventions without breaking them apart. Genre benders work surreptitiously, unlike the self-conscious "genre-breaking" films popular in the 1970s, such as the private-detective film *The Long Goodbye* (1971), the western *Blazing Saddles* (1974), and the gangster-musical *Bugsy Malone* (1976), which broadcast their subversion of genre tradition. Genre benders exploit our cozy familiarity with conventional scenarios in order to catch us off guard. The western *The Searchers* (1956), the suspense thriller *Vertigo* (1958), and the police-detective film *The French Connection* (1971), for instance, rely on our habitual responses to genre topoi in order to subtly mislead us. Such films create aesthetic interest by mixing conventional genre use with unnerving genre deviation. Hence, genre benders offer both the calm pleasure of returning to familiar topoi as well as the exhilarated pleasure afforded by artworks that challenge us with novel or complex genre properties.

Genre bending is not, by its nature, subversive. Unlike genre breakers, which herald a genre's death or exhaustion, genre benders typically reinforce the genre system by illustrating a genre's continued vitality and versatility. Although peculiar at times, a genre bender is nonetheless a genre film, and a distributor can still exploit its genre identity in marketing. Consider the conventional tag lines of *The Searchers* ("He had to find her . . . he had to find her"), *Vertigo* ("Alfred Hitchcock engulfs you in a whirlpool of terror and tension!"), and *The French Connection* ("The time is just right for an out and out thriller like this"). The tag lines could apply just as well to other films in the same genres and end up making these idiosyncratic Hollywood genre films sound more conventional than they really are. Genre benders, moreover, offer product differentiation from more conventional genre films, their novel properties garnering attention in reviews and through word of mouth. Hence, genre bending has twofold commercial potential: risk reduction and product

differentiation. Genre benders enable the industry to exploit both the stability of a film's genre identity and the novelty afforded by its deviation from filmmaking tradition.

Still, genre bending comes with commercial risks, especially in big-budget filmmaking. If a commercial film thwarts spectators' efforts to identify its genre properties, then it might alienate members of a mass audience. Mass audiences will only withstand so much genre deviation before the novelty too greatly taxes their ability to cope with the work. Greater genre deviation can lead to greater aesthetic excitement, but it also threatens to put off viewers unable or unwilling to endure heightened levels of genre disruption. Hence, the key aesthetic problem for a genre filmmaker is to create a film novel enough to generate aesthetic excitement but not so novel that it alienates its target audience.

If theatrical box office indicates success at addressing that problem, then the makers of *Starship Troopers* failed at it. After his *Showgirls* (1995) flop, one wonders how director Paul Verhoeven obtained funding for a big-budget genre-bender as difficult to market (difficult even to explain) as this one. The executives at TriStar and Touchstone Pictures, which financed the movie, hoped Verhoeven would repeat his success with *Robocop* (1987) and *Total Recall* (1990), but *Starship Troopers* earned only $24.4 million in domestic rentals, about one quarter of its negative cost.[4] In 1997, $24.4 million would mark a strong theatrical showing for an indie geared to a select audience but not for a movie designed and budgeted as a blockbuster. Bolstered by a saturation marketing campaign and a release on almost 3,000 screens simultaneously, the film had a strong opening weekend (which brought in 40% of the total theatrical gross), but as negative reviews and word of mouth spread, the box office quickly petered out. An expensive tent-pole film will founder in a mass market if it disrupts expectations too severely.

The film, however, eventually developed a passionate cult following that has contributed to several successful ancillary markets. It has spawned sequels, games, action figures, an animated television series, and fan websites. Fans have made their own *Starship Troopers* computer games, dressed as characters at conventions, designed their own artwork, created comic books, and made films in which they enact original scenes using Legos, live-action performance, and 2-D and 3-D animation.[5] Fans wrote a heavy metal song, "Fighting Bugs." Some offbeat film commentators have recently shown enthusiasm for the film. In 2012, the *AV Club* listed *Starship Troopers* as the 47th and *Slant Magazine* as the 20th best film of the 1990s; *Slant* called it "one of the greatest of all anti-imperialist films."[6] In 2013, film critic Calum Marsh wrote an appreciative remembrance of the film in *The Atlantic*, titled "*Starship Troopers*: One of the Most Misunderstood Movies Ever."[7]

I find it plausible that the very qualities that caused difficulty for *Starship Troopers* in its initial mass market also contribute to the exhilarated response among its current community of fans. We see this very pattern—initial commercial disappointment, followed by passionate engagement within a smaller community—with cult films such as *Freaks*

(1932), *Seconds* (1966), *Harold and Maude* (1971) *Phantom of the Paradise* (1974), *The Rocky Horror Picture Show* (1975), *The Warriors* (1979), *Labyrinth* (1986), *Bottle Rocket* (1996), and *Donnie Darko* (2001). Sometimes even mainstream commercial films do not find a sizable appreciative viewership until sometime after their initial theatrical release, once audiences have had an opportunity to gain greater understanding of the films' challenging properties. The artistic audacity that caused films such as *Citizen Kane* (1941), *Vertigo* (1958), *Touch of Evil* (1958), *Apocalypse Now* (1979), *Raging Bull* (1980), *Blade Runner* (1982), and *Brazil* (1985) to suffer theatrically also helps explain their popularity among circles of devoted fans. The challenges posed by these films account for both their theatrical poor showing and their enduring appeal.

GENRE BENDING IN *STARSHIP TROOPERS*

Unless you have already seen it, *Starship Troopers* is not the movie you think it is. Advertisements cannot capture the tone of the film because the ironies run counter to the film's genre identity. In a sweaty effort to make the film appear conventional, the original theatrical trailer avoids almost all of the film's generically inappropriate and ideologically suspicious properties, such as shots of our protagonists in Nazi-styled decor and campy lines such as "You're some sort of big, fat, smart-bug, aren't you?" "Goddam bugs whacked us, Johnny," and "They sucked his brains out." The trailer excludes the satirical ads for military service interspersed throughout the film, one of which, titled "Everyone's Doing Their Part," shows small children stomping on roaches and yelling "die, die, die," while a mother maniacally claps and laughs.

Still, the trailer does not exactly cohere. We see shots of spaceships, battle scenes, and giant insects brutally attacking human soldiers, images appropriate to the film's primary genres—action, science fiction, and war. But as the trailer's voice-over intones, "Now the youth of tomorrow must travel across the stars to defend our world," we see doll-faced actors who look like they have no business in a brutal sci-fi war picture, especially when compared to the rougher actors featured in similar films made around the same time, such as *The Puppet Masters* (1994) and *Terminator* movies (1984, 1991, and 2009). The images of giant insects are horrifying, but the word "bug" sounds cutesy, so when one of the characters in the trailer says, "The bugs laid a trap for us, didn't they?" a little bit of the film's camp slips in. The makers of the trailer have done a valiant job locating clips that make the film look almost ordinary for its genre, but they can only do so much. The entire look and tone of Verhoeven's film—from the casting to the dialogue to the mise-en-scène—signal genre potpourri. The trailer that results makes *Starship Troopers* look like an action film that wanted to be taken seriously but ended up a cartoon.

Unlike its trailer, *Starship Troopers* embraces its genre incoherence. The film contains stock scenes from a variety of genres and puts them in odd combinations. We see elements

from the high-school picture (such as *Sixteen Candles*, 1984), the war film (*Sands of Iwo Jima*, 1949), the 1950s nuclear monster movie (*Them!*, 1954), and the propaganda documentary, including scenes reminiscent of Fox Movietone News (1928–1963), American World War II propaganda films (1941–1947), and *Triumph of the Will* (1935).

Mixing genres dates back to Hollywood's silent period, but the genre cues in *Starship Troopers* do not cohere. For instance, like the teen sex comedy *Porky's* (1982) and so many women-in-prison movies, the film features a shower scene, replete with nude shots of several of the lead actors. But this shower scene does not work like any other in cinema: First, the shower is co-ed, and, second, the teenagers behave with the kind of wholesomeness one expects of characters in an Andy Hardy movie. Instead of depicting boys leering at naked girls, the film shows the nude teens snapping towels and teasing one another about romance. No one gives a lascivious look or seems at all excited or bothered by naked teens of the opposite sex showering inches away. In the future, the scene leads us to suppose, society has grown so egalitarian that teens of both sexes regularly shower together. The idea accords with the egalitarianism of the depicted world generally—which features female quarterbacks and military leaders—but the scene violates the rules of the cinema locker-room shower scene, whose sine qua non are voyeurism and sexual arousal.

The film's genre cues frequently conflict with expectation, with film tradition, with each other, or with the film's ostensible narrational purpose. The movie contains a "Let's make a vow, we'll always be friends" scene, in which three of the leads—Casper Van Dien as Johnny Rico, Denise Richards as Carmen Ibanez, and Neil Patrick Harris as Carl Jenkins—put their hands together in the familiar Three Musketeers pose (figure 9.1). This type of scene in traditional cinema establishes the friendship of our heroes and foreshadows later events, which test their loyalty or put it to use. Jenkins, however, undermines the genre coherence of the moment when he says about the vow, "Well, chances are we'll never see each other again. . . . But uh, yeah sure, why not?" The line, like many

FIGURE 9.1 Starship Troopers *(1997). Jenkins's inappropriate comment, "Yeah sure, why not?" undermines the genre cues signaled by the familiar Three Musketeers pose.*

FIGURE 9.2 *Michael Ironside oddly cast as a high school teacher in* Starship Troopers.

other incongruous elements in the film, undermines the scene's genre identity and familiar purpose.

Casting and performance contribute to the difficulty of identifying the film's genre. Familiar character actor Michael Ironside plays high school teacher Jean Rasczak. You might have seen Ironside play a drug kingpin or crooked cop but not a high school teacher. Here, his character is missing one of his forearms (figure 9.2). (Ironside's character later becomes a tough military lieutenant, more fitting to the actor's persona.) And consider the cast of actors playing the high school students who enlist in the armed forces to fight the Arachnid enemy. In 1997, most audiences knew Neil Patrick Harris exclusively for his title role in *Doogie Howser, M.D.*, a television comedy of the early 1990s about a teenage genius dealing with the problems of growing up, while also serving as a physician (figure 9.3). Here, his character eventually becomes a colonel specializing in military intelligence. In 1997, it felt strange just seeing Harris grown into a young man, but to see him, by the end of the film, dressed in fascist leather was bizarre, a completely unexpected look for the child star (figure 9.4).

The other leads—Van Dien, Richards, and Dina Meyer—show the same bland prettiness and shallow characterization characteristic of teen soap operas. Indeed, Van Dien and Meyer had both played on *Beverly Hills, 90210* and similar series, and Richards appeared on *Melrose Place, Saved by the Bell*, and *Doogie Houser, M.D.* Verhoeven remarked on the casting incongruity:

> I knew from the start I wanted my actors to be beautiful, like in a comic book. . . . I took a long time to set up their characters—too long, some say—going from extreme innocence and naivety and nostalgic beauty, in a world where everything is beautiful: the grass is really green, there's no crime . . . it's paradise! A fascist Utopian paradise. And from there, it's a descent into hell.[8]

FIGURE 9.3 *Neil Patrick Harris in a publicity photograph for the television series,* Doogie Howser, M.D.

FIGURE 9.4 *Neil Patrick Harris as* Starship Troopers*'s Carl Jenkins dressed in fascist wardrobe.*

The actors—their performances and personae conspicuously wrong for the gory war film in which Verhoeven has cast them—smile and bare their big teeth, mug, bat their eyelashes, pucker their lips, and dart flirtatious glances at one another. Their flawless hair and makeup, even in battle scenes, and idealized good looks give the entire cast of youngsters the kind of perfect veneer we routinely expect from American teen drama.

GENRE AND IDEOLOGY IN *STARSHIP TROOPERS*

Starship Troopers's off-center genre cues lead to strange ambiguities in the film's ideological meaning. Consider an early scene in a high school civics class, as Rasczak lectures his students about democracy. We see the students flirting, teasing, and misinterpreting the teacher's lessons; Rasczak looks annoyed. He attempts to encourage discussion and personal engagement with the material. We have seen this scene in a dozen high school movies, from *To Sir with Love* (1967) to *Fast Times at Ridgemont High* (1982) to *Mr. Holland's Opus* (1995). Although easily identified, the scene contains perverse elements that complicate its genre identity and garble its ideological position—perverse in the literal sense of *turned the wrong way*. The ideological perversity of the scene results from the fact that Rasczak is lecturing his students about the *failure* of democracy. He says that the present governing state, which separates people into "civilians" and "citizens," has restored peace after years of strife caused by "social scientists of the 21st century." He is describing, in short, a fascist utopia, a military state that affords citizenship only to those who serve in the armed forces.

No straightforward ideological proposition can make sense of the classroom scene because genre cues point in two opposing directions—making Rasczak look alternately like a liberal educator or a fascist ideologue. If the scene depicted the students listening slavishly to Rasczak's fascist lessons or if Rasczak stifled dissenting opinions, then we could say that the scene portrays the students' indoctrination into the culture of fascism. In that case, we could describe the ideology of the scene as "Fascism trains students to follow authority uncritically." Or if Rasczak lectured about the importance of democratic government, then the scene, we could say, depicts the naiveté of a group of smart-alecks who think more about their romantic dalliances than they do the future of the world. We could then describe the scene's ideology as "Youth must learn to understand and respect the freedoms they enjoy." Instead, the film combines the two scenes incongruously and creates ideological confusion. The depiction of the high school teens, as they ignore and misinterpret Rasczak, and Rasczak's efforts to encourage class discussion make him look like an enlightened educator, whose wisdom his students fail to appreciate, whereas the content of Rasczak's speech makes him a propagandist of good-natured fascist extremism.

The contradictory genre cues create even greater ideological ambiguity when Rasczak engages two of his students, Dizzy Flores and Carmen Ibanez, on the historical function of violence:

> RASCZAK: Violence [is] the supreme authority from which all other authority is derived.
>
> FLORES: Uh, my mother always said violence never solves anything.
>
> RASCZAK: Really? I wonder what the city fathers of Hiroshima would have to say about that. *[To Ibanez]* You.
>
> IBANEZ: They probably wouldn't say anything. Hiroshima was destroyed.
>
> RASCZAK: Correct. Naked force has resolved more issues throughout history than any other factor. The contrary opinion, that violence never solves anything, is wishful thinking at its worst.

Although the scene presents the exchange as a generically typical classroom argument between a civics teacher and his students, the content of the argument is highly unconventional. A typical Hollywood war film would give Rasczak's line, "Violence is the supreme authority from which all other authority is derived," only to a fascist heavy. One can imagine a Hollywood Nazi delivering that line in a German accent. Hollywood war heroes, by contrast, employ violence reluctantly against enemies who relish violence. Yet, when Rasczak invokes Hiroshima to illustrate his point, his position gains a reverse-logical power. Rasczak seems now to be saying something more ideologically interesting and provocative—not that we *should* regard violence as the supreme authority but that, historically, violence *is* the supreme authority. He summarizes his point with a line taken almost directly from the Heinlein novel that inspired the film, "Naked force has resolved more issues throughout history than any other factor." Rasczak's argument with Flores now has a poignancy that undermines his characterization as a fascist propagandist. His point—unlike hers—is not an ideological commonplace, and it no longer sounds wrong.

When genre cues point in opposing directions, *Starship Troopers* derails efforts to follow its ideological position and identify the film's meaning. Spectators must somehow reconcile the genre cues and grasp the film's worldview so that the film makes some sense.

A War Film and a War Film Satire

Although the film incorporates an odd medley of genres, it often toggles between two that house particularly incompatible worldviews. The first is the action war film—such as *Air Force* (1943), *The Longest Day* (1962), *Midway* (1976), and *Braveheart* (1995)—in which narrative, stylistic, ideological, and genre properties cooperate to extol the

virtues of patriotism, nationalism, and heroism and create thrilling scenes of ferocious battle. The other genre is the war film satire—such as *The Great Dictator* (1940), *Dr. Strangelove* (1964), *M*A*S*H* (1970), *Catch 22* (1970), *Wag the Dog* (1997), and *In the Loop* (2009)—that sets out to undermine war ideology, conventional military heroism, and the thrills associated with Hollywood's depiction of war. These two genres normally appeal to two separate audiences (or, perhaps, to discordant values within a single viewer). The combination, which spectators must find particularly difficult to reconcile, makes *Starship Troopers* more ideologically challenging than films in either genre.

The brief Federal Network video news reports, interspersed throughout the film, make *Starship Troopers* seem like a satire of the undercurrent of fascism in Heinlein's novel. Patterned on both Internet ads and 1940s Movietone reels, these cheeky, self-conscious reports look like staged propaganda, the government's shameless attempt to drum up political support and military enlistment. They often conclude with the jingoistic slogan, "Service guarantees citizenship." In one, soldiers dressed in full military gear share their weaponry with children in a pastoral setting. "Who wants to hold it?" one soldier asks, referring to his automatic weapon. "Me, me, me," the kids cheer, and they begin to fight over the gun ("mine," "gimme"), as the soldiers chuckle and hand out bullets. A quick news report follows: "A murderer was captured this morning and tried today." Already, the proximity of his trial to his capture makes the event suspicious, but the satire grows thicker when we see the image of the "murderer," sheepish and pathetic, as a judge swiftly declares him guilty and sentences him to death. A courtroom audience applauds the verdict. "Execution tonight at six—all net, all channels," the announcer says. (Video 9.1 ⊙.) The ironic combination of tyrannical justice and TV commercialism helps to establish the film's satirical tone and adds a sinister edge to the milieu of blithe totalitarianism.

After the Arachnids destroy Buenos Aires, the home of our protagonists, we witness another Federal Network report of a speech to the Federal Council by Sky Marshal Diennes in Geneva. Here, the satire comes off somewhat more subtly. Against a backdrop reminiscent of Hitler addressing his Nazi Reichstag (figures 9.5 and 9.6), Diennes says, "We must meet the threat with our valor, our blood, indeed with our very lives, to ensure that human civilization, not insect, dominates this galaxy now *and always!*" The speech sounds like standard political rhetoric during time of war, except for the ominous phrases "dominates" and "now and always," which broadcast the government's Übermensch mentality of martial entitlement. In these Federal Network reports, the film surrounds the Troopers with imagery and language that most members of a mass audience have learned to regard as pernicious. Periodically throughout *Starship Troopers*, the war against the Arachnids looks like a militarist society's chauvinist campaign.

FIGURE 9.5 *Hitler addressing the Nazi Reichstag.*

FIGURE 9.6 *Sky Marshal Diennes addressing the Federal Council.*

FIGURES 9.5 AND 9.6 *A photograph of Hitler delivering a speech to Nazi deputies in the Reichstag in Berlin and a similar looking still image from* Starship Troopers *of Sky Marshal Diennes delivering a speech to the Federal Council in Geneva.*

The film complicates the satire, however, by also adopting the conventions of the Hollywood war film, often uncritically and without irony, including scenes of basic training, buddying up, strategic planning, thrilling battle, heroic death on the battlefield, and other scenes that have no comfortable place in a war film satire. The Arachnid enemy, moreover, comes off as hell bent on the destruction of the human species, a fact completely counterproductive to a satirical tone. Hollywood war films made during World War II, film historian Clayton Koppes notes, portrayed the Japanese enemy as "little more than beasts" in such films as *Bataan* (1943), *Guadalcanal Diary* (1943), and *The Purple Heart* (1944).[9] *Starship Troopers* portrays the enemy literally as mindless, vicious vermin. Indeed, one could hardly imagine a more grotesque threat, or an enemy more deserving of death, than swarms of giant insects viciously, remorselessly ripping apart our species. If the film instead portrayed the insects sympathetically, then *Starship Troopers*'s satire of fascism would come across more clearly, since spectators would see a totalitarian society oppressing a weaker civilization. By the same token, if the film depicted human society as wholly democratic, rather than discreetly fascist, then the film would have the ideological unity typical of action war films in which bands of heroes employ violence to defeat a brutal enemy. Historian Brian Crim observes about the movie, "The fact that fascism is the only ideology capable of producing a state strong enough to meet the Arachnid threat places the audience in the uncomfortable position of identifying and sympathizing with a society it is conditioned to despise."[10] As an action war film, *Starship Troopers* encourages us to cheer violence against a vicious enemy, but as a war film satire it undermines the endeavor by stereotyping our heroes as xenophobic extremists ("The only good bug is a dead bug." "I say kill them all."). Throughout the film, the two genres compete for control of the film's ideology.

Genre Bending and Ideological Ambiguity

Satire normally enables audiences to feel a sense of mastery and superiority over a subject. *Starship Troopers*, however, challenges viewers to keep pace as it shifts its attitude toward the characters and subject matter. Indeed, some very smart reviewers barely caught the satire. Manohla Dargis called the film a "fascist fantasy."[11] Writing about the film's "happily fascist world" for *Time* magazine, Richard Schickel says that "the filmmakers are so lost in their slambang visual effects that they don't give a hoot about the movie's scariest implications."[12] Roger Ebert recognized *Starship Troopers*'s "sly satire" but nonetheless says that the bugs merely justify "the film's quasi-fascist militarism"; he concludes that the film is ultimately "totalitarian."[13] Stephen Hunter of the *Washington Post* called it "Nazi to the core."[14] Such accusations are not entirely wrong-minded, just suspiciously adamant, assuming as they do that the filmmakers and other spectators do not also recognize the menace underlying the human society depicted in the film.

I suspect that reviewers, many of whom seem deaf to the satire, criticized *Starship Troopers*'s ideology because the film does not unambiguously condemn the fascism it mocks. Verhoeven remarked on the ambiguity, "I wanted to do something more than just a movie about giant bugs. What I tried to do is use subversive imagery to make a point about society. I tried to seduce the audience to join [*Starship Troopers*'s] society, but then ask, 'What are you really joining up for?' "[15] The depicted society is both wholesome and brutal, egalitarian and authoritarian, a society that encourages, on the one hand, free thinking and free speech, and, on the other, warmongering, jingoism, and obedience to autocratic military rule. Even the attitude toward the Arachnids, whom the film portrays as hideous and vicious, changes discordantly at the climax when the film seems to show some sympathy for the enemy.

The climax of *Starship Troopers* features perhaps the oddest moment of genre bending in a Hollywood blockbuster. After the Federation captures the intelligent leader of the bug species, members of the mobile infantry drag the "brain bug" out of its lair—a giant, slug-like creature trapped in a net that looks around nervously with eight eyes. For the first time in the film, the enemy appears pathetic. Carl Jenkins, replete now in fascist leather, attempts to communicate with it telepathically (Did I mention that some characters have telepathic powers?). He touches its head; the bug retreats nervously. The film has foreshadowed this scene by earlier calling attention to the xenophobia of the Federation's war against the bug species ("Some say the bugs were provoked by the intrusion of humans into their natural habitat," a reporter says in one Federal Network segment, "that a 'live and let live' policy is preferable to war with the bugs.") The genre cues now come into clearer focus: Communicating for the first time with the bug species, Jenkins will learn that the enemy is not so different from us after all. The moment would tie up the story

ideologically and allow us to feel at once that the protagonists used violence appropriately to address the threat and also that the human race has enough compassion to make peace with its enemy. Communicating with the brain bug for the first time, Jenkins says solemnly, "He's afraid." The enemy, not as mindless as they appear, has thoughts and feelings. The movie, however, quickly squanders the ideologically pat ending when Jenkins repeats the line, this time triumphantly, "He's afraid!" In chorus, the troopers cheer the enemy's fear. The film has again used genre cues to confound its ideological meaning, leading us to expect a scene of empathy and reconciliation but ultimately depicting the human race as a pitiless band of jingoes.

CONCLUSION

Ideologically complicated Hollywood films, I argued in chapter 7, disrupt our appraisals of characters and situations and complicate our beliefs, values, and emotions. *Starship Troopers* uses genre properties, particularly properties of the war film and the war film satire, in ways that make the film ideologically incoherent. The film's ideology can't be reconciled without, as several critics have done, ignoring one part of the movie or another.

Although *Starship Troopers* had the action scenes, special effects, and budget of a tentpole genre film, its idiosyncrasy and complexity suited a cult audience better than a mass audience. The film offered so many challenges that I suspect many spectators, unable to cope with the ambiguities of its ideology and genre identity, gave up the effort to understand it. Hollywood blockbusters must not deviate so erratically from their genre identity that they alienate members of their target audience and overwhelm the capacity of average spectators to cope. For a genre film to succeed in a mass market, viewers must be able to identify what *kind* of film they are watching.

However, if we measure the aesthetic value of a Hollywood movie not by its popularity in a mass market—if we take into account the subjective coping potential of different audiences—then *Starship Troopers* did not fail aesthetically. Indeed if, as I have argued, aesthetic pleasure exhilarates when audiences approach the boundary line between coping and not coping with a film's challenging aesthetic properties, then we might value *Starship Troopers* for targeting the area around that line in an impressively risky way. Although the film failed to delight a mass audience, for the smaller audience that continues to feel engaged by it, *Starship Troopers* is that rare, unruly, exhilarating Hollywood genre film that refuses to behave like any other film in its genre.

· · ·

Following the discussion of genre begun in this chapter, the next part of this book sets out to explain the ways in which Hollywood filmmakers negotiate the conflicting pressures for familiarity and novelty in genre filmmaking. In Part 5, I hope to answer several

key aesthetic questions about Hollywood cinema that this book has yet to address: What motivates Hollywood filmgoers to see the same stories told again and again? How have Hollywood filmmakers tailored genre films to please different subsets of the world population? How and when did Hollywood establish and refine its most durable genres? Do genres evolve according to any predictable patterns? Why do some genres endure and develop while others fade away? What causes audience exhaustion with a genre? How have Hollywood filmmakers adapted genres over time and addressed audience demand to see something new? Hollywood makes quintessential genre films, and to understand the aesthetic rewards of Hollywood cinema we must tackle the aesthetics of genre filmmaking.

PART
5

GENRE

The notion that "all westerns (or all gangster films, or all war films, or whatever) are the same" is not just an unwarranted generalisation, it is profoundly wrong: if each text within a genre were, literally, the same, there would simply not be enough difference to generate either meaning or pleasure. Hence there would be no audience. Difference is absolutely essential to the economy of genre.

—Stephen Neale[1]

The Hollywood Genre System

I NAUGURATING THE MOST FINANCIALLY SUCCESSFUL FRANCHISE IN THE history of entertainment, the original *Star Wars* (1977) has become one of the most widely and intensely loved movies of all time. Film scholars, however, have lambasted *Star Wars* for its simplicity, at times blaming the movie for ruining Hollywood's artistic renaissance in the 1970s.[2] Peter Lev admires the film's technical achievement but nonetheless calls it one of the "simple, optimistic genre films in the late 1970s."[3] Alexander Horwath refers to *Star Wars* derogatorily as part of the first wave of "escapist, neo-heroic 'feelies.' "[4] David Cook says it privileges "a juvenile mythos."[5] More scathing, Jonathan Rosenbaum calls the movie mostly "fireworks and pinball machines," a deliberately silly film that offers only "narcissistic pleasures."[6] In his book on *Star Wars*, Will Brooker summarizes the scorn that scholars show toward the film: "Cinema scholarship seems embarrassed by *Star Wars*—embarrassed that a movie series so popular, successful and influential is also, apparently, so childishly simple."[7]

How do we explain the discrepancy between scholars' opinion of the film and its popular success? What pleasure do mass audiences get from *Star Wars* that scholars do not? What aesthetic weaknesses do scholars find in the film that mass audiences don't? In this chapter, I hope to demonstrate that we can attribute much of the discrepancy between the popular and scholarly reception of *Star Wars* to the two audiences' differing levels of genre expertise. Hollywood's genre system makes routine filmgoers into experts, but filmgoers do not share the same level of genre expertise, and more expert filmgoers require greater novelty and complexity to feel an exhilarated aesthetic response.

We will take up the case of *Star Wars* later in the chapter, but first we must understand the relationship between aesthetic pleasure and expertise.

RISK REDUCTION VERSUS PRODUCT DIFFERENTIATION

Fans of Hollywood cinema tend to enjoy genre films, which enable spectators to return to topoi that have pleased them in the past. Let's say that I enjoy comedies in which ne'er-do-well youths overcome impossible odds to beat arrogant peers at a sport (and I do). In that case, *The Bad News Bears* (1976 and 2005), *Breaking Away* (1979), *The Karate Kid* (1984 and 2010), *The Mighty Ducks* (1992), *Little Giants* (1994), and *Kicking and Screaming* (2005) will enable me to enjoy that experience anew. But Hollywood filmgoers do not just enjoy this or that genre: they tend to enjoy genre itself. Genre, irrespective of the particular genre, enables us to experience films as experts. It reduces the anxiety that attends novel artworks and increases our coping potential by limiting outcomes. Genre offers the pleasures associated with familiar objects ("the mere exposure effect"), as well as the pleasures of easy recognition and immediate understanding ("processing fluency")—properties that, we have seen, tend to make artworks spontaneously pleasing for average spectators.

The pleasures that spectators gain from genre squares with the Hollywood film industry's reliance on genre as a form of financial risk reduction. Movies are so expensive and such hit-or-miss investments that the industry depends on risk-reduction strategies (such as bankable stars, previously successful directors and writers, cost-sharing, etc.) to offset the financial uncertainties involved in producing and selling artworks that, these days, cost tens of millions of dollars or more to manufacture. Unlike other manufactured products, artworks are unique. We assume that McDonald's french fries will taste the same every time, but we assume that each movie we see will differ from every other we have seen. Genres, however, derive from similarities among movies. The genre system, therefore, enables the film industry to combine artistry with standardization. Genre makes the risky business of filmmaking more systematic, enabling the industry to repeat commercial successes.

Although familiarity, easy recognition, and immediate understanding make genre films accessible and pleasant to mass audiences, they can also make genre films dull. Novel properties or unusually complex properties, although they threaten to thwart understanding, offer the pleasures of reshaping knowledge and expanding expertise. By disrupting expectations, such properties avert boredom and create cognitive challenges. Indeed, as the quotation from Stephen Neale at the beginning of Part 5 suggests, the genre system depends on product differentiation in order to generate pleasure and profit. Challenging genre films—films that demonstrate genre novelty or uncommon complexity—arouse interest by inviting spectators to probe the films with the hope of understanding them.

We see the combination of risk reduction and product differentiation, for instance, in the recent "reboot" phenomenon, in which a film franchise begins anew, as though

the events of the original film series had never happened. Examples include the rebooted Batman, *Friday the 13th, Texas Chainsaw Massacre*, and *Star Trek* franchises. Once spectators have grown overly familiar with a film series, and excessive repetition of the same conventions has exhausted the ability of the series to generate interest, rebooting enables filmmakers to both exploit the identity of the series (risk reduction) and also refashion fundamental premises (product differentiation). With reboots, the series identity must be strong enough to sustain a complete revision, but the revision cannot be so radical as to make coping with the change difficult for a mass audience.

The James Bond movies have rebooted several times since the series began in 1962 with *Dr. No*, each time with a new actor playing 007, but the 2006 reboot proved more thoroughgoing. In *Casino Royal* (2006), Daniel Craig does not portray the relaxed and refined secret agent played by Sean Connery and every other Bond actor since; he's troubled and angry. The film undermines some of the series' most reliable conventions—conventions that, for a time, remained pleasurable in part because of their familiarity and predictability. When asked whether he wants his vodka martini shaken or stirred, *Casino Royal*'s Bond replies sourly, "Do I look like I give a damn?" Craig's darker 007 added novelty to a series of films that had seemingly exhausted its potential for novelty.

Too much novelty and complexity, we have seen, make it difficult to identify and understand a work of art, which, in turn, threatens to reduce an artwork's hedonic value. We have also seen, however, that novelty and complexity, in moderate amounts, increase the potential for exhilaration in our aesthetic experience by making a work of art more challenging to master, provided the work does not threaten spectators' ability to cope. The balance of familiarity and novelty, unity and complexity, and standardization and artistry fuels genre filmmaking and the pleasures derived from it. To fully exploit the pleasures of genre filmmaking for a mass audience, then, a genre film must fit recognizably within its genre, offering easy recognition, but it must also differ enough from previous films to make it moderately challenging for average spectators. As that difference grows, spectators experience the exhilaration of expanding knowledge, until the point at which they no longer feel comfortable identifying the film's form.

ROCKY III: ROCKY AGAIN AND AGAIN

No one would accuse *Rocky III* of transcending its genre. The fourth-highest grossing movie of 1982, the boxing film—written by, directed by, and starring Sylvester Stallone—would not make any cinephile's top ten list for the year. Although popular upon its release, it flunks the test of time. The film, however, illustrates the ways in which even typical Hollywood genre films differentiate themselves from their predecessors in order to generate moderate interest for a mass audience.

Rocky III typifies routine Hollywood filmmaking: an immediately pleasing work, its genre features easily identified, unable to sustain much interest beyond an initial viewing. The film relies so heavily on the popularity of the first two *Rocky* movies that one can hardly imagine a studio approving the production without the added promotional benefit of a presold franchise. The film enlists the common topoi of the first two movies, including a familiar title sequence, Bill Conti's iconic musical score, an underdog theme, our protagonist's crisis of confidence, and an emotional climax in the ring that settles scores and proves the fighter's mettle. The training montage is so formulaic that I suspect even the film's editors could no longer identify which *Rocky* movie it comes from. The movie's opening sequence extracts footage of the climactic fight sequence from *Rocky II*, the fourth-highest grossing movie of 1979, just as the opening montage of *Rocky II* had extracted footage of the climactic fight sequence from *Rocky*, the highest grossing movie of 1976. The montage not only fills in backstory, but it also imports the thrilling climax of the previous movie as an exciting opener—a clever, economical artistic gimmick.

Constructing a plot for *Rocky III* posed aesthetic challenges to the filmmakers, who needed to differentiate their film not only from other boxing movies but also from the established *Rocky* subgenre, which seemed well exhausted at the time. First, how to vary the plot. In the first film, Rocky loses a split decision to heavyweight champion Apollo Creed and, in the process, earns a personal victory. In *Rocky II*, Rocky beats Creed, winning the heavyweight crown and achieving the full victory that eluded him in their previous bout. What other variations can the franchise offer? The fighter lost; the fighter won. It's a boxing movie. Second, how to again make Rocky's victory a long shot. The *Rocky* movies are quintessential underdog stories, but, as of the climax of *Rocky II*, Rocky is now the heavyweight champion of the world. Finally, how to add interest and variation to the storytelling. To differentiate their movie from the first two films, the filmmakers could try to mine some interesting new material or storytelling possibilities from the franchise, if any remain.

In response to the first two challenges, the filmmakers essentially combined the formulas of *Rocky* and *Rocky II*: In *Rocky III*, the fighter first loses, then wins. This variation on the *Rocky* story offered significant aesthetic benefits. It made the plot tighter, packing two *Rocky* movies into one, and enabled the filmmakers to insert an exciting and suspenseful fight sequence in the middle of the film. The first *Rocky* spent a lot of time establishing Rocky's environment, his personality and history, his relationship with his trainer, his interest in wooing Adrian, and his desire for a title shot, a long setup for an exciting climax. But viewers of *Rocky III* had likely grown tired of that kind of material, impatient for the inevitable fight scene. A lose-then-win formula helps keep viewers engaged, puts a crucial action scene in the center of the film, and establishes Rocky once again as an underdog.

In constructing the plot and themes for *Rocky III*, the filmmakers also hit upon a storytelling possibility unavailable to the makers of the first two *Rocky* movies: a resonance between the stardom Rocky achieves as the heavyweight champion of the world and the stardom Stallone achieved as the star of *Rocky*. During a long montage at the beginning and extending through the first act, the film shows Rocky in a series of commercial endorsements for American Express, Delorean, Nikon, Budweiser, Amoco, Maserati, Tony Lamas boots, designer watches, Wheaties, and other products (video 10.1 ▶). It's impossible to tell whether these images were created for the movie or drawn from Stallone's own history of product endorsement; they would look the same either way. Indeed, the movie uses as props some real objects created in the wake of the success of the *Rocky* movies (such as the Rocky pinball machine), enabling spectators knowingly to pretend that, within the fictional universe of the movie, these real-life objects refer to a real Rocky. We also see photographs of Stallone/Rocky with Bob Hope and Presidents Reagan, Carter, and Ford, photographs drawn from Stallone's life as a movie star. Shots of fans seeking autographs, photographs, and kisses from Rocky create a connection between the story of Stallone, who became a celebrity by creating a popular character and successful film franchise, and the story of *Rocky III*, which concerns a boxer who has himself become a celebrity. The unusually self-conscious storytelling differentiates this *Rocky* from the two previous films, adding some novelty to the franchise.

Hollywood, as we have seen, rarely inserts this type of self-conscious display without integrating it into the cause-effect structure of the story. Indeed, the sequences depicting Rocky's fame set up a plot point necessary to further the story of *Rocky III*: Rocky now leads a celebrity lifestyle, filled with possessions, a mansion, endorsements, and recognition on the street; consequently, he is no longer hungry. Rocky has gotten soft. Act 1 establishes that Rocky must leave his cushy lifestyle, overcome comfortable habits, and develop "the eye of the tiger." The beginning sequences make that message clear in an interesting way. Aside from enabling United Artists to exploit the financial benefits of product placement, the first act of *Rocky III* exploits the sometimes complex relationship between two realities: that of the fictional world of the movie and of the real one outside the movie. The film encourages spectators to reflect on the similarities and interdependencies of these two worlds.

I do not mean to argue that *Rocky III* is an overlooked artistic achievement. On the contrary, it is a routine Hollywood genre film. It faced some particular constraints given the simplistic formulas inherited from the first two *Rocky* movies, but all genre films face comparable constraints. The film shows how even ordinary Hollywood products seek to differentiate themselves to generate interest and thereby obtain commercial success. *Rocky III*'s variations on the Rocky story sufficiently differentiated the film from its predecessors to sustain the franchise.

GENRE EXPERTISE AND THE EVOLUTION
TOWARD COMPLEXITY

Because each genre film differs from its predecessors, genres normally evolve. Much of a genre's evolution seems fairly erratic; however, genres sometimes evolve according to predictable patterns. One common pattern results from the repeated efforts of filmmakers to reinvigorate a genre in the face of a culture's growing genre expertise: the evolution toward complexity.

David Bordwell has questioned whether changes in art forms follow any large-scale patterns. "A style may develop from simplicity to complexity, or from complexity to simplicity," Bordwell says.[8] Indeed, the arts do not progress teleologically toward more complex forms. Abstract expressionist paintings of the early twentieth century exhibit no more evident complexity than impressionist paintings of the late nineteenth century. Indeed some genres, such as the teen film, have had periods of complexity and periods of simplicity, in no particular order, largely as a result of changing audience demographics. However, when a culture gains more experience in an art form, the makers of art, even mass art, will likely create some more complex works in order to appeal to more aesthetically mature audiences. Complexity in the arts functions symbiotically with a culture's art expertise.

Novices, Experts, and Art Preferences

Psychologists have consistently found that experts in an art form prefer more complex art, whereas novices prefer more simple art. Researchers have replicated this finding across all of the arts.[9] It is an obvious finding, but the explanation for it may not be. Why do experts prefer complex art? We might assume that experts prefer to be challenged more than novices, but that answer may not be correct. To properly answer the question, we must understand expertise.

As people gain knowledge in a domain (chess, cooking, etc.), they begin to group units of memory into patterns, called "chunks," enabling them to quickly encode, store, and retrieve information.[10] Experts have knowledge that allows them to "chunk" a lot of information. Psychologists Smith and Smith propose that an art expert's *knowledge base concerning art* (what they term "aesthetic fluency") enables the expert to process complex art more easily than novices.[11] So when film experts experience a movie, they see patterns (stylistic patterns, narrative patterns, genre patterns, historical patterns, etc.) that elude the novice. Because experts chunk more information, the same movie demands less cognitive activity from film experts than from novices. This proposition accords with empirical findings that experts consider confusing movies less confusing, and more interesting,

than novices.[12] Chunking allows the expert to more easily perceive the movie, integrate it into memory, classify it, and evaluate it.[13] So, for experts, the balance between unity and complexity in a positive aesthetic experience is going to tip toward complexity.

Most people seek artworks that are *moderately challenging*—moderately challenging for them individually, not objectively. We may think that film experts seek more challenging works of art because they want to work harder than novices, but it takes more novelty and complexity for experts to work just as hard. To feel the same level of exhilaration that novices feel when watching comparatively easy movies, film experts seek out more difficult movies that challenge an expert's ability to assimilate information.

Experts at whodunits, for instance, will likely appreciate *Gosford Park* (2001) more than novices. The movie exhibits many common whodunit properties that genre experts readily identify: a manor house, a private party, a homicide, multiple suspects, an investigation of personal histories, secrets revealed, etc. However, *Gosford Park* relies on viewers' existing fluency in genre. The film forgoes the traditional whodunit's detective-film structure, which centers on interviews, flashbacks, and a brilliant detective locating clues to solve a puzzling crime. Indeed, learning who committed the homicide is one of the least interesting things about the movie. The whodunit conventions help identify the genre, but they never quite control the plot, which wanders unpredictably in and out of genre in order to investigate personal relationships, characters' feelings, and the practices and attitudes of a bygone society. *Gosford Park*'s assumption of whodunit expertise enables the narration to take complex detours, outside of conventional genre trajectories, that resist understanding even for an expert.

Reber, Schwarz, and Winkielman say their Processing Fluency Model of aesthetic pleasure explains why experts enjoy complex art.[14] As we saw in chapter 1, the model predicts that people will prefer objects that they can easily process. An art expert, the researchers argue, enjoys complex artworks because she finds them easy to process. Hence, Processing Fluency theorists would say that whodunit experts enjoy *Gosford Park* because the film does not confuse them.

The Processing Fluency Model, however, belies a lot of the enjoyment complex artworks offer by means of their complexity. The model accounts neither for the pleasure associated with complex art nor the displeasure associated with simple art, which often bores the expert. Indeed, if artworks are too simple, they even bore the novice.[15] If processing fluency alone accounted for aesthetic pleasure, then we would generally enjoy a movie the more times we see it. Repeatedly viewing a single film does offer the pleasure of familiarity, as our expertise in that individual movie makes it increasingly easy to understand. Eventually, however, we are liable to grow sick of the movie. Complex movies, of course, are the exception. Complex artworks resist understanding on initial contact and may grow increasingly interesting and enjoyable the more we experience them, as we

begin to assimilate properties that may at first elude us. Highly complex artworks— such as *Hamlet*, Beethoven's 3rd Symphony, or *Playtime* (1967)—may require high levels of expertise (multiple exposures and experiences beyond the object itself) before we can maximally enjoy the pleasures they have to offer.

(To put this point in the terms of Berlyne's Psychobiological Model of hedonic pleasure, as described in chapter 1, the first time we encounter a complex artwork, its complexity may limit its hedonic value. In that case, the work would fall to the right of the Wundt Curve, where hedonic value is low or negative [see figure 1.2]. As we gain expertise, however, and our ability to master the object improves, it ceases to overwhelm us. The artwork would therefore move closer on the scale toward the middle of hedonic value, where pleasure is greatest. As we gain even more expertise, pleasure may start to diminish, as the object ceases to challenge us and moves farther to the left of Berlyne's arousal scale.)

Hence, we can view aesthetic pleasure as a factor of an artwork's complexity and novelty (too much complexity and novelty leads to confusion; too little leads to boredom) and the perceiver's expertise (too much expertise leads to boredom; too little leads to confusion). Because this formulation accounts for each perceiver's subjective appraisal of an artwork, it helps explain why one film spectator might find a genre film dull, another might find it baffling, and a third might find it exhilarating. We can often attribute those differences to expertise.

Film Experts and American Film Genres of the 1930s and 1940s

By what historical mechanism does an American film genre progress toward a more complex form?

As masses of filmgoers gain expertise in a genre and simpler iterations fail to exhilarate them, they seek out more challenging films. Leo Braudy notes the impact of a culture's film expertise on the evolution of American film genres:

> When the genre conventions can no longer evoke and shape either the emotions or the intelligence of the audience, they must be discarded and new ones tried out. Genre films essentially ask the audience, "Do you still want to believe this?" Popularity is the audience answering, "Yes." Change in genres occurs when the audience says, "That's too infantile a form of what we believe. Show us something more complicated."[16]

As a filmgoing culture builds up its knowledge base and gains more general understanding of genre properties, then the norms of film reception change. At that point, filmmakers will likely make more complex movies that appeal to the culture's growing expertise.

Like all evolutions, the evolution toward greater genre complexity occurs when new systems build on existing ones. Hence, a genre must first experience a period of stabilization so that the culture has time to identify and master genre properties and filmmakers can refine the conventions. As early as 1905, the motion picture industry began classifying movies according to "story type."[17] However, for the large majority of Hollywood genres that thrived throughout the studio era (the western, the musical, the gangster film, etc.), the period of stabilization and refinement occurred in and around the 1930s, a classical phase in Hollywood's genre development.

Refinement occurred picture by picture, as studios and filmmakers in the 1930s followed trends of public taste. We see this pattern played out with numerous genres. Tino Balio notes that the success of the Warner Bros. costume-adventure films, *Captain Blood* (1935) and *Anthony Adverse* (1936), led to a cycle of similar pictures, including *The Charge of the Light Brigade* (1936), *The Adventures of Robin Hood* (1938), and *The Private Lives of Elizabeth and Essex* (1939), which developed and refined the conventions of the swashbuckler.[18] The success of Warner Bros. gangster movies *Little Caesar* (1930), *The Public Enemy* (1931), and *Scarface* (1932) led to a cycle of similar pictures, including *G-Men* (1935), *Bullets or Ballots* (1936), and *The Amazing Dr. Clitterhouse* (1938). The success of *Grand Hotel* (1932) immediately inspired a cycle of films with interlocking stories, films with large casts of stars, and films set in one locale, including *The Big Broadcast* (1932), *American Madness* (1932), *International House* (1933), and *Dinner at Eight* (1933). Cycles emerge when the industry attempts to exploit public interest in a type of film, and sometimes cycles develop into genres or subgenres with distinct conventions. For instance, *The Big Broadcast* eventually became its own subgenre of the musical, with three *Big Broadcast* sequels throughout the 1930s.

In the 1940s, many Hollywood filmmakers experimented with greater complexity, as filmmakers tested the limits of genre variation. For example, the detective film, the suspense thriller, the melodrama, the crime film, the western, and the political drama explored more complex treatments in the 1940s with such films as *The Maltese Falcon* (1941), *Shadow of a Doubt* (1943), *Leave Her to Heaven* (1945), *Double Indemnity* (1946), *Red River* (1948), and *All the Kings Men* (1949), respectively. Of course, simple iterations continued. We mustn't forget the innumerable B-westerns produced during the war years. And the Lassie pictures and Hope-Crosby *Road to* pictures of the 1940s did not grow more complex as those cycles progressed. Rather, as genres evolved, complex treatments emerged alongside a continued stream of more simplistic productions.

The 1940s also saw a significant number of crime and mystery films with more complex narrative, stylistic, and ideological properties than we tend to find in earlier films in those genres. David Bordwell notes the "fractured, densely plotted" quality of narrative patterning during this period, particularly in the developing use of the flashback. "Films

gave us flashbacks retelling events from different characters' perspectives, flashbacks that proved deceptively incomplete or downright false, even flashbacks narrated by corpses."[19] *Passage to Marseille* (1944) and *The Locket* (1946), Bordwell notes, contain flashbacks within flashbacks within flashbacks.[20] Similarly, stylistic devices in 1940s crime and mystery films challenged Hollywood norms with extreme chiaroscuro, unbalanced frames, and visual contortions. And, as we saw in chapter 8, Hollywood crime films of the forties and fifties sometimes housed dissonant ideologies, condemning and sympathizing with criminals simultaneously. Hollywood cinema matured as audiences developed increasing expertise in commercial cinema's design features. Cinema evolution and audience evolution occurred symbiotically in the 1940s, as Hollywood sought to satisfy the desires of experienced filmgoers for movies with more complex narrative, stylistic, ideological, and genre properties.

We can, of course, find many exceptions to the evolution theory of genre. Sometimes new genres or subgenres draw on the complexities of more mature genres or employ conventions developed in other art forms. The big caper movie appeared full blown in 1950 with *The Asphalt Jungle*, its inaugural complexity resulting from a reliance on conventions of crime films and crime literature that had been developing for decades. Some genres stagnate or fall away because of audience exhaustion or the limitations of the genre itself, as was the case in the 1930s with the swashbuckler, the *Big Broadcast* films, and the "fallen-woman" film. Some genres move through periods of simplicity and periods of complexity, based more on audience demographics than genre expertise. The simplistic teen films of the fifties and of the eighties—such as *The Girl Can't Help It* (1956), *I Was a Teenage Werewolf* (1957), *Sixteen Candles* (1984), and *Ferris Bueller's Day Off* (1986)—targeted a teen audience. By contrast, many teen films of the early seventies—including *Summer of '42* (1971), *The Last Picture Show* (1971), and *American Graffiti* (1973)—targeted adults.

Sometimes external factors stunt a genre's development. Schatz notes that the threat of government censorship and religious boycott disrupted the internal evolution of the gangster genre in the 1930s and that, in war films made during World War II, "the prosocial aspects of supporting a war effort directly ruled out any subversion or even the serious questioning of the hero's attitudes."[21] Similarly, the blacklist and the hearings of the House Un-American Activities Committee (HUAC) in the late 1940s and 1950s stifled anything that smacked of liberal politics in studio productions and stunted the progress of the social-problem film. In support of HUAC, Eric Johnston, head of the Motion Picture Association of America (MPAA), vowed in 1947, "We'll have no more *Grapes of Wrath*, we'll have no more *Tobacco Roads*. We'll have no more films that show the seamy side of American Life."[22] For a variety of reasons, a genre may not survive and evolve. But, in a free market, a genre endures when filmmakers have not yet fully mined its complexities or exhausted its potential for variation.

Star Wars and Genre Expertise

Now that we better understand the relationship between aesthetic preferences and expertise, we can try to explain why masses of spectators might find *Star Wars* exhilarating, whereas film scholars often consider the film simplistic and unoriginal. The discrepancy might at first seem to undermine my theory that simple, unoriginal films tend to bore spectators, not exhilarate them. Those with extensive knowledge of film history, one would think, can best judge a film's complexity and novelty. If many film experts regard *Star Wars* as simplistic and unoriginal, then how do we account for mass culture's enthusiasm for the film? In fact, the discrepancy helps substantiate the theory, which predicts that spectators will find a film's genre use boring or exhilarating in accordance with their individual level of expertise.

For an average spectator, *Star Wars* exhibits more challenging genre properties than most scholars recognize. Indeed, *Star Wars*'s moderate genre complexity, I propose, has contributed to its popularity among mass audiences, as well as its ability to sustain continuing plotlines through sequels, prequels, books, videogames, TV shows, and other spin-offs. The first *Star Wars* movie established an elaborate world that lent itself to seemingly endless further elaboration. The film's fertility and wide appeal result partly from its diversity of genre conventions.

The mere profusion of genre traditions in *Star Wars* speaks to its genre complexity. Writer-director George Lucas said about the film, "It's the flotsam and jetsam from the period when I was twelve years old . . . all the books and films and comics that I liked when I was a child."[23] A simple list of genres that figure fairly prominently in the film would include fairy tales, adventure films, and swashbucklers (swinging on ropes, rescuing a princess, Leia's wardrobe, light saber fights); the western (a cantina scene, desert landscapes, shots of a burning homestead, bounty hunters); the 1930s science fiction serial *Flash Gordon* (ray guns and explosions, an episode format, an opening text that explains previous events); fantasy comics and novels, such as *John Carter of Mars, Buck Rogers*, and *The Lord of the Rings* (alien creatures, monsters, a hero on a quest, a world in peril, battles and adventures in far-off lands); samurai movies (obsolete warriors, light sabers); a comic duo, such as Abbot and Costello and Laurel and Hardy, that pairs a neurotic skinny straight-man with a fat clown (C3PO and R2D2); the philosophical fantasy film, such as *Lost Horizon* (1937) (the Force, spiritual training); horror (Darth Vader, Hammer horror-film actor Peter Cushing); gangster (Han's debt to Jabba the Hutt); Nazi documentaries and World War II films (soldiers in formation, air battles, a prison escape, rebels planning an invasion in a war room, the uniforms of Grand Moff Tarkin and other officers in the Galactic Empire); the foreign film (subtitled dialogue); the historical epic, such as *The Ten Commandments* (1956), *Ben-Hur* (1959), *Spartacus* (1960) and *Lawrence*

of Arabia (1962) (nation-building, spectacular settings, a small band of rebels fighting a mighty empire); and, of course, science fiction film and television, such as *Forbidden Planet* (1956) and *Lost in Space* (robots, interstellar travel), *Star Trek* (photon torpedoes, light-speed space travel, tractor beams, outer space cultures), and *Planet of the Apes* (Chewbacca).[24]

Writing for *Literature Film Quarterly* shortly after the film's release, Andrew Gordon said, "The multiple cross-references, the archetypal characters and situations, give it both reinforcement and deep resonances for an audience which may not consciously recognize the sources, but will still respond emotionally to the conventions."[25] Around the same time, and much less charitably, film scholar Jonathan Rosenbaum said that Lucas's "smorgasbord" is "often more a matter of quantity than quality."[26]

Films blended genres as soon as films had genres, but *Star Wars* exceeds in the sheer variety of genre conventions. Lucas called the film "a compilation . . . all things that are great put together."[27] The appeal of *Star Wars*'s genre use, however, comes from the feeling of unity within its genre diversity. The genres do not collide with one another, as they do in *Starship Troopers* (1997), and the film's use of old genre conventions does not come across as self-conscious commentary on classical Hollywood, as do similar practices in *Little Big Man* (1970), *The Long Goodbye* (1973), and *Blazing Saddles* (1974). Instead, the film finds fortuitous linkages between diverse genre topoi. The figures of C3PO and R2D2 blend the tin man from *The Wizard of Oz*, the comic duo of Abbot and Costello, and the space robot of *Forbidden Planet* in a way that feels unified and inevitable. The figure of Han Solo makes the western's quick drawing gun-for-hire—decked out in a vest, boots, and a gun by his side—seem a lot like both the captain of a pirate ship in an Errol Flynn adventure and, when matched against Princess Leia, one half of a screwball comedy pair. The light saber makes something like a samurai's sword a natural supplement to a *Star Trek* phaser. "A long time ago in a galaxy far, far away" is apropos because Lucas's futuristic science fiction film feels like the past.

The imagery in an early scene with Princess Leia and Darth Vader (figures 10.1 and 10.2) combines a science fiction setting with elements from fairytale (Leia's flowing white gown), horror (Vader's bug-like metallic mask), and the World War II prison movie (handcuffed Leia led by Storm Troopers and the Nazi-like garb of a soldier standing beside Vader). Looking at such diverse elements in still frames may make the movie seem like a genre mishmash, a parodic combination of familiar elements from studio-era Hollywood. However, such elements, during the film experience, do not regularly come off as incongruous. Instead, the combinations create what Hutcheson called "uniformity amidst variety."[28]

The science fiction environment makes familiar properties from *Star Wars*'s other genres look futuristic, otherworldly, and strange. Part of the excitement of *Star Wars* upon

FIGURE 10.1

FIGURE 10.2

FIGURES 10.1 AND 10.2 *"Uniformity amidst variety."* A scene from Star Wars *(1977) combines imagery from science fiction, fairytale, horror, and the World War II prison movie.*

its release resulted from seeing familiar iconography, situations, and characters in novel settings. We had seen sword fights in swashbucklers and samurai movies, but the warriors in those films did not use light sabers. We knew cantina scenes from westerns but not cantinas populated by aliens from outer space. We saw subtitles in foreign films but never subtitles that translated bogus alien languages. The novelty of the combinations added freshness and interest to situations that, for most spectators, seemed vaguely familiar.

I propose that many film scholars find *Star Wars* simplistic and unoriginal because they have too much experience with the film's multifarious genre conventions—conventions that viewers with extensive knowledge of film genres can identify too easily. True film experts have seen it all before, which explains why scholars often celebrate the more self-conscious genre films of the same period, such as *The Long Goodbye* and *All That Jazz* (1979). Ironic and disdainful of Hollywood formula, such films reflect an expert's weariness with mainstream American cinema.

Star Wars reflects no such weariness, irony, or disdain. Although it relies heavily on conventions that film experts have seen many times, average spectators would not so easily identify its genre properties. Rosenbaum's blistering review of the film is largely

a complaint about cinematic poaching from *Triumph of the Will* (1935), *Flash Gordon* (1936), *The 5000 Fingers of Dr. T* (1953), *This Island Earth* (1955), *The Searchers* (1956), *2001: A Space Odyssey* (1968), samurai movies, and other films so familiar to Rosenbaum that, to his mind, the plot could have been regurgitated by "any well-behaved computer fed with the right amount of pulp."[29] In a similarly devastating critique, Robin Wood calls the pleasures of *Star Wars* "mindless and automatic."[30] Wood implies that, whereas he does not appreciate mindless and automatic pleasures, the people who enjoy *Star Wars* do. He says that spectators find reassurance in "the extreme familiarity of plot, characterization, situation, and character relations."[31]

Such conventions may be extremely familiar to Wood and Rosenbaum, but I suspect that their scorn for *Star Wars* results in part from the fact that they have chunked so much film knowledge that they can identify the film's genre properties too easily. Wood thinks he is criticizing *Star Wars* fans for taking pleasure in an "undemanding," "reassuring," "childish" fantasy ("The finer pleasures," he says, "are those we have to work for"), but really he might be condemning their limited cinema expertise.[32] For spectators who have only moderate familiarity with Hollywood genre conventions, *Star Wars* requires cognitive work. Wood would no doubt describe most Hollywood movies as "mindless and automatic" because they are for him. However, Wood's critique cannot explain the enduring and exhilarated passion that we see in generations of *Star Wars* fans, whose engagement with the film does not by any means look "mindless and automatic"; *Star Wars* fans are engrossed and elated. I propose that *Star Wars* makes average viewers, reasonably versed in Hollywood formula, "work for" their pleasures. For an average viewer, the film finds the optimal area between unity and complexity, familiarity and novelty, easy recognition and cognitive challenge.

Complex Plots and Expertise

Because of home video, Americans see more movies now than ever before. Frederick Wasser notes that home video offers audiences "two types of choices: access to more product and control over the time and place of viewing movies."[33] Since the 1980s, these two choices have expanded film viewing at home. Since the release of *Star Wars*, we have seen the explosion of cable TV and VHS tape in the 1980s, the quick adoption of DVD at the end of the 1990s, and the advent of Internet streaming in the twenty-first century. These technological changes, I suspect, have brought about another stage in the evolution toward complexity.

I recognize that my speculation here is liable to draw disagreement, considering the creative state of Hollywood cinema today compared to its heyday during the period of the studio system. Indeed, I would not argue that Hollywood makes better films today, nor

would I argue that most contemporary Hollywood films demonstrate a great deal of complexity, nor that audiences are more generally sophisticated today about cinema than they were during the studio era. My point, here, is not so sweeping. I mean only to observe that many contemporary Hollywood filmmakers take for granted a high level of film experience among some audiences. Of course, spectators have different levels of expertise, and Hollywood has always devised a variety of offerings to cater to such differences. Indeed, many Hollywood films are designed to work on both a simple level and a more sophisticated level, appealing to both novices and experts alike. Films such as *Angels with Dirty Faces* (1938), *His Girl Friday* (1940), *Fort Apache* (1948), *Some Like It Hot* (1959), *Willy Wonka and the Chocolate Factory* (1971), *Annie Hall* (1977), *Groundhog Day* (1993), *Peter Pan* (2003), *The Dark Knight* (2008), *The Lego Movie* (2014), and *Inside Out* (2015) offer both the easy pleasures of immediate understanding and the more challenging pleasures that result from complexities and novelties in their narrative, stylistic, ideological, or genre properties. However, given the amount of exposure Americans today have to movies, the average American ten-year-old has already developed substantial experience with Hollywood's formal conventions. Consequently, Hollywood now designs a number of films to cater to a more film-experienced market.

Consider contemporary Hollywood's use of out-of-order chronology. Hollywood filmmakers since the late 1920s have regularly told stories using flashbacks, and, as I noted earlier, filmmakers complicated the device in the 1940s. Flashbacks, however, have grown more challenging in contemporary Hollywood. Because mentally reordering plot events chronologically requires cognitive effort, studio-era filmmakers eased the process by signaling a time shift redundantly with sound cues, dialogue hooks, visual changes, and a close-up that marked the flashback as a character memory. However, as Bordwell notes, Hollywood has recently reduced the number of flashback cues, relying on spectators' knowledge of the formal conventions of Hollywood narration to smooth the transition between chronologically reordered scenes.[34] We see this pared-down use of flashback cues in *Pulp Fiction* (1994), *Memento* (2000), *Michael Clayton* (2007), and numerous other films that rely on spectators having chunked enough information about cinema flashbacks to make redundant cues unnecessary. In such films, a complex mental process—rearranging events presented out of chronology—that Hollywood had previously made easier through an abundance of narrative and stylistic cues, now relies on an audience's knowledge of the flashback convention.

Growing expertise with Hollywood narration helps explain contemporary mainstream cinema's propensity for convoluted plots, including, as Bordwell notes, "paradoxical time schemes, hypothetical futures, digressive and dawdling action lines, stories told backward and in loops, and plots stuffed with protagonists."[35] Hollywood still produces easily understood entertainment for film novices, for individuals who prefer simple

entertainment, and for filmgoers in the mood for unchallenging art. Accessibility, we know, attracts mass audiences. However, Hollywood now also appeals to a sizable market of cinema experts. It therefore comes as no surprise that we find, in contemporary mainstream American cinema, works with more challenging narration than we can find in the studio era, represented in films such as *Short Cuts* (1993), *Magnolia* (1999), *The Matrix* (1999), *Memento* (2000), *Kill Bill* (2003 and 2004), *Eternal Sunshine of the Spotless Mind* (2004), *The Prestige* (2006), *Premonition* (2007), *Duplicity* (2009), *Inception* (2010), *Source Code* (2011), and *Cloud Atlas* (2012). All of these films employ storytelling devices that the studio era would have regarded as too convoluted for mainstream audiences.

In 2003, Jed Dannenbaum of USC's School of Filmmaking said about his students:

> These are kids who have been thinking about being filmmakers since they were 7 or 8, who've been making films with family camcorders. They're wired to take things in much faster and more easily than older audiences, and they get impatient with very traditional storytelling. They want to break frames and skip around in time, and they're used to films doing that.[36]

Film scholar John Fawell sees this attitude among film students as indicative of their estrangement from Hollywood's rich tradition of classical filmmaking.[37] However, we can better explain the attitude by pointing to students' film *expertise*, which leads them to prefer more convoluted—and, for them, cognitively stimulating—storytelling devices. Of course, the studio era produced many complex movies as well. But more than ever, today's audiences seek the challenge of movies that play mind games.[38]

CONCLUSION

I argued in chapter 1 that aesthetic value in Hollywood cinema comprises both Pleasingness and Interestingness. Pleasing works, I said, offer us "hedonic value" by appealing to our desire for immediate recognition and easy understanding, whereas interesting works offer us "epistemic value" by appealing to our desire for cognitive challenge. Since works of art often become less pleasing as they grow more interesting, every artist must strike a balance between the two aesthetic properties. Hollywood puts that balance in commercial terms, weighing the value of *risk reduction* against the value of *product differentiation*. Risk reduction results mainly from Hollywood's reliance on proven formulas (typically genres) that make Hollywood films immediately pleasing for mass audiences. Unusually novel or complex films are liable to confuse or overwhelm a mass audience. But when understanding is too easy and genre conventions have worn out their capacity

to delight, even mass audiences get bored. Product differentiation (in the form of greater novelty and complexity) prevents genre films from growing too monotonous.

The optimal balance between genre ease and genre challenge, however, depends on the individual spectator's ability to cope with challenging aesthetic properties. Since aesthetic expertise, as many empirical studies have shown, increases coping potential, we should expect genre experts to seek out novel or complex genre films (such as *Gosford Park*) that may confuse or overwhelm an average spectator. And we should expect experts to grow bored with genre films (such as *Star Wars*) that average spectators may find aesthetically exhilarating. Hence the aesthetic pleasure we derive from a Hollywood genre film will be, in part, a factor of the film's novelty and complexity and our own ability to cope.

. . .

We have barely touched on the matter of talent in genre filmmaking. Indeed, one might infer from this chapter that genre evolution results solely from large-scale external factors (audience exhaustion with simple films, growing genre expertise, home video, audience demographics, etc.) and not from the creative contributions of individual filmmakers. Throughout Hollywood's history, talented Hollywood filmmakers have maintained the genre system's aesthetic vitality, addressed the culture's growing expertise, and countered audience's genre exhaustion. The next two chapters trace some creative developments in two Hollywood genres—the musical and the western—that thrived in the studio era but barely survived it. In chapter 11, we study the ways in which filmmakers developed novel uses of song in cinema. In chapter 12, we examine the efforts of filmmakers to continually complicate the figure of the western hero. With a close analysis of one post-studio-era film, each chapter furthermore demonstrates how filmmakers have kept the genre system alive by revitalizing outdated genre conventions and mining new material from genres that seem to have depleted their aesthetic resources.

Bursting into Song in the Hollywood Musical

THE 1976 GANGSTER-MUSICAL *BUGSY MALONE* HAS A CHARMING TWIST. The film, written and directed by Alan Parker, features children in all of the adult roles. But just as unusual is the fact that *Bugsy Malone* calls attention to the actors' lip-synching and outbursts of song, unlike studio-era musicals, which labored hard to conceal the artifice. In *Bugsy Malone*, the child actors speak in their own voices, but when they open their mouths to sing we hear the deep, mature voices of adult singers, voices that clash with the look and sound of the children (video 11.1 ⊙). The novelty requires some cognitive adjustment, but it does arouse one's attention.

Novelty, I argued in chapter 1, makes works of art more difficult to process. Novelty signals unfamiliarity, disrupts expectations, and increases arousal. Hence, spectators may seek to avoid novelty to lower arousal and ease their understanding of an artwork. However, we have also seen that too little novelty in genre filmmaking leads to boredom. Novelty, in moderate amounts, increases interest by making a work of art more unpredictable, as well as more challenging to understand and identify. Hence, to fully exploit the pleasures of genre filmmaking for a mass audience, I argued in chapter 10, a genre film must fit recognizably within its genre, offering easy recognition, but it must also differ enough from previous films in order to make understanding moderately challenging for average spectators.

But noting large-scale trends in genre filmmaking does little to help us understand the particular aesthetic pleasures afforded by novel genre developments. For that, we must examine creative innovations within a genre. Doing so will help explain some of the ways in which filmmakers maintain the genre system's aesthetic vitality by introducing

novelties that combat spectators' weariness with overworked genre conventions. Doing so will also enable us to see how genre conventions are inaugurated, developed, transformed, lost, and reclaimed. We can witness this process by tracing the history of the convention that characters in Hollywood musicals spontaneously burst into song without realistic motivation. The convention emerged in Hollywood toward the end of 1929 and largely vanished by the end of the 1950s. This chapter studies the ways in which Hollywood filmmakers creatively developed the convention in order to fully exploit the aesthetic possibilities of song in cinema. The eventual loss of the convention created new constraints on the uses of song; however, it also enabled new aesthetic possibilities. So this chapter will also study the ways in which post-studio-era filmmakers such as Mike Nichols, Alan Parker, and Woody Allen transformed the convention, exposed it, and reclaimed it in ways that added novelty to the viewer's aesthetic experience.

INAUGURATING THE CONVENTION
OF SPONTANEOUS SONG

When Dorothy Gale (Judy Garland) bursts into "Over the Rainbow" five minutes into *The Wizard of Oz* (1939), audiences at the time would not have found anything odd in the notion that a Kansas farm girl, in an otherwise realistic scenario, would spontaneously express her thoughts and emotions through a song. Nor would it seem odd that the character composed a fully formed, musically and lyrically sophisticated, and emotionally expressive song, in her head, at the moment she sings it. What's more, the character does not even seem to know that she is singing. How did cinema get to do that?

Of course, opera, operetta, and the stage musical had long portrayed characters spontaneously bursting into song. But live theater had never required a realistic excuse for musical outbursts, and applause after a song cushioned the awkward transition back to dialogue. Hollywood, however, did not immediately adopt the convention when it first began making musicals. At the time of *The Jazz Singer* (1927), Hollywood's first musical feature, the principles of cinematic realism seemed to preclude the practice of bursting into song, and film had no conventions for bridging the transition between singing and regular speech. During the first years of sound cinema, according to Hollywood composer Max Steiner, film music required a realistic source: "A constant fear prevailed among producers, directors, and musicians that they would be asked: Where does the music come from? Therefore they never used music unless it could be explained by the presence of a source like an orchestra, piano player, phonograph or radio, which was specified in the script."[1]

According to Katherine Spring, Steiner overstates the case since some early film music had no diegetic source, but "the justification for the presence of songs within narrative

contexts," she notes, "was an aesthetic priority during the onset of sound."[2] Consequently, the earliest film musicals concerned professional singers who performed for on-screen audiences: Performance supplied a realistic pretext for musical numbers. *The Jazz Singer* itself established cinema's "song as performance" convention: Al Jolson sings when his character is performing, rehearsing, or (in the case of the song, "Blue Skies") demonstrating his talents to his proud mother.

In the years after *The Jazz Singer*, Hollywood produced a series of "backstage musicals" (or "backstagers") such as 1929's *On with the Show* and *Broadway Melody*, in which characters sing and dance as they struggle to put on a show. The backstager proved one of the most resilient subgenres of the musical because it permitted filmmakers to present songs as rehearsals, performances, and the effusions of professional singers in love with their jobs. Even after Hollywood had developed its "spontaneous song" convention—in which a song, such as "Over the Rainbow," is portrayed not as a performance for an on-screen audience but as an impulsive outburst—the backstager continued to thrive in Warner Bros.'s Busby Berkeley spectaculars, MGM's "Backyard Musicals," Paramount's *The Big Broadcast* series, and many other musicals.

The convention of "spontaneous song" developed tentatively at the very end of the 1920s. Filmmakers began testing the convention with two types of characters: cartoon figures and blacks. Mickey Mouse and other cartoon animals, for instance, sing in *The Karnival Kid* (1929) (video 11.2 ▶). The animated anthropomorphic figures (which include dancing hot dogs) were already so artificial that spontaneous singing seemed an appropriate addition to the self-consciously imaginative scenario. African American characters sing spontaneously in *Hearts in Dixie* (1929) and *Hallelujah!* (1929), which exploited stereotypes about "primitive impulses" and "natural rhythm." "Because of racial stereotypes about blacks as more 'spontaneous' than whites," Furia and Patterson write, "musicals could be made about blacks in which characters burst into song without having to have the realistic excuse that they were . . . putting on a show."[3] For audiences in 1929, the characters' race offered a realistic pretext for song outbursts, particularly when the films portrayed the characters laboring.

In the early years of the musical, songs rarely expressed characters' dramatic situations. *The Jazz Singer*, for instance, featured already popular tunes, included in the film merely so that Jolson could perform them, not to advance the story through song lyrics. Spring notes that the earliest synchronized sound films "flaunt the spectacle of singing stars," rather tightly integrating song and narrative as later musicals would do.[4] In *Hallelujah!* and *Hearts in Dixie*, the characters sang mostly traditional songs that did not specifically reflect characters' thoughts and emotions. Although Irving Berlin wrote two original songs for *Hallelujah!* the film presents one of them, "Waiting at the End of the Road," as though it were a traditional folk song ("You know that song," one character says), even

though it is in fact a fox-trot. The film presents Berlin's other song, "Swanee Shuffle," as a performance. Neither song resonates with the characters' dramatic situation.[5]

In 1928 and 1929, Hollywood occasionally commissioned original songs that expressed the thoughts and feelings of the characters. These early "expressive songs," although portrayed as performances, laid the groundwork for the "spontaneous songs" of later musicals, when Hollywood would use emotional expression to motivate a musical outburst. Furia and Patterson note that Buddy DeSylva, Lew Brown, and Ray Henderson wrote "Sonny Boy" so that Al Jolson could sing it to his character's dying son in 1928's *The Singing Fool*.[6] Spring says that *Weary River* (1929) portrays its male lead singing the film's title song on a radio broadcast from prison, signaling the criminal's desire to reform: "Oh, how long it took me to learn/Hope is strong and tides have to turn."[7] In *Marianne* (1929), Lawrence Gray performs the original Greer and Klages song, "Just You, Just Me," for Marion Davis. Although the film portrays "Just You, Just Me" as a performance, the lyrics express, albeit in a fairly generalized way, the doughboy's desire to woo the French farm girl ("Let's find a cozy spot, to cuddle and coo") (video 11.3 ▶).

In these and a handful of other films, performance songs express the emotional experiences of the characters who sing them. Indeed, the Hollywood musical—like stage musical, operetta, and opera—has generally placed songs at moments of emotional intensity. Richard Dyer says that "Musicals are discourses of happiness," but songs in Hollywood musicals express any intense emotion.[8] In the universe of the Hollywood musical, song becomes a kind of impulsive, visceral outburst of feeling. The conflation of song and feeling helps explain the thick melodrama we associate with the Hollywood musical, since an excess of emotion and the desire to communicate feelings are the hallmarks of movie characters who burst into song. Although emotional expression at first served as a pretext for musical outbursts, that pretext began to define the genre, so that we now associate the classical Hollywood musical with characters who want to broadcast their feelings.

The convention of spontaneous song developed more fully at the end of 1929, when, according to Furia and Patterson, Paramount produced "the first operetta to be written for the screen."[9] With the release of *The Love Parade* in November of that year, Paramount found that audiences accepted Europeans, notably Maurice Chevalier, breaking into song and even speaking to the audience, signaling the breach of cinematic realism. Chevalier developed a talking-on-key singing style that helped blur the distinction between singing and regular speech, thereby enabling a smoother transition. In the hands of directors Ernst Lubitsch and Rouben Mamoulian, *The Love Parade, Monte Carlo* (1930), *The Smiling Lieutenant* (1931), *One Hour with You* (1932), and *Love Me Tonight* (1932) transformed the conventions of turn-of-the-twentieth-century European operetta into modern film musicals.

The most spectacular number in Mamoulian's *Love Me Tonight* features a contagious spontaneous song. Rogers and Hart's "Isn't It Romantic?" begins when the tailor, Maurice (played by Chevalier), sings to one of his clients after outfitting him in a new suit. The client picks up the tune as he leaves the shop ("A very catchy strain. Oh I forgot my cane"). A taxi driver approaches him ("Taxi?" "Oh no, I need some air") and begins to sing the song himself as he lands a passenger ("At last I've got a fare"). (Video 11.4 ▶) The passenger, naturally, picks up the tune from the driver ("Not too fast, I hate to take a chance." "Isn't it romance?") and continues singing on a train, where soldiers overhear him and then sing it as they march. A gypsy overhears the soldiers and demonstrates it on his violin to a group sitting around a campfire. The song culminates when Princess Jeanette (Jeanette MacDonald) overhears the gypsy from her palace and completes the song on her balcony. Here, spontaneous song links characters, stories, and settings through a euphonic meme. If one tried to use mere dialogue to connect these diverse storylines and spaces, the scene would likely grow chaotic and labored. But spontaneous song makes the chain of connections graceful and charming.

In 1933, the small, struggling RKO studio took a gamble on a dancer, Fred Astaire, whose stage career had flatlined. The studio cast him with Ginger Rogers in a series of musical films in which the characters smoothly moved from talking to singing, walking to dancing, and back again. Films such as *The Gay Divorcee* (1934) and *Top Hat* (1935) took place in foreign locales, where audiences, coming from their experiences with Lubitsch and Mamoulian, had grown accustomed to seeing characters sing spontaneously. The films balanced spontaneous songs with songs portrayed as performances, and Astaire and Rogers usually played the roles of performers to help justify their musical outbursts.

For the Astaire-Rogers musicals, a group of skilled songwriters—mainly Irving Berlin, the Gershwin brothers, Dorothy Fields, and Jerome Kern—wrote songs and surrounding dialogue that deftly eased the transitions between speaking and singing. One scene in *Top Hat* negotiates the transition to song almost seamlessly. Caught in a rainstorm in a London park, Astaire and Rogers take refuge under a bandshell. As he talks about lightning in increasingly stylized dialogue, a sudden thunderclap brings up background music. She cowers, and his speech starts to rhyme—"The weather is frightening"—as he eases into the "verse" of Berlin's "Isn't This a Lovely Day?" The verse—the expendable, prosaic introduction to popular songs at that time—provided musical filmmakers with a convenient transitional device, enabling them to exploit a common convention in popular music of the day in order to segue more seamlessly into song (video 11.5 ▶).

After the verse, which ends with the vernacular phrase, "as far as I'm concerned it's a lovely day," Astaire moves fully from talking to singing. But, even in the more melodic chorus of the song, he still sings with a chattiness bolstered by such colloquial lines as "You were going on your way, now you've got to remain." Since Astaire and Rogers

lip-synched their own pre-recorded voices, their singing seems as effortless as talking, and songwriters took advantage of the playback technology to craft more naturalistic lyrics. Instead of the long vowels singers required to project songs from a live stage—"Blue skies smiling at me-ee-ee"—lyricists supplied Astaire and Rogers with colloquial phrases, clipped words, and crisp consonants more native to the English language: "Let's Call the Whole Thing Off," "Cheek to Cheek," "Stiff Upper Lip," "No Strings."[10]

By 1934, the Astaire-Rogers musicals had established the convention that live-action, human, Caucasian American characters—and, by extension, just about any character— could spontaneously burst into songs that were not portrayed as performances for an on-screen audience. Songwriters wrote original songs directly for the movies, and the songs expressed characters' thoughts and emotions at appropriate moments in the drama, as though the songs came into being, fully formed, at the moment the characters first sang them.

For the next twenty-five years, Hollywood produced a series of original musical films that dexterously integrated spontaneous outbursts of song into their plots. Such films rival the best of Broadway, which, with such musical dramas as *Pal Joey* (1941), *Lady in the Dark* (1941), and *Oklahoma!* (1943), also developed its spontaneous-song convention to make it more expressive of character and dramatic situation. Film audiences throughout this period accepted the convention that just about any performer could give voice to his or her feelings through spontaneous song—not just Gene Kelly, Judy Garland, Astaire and Rogers, but also performers not typically associated with the musical, such as Jimmy Stewart and Marlon Brando. That hard-won convention enabled the many successful Hollywood musicals produced between the 1930s and 1950s.

We can see how the developing use of song in the musical genre—from pure performance numbers to tentative uses of expressive songs and spontaneous songs to full-blown musical outbursts of thought and emotion—enabled filmmakers increasingly to exploit the aesthetic possibilities of song in cinema. Filmmakers could now use songs like dialogue—to express characters' mental states in an extemporaneous way. Because the convention has now grown obsolete, contemporary cinema has no equivalent of the "Over the Rainbow" number in *The Wizard of Oz* or "Isn't This a Lovely Day?" in *Top Hat*. Even an ordinary Hollywood musical such as *The Big Broadcast of 1938* (1938) uses spontaneous song poignantly to reveal character interiority. In one scene, Bob Hope and Shirley Ross play ex-spouses who realize, as they spontaneously sing "Thanks for the Memory," that they are still in love. The duet is shot in an uninventive style, mostly a two-shot of the actors sitting at a bar with occasional cut-ins to one character or the other. It features two competent but unremarkable singers. And the story that surrounds the song is silly and uninspired. But the spontaneous duet establishes the characters' intimacy, affection, and rapport, as though the characters are jointly having the same thoughts and

emotions in the same format and *speaking their minds* through a casual, collaborative act of musical invention (video 11.6 ▶).

The absence of equivalent scenes in contemporary cinema results not from a dearth of talent (today's Broadway could supply busloads of singers more talented than Hope and Ross) but rather from the more lamentable reason that modern film styles no longer allow for such moments and that filmgoers, now unfamiliar with the convention of spontaneous song, no longer accept them. Once movie audiences commit to the realistic, but unromantic, notion that people do not regularly communicate through song, and once a movie must acknowledge that a song as elegant as "Thanks for the Memory" is composed before it is sung, then song in cinema loses some of its immediacy and intimacy and can no longer express impromptu thoughts and emotions.

The convention of spontaneous song furthermore allowed for a variety of scenes, performances, and stories unavailable within the limited parameters of the backstager. Indeed, the backstager had, by the mid-1930s, produced so many similar storylines that today films and TV shows still parody musicals from that period. Spontaneous song opened up the genre, allowing for stories not just about singers but about priests (*Going My Way*, 1944), tailors (*Love Me Tonight*), sailors (*Anchors Aweigh*, 1945; *On the Town*, 1949), and painters (*An American in Paris*, 1951). And it allowed the musical genre to blend with other genres, including fantasy (*The Wizard of Oz*), family drama (*Meet Me in St. Louis*, 1944), swashbuckler (*The Court Jester*, 1955), costume picture (*Maytime*, 1937), and screwball (*Carefree*, 1938; *High Society*, 1956).

The convention also enabled an integration of story and song that added unity to storytelling in the musical. Although we often think of musical numbers as set pieces within a film, Hollywood songs often fit seamlessly into narrative, revealing character and sometimes advancing the story's causal progress (e.g. "Follow the Yellow Brick Road/You're Off to See the Wizard" in *The Wizard of Oz*). Producers rarely involved songwriters at the scriptwriting stage and, as a consequence, Hollywood seldom merged story and song as tightly as Broadway. However, the spontaneous song convention allowed Hollywood movies to better integrate songs with cinema's other storytelling devices.

Finally, the convention allowed a group of extremely talented performers to fully explore their acting and singing capabilities through a variety of roles and stories and to demonstrate their dancing and vocal skills in diverse styles and situations.

LOSING THE CONVENTION

"Whatever happened to the musical?" Is it just that Astaire, Rogers, Kelly, Garland, and Charisse got too old — or too dead — to do it anymore? Did the astonishing age of American songwriting just lapse? . . . *Did rock and roll crush*

the musical? Did the genre need the studio system, rich in chorines, arrangers and choreographers? ... why haven't the movies been capable of fashioning decent musicals since the late 50s? One moment we were getting Funny Face *(1956),* Silk Stockings *(1957), and* Gigi *(1957) — and then there was nothing.*

—David Thompson[11]

In the late fifties, a variety of factors contributed to the loss of the spontaneous song convention, so that nowadays audiences have again grown uncomfortable with the notion that film characters can burst into song without realistic motivation. Fehr and Vogel note that "musical pictures, traditionally the most expensive of Hollywood properties, have simply priced themselves out of a market that has grown singularly unappreciative of them to begin with."[12] Declining audience attendance, the emergence of television, the rising cost of film production, and the Paramount court case (which initiated the breakup of the studio system) created financial troubles for Hollywood studios, forcing them to give up backlots and huge production crews of songwriters, arrangers, choreographers, background singers, chorines, and orchestras necessary to make original musicals. Fehr and Vogel also note that changing film styles quickly robbed the musical of its most valuable conventions.

> The principles that had guided filmmaking for decades were displaced by a realism so inimical to musical pictures that they dwindled down to a not-so-precious few. . . . The largely harmonious, ever-cheerful movie universe of the 1929–65 period dissolved without a whimper, a victim of the growing disdain for accepting backlot fantasy as a means of evading the depressingly large assortment of social ills demanding real-world remedies.[13]

According to Fehr and Vogel, in the late sixties, when the courts replaced censorship with the film ratings system and removed restrictions on American cinema's subject matter, "older generations imposed a self-censorship that has estranged them from the box office. Their abstinence has diluted the supply of antiquarians whom old-style movie musicals logically might have been expected to attract."[14]

Three forms of film musicals remained, but they could not fully exploit the aesthetic potential that Hollywood musicals had earned during the studio era. First, Hollywood mounted lavish film versions of successful Broadway musicals, such as *My Fair Lady* (1964) and *The Sound of Music* (1965). Apparently, movie audiences more readily accepted spontaneous outbursts of song in films that inherited the convention from their Broadway sources. Second, rock offered another form of musical film, including the Elvis Presley vehicles and other musicals aimed at teen-age audiences, such as *The Girl*

Can't Help It (1956) and *A Hard Day's Night* (1964). Although the image of rock music as instinctual and uncontrolled allowed for a degree of spontaneous musical expression, such films typically relied on the song-as-performance convention to integrate musical numbers into their plots. Finally, Hollywood continued to release musicals aimed at children, such as *Mary Poppins* (1964), *The Muppet Movie* (1979), and *The Nightmare before Christmas* (1993). These musical forms left little room for the sophisticated and casually spontaneous original songs that had emerged out of studio-era Hollywood. Such songs had started to sound quaint when rock took over popular music. Songwriters who had once flourished in Hollywood found that filmmakers no longer called upon them to write full sets of songs for musicals.[15] Johnny Mercer, for instance, sank to the piece-work of writing lyrics to the music of Henry Mancini for "theme songs" that played over the opening titles of *The Days of Wine and Roses* (1962) and *Charade* (1964). Without the steady stream of musicals and with changes in song styles and film styles, audiences eventually lost touch with the spontaneous song convention.

TRANSFORMING THE CONVENTION: INTERNAL SONG

Unable to rely on the convention of spontaneous musical outburst, filmmakers would require new conventions if they wanted to continue to exploit the potential of song to express the thoughts and emotions of film characters. They would have to develop novel forms of expressive song, adapted to contemporary film, performance, and music styles.

Shortly after the classical period of the musical ended, *The Graduate* (1967) helped establish a new means of using songs in cinema. The film, directed by Mike Nichols, starred Dustin Hoffman as Benjamin Braddock. While no one would accept Dustin Hoffman suddenly bursting into song, that very fact makes the actor a fitting choice for a new expressive-song convention. During the film's opening credits, as we see Benjamin standing on an airport moving walkway, the soundtrack plays Simon and Garfunkel's "The Sounds of Silence" (video 11.7 ▶). The song does not merely set a tone for the movie. The melancholy melody and lyrics ("Hello darkness, my old friend," "I turned my collar to the cold and damp") indicate Benjamin's loneliness, sadness, and fear, in effect telling us what Benjamin's expressionless face does not.

The novel use of song in *The Graduate* was not entirely new. Hollywood had already used theme songs in non-musicals in order to comment on character psychology. As Spring notes, some of the lyrics in Stan Jones's "The Searchers," written for the 1956 movie of the same name, concern the psychology of the film's protagonist, Ethan Edwards: "A man will search his heart and soul/Go searching way out there/His peace o' mind, he knows he'll find/But where, Oh Lord, Lord where?"[16] But there's a crucial difference between the uses of song in *The Searchers* and in *The Graduate*: Whereas the ballad,

"The Searchers," is *about* its film's protagonist, "The Sounds of Silence" seems to emanate *from* its film's protagonist. Indeed, the lyrics and melody of "The Searchers" are far too romantic to issue from the mind of a cynic like Edwards. *The Graduate*, by contrast, invites us to understand that the melancholy song, although not sung by Hoffman, expresses the character's own thoughts and emotions, much in the way spontaneous songs did in the studio-era musical.

"The Sounds of Silence" plays at two other points in *The Graduate* and seems to express Ben's thoughts and emotions each time, although variations in narrative context add nuances to each musical expression. We hear the entire song again during a montage sequence that shows Benjamin alternately lolling around his parents' home and meeting Mrs. Robinson, a friend of his parents, for passionless sex in a hotel room. Again, the mood of the song resonates with Benjamin's dejected manner, but the lyrics we heard during the credit sequence gain new resonance because of the character's present predicament. Here, they specifically express Ben's alienation from his parents, the world around him, and the sex he seems not to enjoy ("In restless dreams I walked alone, narrowed streets of cobblestone"). Nichols and editor Sam O'Steen first used the song as a temporary track while they edited the montage, but they ultimately committed to it. "'Hello, darkness, my old friend . . .' was what was happening in Benjamin's head," Nichols said. "O'Steen and I were beside ourselves, because we knew nothing else would work. We felt that the song expressed the deep depression he'd been in since he got home, an emotional suicide that he commits by starting to fuck Mrs. Robinson."[17] Moreover, Benjamin's inability to tell anyone his feelings about the events in his life—feelings that would revile his parents—becomes a subject of the film in part by means of the soundtrack, expressed through such lyrics as, "But my words like silent raindrops fell and echoed in the wells of silence."

The final appearance of "The Sounds of Silence" during the film's last scene shows the most subtlety and narrative complexity. After Benjamin lures Mrs. Robinson's daughter, Elaine, from her marriage to a medical student, the two of them escape the crowd at the wedding chapel and triumphantly leap aboard a public bus, Elaine still in her wedding gown. As the reality of their actions settles into their faces, "The Sounds of Silence" resumes in the soundtrack at the moment their expressions turn from jubilation to anxiety. The melancholy song, which we have already associated with Ben's sadness, loneliness, and indecision, works in tandem with their worried looks to undermine what might otherwise have been a happy ending.

This new form of expressive song offered a fresh manifestation of an obsolete convention, adapted to contemporary film styles and musical tastes. Like the "spontaneous songs" of studio-era musicals, the "internal songs" in *The Graduate* express the character's most intimate thoughts and emotions. "The Sounds of Silence," like "Over the Rainbow,"

establishes a connection between the protagonist and the spectator, who enjoys privileged access to the character's mental state. However, unlike the expression of feeling in a spontaneous song, Ben's "outburst" is by nature contained. Indeed, the character's silence allows for the musical intrusion. "The Sounds of Silence" says what Ben cannot say to his parents, to the other adults who badger him, perhaps even to himself. Since Ben, in every sense of the phrase, "can't sing," the song becomes an interior monologue, a musical soliloquy that he would sing if he could. Indeed, internal songs suit Method actors, such as Hoffman, since their performances often emphasize failures of speech, their characters' deepest emotions revealed through a rhetoric of pauses, stammers, and lines unsaid. In that way, internal songs oppose the tradition of singing in studio-era musicals, signifying not the emotional release that comes through musical expression but rather the frustration of a character who cannot express himself.

Such interior outbursts of song in non-musical films—from performers and characters who seem the farthest cry from those of studio-era musicals—opened up the possibilities for songs in cinema of the late sixties and early seventies, when the new internal-song convention peaked. In *Easy Rider* (1969), Peter Fonda and Dennis Hopper in effect "sing" Steppenwolf's "Born to Be Wild" as they drive motorcycles across America's highways. Riding the Greyhound bus to New York, John Voight in *Midnight Cowboy* (1969) expresses himself inwardly, as he cannot do outwardly, with "Everybody's Talkin.'" Bud Cort expresses his spiritual awakening through the songs of Cat Stevens in *Harold and Maude* (1971) (video 11.8 ⓟ). Slim Pickens, as a mortally wounded cowboy, "sings" "Knockin' on Heaven's Door," with Bob Dylan's voice, in *Pat Garrett and Billy the Kid* (1973). Songwriters often composed internal songs directly for the films in which the songs appeared. Hence audiences did not register them as preexisting popular songs (although many became popular) and more easily imagined them emanating for the first time from a befitting moment in the movie.

The internal-song convention that developed between 1967 and 1973 allowed Hollywood to resume the practice of expressive song, albeit in a diminished format, breathing a bit of life into a dead trope. By integrating the expressive song convention with contemporary storytelling and performance styles, Hollywood could continue to employ songs to convey story information, particularly information about characters' mental states. Internal song added novelty to the use of song in cinema, enabling new scenarios unavailable within the conventions of the studio-era musical. Whereas the spontaneous song convention of the studio-era musical treated song like dialogue, blazoning characters' thoughts and feelings, the internal-song convention used song to signify muteness, an index of lines unspoken. The new convention encouraged spectators to associate the thoughts and feelings expressed in a song with thoughts and feelings unexpressed by a character.

EXPOSING THE CONVENTION: THE IRONIC MUSICAL

In the 1970s, Hollywood began generating new forms of full-fledged musicals that accorded with contemporary film styles, which, more than at any other time in Hollywood, expressed bleakness. Discussing the post-classical Hollywood musical, Babington and Evans write: "What we see is the encounter between a utopian urge (without which the musical, as we know it, would be unrecognizable) and a dystopian reality given prominence, even predominance, in a way that it never was before."[18] We can witness this conflict, for example, in Bob Fosse's 1972 film adaptation of the stage show *Cabaret*, which concerns Nazism in Germany, an idea for a musical so outrageous that Mel Brooks had already parodied it in *The Producers* (1967). The downbeat strain in the musical genre expanded in the seventies, which produced such dark musicals as *Lady Sings the Blues* (1972), *New York, New York* (1977), and *The Rose* (1979).

The conflict between the exaggerated cheeriness of the Hollywood musical of the studio era and the gritty realism of contemporary film led some filmmakers to musical-genre irony. Spring notes that Hollywood began parodying the musical as early as 1930's *A Hollywood Theme Song*.[19] In the 1970s, however, when a generation of American filmmakers grew fascinated with calling attention to the artifice of cinema that their predecessors had tried so hard to mask, a trend of ironic musicals emerged that seemed to comment on the genre's struggles with the convention of bursting into song. Rather than trying to conceal the artifice, as earlier filmmakers had done, some filmmakers in the seventies called conspicuous attention to it.

In a curious way, the musical genre suited filmmaking in the seventies. For one thing, the 1970s fell close enough to the musical's prime that audiences understood when movies of this period alluded to studio-era musicals. Exploiting the fact that the public already considered the genre passé, filmmakers found musicals a convenient critical tool for revealing cinema's artifice. Martin Scorsese's *New York, New York* (1977) contains a sequence that shows Liza Minnelli starring in a 1940s Hollywood musical, appropriately titled *Happy Endings*. The main character of the film within the film becomes a singing Broadway star who eventually marries her true love. The artificiality of the forties musical juxtaposes the depressing realism of the larger story in which the characters fail to remain together. Brian de Palma's horror-musical *Phantom of the Paradise* (1974) also associates musical performance with artifice: the stage shows depicted in the film come off as glitzy, bastardized pop versions of the heart-felt musical compositions of the film's central character, Winslow Leach. Whereas many earlier musicals (such as *Meet Me in St. Louis* and *An American in Paris*) represent songs as spontaneous outbursts of authentic feeling, the ironic musicals of the seventies often portray musical performance as a sham.

All That Jazz (1979) represents the death-bed scene of its main character, Joe Gideon (Bob Fosse's semi-autobiographical filmmaker and Broadway choreographer) as a series of musical hallucinations. In a setting that looks like a surreal mixture of hospital room and Hollywood sound stage (figure 11.1), Gideon imagines that his family and friends talk to him through a series of musical performances. When Gideon's family and a cast of dancing chorus girls break into the 1923 song "Who's Sorry Now?"—performed in the fanciful style of a Busby Berkeley number—the film associates Gideon's fantasy with the fantasy of the musical genre. The death-bed scene supplies merely the most outrageous example of the film's tendency to equate outbursts of song with fantasy. Earlier in the film, after Gideon's heart attack, his ex-wife tries to cheer up an anxious cast, reassuring them of his good spirits and quick recovery and then performing a lively musical number. During her performance, the film intersperses flashbacks in which she weeps in front of Gideon's hospital bed, an oxygen-mask covering his comatose face, shots that belie the optimism of the song-and-dance.

The ironic musicals of the 1970s exposed and mocked the musical's conventions. Thomas Schatz identifies this point in a genre's evolution when he says, "As a genre's classic conventions are refined and eventually parodied and subverted, its transparency gradually gives way to *opacity*: we no longer look *through* the form . . . rather we look *at* the *form itself*."[20] Indeed, Hollywood's ironic musicals followed a trend of ironic genre filmmaking in the seventies, which included private detective films such as *The Long Goodbye* (1973); westerns such as *Little Big Man* (1970), *Blazing Saddles* (1974) and *Buffalo Bill and the Indians* (1976); and whodunits such as *The Last of Sheila* (1973) and *Murder by Death* (1976). Such films rely on our genre expertise in order to comment on earlier movies and make them look passé. Leo Braudy describes the message of such films as, "Well, at least if we make fun of [former genre beliefs] for being infantile, it will show how far

FIGURE 11.1 All That Jazz *(1979) incongruously combines hospital room props, Busby Berkeley–styled choreography, and a Hollywood sound stage.*

we've come."[21] Ironic genre films enable us to feel movie-literate, congratulating us for having gained mastery over conventions that deluded earlier generations of filmgoers.[22]

RECLAIMING THE CONVENTION: *EVERYONE SAYS I LOVE YOU* AND CONVENTION FOR ITS OWN SAKE

Once a genre reaches its ironic stage, it's difficult to keep it alive. By that point, the classical conventions of the genre no longer have sufficient power to delight. But Woody Allen had the sensibility to rethink the way cinema uses song and create a bridge between contemporary film styles and the conventions of the classical musical of the studio era. Songs from that period figure prominently in many of Allen's films, including *Annie Hall* (1977), *Stardust Memories* (1980), and *Radio Days* (1987), but he took on the genre directly in the innovative musical *Everyone Says I Love You* (1996).

Like *When Harry Met Sally* (1989), which contains such classics as "Love Is Here to Stay," "Let's Call the Whole Thing Off," and "It Had To Be You," *Everyone Says I Love You* incorporates old love songs, but Allen's actors do their own singing and the songs are not all familiar standards. Alan Alda, for instance, sings Cole Porter's "Looking at You" to his character's wife, played by Goldie Hawn. By presenting a less-familiar song by a well-known songwriter from the studio era, the film allows Alda to "own" the song. If Alda had instead sung Porter's "Night and Day," audiences might have recalled Frank Sinatra's famous cover of the song or Fred Astaire's canonical performance in 1934's *The Gay Divorcee*. Alda's casual delivery of the song, moreover, bespeaks his character's deep and comfortable love for his wife, whom he offhandedly compares to Helen of Troy.

David Thompson considers Allen's musical a mere "wistful glancing back at a form that is no more."[23] While the film does, as Thompson says, pay "due reverence to a lost past,"[24] *Everyone Says I Love You* does not come across as merely nostalgic, nor does it simply mimic the musicals it honors. Rather, the movie does something novel with the musical genre, something we find neither in classical Hollywood musicals nor in the ironic musicals of the seventies: The film celebrates the convention of spontaneous song itself. Let's examine how.

Like characters in studio-era musicals, the characters in *Everyone Says I Love You* burst into spontaneous songs, but Allen's film makes no effort to ease us into the contrivance. The film does little to realistically motivate the characters' singing and dancing (the actors do not play professional singers, for instance) or to smooth over the awkward transitions into or out of song and dance. On the contrary, *Everyone Says I Love You* seems intent upon showing the seams that join songs to "regular" narrative. Indeed, even though the film's initial audiences must have known they were going to see a musical, when Edward Norton bursts into the 1929 song, "Just You, Just Me," in the film's opening seconds, it

is startling (video 11.9 ⏵). After the initial title card, Norton begins singing right away, without any talking or orchestral prologue to help facilitate the transition into the musical world of the movie. That world seems a ready-made alternate universe—one similar to ours but one that has strangely adopted the conventions of an obsolete genre.

The fact that most of the stars in the film do not have strong singing voices enhances the strangeness of the artifice. Some of the actors, such as Alda and Hawn, sing extremely well. Other actors, such as Norton, Tim Roth, and Julia Roberts, are obvious amateurs; they sound no better than most of us would sound had we been cast in the movie. In spite of the clumsiness of some of the performances, they usually sound delightful. When Allen himself sings the 1924 song "I'm Thru with Love," his weak singing voice makes him more pitiable and the performance more touching for its lack of polish and professionalism. The experience of watching the stars struggle through their songs differs from that of watching, say, Jimmy Stewart singing "Easy to Love" in *Born to Dance* (1936) or Marlon Brando singing "Luck Be a Lady" in *Guys and Dolls* (1955). Those films seem to be making do with their actors' weak voices; the films would be better if the actors could sing better. *Everyone Says I Love You*, by contrast, is deaf to musical ability. Instead, it relishes the fact that, although it may seem strange to us now, film has a tradition of spontaneous musical outbursts and need not apologize for it.

Unlike his classical-era predecessors, Allen seems more concerned with the pleasure of the spontaneous-song convention itself than with the talent displayed in the performances. Studio-era filmmakers could justify musical outbursts because the songs allowed for the spectacle of musical entertainment. Motivated by audiences' desire to see Astaire, Kelly, Garland, and other talented performers sing and dance on screen, filmmakers developed elaborate contrivances to integrate songs into film. Audiences accepted the convention that characters could spontaneously burst into song, despite its evident absurdity, for the privilege of watching supremely gifted performers. Allen's film rejects the fundamental purpose of the convention, taking delight in the convention itself. The movie demonstrates what fun we could have if everyday people, even people with no musical talent, burst into song and dance from time to time to express their thoughts and emotions.

Although unlike any musical that preceded it, *Everyone Says I Love You* derives from the history of movie musicals and the conventions for presenting songs in film. Studio-era filmmakers attempted to mask the convention of spontaneous song by surreptitiously easing the transition from regular speech into and out of musical performance. Post-studio-era filmmakers of the period 1967 to 1973 developed the convention of internal song in order to adapt expressive songs to the constraints of contemporary film, performance, and music styles. And the ironic musicals of the seventies mocked the contrivances of

the genre. Like a studio-era musical, *Everyone Says I Love You* embraces the spontaneous song convention, and, like post-studio-era films, it responds to the loss of that convention. Allen's film, however, does not view the convention as something to hide, temper, or mock. Rather, for him, the convention itself accounts for at least some of the musical genre's peculiar pleasures. It's hard to imagine a filmmaker ever taking Allen's novel approach to the musical again, but the film briefly revitalizes the genre's conventions by transporting them into the modern day. Combining contemporary film and performance styles with the musical genre's outdated tropes, *Everyone Says I Love You* shows us what our world would look like if it obeyed the absurd conventions of a Hollywood musical.

CONCLUSION

At each stage in the development of the spontaneous-song convention, Hollywood filmmakers built on existing uses of song in cinema. Novel conventions were familiar enough to allow spectators to readily grasp a new device in light of contemporary practices and recent film history. The *internal song* convention employed by *The Graduate*, for instance, built on the *spontaneous song* convention of classical-era musicals, such as *The Wizard of Oz*, which built on the *expressive song* convention of early backstage musicals, such as *The Singing Fool*. Each new convention offered enough novelty to sustain aesthetic interest but not too much to prevent an average spectator from understanding the convention's function within the context of its genre. By offering easy recognition and only moderately disrupting audience expectations, Hollywood filmmakers continued to exploit the aesthetic potentials of song in cinema, adding novel variations, even after the era of the classical musical ended.

. . .

This chapter has sought to demonstrate the ways in which filmmakers have maintained the aesthetic vitality of the Hollywood genre system as they developed novel conventions that expanded a genre's standard repertoire of narrative and stylistic practices. But to fully understand the aesthetics of the Hollywood genre system, we must examine the other major strategy for combatting audience exhaustion with prevailing genre conventions: We must study not just *novelty* in genre filmmaking but *complexity*. In the final chapter of this book, we examine the ways in which filmmakers, from the studio era to the New Hollywood, periodically complicated the conventions of the Hollywood western.

Complexity and Experimentation
in the Western

G ENRES, IT IS SOMETIMES SAID, PROGRESS THROUGH PREDICTABLE
stages: From classicism (when filmmakers refine the genre's topoi) to complexity
(when they explore contradictions) to exhaustion (when the genre's topoi have worn out
their effectiveness) and eventually to parody (when filmmakers reverse and mock the
topoi and make apparent the genre's conventions).[1] Of course, this description character-
izes genre evolution too simplistically: Genres rarely evolve so straightforwardly, and the
arts, I noted in chapter 10, do not progress teleologically. Genres, such as the swashbuck-
lers of the 1930s and the disaster films of the 1970s, sometimes fade away if they lack
enough inherent complexity in their early stages to sustain multiple retellings. And genre
parodies, such as 1925's *Dr. Pyckle and Mr. Pryde*, sometimes appear early in a genre's
evolution, where, according to the generalization, they don't belong. But there is *some*
truth to the generalization. And the western offers us an illustrative case study of the ways
in which filmmakers experiment with more complex properties, maintaining a genre's
aesthetic vitality as members of a mass audience expand their genre expertise.

This chapter does not seek to explain the historical popularity of the western or
the attraction of the genre's most broadly appealing films. Rather, it tries to account for
(1) the western's endurance as a genre, (2) filmmakers' repeated experimentation with
western conventions, and (3) the appeal of some of Hollywood's most complex westerns
among cinephiles and other audiences with greater-than-average experience of the genre.

By the end of the 1960s, we shall see, the western seemed to have depleted its ability
to delight. However, post-studio-era filmmakers have continued to mine aesthetic value
from the genre, at times uncovering complexities that earlier filmmakers had glossed

over. The end of the chapter, then, examines the 1992 film *Unforgiven* to illustrate how a modern Hollywood western can still make creative contributions to the genre. *Unforgiven* could come along only after a long history of the western—past a period of classicism, complexity, and parody—since it draws on the western's earlier iterations, making something aesthetically vibrant out of conventions that had previously seemed exhausted.

THE INHERENT COMPLEXITY
OF THE CLASSICAL WESTERN

In a genre's classical phase, filmmakers develop and refine topoi as audiences learn to identify common themes, scenarios, iconography, and other genre properties. At this point, audiences begin to understand the genre and enjoy the aesthetic pleasures that result from increasing mastery (easy processing, familiarity, and expertise). During this stage of a genre's development, Hollywood filmmakers tend to limit experimentation so that their films remain accessible to mass audiences. Consequently, when we look back on films made during the beginning of a genre's classical phase, our own genre expertise sometimes causes them to appear overly simplistic. We should not conclude, however, that classical filmmakers were themselves simplistic. They were merely attempting to strike the right balance between genre unity and complexity for their intended audience.

Each year during the silent period, Hollywood released hundreds of mostly low-budget western shorts and features starring "Bronco Billy" Anderson, Tom Mix, William S. Hart, and other western actors. These silent films—along with later B-westerns of the 1930s and the popular western novels of James Fenimore Cooper, Zane Grey, and Louis L'Amour—shaped a distinct western myth, one enchanting enough to excite people's imaginations and also complex enough to sustain a century of exploitation in film. Indeed, from its early iterations, the western had already amassed complexities and contradictions that would take generations of filmmakers to unpack.

In the classical western, the hero (or westerner) comes across as rugged and determined, heroic and skilled, but he is also an outcast, a renegade, and a loner. Andre Bazin pointed to the inherent contradiction in the genre when he noted that justice in the western "must be dispensed by men who are just as strong and just as daring as the criminal. . . . There is often little moral difference between the outlaw and the man who operates within the law."[2] A reluctant hero, the westerner does not seek gunfights, although circumstances or honor force him into violent confrontation. Thomas Schatz notes that the western hero identifies with the violent world and that he shares traits with the savages he fights (Indians or outlaws), as well as with the civilization whose oppression he resists.[3] Indeed, the hero might himself be an outlaw, as in *Hell's Hinges* (1916),

Billy the Kid (1930), and *Stagecoach* (1939). John Cawelti calls western heroes "men in the middle" because they "possess many qualities and skills of the savages, but are fundamentally committed to the townspeople."[4]

Bazin recognized the moral complexity of the classical western. *Stagecoach*, he says, demonstrates

> that a prostitute can be more respectable than the narrow-minded people who drove her out of town and just as respectable as an officer's wife; that a dissolute gambler knows how to die with all the dignity of an aristocrat; that an alcoholic doctor can practice his profession with competence and devotion; that an outlaw who is being sought for the payment of past and possibly future debts can show loyalty, generosity, courage, and refinement, whereas a banker of considerable standing and reputation runs off with the cashbox.[5]

The classical western's conventional mode of presentation, however, often obscured its moral ambiguities. The westerner's goal (to defeat Indians or outlaws) seems obvious and proper because conventional narrative and stylistic devices concentrate our sympathy for the hero and our antipathy for his antagonists.

Western filmmakers of this period, for instance, employed conventional stylistic devices to sway our attitudes toward characters. As we saw in chapter 7, style in Hollywood cinema typically connects magically to character, so that morally good figures appear attractive and their antagonists unattractive. In this way, filmmakers conform the viewer's sensory preferences to a film's moral design, distinguishing heroes from villains by means of style. In figure 12.1 from 1931's *Cimarron*, for instance, we see the hero, Yancey Cravat (Richard Dix), in a romantic pose with his wife, Sabra (Irene Dunne). Soft glamour lighting on Dix, combined with a halo of backlight, enhance the actor's perfect nose and distinctive jaw. *Stagecoach* introduces its outlaw hero with a dramatic tracking shot toward the Ringo Kid (John Wayne), who stands with masculine authority and dusty ruggedness against a picturesque western landscape (figure 12.2). Just by itself, the style of the tracking shot tells us that Ringo is the film's hero (video 12.1 ▶). *Union Pacific* (1939) portrays actor Joel McCrae with soft frontal lighting, and McCrae invariably stands and moves with confidence and determination (figure 12.3).

By contrast, these and other films from the western's classical period regularly portray their villains as grimacing, unkempt, or otherwise shady. Unlike classical western heroes, who stand tall, classical western villains often slouch (figures 12.4 and 12.6); they are often lit hard, with shadows and heavy facial modeling (figures 12.4 and 12.6); and they might have facial hair and shifty eyes (figures 12.4 and 12.5) or else appear overly primped and swaggering (figure 12.6). The actors who play villains often hold props—drinks, food,

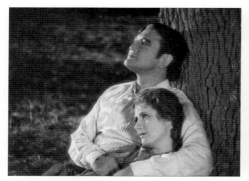

FIGURE 12.1 Cimarron *(1931).*

FIGURE 12.2 *Stagecoach (1939).*

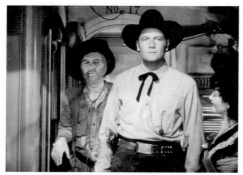

FIGURE 12.3 *Union Pacific (1939).*

FIGURES 12.1–12.3 *Images of Western heroes.*

guns, etc.—in an insouciant manner, reflecting their indifferent attitude toward the feel-
ings, or lives, of other characters (figures 12.4 and 12.6).

Whereas westerns of this period typically portrayed outlaw villains as repellent, unscrupulous, and vengeful, they typically portrayed Indian villains as barely human—wild, murderous, beastly creatures who kill from instinct, not for any reasonable moti-vation. White characters might refer to them as "bucks." In the classical western, many Indians are apish figures who kill Caucasians and destroy Caucasian property out of primitive malice (figure 12.7). Except for the often comical Indians who are aligned with the whites, Indians in classical westerns rarely warranted close-ups, intelligible dialogue, or any other kind of individuation.

In short, notwithstanding the genre's inherent moral ambiguities, classical west-erns relied on conventional devices to promote an idealized western hero and to make his antagonists appear unattractive, odious, and nasty. The classical western developed a complex moral code for the hero, who might have more in common with villains than with the townspeople he protects. However, the genre adopted Hollywood's

FIGURE 12.4 Cimarron *(1931).*

FIGURE 12.5 Stagecoach *(1939).*

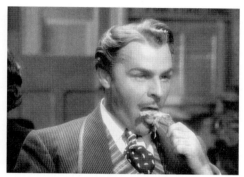

FIGURE 12.6 Union Pacific *(1939).*

FIGURES 12.4–12.6 *Images of Western villains.*

FIGURE 12.7 Cimarron *(1931) portrays Indians as beastly primitives without reasonable motivation.*

conventional narrative and stylistic devices to make it relatively easy to distinguish heroes from villains and, ultimately, to make the hero's behavior seem appealing and correct. Such devices thrust fixed meanings on morally ambiguous characters and scenarios.

Even the Code violation at the end of *Stagecoach* seems fitting because of our hero's appeal and because the ending conforms to some fundamental conventions of the genre: Our protagonist, an escaped outlaw, gets off scot-free after killing for revenge and then flees to Mexico with a prostitute. One might think such an ending would violate studio-era Hollywood's artificial moral universe, but the Production Code Administration gave more latitude to westerns than it did to other genres. And, besides, Doc Boone's epigram, spoken to Marshal Wilcox as they watch the couple ride off, makes the moment seem correct, even destined: "Well, they're saved from the blessings of civilization." The ending may appear morally strange in the context of Code-era Hollywood, but the line sounds appropriate for a western, given the genre's conflicted attitude toward civilization's taming forces.

The aesthetic complexity of the classical western results largely from a tension between two antithetical tendencies: on the one hand, narrative and stylistic devices that enhance a western's moral clarity and, on the other, genre traditions that make the westerner ideologically ambiguous. Joseph Reed describes the "difficult truths" of John Ford's westerns as "unconventional wisdom revealed by conventional means."[6] He could just as well have been describing the paradox of the classical western generally.

EXPERIMENTATION WITH GREATER COMPLEXITY

Chapter 10 proposed that genres evolve when filmmakers build on existing conventions, exploring more complex renditions of existing formulas. Balancing the pressures of risk reduction and product differentiation, I argued, genre filmmakers in Hollywood seek to maintain enough familiarity so as not to alienate a mass audience while also generating enough cognitive challenge to excite aesthetic interest. Since that balance is determined by the coping potential of individual spectators, Hollywood filmmakers tailor their films to the aesthetic expertise of their intended mass audience, aiming for enough complexity to prevent boredom but not so much as to create confusion.

By the late 1940s, the general filmgoing culture had enough experts in the conventions of the western that filmmakers could mine the complexities of the genre more deeply without alienating too many members of a mass audience. Filmmakers persisted in finding psychological and ideological richness in a genre that, had it failed to evolve, might have depleted its ability to delight, as was the case, say, with the "fallen woman" genre of the 1930s. Many westerns of the forties and fifties exhibit the kind of ideological

complexity found in films noirs of the same period. The classical virtues of western heroism in, say, *Cimarron* and *Stagecoach*, receive a more complex treatment in *Red River* (1948), *Fort Apache* (1948), *The Naked Spur* (1953), and *The Searchers* (1956).[7] The westerner's typical virtues—his rugged individualism, single-mindedness, intractability, pride, authoritativeness, adeptness with his gun, and desire for speedy, violent justice outside the narrow confines of the law—receive more complex treatments between the late 1940s and early 1960s, when several westerns intensified the moral contradictions of the westerner and explored them in more provocative ways. The western evolved as filmmakers intensified the psychological complexities of the western hero and the ideological complexities of the genre's worldview.

Red River illustrates these complexities. Thomas Dunson (John Wayne) transforms into a tyrant on a long cattle drive to Missouri, growing increasingly brutal and despotic toward his own men. The beginning of the film exhibits some of the classical western's inherent moral ambiguities, which gain increasing thematic prominence as the film progresses. For instance, Dunson's claim to the land he cultivates results from killing one of the gunslingers of Don Diego, the land's current owner, in a draw. The killing alone would not cause much concern, but the film takes pains to portray the Mexican gunslinger as hospitable ("You are welcome for a night, a week"). Indeed, the dutiful gunslinger seems no less virtuous than Dunson. If the film had portrayed him as rude or villainous and if Dunson did not kill him so blithely, then the moment when Dunson shoots the gunslinger—who was only protecting Diego's land from trespassers—would have felt more justified. Still, at this point in the film, Dunson's behavior remains relatively unobjectionable. The scene justifies the killing ("That's too much land for one man," Groot says about Diego), and here, unlike in later scenes, no other characters object to Dunson's behavior. The narration, furthermore, does not elicit much sympathy for the gunslinger or use stylistic devices (such as a close-up of him after he's shot) to emphasize the scene's moral ambiguity.

Later in the film, however, the very traits that we admired in *Stagecoach*'s Ringo Kid—determination, independence, boldness, fearlessness, self-confidence, and strength—seem morally suspicious when Dunson exhibits them. For instance, when Dunson endeavors to whip and kill Bunk Keneally (Ivan Parry) for causing a deadly stampede, the narration centers on Keneally's anxiety and the shocked response of Matthew Garth (Montgomery Clift) to Dunson's brutal proposal. This and other scenes in the second half of the film emphasize the dark and dangerous side of the westerner's character.

The ambiguity of the western hero of the studio era reached its zenith in 1956's *The Searchers*. The film's protagonist, Ethan Edwards (Wayne), hates Indians with a racist savagery, and his fierce independence makes him intractable, intolerant, and frightening. Here, the westerner's reliance on his own ethical code, separate from that

of society, comes across as more disturbing than admirable. For instance, Edwards seems to have robbed some gold coins; he wants to kill his own niece, Debbie, because Comanche Indians have captured her; and we see him shoot three men in the back. In the language of the western, "shot in the back" translates as "killed by a coward." Although the three men had it coming—they had tried to kill and rob Edwards—an earlier western would have had the westerner shoot them in a more noble fashion, say to protect his own life or someone else's, rather than fire on the men while they fled in fear.

The Searchers questions the morality not only of its hero but also of the U.S. cavalry, which studio-era Hollywood normally portrayed reverently. In one troubling and narratively gratuitous scene, Debbie's brother, Martin Pawley (Jeffrey Hunter), and Ethan come upon a group of slaughtered Indians. Viewers might assume at first that another Indian tribe has attacked the group because the dead bodies fan out with the kind of messiness westerns normally reserve for Indian attacks (figure 12.8). We soon learn, however, that the cavalry killed them, in the Caucasian equivalent of an Indian "murder raid," and left the dead bodies exposed. Martin, shocked, decries the cavalry upon finding his Indian bride, dead in a tent: "What did them soldiers have to go and *kill* her for, Ethan! She never done nobody any harm!" Here, the film briefly adopts an Indian's perspective of white soldiers as senseless slaughterers.

The film's final battle sequence—when Martin, Ethan, and members of the town and cavalry set out to save Debbie and attack the Comanche village—inserts shots that interfere with the efficiency, thrill, and moral clarity of the scenario. During the raid on the village, we see brief images of Comanche children running in fear as older Indian villagers try to protect them from the white attackers (figure 12.9). Someone had to hire, clothe, make up, and direct those children: Why include them at all, except to interfere with

FIGURE 12.8 The Searchers *(1956). An attack on an Indian camp makes the U.S. cavalry look like brutal slaughterers.*

FIGURE 12.9 *The framing of this shot from* The Searchers *(1956) emphasizes a Comanche woman protecting a child as our protagonists shoot up the Indian village.*

FIGURE 12.10 *Ethan Edwards (John Wayne) holding Scar's bloody scalp, which Edwards has cut off himself, at the climax of* The Searchers *(1956).*

spectators' full hearted support of the raid? The scene moreover includes perhaps the most astonishing image in any studio-era western: John Wayne's character holding the bloody scalp of his Indian adversary, Scar (figure 12.10). According to the conventions of the classical western (although not according to history), only Indians scalped their victims. Here, Ethan scalps the dead Comanche leader, then holds the bloody scalp in his hand as he chases down his niece, presumably to kill her. Although this image of the western hero would not have appeared in classical westerns of previous decades, we can nonetheless view the figure in this image from *The Searchers* as the barbaric endpoint of the westerner of the studio era.

"*The Searchers,*" Richard Slotkin says, "goes beyond the limitations of the classical myth by developing a psychological critique of its hero."[8] We see similar psychological, and ideological, critiques throughout westerns of this period. Jim Kitses says that "*Fort Apache* is a film of antithetical energies, a liberal critique of militarism that culminates in a conservative defence of tradition, at once both revisionist and reactionary."[9] And Schatz says that in *Winchester 73* (1950), *The Naked Spur* (1953), *The Man from Laramie* (1955), and *Two Rode Together* (1961), "James Stewart's 'aw-shucks' naiveté [is] effectively inverted to reveal genuinely psychotic, antisocial figures."[10]

From the late forties and into the sixties, filmmakers explored previously latent ideological and psychological complexities inherent in the western's classical foundations. Although Hollywood released hundreds of more simple westerns during this period—and television contributed to the genre's exhaustion with such shows as *Gunsmoke, The Lone Ranger, The Rifleman, Rawhide, Bonanza,* and many others—the American film industry also created several complex westerns that appealed to filmgoers tired of the traditional formula, making the genre more challenging for fans and expanding their expertise.

I argued in chapter 10 that aesthetic pleasure is, in part, a factor of an artwork's complexity and novelty (too much leads to confusion; too little leads to boredom) and the perceiver's expertise (too much leads to boredom; too little leads to confusion). By the late forties and fifties, the western had grown so popular that filmmakers could explore more complex treatments of traditional scenarios, sufficiently challenging the genre's experts. Judging from the existence of these westerns, we can assume that a sufficient number of western fans possessed enough expertise that they would not feel overwhelmed by increased complexity in the genre. Indeed, we can view these films as Hollywood's effort to differentiate, for a sizable niche market, some complex westerns from the overwhelming number of simple westerns released around the same time. The western had established its topoi so firmly (horses, homesteads, desert landscapes, saloons, gunfights, dances, cowboys, outlaws, Indians, etc.) that filmmakers could explore the genre's fringes, relying on the ability of filmgoers to comfortably identify the genre and predict an individual western's narrative development. The genre's sturdiness and stability and the expertise of some mass audience members encouraged filmmakers to test the limits of genre variation and even seriously question one of the western's most fundamental features: the hero's righteousness.

EXHAUSTION, PARODY, AND REVERSAL

During the studio era, Hollywood made more westerns than it did any other genre. But by the mid-1960s audiences seemed to have grown tired of the genre and its popularity plummeted. In 1945 the American film industry released a total of 89 westerns, in 1955 it

released 69 westerns, and in 1965 only 29 westerns, a 67 percent decrease in twenty years, more than double the decrease in U.S. film production generally during that time. Then, in the 1970s, alongside a few serious treatments of the genre, Hollywood began to parody the western by reversing its topoi or reversing their significance. The "mock westerns" of this period turn classically negative traits into the heroes' virtues and make the heroes' traditional virtues look unattractive: The result is a comic parody of western mythology.

Little Big Man (1970), *The Ballad of Cable Hogue* (1970), *McCabe & Mrs. Miller* (1971), *Blazing Saddles* (1974), and *Buffalo Bill and the Indians, or Sitting Bull's History Lesson* (1976) portray the western hero not as reluctant, honest, and capable but rather as lucky, vainglorious, militant, or inept; they often make the Indians heroes; and they make the act of mythologizing the West an explicit parodic theme. Simon and Spence argue that *Buffalo Bill and the Indians* "employs irony as a self-critical discursive trope to debunk and demystify the central motifs and icons of the genre."[11] Schatz notes that Custer's Last Stand, depicted as glorious and heroic in *They Died With Their Boots On* (1941), comes across as "a self-destructive imperialist venture of absurd proportions" thirty years later in *Little Big Man*.[12] The Custer of *Little Big Man* fails to listen to the voice of experience, he wants military glory, and his folly causes his own death and the deaths of his soldiers. We could say the same thing about Lt. Col. Owen Thursday (Henry Fonda) in the 1948 western *Fort Apache*; however, *Little Big Man* takes its military leader's arrogance to comic extremes. Whereas *Fort Apache* honors Thursday, even as it criticizes him, *Little Big Man* simply mocks Custer and his arrogance. Even the protagonist of *Little Big Man*, Jack Crabb (Dustin Hoffman), comes across as a ridiculous parody of a western hero, particularly during his gunslinger phase, when he adopts the moniker the "Soda Pop Kid" because he enjoys soda pop. *Fort Apache*, like many other westerns of the late forties and fifties, questions the myths surrounding the westerner, but *Little Big Man* thoroughly deflates those myths by making the westerner absurd.

Mock westerns create comedy through genre paradox. Instead of virtue, the western hero displays vanity. He does not avoid gunfights; he seeks them out. The hero demonstrates luck or clumsiness, not competence. He's not even a hero; he's ridiculous. An explicitly self-reflexive form, the western parodies of the seventies imitate the classical western while reversing the genre's attitude toward the western hero. Instead of celebrating the westerner, the films make fun of him and of the myth of the West, turning the classical tropes of the genre upside down.

UNFORGIVEN AND THE REVERSAL OF REVERSAL

Normally, parody marks the end of a genre's evolution, and further treatments, the few that remain, adopt the form of one or another evolutionary stage. *Dances with Wolves*

(1990), for instance, adopts many of the traits of a classical western, albeit with Indians rather than cowboys as protagonists. *Tombstone* (1993) and *True Grit* (2010) take a more complex approach to western heroism. *Silverado* (1985), *City Slickers* (1991), *Maverick* (1994), *The Lone Ranger* (2013), and *A Million Ways to Die in the West* (2014) flip the genre through comic parody.

However, a genre film can take an additional, less common step: it can flip the parody. A film can take the comic elements of a genre parody and treat them in a serious way. *Unforgiven* enacts just that sort of turnaround. The filmmakers adopt the comic topoi of the mock western of the 1970s—the eager gunslinger, the exaggerated mythologizing of the West, the bumbling outlaw, the stock characters whose traditional attributes are turned on their head—and, out of conventions so passé that many recent treatments had ridiculed the western, make a deeply solemn, even grim, film.

Unforgiven helps us see how filmmakers with knowledge of film history can reinvigorate the Hollywood genre system by revitalizing outdated conventions. The film, written by David Webb Peoples and directed by Clint Eastwood, exploits previously untapped complexities in the western's long history, drawing on the conventions of studio-era westerns and later western parodies in order to make something novel, complex, and aesthetically exciting out of the ashes of a dying genre.

A Classical Western

We can easily identify *Unforgiven*'s genre because the film follows the format of a classical western. It satisfies, for instance, Will Wright's description of the western plot: "a lone stranger rides into a troubled town and cleans it up," a plot popularized in such films as *Cimarron* (1931), *Dodge City* (1939), and *Shane* (1953).[13] More specifically, the film follows the justice/revenge plot of the classical western, which, according to Jon Tuska, falls into two types. The first type equates justice with revenge and features a hero who must enact the justice that the law fails to deliver (e.g. *Stagecoach*). The second type portrays revenge as a dangerous and morally dubious perversion of justice; it features characters who come to understand that due process and the moral authority of the state must subsume the desire for revenge (e.g., *The Ox-Bow Incident*, 1943).[14]

In *Unforgiven*, former outlaw turned pig farmer William Munny (Clint Eastwood) sets out on a revenge killing with his former partner-in-crime, Ned Logan (Morgan Freeman), and an eager young gunslinger, the Schofield Kid (Jaimz Woolvet). The film's first scenes provide the type of instigating scenario that Hollywood movies typically construct in order to justify violent revenge. In it, we see a brutal knife attack on a prostitute, Delilah Fitzgerald (Anna Levine), followed by the failure of the law, in the person of Sheriff "Little" Bill Daggett (Gene Hackman), to properly punish the perpetrators.

The Schofield Kid enlists Munny to kill the two cowboys responsible for cutting Delilah in order to earn the reward money raised by the other prostitutes in the town of Big Whiskey. Munny, we learn, used to be "the meanest goddamn sonofabitch alive" before his departed wife, Claudia, "cured [him] of drink and wickedness." The first act of the film leads us to hypothesize that Munny, through a transformation back into mean goddamn sonofabitch, will avenge—in either a morally righteous or dubious way—the injustices portrayed in the opening scenes.

A Complex Western

Like *The Searchers, The Naked Spur,* and other complex westerns of the studio era, *Unforgiven* emphasizes the ideological complexities latent in the classical western scenario, denying spectators any clear-cut satisfaction they might have gained from the justice/revenge plot and complicating the film's moral closure. Almost from the start, the movie frustrates the easy pleasures typically associated with such scenarios by making the assassins' goal difficult to support. Ned immediately questions the morality of the bounty hunt ("If Claudia was alive, you wouldn't be doing this"), and the Schofield Kid and Munny exaggerate the story of the attack when justifying the revenge killing ("They cut up her face, cut her eyes out, cut her fingers off, cut her tits"). Delilah, moreover, has never supported the revenge plan, and one of the assassins' targets, Davey Bunting (Rob Campbell), feels so guilty about his part in Delilah's injury that he offers her a horse, even though he had little to do with hurting her in the first place. Although the other women proudly reject the gift, Delilah appears to want it. In all, the film prevents us from clearly identifying the film as a story of justified revenge (as implied by the brutal cutting and insufficient punishment) or a story of wrongful vigilantism. Are we watching another *Stagecoach* or *The Ox-Bow Incident*?

The scene in which our protagonists kill Davey Bunting seems designed to complicate the thrills typically associated with vengeful violence in Hollywood movies.[15] Munny, Ned, and the Schofield Kid lay in wait at the top of a canyon to shoot Davey as he and his fellow cowboys pass below. Ned shoots Davey's horse, which falls on the cowboy and breaks his leg. Too upset to follow through with the killing, Ned hands the rifle off to Munny. The scene then employs a variety of point-of-view devices that align spectators with different characters in the scene, preventing a decisive allegiance to one side or the other:

- *Ned,* who cannot bring himself to kill the young cowboy. Medium close-ups of Ned's distraught face create sympathy for his moral plight (figure 12.11);

- *Munny*, trying to kill Davey before the kid can escape. Crosscutting between shots of Munny running out of bullets and shots of Davey crawling toward the rocks add urgency to Munny's efforts to finish him off quickly (figure 12.12);
- *Davey*, desperately fleeing Munny's bullets. The framing of Davey's desperate face and laborious progress ally spectators with his efforts to escape the assassins (figure 12.13). Shots of the injured cowboy crying out after Munny shoots him in the gut ("I'm dying, boys. Jesus, I'm so thirsty") create further sympathy for his pain and inevitable death (figure 12.14);
- *The cowboys*, trying to help their injured friend, urging him to crawl to safety (figure 12.15).

The conflict between these perspectives reaches peak intensity when the camera alternates between shots of Munny at the top of the canyon firing down on Davey (figure 12.12) and shots of Davey below trying to escape his assassins (figure 12.13). Dialogue

FIGURE 12.11

FIGURE 12.12

FIGURE 12.13

FIGURE 12.14

FIGURE 12.15

FIGURES 12.11–12.15 *A variety of camera positions allies the audience with conflicting perspectives in the assassination scene in* Unforgiven *(1992).*

between the characters at the top of the canyon has emphasized the urgency of killing the cowboy quickly ("If he gets in those rocks, we ain't gonna get him, unless we go down there"), whereas the framing at the bottom of the canyon reveals Davey's growing desperation as he tries to crawl to safety just inches away from him. The crosscutting encourages inversely suspenseful reactions that could be articulated, "Hurry, he's getting away" and "Hurry, you're almost safe."

After Munny shoots Davey in the stomach, the scene lingers uncomfortably because Davey does not die right away. "They shot me boys," he wails. His friends yell up to the assassins, "You killed our Davey Boy." "Well, then you shouldn't a cut up no woman, you asshole," the Schofield Kid yells back. It's a desperate reply, the Kid's evident effort to justify the killing to himself. Besides, neither Davey nor anyone else the Kid is yelling at cut anybody. The exchange of information between the shooters and the cowboys as the two groups negotiate how to get water to the fatally wounded Davey—"Will you give him a drink of water, for chrissake, we ain't gonna shoot?" "You ain't gonna shoot?" "No!"—clutters the scene with an uncomfortable normality that interferes with any clean resolution. The scene lacks even the closure of depicting Davey's death, cutting to the next scene while Davey is still conscious and bleeding out.

Unforgiven's epilogue also resists resolution. Like traditional epilogues, it offers narrative and stylistic closure, but it also does just the opposite. The epilogue unites with the prologue to bracket the narration of the story (12.16 and 12.17), replaying the prologue's narrative and stylistic devices: identically framed extreme long-shots of a house against a western landscape and narrative text crawling up the screen. The crawl text in both segments includes some of the same ideas and flowery phrases ("a known thief and murderer, a man of notoriously vicious and intemperate disposition"), and somber guitar music in both segments creates what Richard Neupert calls "frame by musical theme."[16] The repetition of devices reinforces the return to narrative stability, emphasizing a tonal parallel between the film's beginning and its end.

The framing devices, however, create strange contradictions between the epilogue and the climax in which Munny massacres Little Bill and his deputies. Indeed the style and narrative content of the epilogue practically deny the horrific events we just witnessed. Rather than adopting the omniscient perspective and authoritative attitude customary in epilogues, *Unforgiven*'s epilogue continues the description in the prologue as though nothing had intervened. Indeed, the writer of the crawl text seems entirely ignorant of the events of the story and the change in Munny's character. It seems strange, moreover, that Munny, after turning into the monster we see in the film's climax, would later, as the epilogue supposes, prosper in dry goods in San Francisco, a bizarre future for him that the plot never predicted. Did he transform back into a killer temporarily? Finally, the tone of the idyllic "magic hour" shot—its soft, glowing gold and orange hues and purple sky

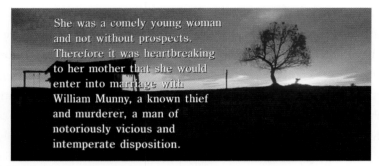

FIGURE 12.16 *Prologue from* Unforgiven.

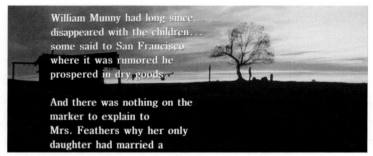

FIGURE 12.17 *Epilogue from* Unforgiven.

FIGURES 12.16 AND 12.17 *The prologue and epilogue in* Unforgiven *(1992) unite to create a traditional framing device. Subtle contradictions, however, complicate the film's narrative, stylistic, and ideological closure.*

(figure 12.17)—and serene guitar music convey no sympathy for the feeling of the film's dark, horrific climax.

Typically, in a classical Hollywood film, an epilogue's narrative and stylistic devices reinforce the resolution of the climax, but *Unforgiven*'s epilogue undermines resolution. At the end of *Unforgiven*, both the climax and the epilogue signal closure, but they do so in counterproductive ways.

A Reversal of the Western Parody

One can see that *Unforgiven* serves as a strong, if belated, example of a complex Hollywood western. The film, however, also makes a contribution to the evolution of the genre by imitating, and inverting, the conventions of the comedic western parody of the 1970s.

Like the cowboys in mock westerns, Munny does not come across as a capable hero. He seeks gunfights, like Jack Crabb in *Little Big Man*. Munny's desire is savage, however, not comic. Like William Cody in *Buffalo Bill and the Indians*, he strikes us as a bumbling

figure, but his ineptness leads to grave and unsettling moments of violence. His poor shooting skills, for instance, prevent him from cleanly killing the young Davey Bunting. As a gunslinger, he shows more luck than skill. "I've always been lucky when it comes to killing folks," he says, a creepy line that the character delivers matter of factly.

Throughout, the film introduces potentially comedic narrative devices—Munny's poor cowboy skills, the comeuppance of the grandiose English Bob, the water negotiation during Davey's death scene, and the poor eyesight and annoying energy of the Schoefield Kid—and uses them instead for a serious effect. One potentially comic scene occurs when the Kid shoots Delilah's cutter while the man is sitting on an outhouse toilet, his pants down by his feet (figure 12.18). The Kid's nearsightedness forces him to shoot the man at very close range. He succeeds mainly because the cutter had hung his gun on the inside of the outhouse door: Luckily for the Kid, when he pulls open the door, the gun swings out of the man's reach. The scene has many hints of comedy (Why else sit the man on a toilet?), but it comes across mostly as uncomfortable and disturbing, particularly as the man briefly pleads for his life before he is shot. Afterward, the Kid grows so distraught by the grim killing that he abandons his goal of becoming a gunslinger.

The scene in which Munny kills Skinny, the film's slimy saloon owner and pimp to the town's prostitutes, illustrates *Unforgiven*'s tendency to make something serious out of the western's parodic form. After seeing Ned's dead body displayed outside the saloon, Munny shoots Skinny with a shotgun. Consider the comic potential of the exchange between Munny and Little Bill immediately after the killing (video 12.2 ▶):

LITTLE BILL: Well, sir, you are a cowardly son of a bitch. You just shot an
 unarmed man.
MUNNY: Well, he should have armed himself, if he's gonna decorate his saloon
 with my friend.

FIGURE 12.18 Unforgiven. *The Schoefield Kid shoots Delilah's "cutter" while the man is sitting on the toilet, adding a potentially comic image to a disturbing scene.*

Munny's reply to Little Bill—"Well he should have armed himself"—sounds at first like a comic version of a western hero's one-liner, a witty justification for an apparently sense-less murder. But when Munny adds "before he decorated his saloon with my friend," the line turns solemn. The second half of the line reverses the humorous effect of its opening clause and turns a facetious rejoinder into an expression of mourning.

The film's climactic gunfight (what Schatz calls "the most fundamental of all western plot conventions"[17]) is a bloodbath, but it too has elements one might expect in a comic parody of a western climax. Little Bill's deputies fumble with their guns in the midst of the shootout. And, long after the danger in the saloon has dissipated, Munny, on his way out, casually fires his shotgun into the stomach of the one-armed deputy groaning on the ground. The moment is disturbing in part because we knew that deputy and liked him. Still, when I screen the film, audiences regularly chuckle at the killing. And it is funny: Munny's blasé action is so unexpected and pointless, simultaneously comic and horrifying.

Finally, like a mock western, *Unforgiven* makes mythologizing the West an explicit theme of the film when we hear the hyperbolic stories of gunfighter exploits written by W. W. Beauchamp, the exaggerated descriptions of Delilah's cutting, and the Schofield Kid's fantasies of western heroism. The film does not use the difference between myth and reality elegiacally, as does *The Man Who Shot Liberty Valence* (1962), or for comic parody, as westerns in the 1970s tended to do: here, the difference emphasizes violence's unjust, brutal reality.

In the 1970s, Hollywood filmmakers reversed the conventions of the classical western and turned the genre into a mockery. *Unforgiven* reverses the mock western by taking it seriously.

Conclusion

IT IS FITTING THAT WE END OUR INVESTIGATION OF HOLLYWOOD AES-thetics with the western, Hollywood's most enduring, emblematic, and historically popular genre. Whenever the western seems finally depleted of its ability to interest an audience, filmmakers manage to mine interesting new material from it. The genre's potential for novelty and complexity seems, after all these years, inexhaustible. The western is so reliable that filmmakers have found they could jump up and down on it, even sledge-hammer its foundational myths, without cracking its structure. Filmmaker Jean Renoir said, "The marvelous thing about Westerns is that they're all the same movie. That gives a director unlimited freedom."[1] Renoir could have said the same about Hollywood cinema as a whole. Hollywood films anchor themselves to a sturdy, time-tested framework. That framework limits options, but it also encourages artistry.

Contrary to common belief, the Hollywood film industry does not resist artistry. It promotes it, up to a point, in an effort to appeal to various *aesthetic markets*. If the public demanded only westerns, then that's all Hollywood would make, but moods and tastes vary so productions do as well. Public demand for variety finances innovation in Hollywood. So, by way of conclusion to this study, let's consider some of Hollywood's aesthetic markets and the ways in which the demand for diverse aesthetic experiences encourages limited variety in Hollywood filmmaking.

Film commentators often note that Hollywood divvies up the world population based on race, age, gender, nationality, and cultural background (the "female audience," "millennials," the "Chinese market," etc.). But Hollywood also tailors its products to suit varying aesthetic tastes, moods, coping potentials, and levels of cinema expertise. Appealing to different aesthetic preferences serves Hollywood's economic interests as much as reaching a "Latino audience" or the "European market" does. Indeed, we know

from experience that our individual aesthetic preferences fluctuate, perhaps even in the course of an evening's entertainment. We might be in the mood for the cognitive challenge of a puzzle film, the ease of a simple romantic comedy, the amusement of a musical, or the emotional intensity of a tear-jerker or horror film. Or we might, over the course of a weekend, develop our gangster-film expertise and thereby increase our desire for (and our ability to cope with) greater novelty and complexity within that genre. We move among different aesthetic markets, expanding the demand for different types of films.

But, whatever type of film it is making, the Hollywood film industry seeks to entertain spectators on a mass scale. The industry targets only those markets sizable enough to justify the enormous investment. Production and distribution of mainstream cinema cost too much money to target small groups, an economic restriction that limits opportunities for creative variation. Consequently, Hollywood does not address the market for films like Fernand Léger's *Ballet mécanique* (1924) or Mike Leigh's *Naked* (1993), which exhibit too much novelty and complexity to appeal to vast numbers of viewers. These are interesting movies, not pleasing ones, and the demand for inordinately interesting movies is comparatively small. It is more profitable for the American film industry to please larger audiences than to interest smaller ones.

As we saw at the beginning of this study, psychologists have discovered a tension between aesthetic Interestingness (epistemic value) and aesthetic Pleasingness (hedonic value). As a work grows more novel or complex, psychologists found, interest increases. Pleasingness, however, works differently, increasing at first but then decreasing when the work has grown so novel or complex that it becomes confusing. Hollywood, for the most part, produces optimally pleasing movies that elicit only minimal or moderate interest so as not to jeopardize their immediate appeal among mass audiences.

Without straying too far from this central tendency, the Hollywood tradition shows enough flexibility to support some aesthetically bold films, venturing into aesthetic markets that prefer more novel or complex movies. Indeed, we might divide Hollywood's aesthetic successes into three categories, based on levels of novelty and complexity:

- Routine Hollywood films—such as *No Time for Sergeants* (1958) and *Rocky III* (1982)—enable viewers to avoid novelty and complexity for the sake of easy processing. Immediately understandable (and normally forgettable), such films offer spontaneous pleasure for mass audiences. But even these relatively undemanding movies, we have seen, require some cognitive activity because any kind of aesthetic engagement involves mental work.
- Many of the movies that show long-term popularity among mass audiences—such as *The Godfather* (1972) and *Star Wars* (1977)—coax viewers toward greater

novelty and complexity. Moderately challenging and yet accessible to large audiences, such films hit the optimal area necessary for long-term mass engagement.

- Finally, films beloved by cinephiles—such as *Vertigo* (1958) and *Raging Bull* (1980)—show a relatively high degree of novelty and complexity when compared to their counterparts in Hollywood cinema. Such films risk displeasing audiences in order to challenge them. They sustain more long-lasting interest for film experts, although they run the risk of being too displeasing to succeed on a truly mass scale.

Of course, films might straddle more than one category, but I believe the general tendency holds in most cases: Whereas average spectators prefer minimal or moderate novelty and complexity, film experts tend to appreciate greater amounts and devote little aesthetic attention to routine films. As a result, films that confound the film novice might delight the expert, while films that delight the film novice are liable to bore the expert.

The market for more novel and complex entertainment may be comparatively small but it is not negligible. Because Hollywood regards that market as potentially profitable, filmmakers such as Orson Welles, Stanley Kubrick, David Lynch, and the Coen Brothers have managed to secure studio financing for films that appeal largely to cinephiles. More commercial filmmakers—such as John Ford, Howard Hawks, Alfred Hitchcock, Woody Allen, and Martin Scorsese—have also appealed to that market and, in so doing, made some of their most enduring movies. The films endure not only because they enjoy the appreciation of tastemakers but also because they sustain spectator interest upon repeat viewings; their long-term propensity to deliver pleasure makes them worthy of aesthetic attention. Film narratives that require more strenuous story construction processes, for instance—such as *The Big Sleep* (1946), *The Killing* (1956), and *The Godfather, Part II* (1974)—often end up on film course syllabi, on critics' lists, and in the personal libraries of cinephiles. The same is true of films with novel or dissonant styles, such as *Frankenstein* (1931), *Touch of Evil* (1958), and *Goodfellas* (1990), and films that house complex ideologies, such as *Invasion of the Body Snatchers* (1956), *The Searchers* (1956), and films noirs. Cinephiles also tend to prefer genre films—such as *Double Indemnity* (1944), *Vertigo* (1958), and *Unforgiven* (1992)—that disrupt genre expectations. We canonize such films for enduring over decades; the films withstand the test of time.

This book has argued that many of the Hollywood movies that provide intense and sustained aesthetic pleasure—pleasure that extends beyond a single encounter, over prolonged periods, and to many people—test the limits of Hollywood's aesthetic system. Although such films challenge spectators more than typical films, they rarely threaten a mass audience's ability to cope with the challenge. As we move closer to our own personal boundary line between coping and not coping, provided we do not cross the line, we stretch our mental capacities and reach toward greater understanding. In one way, then,

such films seem clear and intelligible, but in another way they seem intent on confounding us. Resistant to mastery, they offer exhilarated pleasure to those seeking to expand and reshape their knowledge.

Delight from aesthetic experience, Gombrich says, lies somewhere between boredom and confusion.[2] The nebulous area between boredom and confusion would seem hard to pinpoint and different for every spectator, but the Hollywood film industry banks on the assumption that, with some reliability, it can locate an optimal spot for entertaining a mass audience. One would think that an art form whose business model relies on systematic production and mass accessibility would produce only formulaic entertainment and eventually exhaust its ability to delight. Yet we find that Hollywood filmmakers, working within some fairly tight constraints, have managed to create more than a handful of aesthetically bold works and, when they do, they energize the system all over again.

Notes

PREFACE: THE TEST OF TIME

1. David Bordwell, Janet Staiger, and Kristin Thompson, *The Classical Hollywood Cinema: Film Style & Mode of Production to 1960* (New York: Routledge, 1988), 97.
2. Jerrold Levinson, *The Pleasures of Aesthetics: Philosophical Essays* (Ithaca, NY: Cornell University Press, 1996), 13.
3. Levinson, *Pleasures of Aesthetics*, 13.
4. Anthony Savile, *The Test of Time: An Essay in Philosophical Aesthetics* (Oxford: Clarendon, 1982), 6.
5. Savile, *Test of Time*, 14.

INTRODUCTION

1. Carl E. Milliken, "The Motion Picture as a Business" (speech April 1928), Motion Picture Association Archive, New York, cited in Richard Maltby, *Hollywood Cinema*, 2nd ed. (Malden, MA: Wiley-Blackwell, 2003), 14.
2. B. A. Austin, *Immediate Seeing: A Look at Movie Audiences* (Belmont, CA: Wadsworth, 1988); R. J. Faber, T. C. O'Guinn, and A. P. Hardy, "Art Films in the Suburbs," in *Current Research in Film: Audiences, Economics, and Law*, vol. 4, edited by B. A. Austin (Norwood, NJ: Ablex, 1988), 45–53; A. Lichtenstein and L. B. Rosenfeld, "Uses and Misuses of Gratification Research: An Explication of Media Functions," *Communication Research* 10 (1983): 97–109; K. E. K. Möller and P. Karppinen, "Consumer Motion Picture Choice," *Journal of Economic Psychology* 4 (1983): 239–262; P. Palmgreen, P. L. Cook, J. G. Harvill, and D. M. Helm, "The Motivational Framework of Moviegoing: Uses and Avoidances of Theatrical Films" in Austin, *Current Research in Film*, 1–23; R. O. Wyatt and D. P. Badger, "What Newspaper Critics Value in Film and Film Criticism: A National Survey," in Austin, *Current Research in Film*, 54–71.
3. Harold L. Vogel, *Entertainment Industry Economics: A Guide for Financial Analysis*, 8th ed. (Cambridge, UK: Cambridge University Press, 2001), xix–xx.
4. R. L. Rutsky and Justin Wyatt, "Serious Pleasures: Cinematic Pleasure and the Notion of Fun," *Cinema Journal* 30, no. 1 (Fall 1990): 11.
5. For one example of a critic who equates entertainment with reassuring ideologies, see Robin Wood's, "Papering the Cracks: Fantasy and Ideology in the Reagan Era," in *Hollywood from Vietnam to Reagan* (New York: Columbia University Press, 1986), 144–167.
6. Maltby, *Hollywood Cinema*.

7. Noël Carroll, "The Power of Movies," in *Aesthetics and the Philosophy of Art: The Analytic Tradition*, edited by Peter Lamarque and Stein Haugom Olsen (Malden, MA: Blackwell, 2004), 485–497.

8. Jon Lewis, *American Film: A History* (New York: W. W. Norton, 2007).

9. Thomas Schatz, "New Hollywood, New Millennium" in *Film Theory and Contemporary Hollywood Movies*, edited by Warren Buckland (New York: Routledge, 2009), 19–46.

10. Justin Wyatt, *High Concept: Movies and Marketing in Hollywood* (Austin: University of Texas Press, 1994).

11. Tino Balio, *Grand Design: Hollywood as a Modern Business Enterprise, 1930–1939* (Berkeley: University of California Press, 1996).

12. For an account of the dominant theories of film spectatorship, see Carl Plantinga, "Spectatorship," in *The Routledge Companion to Philosophy and Film*, edited by Paisley Livingston and Carl Plantinga (London: Routledge, 2009), 249–259.

13. Jean-Louis Comolli and Jean Narboni, "Cinema/Ideology/Criticism," in *Movies and Methods: Volume 1*, edited by Bill Nichols (Berkeley: University of California Press, 1976), 26.

14. Richard Dyer, *Only Entertainment* (New York: Routledge, 2002), 20.

15. Laura Mulvey, *Visual and Other Pleasures* (Bloomington: Indiana University Press, 1989).

16. For examples of Screen Theory's deterministic approach to film spectatorship, see E. Deidre Pribram, "Spectatorship and Subjectivity," in *A Companion to Film Theory*, edited by Toby Miller and Robert Stam (Malden, MA: Blackwell, 1999), chap. 9; Robert Stam, *Film Theory: An Introduction* (Malden, MA: Blackwell, 2000); Michele Aaron, *Spectatorship: The Power of Looking On* (London: Wallflower, 2007).

17. Barbara Klinger, "Digressions at the Cinema: Reception and Mass Culture," *Cinema Journal*, 28, no. 4 (Summer 1989): 15.

18. Wyatt, *High Concept*.

19. Theodor Adorno, "Culture Industry Reconsidered," translated by Anson G. Rabinbach, *New German Critique* 6 (Fall 1975): 12–19.

20. Lewis, *American Film*, 425.

21. Nick Zangwill, *The Metaphysics of Beauty* (Ithaca, NY: Cornell University Press, 2001), 144.

22. Jerrold Levinson summarizes various definitions of aesthetics and aesthetic properties in "Philosophical Aesthetics: An Overview" in *The Oxford Handbook of Aesthetics*, edited by Jerrold Levinson (Oxford: Oxford University Press, 2005), 6. Alan Goldman argues that aesthetic properties "are to be analyzed in terms of the shared responses of competent subjects with the particular tastes to the intrinsic (usually formal) properties of objects." "The Aesthetic," in *The Routledge Companion to Aesthetics*, edited by Berys Gaut and Dominic McIver Lopes (London: Routledge, 2001), 184. Frank Sibley argues that to correctly ascribe aesthetic properties requires "taste" or "perceptiveness." Frank Sibley, "Aesthetic Concepts," in *Aesthetics and the Philosophy of Art: The Analytic Tradition*, edited by Peter Lamarque and Stein Haugom Olsen (Malden, MA: Blackwell, 2004), 127. In *Metaphysics of Beauty*, Zangwill argues that aesthetic propositions necessarily point to merit or value.

23. For a discussion of aesthetic properties and human sensibility, see Noël Carroll, *Philosophy of Art: A Contemporary Introduction* (London: Routledge, 1999), 190.

24. Jerrold Levinson provides a stricter definition of aesthetic pleasure in "What Is Aesthetic Pleasure," in *The Pleasures of Aesthetics: Philosophical Essays* (Ithaca, NY: Cornell University Press, 1996), 3–10. For a psychological review of "pleasures of the mind," see Michael Kubovy, "On the Pleasures of the Mind," in *Well-Being: The Foundations of Hedonic Psychology*, edited by Daniel Kahneman, Ed Diener, and Norbert Schwarz (New York: Russell Sage Foundation, 1999), 135–154.

25. Maltby, *Hollywood Cinema*, 15.

26. For a defense of the position that Hollywood cinema comprises a historically continuous "group style," see David Bordwell, Janet Staiger, and Kristin Thompson, *The Classical Hollywood Cinema: Film Style & Mode of Production to 1960* (New York: Routledge, 1988), 3–11.

27. Quoted in E. H. Gombrich, *Art and Illusion: A Study in the Psychology of Pictorial Representation* (Princeton, NJ: Princeton University Press, 1969), 3.

28. Aleksandr Nikolaevich Veselovskii, "Istoricheskaia Poetika (A Historical Poetics), Chapter 1, Section 8," translated by Ian M. Helfant, *New Literary History* 32, no. 2 (Spring, 2001): 409–428.

29. For a more complete discussion of bias in the humanities against the sciences, see Ted Nannicelli and Paul Taberham, "Introduction: Contemporary Media Theory," in *Cognitive Media Theory* (New York: Routledge, 2014), 10–15; Noël Carroll, "Prospects for Film Theory: A Personal Assessment," in *Post-theory: Reconstructing Film Studies*, edited by. David Bordwell and Noël Carroll (Madison: University of Wisconsin Press, 1996), 37–70.

30. D. N. Rodowick, "An Elegy for Theory," *October* 122 (2007): 98. For another critique of empirical approaches to the arts, see Robert Sinnerbrink, "Re-enfranchising Film: Towards a Romantic Film-Philosophy," in *New Takes in Film-Philosophy*, edited by Havi Carel and Greg Tuck (Basingstoke, UK: Palgrave Macmillan, 2011), 25–47.

CHAPTER 1

1. E. H. Gombrich, *The Sense of Order: A Study in the Psychology of Decorative Art* (Ithaca, NY: Cornell University Press, 1979), 9.

2. David Bordwell, Janet Staiger, and Kristin Thompson, *The Classical Hollywood Cinema: Film Style & Mode of Production to 1960* (New York: Routledge, 1988), 3–4.

3. Noël Carroll, *A Philosophy of Mass Art* (New York: Oxford University Press, 1998), 196.

4. Rolf Reber, Norbert Schwarz, and Piotr Winkielman, "Processing Fluency and Aesthetic Pleasure: Is Beauty in the Perceiver's Processing Experience?" *Personality and Social Psychology Review* 8, no. 4 (2004): 364–382.

5. H. Leder, B. Belke, A. Oeberst, and D. Augustin, "A Model of Aesthetic Appreciation and Aesthetic Judgements," *British Journal of Psychology* 95 (2004): 489–508.

6. See J. H. Langlois, and L. A. Roggman, "Attractive Faces Are Only Average," *Psychological Science* 1 (1990): 115–121; C. Martindale and K. Moore, "Priming, Prototypicality, and Preference," *Journal of Experimental Psychology: Human Perception and Performance* 14 (1988): 661–670; D. Rhodes and T. Tremewan, "Averageness, Exaggeration, and Facial Attractiveness," *Psychological Science* 7 (1996): 105–110; T. W. Whitfield and P. E. Slatter, "The Effects of Categorization and Prototypicality on Aesthetic Choice in a Furniture Selection Task," *British Journal of Psychology* 70 (1979): 65–75; and B. W. A. Whittlesea, "Illusions of Familiarity," *Journal of Experimental Psychology: Learning, Memory, and Cognition* 19 (1993): 1235–1253.

7. R. B. Zajonc, "Attitudinal Effects of Mere Exposure," *Journal of Personality and Social Psychology* 9 (1968): 1–27; and R. F. Bornstein, "Exposure and Affect: Overview and Meta-analysis of Research, 1968–1987," *Psychological Bulletin* 106 (1989): 265–289.

8. D. E. Berlyne, *Aesthetics and Psychobiology* (New York: Appleton-Century-Crofts, 1971); Joachim F. Wohlwill, "Amount of Stimulus Exploration and Preference as Differential Functions of Stimulus Complexity," *Perception & Psychophysics* 4–5 (1968): 307–312; Ako Tsutsui and Gentarow Ohmi, "Complexity Scale and Aesthetic Judgments of Color Combinations," *Empirical Studies of the Arts* 29, no. 1 (2011): 1–15; Lambert Deckers and Robert Thayer Buttram, "Humor as a Response to Incongruities within or between Schemata," *Humor* 3, no. 1 (1990): 53–64; and Martina Jakesch and Helmut Leder, "Finding Meaning in Art: Preferred Levels of Ambiguity in Art Appreciation," *Quarterly Journal of Experimental Psychology* 62, no. 11 (2009): 2105–2112.

9. Thomas Armstrong and Brian Detweiler-Bedell, "Beauty as an Emotion: The Exhilarating Prospect of Mastering a Challenging World," *Review of General Psychology* 12, no. 4 (2008): 312.

10. Armstrong and Detweiler-Bedell, "Beauty as an Emotion," 305.

11. Armstrong and Detweiler-Bedell, "Beauty as an Emotion," 322.

12. Bordwell, Staiger, and Thompson, *Classical Hollywood Cinema*, 4–5.

13. Bordwell, Staiger, and Thompson, *Classical Hollywood Cinema*, 5.

14. Bordwell, Staiger, and Thompson, *Classical Hollywood Cinema*, 108–109.

15. Bordwell, Staiger, and Thompson, *Classical Hollywood Cinema*, 97.

16. Bordwell, Staiger, and Thompson, *Classical Hollywood Cinema*, 108.

17. Bordwell, Staiger, and Thompson, *Classical Hollywood Cinema*, 3.

18. Monroe Beardsley, *Aesthetics: Problems in the Philosophy of Criticism* (Indianapolis: Hackett, 1981), 192–194.

19. David Bordwell, *Narration in the Fiction Film* (Madison: University of Wisconsin Press, 1985), 159.

20. Bordwell, *Narration*, 162.

21. Bordwell, Staiger, and Thompson, *Classical Hollywood Cinema*, 70.

22. Bordwell, Staiger, and Thompson, *Classical Hollywood Cinema*, 99.

23. Bordwell, Staiger, and Thompson, *Classical Hollywood Cinema*, 109.

24. Bordwell, Staiger, and Thompson, *Classical Hollywood Cinema*, 110.

25. Beardsley, *Aesthetics*, 205.

26. Beardsley, *Aesthetics*, 208.

27. Immanuel Kant, *Critique of Judgment*, translated by Werner S. Pluhar (Indianapolis: Hackett, 1987), 62.

28. Jerrold Levinson, *The Pleasures of Aesthetics: Philosophical Essays* (Ithaca, NY: Cornell University Press, 1996), 13.

29. John Dewey, *Art as Experience* (New York: Putnam, 1980), 56. Originally published 1934.

30. Monroe C. Beardsley, "In Defense of Aesthetic Value," *Proceedings and Addresses of the American Philosophical Association* 52, no. 6 (August 1979): 741.

31. Paul Silvia argues that the Appraisal Model of emotions better explains people's emotional responses to art than Berlyne's psychobiological model. "Emotional Responses to Art: From Collation and Arousal to Cognition and Emotion," *Review of General Psychology* 9, no. 4 (2005): 342–357.

32. Gombrich, *Sense of Order*, 9.

33. For aesthetic studies that lead to inverted-U results among different cultures, see Çagri Imamoglu, "Complexity, Liking and Familiarity: Architecture and Non-architecture Turkish Students' Assessments of Traditional and Modern House Facades," *Journal of Environmental Psychology* 20, no. 1 (March 2000): 5–16; Margot van Mulken, Rob Le Pair, and Charles Forceville, "The Impact of Perceived Complexity, Deviation and Comprehension on the Appreciation of Visual Metaphor in Advertising Across Three European Countries," *Journal of Pragmatic* 42, no. 12 (December 2010): 3418–3430; D. E. Berlyne, "Psychological Aesthetics," in *Handbook of Cross-Cultural Psychology*, vol. 3, edited by H. C. Traindis and W. J. Lonner (Boston: Allyn and Bacon, 1980), 323–361; Harry C. Triandis, "Reflections on Trends in Cross-Cultural Research," *Journal of Cross-Cultural Psychology* 11, no. 1 (March 1980): 35–58.

34. Richard Maltby, *Hollywood Cinema*, 2nd ed. (Malden, MA: Wiley-Blackwell, 2003), 15.

35. Paul Silvia, "Looking Past Pleasure: Anger, Confusion, Disgust, Pride, Surprise, and Other Unusual Aesthetic Emotions," *Psychology of Aesthetics, Creativity, and the Arts* 3, no. 1 (2009): 48.

36. Paul Silvia, "What Is Interesting? Exploring the Appraisal Structure of Interest," *Emotion* 5 (2005): 89–102; Paul Silvia, *Exploring the Psychology of Interest* (New York: Oxford University Press, 2006); Paul Silvia, "Interest—The Curious Emotion," *Current Directions in Psychological Science* 17 (2008): 57–60.

37. Silvia, "What Is Interesting?" 97.

38. K. Millis, "Making Meaning Brings Pleasure: The Influence of Titles on Aesthetic Experience," *Emotion* 1 (2001): 320–329.

39. F. G. Hare, "Artistic Training and Responses to Visual and Auditory Patterns Varying in Uncertainty," in *Studies in the New Experimental Aesthetics: Steps Toward an Objective Psychology of Aesthetic Appreciation*, edited by D. E. Berlyne (Washington, DC: Hemisphere, 1974), 159–168; H. J. McWhinnie, "A Review of Research on Aesthetic Measure," *Acta Psychologica* 28 (1968): 363–375; J. D. Smith and R. J. Melara, "Aesthetic Preference and Syntactic Prototypicality in Music: Tis the Gift to be Simple," *Cognition* 34 (1990): 279–298; E. L. Walker, *Psychological Complexity and Preference: A Hedgehog Theory of Behavior* (New York: Brooks/Cole, 1980).

40. Paul Silvia, "Artistic Training and Interest in Visual Art: Applying the Appraisal Theory of Aesthetic Emotions," *Empirical Studies of the Arts* 24 (2006): 139–161.

41. *Rivers and Tides: Andy Goldsworthy Working with Time*, directed by Thomas Riedelsheimer (2001; Docudramafilms, 2004), DVD.

42. Stephen Booth, *Precious Nonsense: The Gettysburg Address, Ben Jonson's Epitaphs on His Children, and Twelfth Night* (Berkeley: University of California Press, 1998), 35.

CHAPTER 2

1. Marilyn Fabe, *Closely Watched Films: An Introduction to the Art of Narrative Film Technique* (Berkeley: University of California Press, 2004), 67–69.
2. Peter Wollen, "Introduction," in *Howard Hawks: American Artist*, edited by Jim Hillier and Peter Wollen (London: British Film Institute, 1996), 5.
3. Richard Maltby, *Hollywood Cinema*, 2nd ed. (Malden, MA: Wiley-Blackwell, 2003), 325.
4. Fabe, *Closely Watched Films*, 70–71.
5. Maria DiBattista, *Fast Talking Dames* (New Haven, CT: Yale University Press, 2001), 285.
6. Thomas Schatz, *Hollywood Genres* (New York: Random House, 1981), 166–167.
7. Fabe, *Closely Watched Films*, 72.
8. Fabe, *Closely Watched Films*, 74.
9. Lee Russell, "Howard Hawks," in Hillier and Wollen, 85.
10. Tom Powers, "His Girl Friday: Screwball Liberation," *Jump Cut: A Review of Contemporary Media* 17 (April 1974): 25–28.
11. Howard Barnes, "On the Screen: 'Double Indemnity,'" *New York Herald-Tribune*, September 7, 1944, 18. Scheur is quoted in James Naremore, *More than Night: Film Noir in Its Contexts* (Berkeley: University California Press, 1998), 17.
12. Cameron Crowe, *Conversations with Wilder* (New York: Alfred A. Knopf, 1999), 49.
13. Kahn, "Double Indemnity," *Variety*, May 4, 1944, 18.
14. Bosley Crowther, "THE SCREEN; 'Double Indemnity,' a Tough Melodrama, with Stanwyck and MacMurray as Killers, Opens at the Paramount," *New York Times*, September 7, 1944.
15. Richard Schickel, *Double Indemnity* (London: British Film Institute, 1992), 58–59.
16. Schickel, *Double Indemnity*, 59. Wilder said that Alan Ladd, James Cagney, Spencer Tracy, Gregory Peck, and Frederic March also turned down the part of Walter Neff; see Kevin Lally, *Wilder Times: The Life of Billy Wilder* (New York: Henry Holt, 1996), 134.
17. Roy Hoopes, *Cain* (Carbondale: Southern Illinois University Press, 1982), 335.
18. Ed Sikov, *On Sunset Boulevard: The Life and Times of Billy Wilder* (New York: Hyperion, 1998), 202.
19. Several books tell the story of casting Fred MacMurray in *Double Indemnity*. See Sikov, *On Sunset Boulevard*, 202–203; Lally, *Wilder Times*, 134–135; and Maurice Zolotow, *Billy Wilder in Hollywood* (New York: Limelight, 1996).
20. Kahn, "Double Indemnity," 18; Crowther, "THE SCREEN."

CHAPTER 3

1. Quoted in James Naremore, ed., *North by Northwest* (New Brunswick, NJ: Rutgers University Press, 1993), 181.
2. David Bordwell, *Narration in the Fiction Film* (Madison: University of Wisconsin Press, 1985), xi.
3. See Rolf Reber, Norbert Schwarz, and Piotr Winkielman, "Processing Fluency and Aesthetic Pleasure: Is Beauty in the Perceiver's Processing Experience?" *Personality and Social Psychology Review* 8, no. 4 (2004): 364–382. Neuroscientists V. S. Ramachandran and William Hirstein argue that an emphasis on unity in the arts has a biological basis in our drive to make connections, "The Science of Art: A Neurological Theory of Aesthetic Experience," *Journal of Consciousness Studies* 6, nos. 6–7 (1999): 21 and 31.
4. David Bordwell, *The Way Hollywood Tells It: Story and Style in Modern Movies* (Berkeley: University of California Press, 2006), 4–17.
5. See David Bordwell, Janet Staiger and Kristin Thompson, *The Classical Hollywood Cinema: Film Style & Mode of Production to 1960* (New York: Routledge, 1988); Warren Buckland, *Directed by Steven Spielberg: Poetics of the Contemporary Hollywood Blockbuster* (New York: Continuum Press, 2006); V. F. Perkins, *Film as Film: Understanding and Judging Movies* (New York: Da Capo Press, 1993); Noël Carroll, *Mystifying Movies* (New York: Columbia University Press, 1988).
6. Perkins, *Film as Film*, 121.
7. Lewis Herman, *A Practical Manual of Screen Playwriting* (New York: Meridian, 1963), 39. Cf. Eustace Hale Ball, *Cinema Plays: How to Write Them* (London: Stanley Paul, 1917), 38–40; and Linda J. Cowgill,

Secrets of Screenplay Structure: How to Recognize and Emulate the Structural Frameworks of Great Films (Los Angeles: Lone Eagle, 1999), 80.

8. Seymour Chatman, *Story and Discourse: Narrative Structure in Fiction and Film* (Ithaca, NY: Cornell University Press, 1978), 45–48, 53–56.

9. Cowgill, *Secrets of Screenplay*, 2; cf. Frances Marion, *How to Write and Sell Film Stories* (New York: Covici Friede, 1937), 91.

10. Noël Carroll, "The Power of Movies," in *Aesthetics and the Philosophy of Art: The Analytic Tradition*, edited by Peter Lamarque and Stein Haugom Olsen (Malden, MA: Wiley-Blackwell, 2004), 485–497.

11. Bordwell, *Narration*, 157–158.

12. Bordwell, Staiger, and Thompson, *Classical Hollywood Cinema*, 17.

13. Bordwell, *Narration*, 158.

14. Monroe Beardsley, *Aesthetics: Problems in the Philosophy of Criticism* (Indianapolis: Hackett, 1981), 192–194.

15. Carroll, "Power," 492.

16. Carroll, "Power," 495.

17. Reber, Schwarz, and Winkielman, "Processing Fluency."

18. I use the word "logic" not in the strict sense employed by logicians but as it is regularly used in narratology to denote either (1) the relationship between elements and between an element and the whole, or (2) any kind of valid reasoning. See Chatman, *Story and Discourse*; David Herman, *Story Logic: Problems and Possibilities of Narrative* (Lincoln: University of Nebraska Press, 2002).

19. Cited in Marie-Laure Ryan, "Cheap Plot Tricks, Plot Holes, and Narrative Design," *Narrative* 17, no. 1 (2009): 66.

20. See Marion, *How to Write and Sell*, 124; Frederick Palmer, *Author's Photoplay Manual* (Hollywood, CA: Palmer Institute, 1924), 69–70; Eugene Vale, *The Technique of Screenplay Writing* (New York: Crown, 1944), 39; Moresby White and Freda Stock *The Right Way to Write for the Films* (Kingswood, UK: A.G. Elliot, 1948), 27.

21. Paul Lucey, *Story Sense: Writing Story and Script for Feature Films and Television* (New York: McGraw-Hill, 1996), 91.

22. Ryan, "Cheap Plot Tricks," 56 and 68.

23. Bordwell, *Narration*, 165.

24. Bordwell, *Narration*, 52.

25. Bordwell, *Narration*, 165.

26. Peter Lipton, *Inference to the Best Explanation*, 2nd ed. (London: Routledge, 2004).

27. Peirce Edition Project, ed., *The Essential Peirce: Selected Philosophical Writings*, vol. 2, *1893–1913* (Bloomington: Indiana University Press, 1998).

28. See Richard E. Mayer, *Thinking, Problem Solving, Cognition*, 2nd ed. (New York: Worth Publishers, 1992); Steven M. Smith, Thomas B. Ward, and Ronald A. Finke, eds., *The Creative Cognition Approach* (Cambridge, MA: MIT Press, 1995).

29. N. R. F. Maier, "Reasoning in Humans. II. The Solution of a Problem and Its Appearance in Consciousness," *Journal of Comparative Psychology* 12 (1931): 181–194.

30. E. M. Bowden, M. Jung-Beeman, and J. Kourios, "New Approaches to Demystifying Insight," *Trends in Cognitive Sciences* 9, no. 7 (2005): 322–328; G. Knoblich, S. Ohlsson, H. Haider, and D. Rhenius, "Constraint Relaxation and Chunk Decomposition in Insight Problem Solving," *Journal of Experimental Psychology: Human Learning and Memory* 25 (1999): 1534–1555.

31. J. Metcalfe and D. Wiebe, "Intuition in Insight and Noninsight Problem Solving," *Memory & Cognition* 15 (1987): 238–246.

32. C. A. Kaplan, and H. A. Simon, "In Search of Insight," *Cognitive Psychology* 22 (1990): 374–419; J. Metcalfe, "Feeling of Knowing in Memory and Problem Solving," *Journal of Experimental Psychology: Learning, Memory, and Cognition* 12 (1986): 288–294. For studies of the pleasures of insight, see Robert J. Sternberg and Janet E. Davidson, ed., *The Nature of Insight* (Cambridge, MA: MIT Press, 1995), especially chapters by M. L. Gick and R. S. Lockhart. "Cognitive and Affective Components of Insight," 197–228; H. E. Gruber, "Insight and Affect in the History of Science," 397–432; and C. M.

Seifert, et. al., "Demystification of Cognitive Insight: Opportunistic Assimilation and the Prepared-Mind Perspective," 65–124. For evidence of pleasurable neural activity during insight, see M. Jung-Beeman, et. al., "Neural Activity When People Solve Verbal Problems with Insight," *Public Library of Science: Biology* 2 (2004): 500–510.

33. John Morreall, *Taking Laughter Seriously* (Albany: State University of New York Press, 1983), 15.

34. Many researchers find the Incongruity-Resolution Theory inadequate in explaining all humor. The two other leading theories of humor are Superiority Theory and Tension-Relief Theory; see Morreall, *Taking Laughter*. Morreall believes incongruity alone is sometimes sufficient to generate humor, whereas Shultz calls incongruity without resolution "nonsense" and finds that it is not amusing to adults and children older than seven. T. R. Shultz, "A Cognitive-Developmental Analysis of Humour," in *Humour and Laughter: Theory, Research and Applications*, edited by Antony J. Chapman and Hugh C. Foot (New Brunswick, NJ: Transaction Publishers, 2007), 11–36.

35. For a discussion of joke appreciation as problem solving, see Jerry Suls, "Cognitive Processes in Humor Appreciation" in *Handbook of Humor Research*, vol. 1, *Basic Issues*, edited by Paul E. McGhee and Jeffrey H. Goldstein (New York: Springer-Verlag, 1983), 39–58; and Jerry Suls, "A Two-Stage Model for the Appreciation of Jokes and Cartoons: An Information-Processing Analysis," in *The Psychology of Humor: Theoretical Perspectives and Empirical Issues*, edited by Jeffrey Goldstein and Paul McGee (New York: Academic Press, 1972), 81–100.

36. Reported in Suls, "Cognitive Processes," 47.

37. Oring, Elliott. *Engaging Humor* (Urbana: University of Illinois Press, 2003).

38. Neil Schaeffer calls laughter "a vacation from the workaday economy of the mind." *The Art of Laughter* (New York: Columbia University Press, 1981), 22. For Schaeffer, laughter gives free expression to creative mental processes that serious situations and "our practical investment in the process of reason" inhibit and treat as dysfunctional, 24.

39. See Kristin Thompson, *Breaking the Glass Armor: Neoformalist Film Analysis* (Princeton, NJ: Princeton University Press, 1988), 8.

40. Chatman, *Story and Discourse*, 45–46; Brian Richardson, *Unlikely Stories: Causality and the Nature of Modern Narrative* (Newark: University of Delaware Press, 1997), 106.

41. John Morreall, "Funny Ha-Ha, Funny Strange, and Other Reactions to Incongruity" in *The Philosophy of Laughter and Humor*, edited by John Morreall (Albany: State University of New York Press, 1987), 204. Research suggests that whether incongruity provokes mirth depends mostly upon contextual cues. See Dana L. Alden, Asheesh Mukherjee, and Wayne D. Hoyer, "The Effects of Incongruity, Surprise and Positive Moderators on Perceived Humor in Television Advertising," *Journal of Advertising* 29, no. 2 (2000): 1–15; Michael K. Cundall Jr., "Humor and the Limits of Incongruity," *Creativity Research Journal* 19, nos. 2–3 (2007): 203–211; Stacey L. Ivanko and Penny M. Pexman, "Context Incongruity and Irony Processing," *Discourse Processes* 35, no. 3 (2003): 241–279.

42. J. M. Jones, "Cognitive Factors in the Appreciation of Humor: A Theoretical and Experimental Analysis," PhD diss., Yale University, New Haven, CT, 1970.

43. Lambert Deckers and Robert Thayer Buttram, "Humor as a Response to Incongruities within or between Schemata," *Humor* 3, no. 1 (1990): 53–64; R. A. Hoppe, "Artificial Humor and Uncertainty," *Perceptual and Motor Skills* 42 (1976): 1051–1056; P. E. McGhee, "Children's Appreciation of Humor: A Test of the Cognitive Congruency Principle," *Child Development* 47 (1976): 420–426.

44. Paul Silvia, "What Is Interesting? Exploring the Appraisal Structure of Interest," *Emotion* 5 (2005): 89–102. F. G. Hare, "Artistic Training and Responses to Visual and Auditory Patterns Varying in Uncertainty," in *Studies in the New Experimental Aesthetics: Steps toward an Objective Psychology of Aesthetic Appreciation*, edited by D. E. Berlyne (Washington, DC: Hemisphere, 1974), 159–168.

45. Thomas Armstrong and Brian Detweiler-Bedell, "Beauty as an Emotion: The Exhilarating Prospect of Mastering a Challenging World," *Review of General Psychology* 12, no. 4 (2008): 320.

46. David Thomson, *The Big Sleep* (London: British Film Institute, 1997), 44.

47. Joseph McBride, *Hawks on Hawks* (Berkeley: University of California Press, 1982), 9.

48. Bordwell, Staiger, and Thompson, *Classical Hollywood Cinema*, 3.

49. Quoted in James Naremore, ed., *North by Northwest* (New Brunswick, NJ: Rutgers University Press, 1993), 181.

50. Armstrong and Detweiler-Bedell, "Beauty as an Emotion," 312. Schaeffer, discussing humor, describes the experience similarly: "In the after-experience of incongruity, we know and feel that something significant has occurred in our mind, but we do not know exactly what it is. We have a tense notion that we know more than we know, and we preserve this uncertain feeling as a means of arousing and sustaining our curiosity for the search." Schaeffer, *The Art of Laughter*, 10.

51. Numerous studies find a correlation between expertise and art preferences. See, for example, F. G. Hare, "Artistic Training"; H. J. McWhinnie, "A Review of Research on Aesthetic Measure," *Acta Psychologica* 28 (1968): 363–375; J. D. Smith and R. J. Melara, "Aesthetic Preference and Syntactic Prototypicality in Music: Tis the Gift to Be Simple," *Cognition* 34 (1990): 279–298; E. L. Walker, *Psychological Complexity and Preference: A Hedgehog Theory of Behavior* (New York: Brooks/Cole, 1980).

52. Vladimir J. Konecni and Dianne Sargent-Pollock, "Choice between Melodies Differing in Complexity under Divided-Attention Conditions," *Journal of Experimental Psychology: Human Perception and Performance* 2, no. 3 (1976): 347–356.

53. Konecni and Sargent-Pollock, "Choice between Melodies," 354.

CHAPTER 4

1. Quoted in John Lahr, "High Marx: Tony Kushner's Socialist Spectacular," *The New Yorker*, May 16, 2011, 130–131.

2. Linda J. Cowgill, *Secrets of Screenplay Structure: How to Recognize and Emulate the Structural Frameworks of Great Films* (Los Angeles: Lone Eagle, 1999), 229. Cf. Frances Marion, *How to Write and Sell Film Stories* (New York: Covici Friede, 1937), 89; Moresby White and Freda Stock, *The Right Way to Write for the Films* (Kingswood, UK: A. G. Elliot, 1948), 28.

3. Robin Wood, *Howard Hawks* (Garden City, NY: Doubleday, 1968), 129.

4. Syd Field, *The Screenwriter's Problem Solver: How to Recognize, Identify, and Define Screenwriting Problems* (New York: Dell, 1988), 277–278.

5. "Hawks and Bogdanovich," Supplemental Features, *Red River*, Blu-Ray, directed by Howard Hawks (The Criterion Collection, 2014).

6. For a description of the script's production history, see the chapter on *Red River* in Gerald Mast, *Howard Hawks, Storyteller* (New York: Oxford University Press, 1982).

7. Suzanne Liandrat-Guigues, *Red River* (London: British Film Institute, 2000), 26.

8. Wood, *Howard Hawks*, 129; Varun Begley, "'One Right Guy to Another': Howard Hawks and Auteur Theory Revisited," *Camera Obscura* 22, no. 64 (2007): 43–75.

9. See, for instance, Jim Hitt, *The American West from Fiction (1823–1976) to Film (1906–1986)* (Jefferson, NC: McFarland, 1990), 72; Richard Corliss, "Borden Chase, Howard Hawks and *Red River*," in *Howard Hawks: American Artist*, edited by Jim Hillier and Peter Woolen (London: British Film Institute, 1996), 185–189.

10. Liandrat-Guigues, *Red River*, 13. John Belton, "Hawks and Co.," in *Focus on Howard Hawks*, edited by Joseph McBride (Englewood Cliffs, NJ: Prentice Hall, 1972), 102.

11. Wood, *Howard Hawks*, 125.

12. John Morreall, *Taking Laughter Seriously* (Albany: State University of New York Press, 1983), 91.

13. John Morreall, "Funny Ha-Ha, Funny Strange, and Other Reactions to Incongruity," in *The Philosophy of Laughter and Humor*, edited by John Morreall (Albany: State University of New York Press, 1987), 201.

14. For Hawks's response to the criticisms of his ending, see McBride, *Focus on Howard Hawks*, 123.

15. Wood, *Howard Hawks*, 125.

CHAPTER 5

1. Henry Jaglom, "The Independent Filmmaker," in *The Movie Business Book*, edited by Jason E. Squire (New York: Fireside, 2004), 54.

2. Thomas D. Clagett, *William Friedkin: Films of Aberration, Obsession, and Reality* (Jefferson, NC: McFarland, 1990), 121–122.

3. Mayer Schapiro defines style as the "constant form" in the art of an individual or group; *Theory and Philosophy of Art: Style, Artist, and Society* (New York: George Braziller, 1994), 51. Style, according to E. H. Gombrich, denotes "any distinctive way" in which an act is performed or an artifact made; "Style," in *The International Encyclopedia of the Social Sciences*, vol. 15, edited by D. L. Sills (New York: Macmillan, 1968), 352.

4. David Bordwell defines film style as the "systematic and significant use of techniques of the medium,. the texture of the film's images and sounds, the result of choices made by the filmmaker(s) in particular historical circumstances." *On the History of Film Style* (Cambridge, MA: Harvard University Press, 1997), 4.

5. E. H. Gombrich, *Art and Illusion: A Study in the Psychology of Pictorial Representation* (Princeton, NJ: Princeton University Press, 1969), 36.

6. Leonard B. Meyer, "Toward a Theory of Style," in *The Concept of Style*, edited by Berel Lang (Ithaca, NY: Cornell University Press, 1987), 21.

7. David Bordwell, *The Way Hollywood Tells It: Story and Style in Modern Movies* (Berkeley: University of California Press, 2006), 121–138.

8. J. E. Cutting, J. E. DeLong, K. L. Brunick, C. Iricinschi, and A. Candan, "Quicker, Faster, Darker: Changes in Hollywood Film over 75 Years," *i-Perception* 2, no. 6 (September 2011): 569–576.

9. David Bordwell, *Narration in the Fiction Film* (Madison: University of Wisconsin Press, 1985), 162.

10. Bordwell, *Narration*, 163.

11. Bordwell, *Narration*, 164.

12. Quoted in Patrick Keating, *Hollywood Lighting from the Silent Era to Film Noir* (New York: Columbia University Press, 2010), 208.

13. Bordwell, *Narration*, 164.

14. Rolf Reber, Norbert Schwarz, and Piotr Winkielman, "Processing Fluency and Aesthetic Pleasure: Is Beauty in the Perceiver's Processing Experience?" *Personality and Social Psychology Review* 8, no. 4 (2004): 366.

15. S. F. Checkosky and D. Whitlock, "The Effects of Pattern Goodness on Recognition Time in a Memory Search Task," *Journal of Experimental Psychology* 100 (1973): 341–348.

16. D. Humphrey, "Preferences in Symmetries and Symmetries in Drawings: Asymmetries between Ages and Sexes," *Empirical Studies of the Arts* 15 (1997): 41–60; K. Koffka, *Principles of Gestalt Psychology* (London: Routledge and Kegan Paul, 1935); R. Reber, "Reasons for the Preference for Symmetry," *Behavioral and Brain Sciences* 25 (2002): 415–416.

17. B. W. A. Whittlesea, L. L. Jacoby, and K. Girard, "Illusions of Immediate Memory: Evidence of an Attributional Basis for Feelings of Familiarity and Perceptual Quality," *Journal of Memory and Language* 29 (1990): 716–732.

18. Reber, Schwarz, and Winkielman, "Processing Fluency," 365.

19. Noël Carroll, "The Power of Movies," in *Aesthetics and the Philosophy of Art: The Analytic Tradition*, edited by Peter Lamarque and Stein Haugom Olsen (Malden, MA: Blackwell, 2004), 487.

20. Carroll, "Power of Movies," 487.

21. Vicki Bruce, Tim Valentine, Alan Baddeley, "The Basis of the 3/4 View Advantage in Face Recognition," *Applied Cognitive Psychology* 1, no. 2 (April–June 1987): 109–120.

22. Quoted in David Bordwell, *Figures Traced in Light: On Cinematic Staging* (Berkeley: University of California Press, 2005), 35.

23. Carroll, "Power of Movies," 490.

24. Carroll, "Power of Movies," 490.

25. Jonathan Rosenbaum, *Movies as Politics* (Berkeley: University of California Press, 1997), 38.

26. Carroll, "Power of Movies," 490.

27. E. H. Gombrich, *The Sense of Order: A Study in the Psychology of Decorative Art* (Ithaca, NY: Cornell University Press, 1979), 15.

28. Richard Maltby, *Hollywood Cinema*, 2nd ed. (Malden, MA: Wiley-Blackwell, 2003), 42.

29. Maltby, *Hollywood Cinema*, 15.

30. Quoted in Maltby, *Hollywood Cinema*, 40.

31. Kristin Thompson, *Breaking the Glass Armor: Neoformalist Film Analysis* (Princeton, NJ: Princeton University Press, 1988), 259.

32. Gombrich, *Sense*, 121.

33. Keating, *Hollywood Lighting from the Silent Era to Film Noir*, 50.

34. Karl Struss, "Photographic Modernism and the Cinematographer," *American Cinematographer*, November 1934, 296–297.

35. Keating, *Hollywood Lighting*, 179.

36. Quoted in Keating, *Hollywood Lighting* 179.

37. Tino Balio, *Grand Design: Hollywood as a Modern Business Enterprise, 1930–1939* (Berkeley: University of California Press, 1996), 96.

38. Quoted in Balio, *Grand Design*, 97.

39. Scott Higgins, *Harnessing the Technicolor Rainbow: Color Design in the 1930s* (Austin: University of Texas Press, 2007), chaps. 3, 4, and 5.

40. John Belton, *Widescreen Cinema* (Cambridge, MA: Harvard University Press, 1992), chaps. 4 and 5.

41. See Introduction to Gombrich, *Sense*.

42. O. Mason and F. Brady, "The Psychotomimetic Effects of Short-Term Sensory Deprivation," *Journal of Nervous and Mental Disease* 197, no. 10 (2009): 783–785.

43. Noël Burch, *Theory of Film Practice*, translated by Helen R. Lane (New York: Praeger, 1973), 67.

44. Stephen Booth, *Precious Nonsense: The Gettysburg Address, Ben Jonson's Epitaphs on His Children, and Twelfth Night* (Berkeley: University of California Press, 1998), 6.

45. Zanuck to writer Jules Furthman, April 2, 1947, quoted in Thomas Schatz, *Boom and Bust: The American Cinema in the 1940s* (New York: Scribner, 1997), 374.

46. Review in *Time*, January 7, 1946, reprinted in James Agee, *Agee on Film*, vol. 1 (New York: Grossett and Dunlap, 1958), 360.

47. Roger Ebert, review of *Monster*, web, January 1, 2004, http://www.rogerebert.com/reviews/monster-2003.

48. For more on the pleasure derived from the discrepancy between actors and their roles, see Stephen Booth, "On the Aesthetics of Acting," in *Shakespearean Illuminations: Essays in Honor of Marvin Rosenberg*, edited by. Jay L. Halio and Hugh Richmond (Newark: University of Delaware Press, 1998), 255–266.

CHAPTER 6

1. Quoted in David Thompson and Ian Christie, eds., *Scorsese on Scorsese* (London: Faber and Faber, 1989), 77.

2. Quoted in Mary Pat Kelly, *Martin Scorsese: A Journey* (New York: Thunder's Mouth Press, 1991), 132.

3. Quoted in Kelly, *Martin Scorsese*, 148.

4. Quoted in Kelly, *Martin Scorsese*, 150.

5. Quoted in Andy Dougan, *Martin Scorsese* (New York: Thunder's Mouth Press, 1998), 93–94.

6. David Bordwell draws a distinction between the early theoretical writings of Eisenstein during the period 1923 and 1930 (which emphasized a montage of contradiction and collision) and those of the period 1930 to 1948 (which more greatly emphasized "synethesia"). "Eisenstein's Epistemological Shift," *Screen* 15, no. 4 (Winter 1974–1975): 29–58.

7. Sergei Eisenstein, *Film Form: Essays in Film Theory*, ed. and trans. Jay Leyda (New York: Harcourt, Brace & World: 1949), 52.

8. Eisenstein, *Film Form*, 53.

9. Scorsese said about this portion of the fight sequence, "It's not a matter of literally translating what Jake sees and hears, but to present what the match means for him, all the while respecting, as much as possible, historical truth." Quoted in Peter Brunette, ed., *Martin Scorsese: Interviews* (Jackson: University Press of Mississippi, 1999), 95.

10. Quoted in Kelly, *Martin Scorsese*, 139.

11. Describing how he got the camera into the air in the last moments of the Steadicam shot, Chapman said, "The Steadicam operator stepped onto a platform rigged on a stage crane which was wheeled into position when the lens had passed it and it thus wouldn't be seen. Then as Bobby [de Niro] walked away and

climbed into the ring the grips simply raised the crane and, as I remember, swung it to the right." Michael Chapman, e-mail message to author, July 7, 2003.

12. Ric Gentry, "Michael Chapman Captures *Raging Bull* in Black and White," *Millimeter* 9, no. 2 (February 1981): 112.

13. Quoted in Thompson and Christie, *Scorsese on Scorsese*, 83. Donald O. Mitchell, a sound re-recording engineer for *Raging Bull*, said that Warner used "animal sounds such as a lion roar mixed over a man's scream." Quoted in David Weishaar, "Interview with Donald O. Mitchell (Part I)," September 9, 2003, *FilmSound.Org* and *Cinema Audio Society*, http://www.filmsound.org/cas/mitchell1.htm.

CHAPTER 7

1. Jane Tomkins, "Fighting Words: Unlearning to Write the Critical Essay," *The Georgia Review* 42, no. 3 (Fall 1988): 586–587.

2. See Karl Marx and Friedrich Engels, *The German Ideology* (Amherst, NY: Prometheus, 1998); originally published 1932.

3. Louis Althusser, *For Marx*, translated by Ben Brewster (London: New Left Books, 1979), 231. Similarly, Chuck Kleinhans says that ideology operates "like myth," "Marxism and Film," in *The Oxford Guide to Film Studies*, edited by John Hill and Pamela Church Gibson (Oxford: Oxford University Press, 1998), 110.

4. For a summary of conceptions of ideology in film studies, see Philip Rosen, "Introduction: Text and Subject," in *Narrative, Apparatus, Ideology: A Film Theory Reader* (New York: Columbia University Press, 1986), 155–171.

5. Noël Carroll, *A Philosophy of Mass Art* (New York: Oxford University Press, 1998), 378.

6. Carl Plantinga, *Moving Viewers: American Film and the Spectator's Experience* (Berkeley: University of California Press, 2009), 200.

7. For a discussion of the effects of an artwork's ideology on our aesthetic response, see Noël Carroll, "Moderate Moralism," *The British Journal of Aesthetics* 36, no. 3 (July 1996): 223–238.

8. See R. L. Rutsky and Justin Wyatt, "Serious Pleasures: Cinematic Pleasure and the Notion of Fun," *Cinema Journal* 30, no. 1 (Fall 1990): 11.

9. Fredric Jameson, "Reification and Utopia in Mass Culture," *Social Text* 1 (Winter 1979): 141 and 144.

10. Laura Mulvey, *Visual and Other Pleasures* (Bloomington: Indiana University Press, 1989), 26. Mary Ann Doane makes a similar argument. She sees the femme fatale, for instance, as an object of male fear and desire who must be eradicated in "a desperate reassertion of control on the part of the threatened male subject." *Femmes Fatales: Feminism, Film Theory, Psychoanalysis* (New York: Routledge, 1991), 2. Jean-Louis Baudry views the entire "apparatus" of the cinema as an instrument of ideology. See his "Ideological Effects of the Basic Cinematographic Apparatus," in *Narrative, Apparatus, Ideology: A Film Theory Reader*, edited by Philip Rosen (New York: Columbia University Press, 1986), 286–298.

11. Jameson, "Reification and Utopia," 147.

12. Robin Wood, *Hollywood from Vietnam to Reagan* (New York: Columbia University Press, 1986), 146.

13. Douglas Kellner, "Hollywood Film and Society," in *The Oxford Guide to Film Studies*, edited by John Hill and Pamela Church Gibson (Oxford: Oxford University Press, 2002), 357.

14. Jean-Louis Comolli and Jean Narboni, "Cinema/Ideology/Criticism," in Nichols, *Movies and Methods*, 26.

15. Robert Ray, *A Certain Tendency of the Hollywood Cinema, 1930–1980* (Princeton, NJ: Princeton University Press, 1985), 21.

16. Ray, *A Certain Tendency*, 58.

17. Richard Dyer, "Entertainment and Utopia," in *Only Entertainment* (New York: Routledge, 2002), 19–35.

18. Robin Wood, "An Introduction to the American Horror Film," in *Movies and Methods: Volume 1*, edited by Bill Nichols (Berkeley: University of California Press, 1976), 201.

19. Barbara Klinger, *Melodrama and Meaning: History, Culture, and the Films of Douglas Sirk* (Bloomington: Indiana University Press, 1994), 159.

20. Janet Wasko, *How Hollywood Works* (London: SAGE, 2003), 3.

21. For a discussion of the relationship between violence, ideology, and emotion, see Carl Plantinga, "Notes on Spectator Emotion and Ideological Film Criticism," in *Film Theory and Philosophy*, edited by Richard Allen and Murray Smith (Oxford: Oxford University Press, 1997), 372–393.

22. Ed Tan, *Emotion and the Structure of Narrative Film: Film as an Emotion Machine* (New York: Routledge, 1995).

23. Dirk Eitzen, "Comedy and Classicism," in *Film Theory and Philosophy*, edited by Richard Allen and Murray Smith (New York: Oxford University Press, 1999), 404.

24. Patrick Keating, "Emotional Curves and Linear Narratives," *The Velvet Light Trap* 58 (Fall 2006): 13.

25. Richard Maltby, *Hollywood Cinema*, 2nd ed. (Malden, MA: Wiley-Blackwell, 2003), 14.

26. For a summary of various theories of emotion, see Richard S. Lazarus, *Emotion and Adaptation* (New York: Oxford University Press, 1991), 3–41. For a critical review, see Lisa Feldman Barrett, "Are Emotions Natural Kinds?" *Perspectives on Psychological Science* 1, no. 1 (2006): 28–58.

27. Lazarus, *Emotion and Adaptation*, 145.

28. See Tan, *Emotion*, for a discussion of the spectator's role as a privileged witness (pp. 55–56). In *Engaging Characters: Fiction, Emotion, and the Cinema* (Oxford: Oxford University Press, 1995), Murray Smith proposes that films elicit sympathy and antipathy for characters by cuing spectators to form moral evaluations of characters and their behavior.

29. For a discussion of emotion as a construal-based concern, see Robert C. Roberts, *Emotions: An Essay in Aid of Moral Psychology* (Cambridge, UK: Cambridge University Press, 2003), 47–49, 64–83.

30. Plantinga, *Moving*, 88.

31. Plantinga, *Moving*, 111.

32. Plantinga, *Moving*, 150.

33. Tan, *Emotion*, 76.

34. B. L. Fredrickson, "Psychophysiological Functions of Positive Emotions," in *ISRE '96 Proceedings of the Ninth Conference of the International Society for Research on Emotions*, edited by N. H. Frijda (Toronto: Isre Publications), 92–95.

35. Jerrold Levinson, *The Pleasures of Aesthetics: Philosophical Essays* (Ithaca, NY: Cornell University Press, 1996), 12.

36. Paul Silvia, "Looking Past Pleasure: Anger, Confusion, Disgust, Pride, Surprise, and Other Unusual Aesthetic Emotions," *Psychology of Aesthetics, Creativity, and the Arts* 3, no. 1 (February 2009): 48.

37. Silvia, "Looking"; S. A. Turner Jr., and P. J. Silvia, "Must Interesting Things Be Pleasant? A Test of Competing Appraisal Structures," *Emotion* 6 (2006): 670–674; P. A. Russell, "Preferability, Pleasingness, and Interestingness: Relationships between Evaluative Judgments in Empirical Aesthetics," *Empirical Studies of the Arts* 12 (1994): 141–157; P. A. Russell and C. D. Gray, "The Heterogeneity of the Preferability Scale in Aesthetic Judgments of Paintings," *Visual Arts Research* 17 (1991): 76–84.

38. For a discussion of pleasure as reinforcement, see Bartley G. Hoebel, et. al., "Neural Systems for Reinforcement and Inhibition of Behavior: Relevance to Eating, Addiction, and Depression," in *Well-Being: The Foundations of Hedonic Psychology*, edited by Daniel Kahneman, Ed Diener, and Norbert Schwarz (New York: Russell Sage Foundation, 1999), 559–572.

39. P. J. Silvia and C. Berg, "Finding Movies Interesting: How Expertise and Appraisals Influence the Aesthetic Experience of Film," *Empirical Studies of the Arts* 29, no. 1 (2001): 75.

40. Lazarus, *Emotion and Adaptation*, 19.

41. Maltby, *Hollywood Cinema*, 14.

42. Michael Kubovy, "On the Pleasures of the Mind," in Kahneman, Diener, and Schwarz, *Well-Being*, 135–154.

43. Daniel Kahneman, "Objective Happiness," in Kahneman, Diener, and Schwarz, *Well-Being*, 3–25.

44. Kubovy, "On the Pleasures of the Mind," 135.

45. Nico H. Frijda, "Emotions and Hedonic Experience," in Kahneman, Diener, and Schwarz, 204.

46. Sarah Kozloff, "Empathy and the Cinema of Engagement: Reevaluating the Politics of Film," *Projections: The Journal of Movies and Mind* 7, no. 2 (Winter 2013): 24.

47. Comolli and Narboni, "Cinema/Ideology/Criticism," 25.

48. Comolli and Narboni, "Cinema/Ideology/Criticism," 26.

49. Comolli and Narboni, "Cinema/Ideology/Criticism," 26.

50. Comolli and Narboni, "Cinema/Ideology/Criticism," 27.

51. Monroe Beardsley, *Aesthetics: Problems in the Philosophy of Criticism* (Indianapolis: Hackett, 1981), 528.

52. Beardsley, *Aesthetics*, 528.

53. Plantinga, *Moving*, 44.

54. Plantinga, *Moving*, 80 and 44.

55. Plantinga, *Moving*, 79

56. Carroll, *Philosophy*, 394.

57. Plantinga, *Moving*, 156–158.

58. Carroll, *Philosophy*, 399.

59. Victor Shklovsky, "Art as Technique," in *Russian Formalist Criticism: Four Essays*, translated and edited by Lee T. Lemon and Marion J. Reis (Lincoln: University of Nebraska Press, 1965), 11–12.

60. Ernesto G. Laura, "Invasion of the Body Snatchers," *Bianco e Nero* 18, no. 12 (1957): 69, reprinted in *Focus on the Science Fiction Film*, edited by William Johnson (Englewood Cliffs, NJ: Prentice Hall, 1972), 71–73; Nora Sayre, *Running Time: Films of the Cold War* (New York: Dial Press, 1950), 199–201; Peter Biskind, *Seeing Is Believing: How Hollywood Taught Us to Stop Worrying and Love the Fifties* (New York: Henry Holt, 1983), 137–144.

61. Paul Buhle and Dave Wagner, *Hide in Plain Sight: The Hollywood Blacklistees in Film and Television, 1950–2002* (New York: Palgrave Macmillan), 73.

62. For several months in 1988, *Variety* featured special sections on the controversy surrounding *The Last Temptation of Christ*, reporting boycotts and protests as well as bannings in several countries. The Moral Majority jammed the phones of Universal Pictures, which distributed the film, and picketed studio offices. On August 9, 1988, before the film's release, the U.S. Catholic Conference called for a nationwide boycott, the first the conference had ever recommended.

63. Levinson, *Pleasures of Aesthetics*, 7.

64. See Thomas Armstrong and Brian Detweiler-Bedell, "Beauty as an Emotion: The Exhilarating Prospect of Mastering a Challenging World," *Review of General Psychology* 12, no. 4 (2008): 312.

CHAPTER 8

1. Quoted in Leighton Grist, "Moving Targets and Black Widows: Film Noir in Modern Hollywood," in *Book of Film Noir*, edited by Ian Cameron (New York: Continuum, 1993), 267.

2. Stephen Prince, *Classical Film Violence: Designing and Regulating Brutality in Hollywood Cinema, 1930–1968* (New Brunswick, NJ: Rutgers University Press, 2003), 205.

3. Prince, *Classical Film Violence*, 205.

4. James Naremore, *More than Night: Film Noir in Its Contexts* (Berkeley: University of California Press, 1998), 99–100, 118. See, in particular, Naremore's discussion of traces of the censor in *Crossfire* (1947) and other noir films (pp. 96–135). His discussion of censorship's effects on film follows that of Christian Metz in *The Imaginary Signifier: Psychoanalysis and the Cinema* (Bloomington: Indiana University Press, 1982).

5. Thomas Schatz, *Hollywood Genres* (New York: Random House, 1981), 99.

6. David Bordwell, Janet Staiger, and Kristin Thompson, *The Classical Hollywood Cinema: Film Style & Mode of Production to 1960* (New York: Routledge, 1988), 37.

7. Bordwell, Staiger and Thompson, *Classical Hollywood Cinema*, 37.

8. Naremore, *More than Night*, 129.

9. Christine Gledhill, "*Klute* 1: A Contemporary Film Noir and Feminist Criticism," in *Women in Film Noir*, edited by E. Ann Kaplan (London: British Film Institute, 1998), 29–30.

CHAPTER 9

1. Janet Maslin, "FILM REVIEW; No Bugs Too Large for This Swat Team," rev. *Starship Troopers, New York Times*, November 7, 1997. *Infotrac Newsstand*. Web, March 24, 2014.

2. Roger Ebert, "Good Guys vs. Bad Bugs," rev. *Starship Troopers, The Hamilton Spectator* (Ontario, Canada), November 7, 1997, Friday Final Edition, C5.

3. Todd Berliner, *Hollywood Incoherent: Narration in Seventies Cinema* (Austin: University of Texas Press, 2010), 91–99.

4. *Starship Troopers* grossed $54,188 million domestically. "Variety Box Office," *Variety* 369, no. 8, January 5, 1998, 13.

5. One can find a sampling of these fan creations on the website www.starshiptroopers.net.

6. *A.V. Club*, "The 50 Best Films of the '90s (1 of 3)," October 8, 2012, http://www.avclub.com/articles/the-50-best-films-of-the-90s-1-of-3,86304/. *Slant*, "The 100 Best Films of the 1990s," November 5, 2012, http://www.slantmagazine.com/features/article/the-100-best-films-of-the-1990s/P9.

7. Colum Marsh, "*Starship Troopers*: One of the Most Misunderstood Movies Ever," *The Atlantic*, November 7, 2013, http://www.theatlantic.com/entertainment/archive/2013/11/-em-starship-troopers-em-one-of-the-most-misunderstood-movies-ever/281236/.

8. Quoted in Dominic Wells, "It's Life, Jim . . . *Time Out* (London) (December 17–23, 1997), 23.

9. Clayton R. Koppes, "Regulating the Screen: The Office of War Information and the Production Code Administration," in Thomas Schatz *Boom and Bust: The American Cinema in the 1940s* (New York: Scribner, 1997), 278.

10. Brian E. Crim, "'A World That Works':Fascism and Media Globalization in *Starship Troopers*," *Film & History: An Interdisciplinary Journal of Film and Television Studies*, 39, no. 2 (Fall 2009): 17.

11. Manohla Dargis, rev. *Starship Troopers*, *LA Weekly* (November 7, 1997), 41.

12. Richard Schickel, "All Bugged Out, Again," rev. *Starship Troopers*, *Time*, 150, 20 (November 10, 1997), 102.

13. Ebert, "Good Guys vs. Bad Bugs," C5.

14. Stephen Hunter, "Goosestepping at the Movies; 'Starship Troopers' and the Nazi Aesthetic," *Washington Post*, November 11, 1997, final ed., Style Section, D01.

15. Quoted in Benjamin Svetkey, "The Reich Stuff: Director Paul Verhoeven Copies German Propaganda Films in a Twisted Reference to the Third Reich," *Entertainment Weekly* 46, November 21, 1997.

CHAPTER 10

1. Stephen Neale, *Genre* (London: British Film Institute, 1980), 49–50.

2. See, for example, Noel King, "'The Last Good Time We Ever Had': Remembering the New Hollywood Cinema," in *The Last Great American Picture Show: New Hollywood Cinema in the 1970s*, edited by Thomas Elsaesser, Alexander Horwath, and Noel King (Amsterdam: Amsterdam University Press, 2004), 24.

3. Peter Lev, *American Films of the 70s: Conflicting Visions* (Austin: University of Texas Press, 2000), 167–168.

4. Alexander Horwath, "A Walking Contradiction (Partly Truth and Partly Fiction)," in *The Last Great American Picture Show: New Hollywood Cinema in the 1970s*, edited by Thomas Elsaesser, Alexander Horwath, and Noel King (Amsterdam: Amsterdam University Press, 2004), 102.

5. David A. Cook, *Lost Illusions: American Cinema in the Shadow of Watergate and Vietnam, 1970–1979* (New York: Charles Scribner's Sons, 2000), xvi.

6. Jonathan Rosenbaum, "The Solitary Pleasures of *Star Wars*," *Sight and Sound* (October 4, 1977), 208–209.

7. Will Brooker, *Star Wars* (Basingstoke, UK: Palgrave Macmillan, 2009), 8.

8. David Bordwell, *On the History of Film Style* (Cambridge, MA: Harvard University Press, 1997), 43.

9. Östen Axelsson, "Individual Differences in Preferences to Photographs," *Psychology of Aesthetics, Creativity, and the Arts* 1, no. 2 (May 2007): 61–72; P. Hekkert and P. C. W. van Wieringen, "The Impact of Level of Expertise on the Evaluation of Original and Altered Versions of Post-impressionistic Paintings," *Acta Psychologica* 94 (1996): 117–131; J. D. Smith and R. J. Melara, "Aesthetic Preference and Syntactic Prototypicality in Music: Tis the Gift to be Simple," *Cognition* 34 (1990): 279–298; A. S. Winston, and G. C. Cupchik, "The Evaluation of High Art and Popular Art by Naive and Experienced Viewers," *Visual Arts Research* 18 (1992): 1–14; P. J. Silvia and C. Berg, "Finding Movies Interesting: How Expertise and Appraisals Influence the Aesthetic Experience of Film," *Empirical Studies of the Arts* 29, no. 1 (2001): 73–88.

10. W. G. Chase and H. A. Simon, "Perception in Chess," *Cognitive Psychology* 4 (1973): 55–81.

11. L. F. Smith and J. K. Smith, "The Nature and Growth of Aesthetic Fluency," in *New Directions in Aesthetics, Creativity, and the Arts*, edited by P. Locher, C. Martindale, and L. Dorfman (Amityville, NY: Baywood: 2006), 50.

12. Silvia and Berg, "Finding Movies Interesting."

13. H. Leder, B. Belke, A. Oeberst, and D. Augustin, "A Model of Aesthetic Appreciation and Aesthetic Judgements," *British Journal of Psychology* 95 (2004): 489–508.

14. Rolf Reber, Norbert Schwarz, and Piotr Winkielman, "Processing Fluency and Aesthetic Pleasure: Is Beauty in the Perceiver's Processing Experience?" *Personality and Social Psychology Review* 8, no. 4 (2004): 364–382.

15. D. E. Berlyne, *Aesthetics and Psychobiology* (New York: Appleton-Century-Crofts, 1971).

16. Leo Braudy, *The World in a Frame* (Garden City, NY: Anchor Books, 1977), 179.

17. Richard Maltby, *Hollywood Cinema*, 2nd ed. (Malden, MA: Wiley-Blackwell, 2003), 78.

18. Tino Balio, *Grand Design: Hollywood as a Modern Business Enterprise, 1930–1939* (Berkeley: University of California Press, 1996), 203–205.

19. David Bordwell, "Chinese Boxes, Russian Dolls, and Hollywood Movies," *Observations on Film Art* website, accessed March 24, 2014, http://www.davidbordwell.net/blog/2011/06/06/chinese-boxes-russian-dolls-and-hollywood-movies/.

20. David Bordwell, Janet Staiger and Kristin Thompson, *The Classical Hollywood Cinema: Film Style & Mode of Production to 1960* (New York: Routledge, 1988), 42.

21. Thomas Schatz, *Hollywood Genres* (New York: Random House, 1981), 40.

22. Quoted in Thomas Schatz, *Boom and Bust: The American Cinema in the 1940s* (New York: Scribner, 1997), 382.

23. Quoted in Richard Corliss, "A Cool Look at a Hot 'Star,'" *New Times*, June 24, 1977, 56.

24. Andrew Gordon discusses the film's multifarious use of genre conventions in "*Star Wars*: A Myth for Our Time," *Literature Film Quarterly* 6, no. 4 (Fall 1978): 314–326.

25. Gordon, "*Star Wars*: A Myth for Our Time," 319–320.

26. Rosenbaum, "The Solitary Pleasures of *Star Wars*," 209.

27. Quoted in Stephen Zito, "George Lucas Goes Far Out," *American Film* (April 1977), 10.

28. Francis Hutcheson, *Philosophical Writings* (London: J. M. Dent, 1994), 7–44.

29. Rosenbaum, "The Solitary Pleasures of *Star Wars*," 208.

30. Robin Wood, *Hollywood from Vietnam to Reagan* (New York: Columbia University Press, 1986), 164.

31. Wood, *Hollywood from Vietnam to Reagan*, 167.

32. Wood, *Hollywood from Vietnam to Reagan*, 164–165.

33. Frederick Wasser, *Veni, Vidi, Video: The Hollywood Empire and the VCR* (Austin: University of Texas Press, 2002), 130. For a discussion of the effect of home video on viewing habits, see Stephen Prince, *A New Pot of Gold: Hollywood under the Electronic Rainbow, 1980–1989* (Berkeley: University of California Press, 2000), 123–124.

34. David Bordwell, *The Way Hollywood Tells It: Story and Style in Modern Movies* (Berkeley: University of California Press, 2006), 90.

35. Bordwell, *The Way*, 73.

36. Quoted in Ty Burr, "Once upon a Classic," *Boston Globe Magazine*, March 23, 2003, 14+.

37. John Fawell, *The Hidden Art of Hollywood: In Defense of the Studio Era Film* (Westport, CT: Praeger, 2008), xii.

38. For essays on the recent trend in complex storytelling, see *Puzzle Films: Complex Storytelling in Contemporary Cinema*, edited by Warren Buckland (Malden, MA: Wiley-Blackwell, 2009).

CHAPTER 11

1. Max Steiner, "Scoring the Film," in *We Make the Movies*, edited by Nancy Naumburg (New York: W. W. Norton, 1937), 218.

2. Katherine Spring, *Saying It with Songs: Popular Music & the Coming of Sound to Hollywood Cinema* (Oxford: Oxford University Press, 2013), 8.

3. Philip Furia and Laurie Patterson, *The Songs of Hollywood* (New York: Oxford University Press, 2010), 24–42.

4. Spring, *Saying It with Songs*, 8.

5. Furia and Patterson, *Songs of Hollywood*, 43–44.

6. Furia and Patterson, *Songs of Hollywood*, 24–25.

7. Spring, *Saying It with Songs*, 96.

8. Richard Dyer, *In the Space of a Song: The Uses of Song in Film* (London: Routledge, 2012), 101.

9. Furia and Patterson, *Songs of Hollywood*, 49.

10. Furia and Patterson, *Songs of Hollywood*, 64.

11. David Thompson, "Sweet Unison," *Sight and Sound* 7, no. 4 (April 1997): 22.

12. Richard Fehr and Frederick G. Vogel, *Lullabies of Hollywood: Movie Music and the Movie Musical, 1915–1992* (Jefferson, NC: McFarland, 1993), 255.

13. Fehr and Vogel, *Lullabies of Hollywood*, 241–242.

14. Fehr and Vogel, *Lullabies of Hollywood*, 249.

15. Gary Marmorstein, *Hollywood Rhapsody: Movie Music and Its Makers, 1900 to 1975* (New York: Schirmer, 1997), 402.

16. Spring, *Saying It with Songs*, 148.

17. Quoted in Mark Harris, *Pictures at a Revolution: Five Movies and the Birth of the New Hollywood* (New York: Penguin, 2009), 360–361.

18. Bruce Babington and Peter William Evans, *Blue Skies and Silver Linings: Aspects of the Hollywood Musical*. (Manchester, UK: Manchester University Press, 1985), 225–226.

19. Spring, *Saying It with Songs*, 1.

20. Thomas Schatz, *Hollywood Genres* (New York: Random House, 1981), 38.

21. Leo Braudy, *The World in a Frame* (Garden City: Anchor Books, 1977), 179.

22. For more on the uses of song in Hollywood movies after the period of the classical musical, see Todd Berliner and Philip Furia, "The Sounds of Silence: Songs in Hollywood Films since the 1960s," *Style* 36, no. 1 (2002), 21.

23. Thompson, "Sweet Unison," 20.

24. Thompson, "Sweet Unison," 23.

CHAPTER 12

1. See, for instance, Thomas Schatz, *Hollywood Genres* (New York: Random House, 1981), 38.

2. André Bazin, "The Western, or the American Film Par Excellence," *What Is Cinema?* Vol. 2 (Berkeley: University of California Press, 1971), 144.

3. Thomas Schatz, "The Western," in *Handbook of American Film Genres*, edited by Wes D. Gehring (New York: Greenwood, 1988), 29.

4. John Cawelti, "Savagery, Civilization, and the Western Hero," in *Focus on the Western*, edited by John G. Nachbar (Englewood Cliffs, NJ: Prentice Hall, 1974), 62.

5. Bazin, "The Western," 146–147.

6. Joseph W. Reed, *American Scenarios: The Uses of Film Genre* (Middletown, CT: Wesleyan University Press, 1989), 262.

7. Richard Slotkin says, "The 1948–56 period—beginning with *Fort Apache* and ending with *The Searchers*—is extraordinarily rich in Westerns that are formally sophisticated, intellectually interesting—and *seminal*, in that some of them inaugurated major revisions of or additions to the genre's vocabulary." *Gunfighter Nation: The Myth of the Frontier in Twentieth-Century America* (New York: HarperCollins, 1993), 249.

8. Slotkin, *Gunfighter Nation*, 464.

9. Jim Kitses, *Horizons West: Directing the Western from Ford to Clint Eastwood* (London: British Film Institute, 2004), 68–69.

10. Schatz, *Hollywood*, 40.

11. William G. Simon and Louise Spence, "Cowboy Wonderland, History and Myth: 'It Ain't All That Different than Real Life,'" *Journal of Film and Video* 47 (Spring–Fall 1995): 79.

12. Schatz, "Western," 27.

13. Will Wright, *Sixguns and Society: A Structural Study of the Western* (Berkeley: University of California Press, 1975), 32.

14. Jon Tuska, *The American West in Film: Critical Approaches to the Western* (Lincoln: University of Nebraska Press, 1988), 29.

15. Carl Plantinga notes that in this scene "our allegiance shifts to the doomed cowboy" and that "spectators' sympathies now become entirely conflicted." "Spectacles of Death: Clint Eastwood and Violence in *Unforgiven*," *Cinema Journal* 37, no. 2 (Winter 1998): 76.

16. Richard Neupert, *The End: Narration and Closure in the Cinema* (Detroit: Wayne State University Press, 1995), 53.

17. Schatz, "Western," 27.

CONCLUSION

1. Cited in Joseph McBride, *Searching for John Ford: A Life* (New York: St. Martin's, 2001), 103.

2. E. H. Gombrich, *The Sense of Order: A Study in the Psychology of Decorative Art* (Ithaca, NY: Cornell University Press, 1979), 9.

Glossary

30-degree rule A guideline that instructs filmmakers to move the camera position by at least 30 degrees between consecutive shots of the same **mise-en-scène** elements so as to avoid a **jump cut**.

180-degree system A system for filming and editing scenes that helps maintain the **screen direction** of characters and objects in the frame. The system keeps the camera on one side of an imaginary line ("axis of action") during filming. As a result of the "180-degree rule," characters and objects face the same direction, left or right, from shot to shot.

Academy Ratio A 1.33:1 **aspect ratio** standardized by the Academy of Motion Picture Arts and Sciences in the early 1930s.

Aesthetic pleasure A pleasure of the mind, dependent on an artwork's sensory properties, involving appreciation of the work's character, content, or structure. The term is contested, but this study uses a broad, pluralistic definition.

Aesthetic properties Intrinsic properties of artworks (such as balance, boldness, gaudiness, garishness, or expressiveness) that determine aesthetic value, often contrasted with **sensory properties**.

Analytical editing The practice of organizing the shots of a film sequence by first providing an overall view (**establishing shot**) of the space and then breaking up the space into closer views that provide the viewer with spatial information in accordance with narrative needs.

Angle of framing The position of the camera in relation to mise-en-scène objects. For example, a high angle shot is filmed from above the object.

Anticipatory framing The practice of adjusting the framing before a change in mise-en-scène elements so as to anticipate the change, rather than react to it.

Artistic motivation One of the four ways in which perceivers justify the inclusion of a formal device in a work of art. A device has an "artistic motivation" when perceivers justify its inclusion in the artwork by inferring that the device exists for its own aesthetic value. For instance, we may justify an unusual animated sequence in a movie because the animation is aesthetically attractive or novel. See **motivation, compositional motivation, realistic motivation**, and **transtextual motivation**.

Aspect ratio The ratio of the width of the film frame to the height. Some standard aspect ratios in Hollywood cinema are 1.33:1 (**Academy Ratio**), 1.85:1 (a common flat **widescreen** ratio), and 2.40:1 (a common anamorphic **widescreen** ratio).

B-movie A low-budget film created by a "B unit" at a major studio or by independent studios between the 1930s and the 1950s. A "B-movie" was intended to be paired with an "A-movie" as the bottom half of a double feature.

Backlighting Lighting that comes from behind the figure, creating a contour of light. See **three-point lighting**.

Blocking The positioning of actors in the scene.

Camp An ironic and exaggerated style of art that often inverts traditional notions of aesthetic value.

Causality The narrative principle that one event leads to another by means of cause and effect.

Compositing Combining visual elements from separate shots into a single image.

Compositional motivation A justification of the presence of a formal device by its function in constructing the story. For example, spectators may justify the presence of voice-over in a film because it explains a character's goals. See **motivation, artistic motivation, realistic motivation**, and **transtextual motivation**.

Continuity editing A system of editing devices that establishes a continuous presentation of space and time. See **180-degree system, establishing shot, matching, reestablishing shot, screen direction**, and **shot/reverse shot**.

Deep focus A cinematography device that keeps both foreground and background objects simultaneously in focus by using a large **depth of field**. It is contrasted with **selective focus**.

Defamiliarization A Russian formalist term for the way in which artworks make us see the world in a new way, overcoming habits of perception and making familiar experience strange.

Depth of field The range of the distance between the nearest and farthest objects in front of the camera that appear in sharp focus.

Dialogue hook A line of dialogue at the end of a scene that prepares audiences for the next scene.

Diegesis Greek for "narrative." The world of a work of art. A "diegetic" element has its source within the fictional world. For example, music that the audience understands to be emanating from a character's car stereo is diegetic. See **non-diegetic**.

Director of Photography (DP) The chief cinematographer in charge of camera and lighting.

Dissolve A transition in film editing in which one shot fades out while another fades in so that the film for a time depicts two shots superimposed. See **fade**.

Distance of framing The apparent distance of the camera from mise-en-scène elements in the frame. See **establishing shot**, **long shot**, and **medium-long shot**.

Establishing shot A shot, usually at the beginning of a scene and usually from a long distance, that establishes the spatial relations among the objects and characters in a scene.

Exposition A portion of a narrative, usually at the beginning of the **plot**, that provides background information important to understanding the **story**.

Eyeline match A **continuity editing** device in which one shot depicts someone looking at something and the subsequent shot shows what the person sees. See **matching**.

Fade A transition in film editing in which a shot gradually darkens ("fade out" or "fade to black") or a dark shot gradually brightens as the image becomes legible ("fade in"). Alternatively, a shot can fade to a bright image ("fade to white").

Femme fatale An alluring, dangerous female character, often present in Hollywood crime films.

Fill light A soft light used to fill in shadows cast by the **key light**. See **three-point lighting**.

Foley The process by which sound effects are added to a film during **postproduction**, named after Jack Foley who worked at Universal during the transition to sound cinema.

Frontal lighting Lighting on a figure that illuminates the side facing the camera.

Frontality The practice of **blocking** actors so that they face the camera.

Graphic match A term, first used by David Bordwell and Kristin Thompson, that describes two consecutive shots that duplicate major graphic features. See **matching**.

Gross The cumulative amount that a film earns at the box office. It is contrasted with **rentals**.

High concept An immediately appealing and easily marketed storyline.

High Frame Rate 3D A digital 3D format, introduced commercially in 2012 with *The Hobbit: An Unexpected Journey*, that shoots and projects at 48 frames per second (fps),

rather than the industry standard of 24 fps, making image and movement extremely sharp and vivid.

High-key lighting A lighting scheme, typical of mainstream cinema, featuring low contrast and using **fill light** to eliminate shadows cast by the **key light**.

Intertitle Printed text, inserted in a film sequence between photographed action, that normally conveys dialogue or descriptive information pertaining to the action.

Jump cut. A transition between shots in which mise-en-scène elements appear to move in a jarring fashion, creating an abrupt sense of object or background motion. See **30-degree rule**.

Key light The brightest source of light in a shot. See **three-point lighting**.

Long shot. A **distance of framing** in which a figure is seen in its entirety, and the background dominates the image.

Low-key lighting A lighting technique that creates defined shadows and strong contrast between bright and dark areas in the frame, created by reducing or eliminating **fill light**.

Magic hour A cinematography term for the period just after the sun has set or just before it has risen when the color temperature drops; also called the "golden hour."

Matching A **continuity editing** practice used to disguise cuts and make transitions smoother by creating a visual connection between two shots. See **eyeline match**, **graphic match**, and **match-on-action**.

Match-on-action A **continuity editing** device in which an action shown in one shot is continued in the subsequent shot. See **matching**.

Mattes Painted, animated, or photographed images that are combined with photography during postproduction in order to create the illusion that separate images are part of one shot. See **compositing**.

Medium-long shot (also know as "plain American" or "American shot"). A **distance of framing** in which the human figure is seen from the mid-calf or knees up.

Mental model A mind's representation of the world, used to make predictions. See **schema**.

The Mere-Exposure Effect The psychological phenomenon whereby people develop preferences for things (words, objects, sounds, paintings, faces, etc.) that are familiar to them. According to the theory, the more exposure someone has to something, the stronger the preference.

Mise-en-scène French for "putting on stage." A critical term borrowed from theater that, in cinema, refers to all of the elements in front of the camera, including props, costumes, settings, makeup, the physical behavior of actors, and all other aspects of **staging**.

Motion Picture Association of America (MPAA) A trade association that represents the American film industry.

Motivation A formalist concept denoting the perceiver's understanding of the reason for a formal device's presence in a work of art. A perceiver may ascribe to a device an **artistic motivation**, **compositional motivation**, **realistic motivation**, and/or **transtextual motivation**.

Narration The process by which an artwork selects, arranges, and renders narrative information; a technical term for "storytelling."

Negative cost The cost of film production required to make the final negative, including all of the **production** costs and excluding the costs of promotion and distribution.

Non-diegetic Having come from outside of the story world. For example, a movie's credits are non-diegetic, as is mood music or voice-over that comes from a source outside of the narrative world. See **diegesis**.

Optical printer A device, employing both a camera and one or more projectors, used to combine separate strips of film.

Pan Short for "panorama shot." The practice of rotating a camera left or right on a vertical axis, as though the camera is turning its head.

Plot The presentation of narrative events to the perceiver. It is often contrasted with **story**.

Postproduction The phase of the film **production** process following **principal photography**, during which images and sounds are assembled into a finished film.

Preproduction The phase of the film **production** process before **principal photography** that includes budgeting, location scouting, casting, financing, and other preparations.

Principal photography Typically the most expensive phase of film **production**, between **preproduction** and **postproduction**, during which cameras are used to shoot the movie.

Processing capacity A psychology term that refers to the maximum amount of information that an individual can process within a cognitive system.

Processing fluency The ease with which the perceiver assimilates information psychologically. In the arts, processing fluency often denotes the ease with which someone perceives an artwork, integrates it into memory, classifies it, and cognitively masters and evaluates it.

Production The process of creating a film, from **preproduction**, through **principal photography**, to **postproduction**. The end result of production is a final negative.

Realistic motivation A justification of the presence of a formal device using notions from the real world. For example, spectators may justify the red color of a fire engine

in a movie because fire engines in the real world are often red. See **motivation**, **artistic motivation**, **compositional motivation**, and **transtextual motivation**.

Reestablishing shot A return to an **establishing shot** during the middle portion of a scene, normally after a change in mise-en-scène elements.

Rentals The share of the **gross** returned to the distributor. Typically, the rental amount is divided among the distributor and the film's profit participants, once the distributor deducts film printing and advertising costs.

Schema (plural "schemata"). A mental representation of some concept or aspect of the world. People employ schemata to frame, organize, and make sense of information, as well as to make predictions and inferences. See **mental model**.

Screen direction The direction in which characters or objects are facing, left or right, within a shot. See **180-degree system**, **continuity editing**, and **shot/reverse shot**.

Selective focus Limiting the **depth of field** so that only parts of the frame are in focus. It is contrasted with **deep focus**.

Sensory Properties Intrinsic properties of artworks (such as color, shape, sound, and movement) that create sensory experiences, often contrasted with **aesthetic properties**.

Shot/reverse shot A common **continuity editing** technique, particularly during conversation scenes, in which a shot that shows a character looking at another character is followed by a shot of the other character looking back. Normally, **screen direction** is maintained and **eyeline matches** connect the shots.

Soft lighting Illumination that creates soft edges and diffuse shadows.

Sound bridge A sound that briefly carries over from one scene to the next.

Staging The arrangement of mise-en-scène elements in the frame.

Star system The practice of creating and managing a movie star's image by establishing a distinct persona. During the studio era, a studio promoted and exploited a star's persona both on screen and through the studio's public relations department.

Story All of the events of the narrative—including events presented in the **plot** and events inferred by the perceiver—causally linked and in chronological order. Unlike the **plot**, which refers to presented events, the story is an imaginary construct of the perceiver: the **plot** cues a perceiver to construct the story in her mind.

Tent-pole film A blockbuster film designed to "hold up" the financial performance of a studio.

Three-point lighting A standard arrangement of three primary lights in a scene—**key light**, **fill light**, and **backlight**—in which the figure is clearly illuminated, shadows are diffuse, and the illuminated figure appears to have a natural look of volume.

Topos (plural, "topoi"). The traditional material of a group of artworks, including, for example, traditional themes, settings, scenarios, or characters.

Tracking shot A shot in which the camera travels in any direction along the ground.

Transtextual motivation A justification of the presence of a formal device that appeals to conventions established by other artworks. For example, spectators may justify the presence of outbursts of song in a musical because other musicals employ the same convention. See **motivation, artistic motivation, compositional motivation**, and **realistic motivation**.

Typecasting The practice of casting actors in accordance with their customary traits and behaviors or with their typical on- or off-screen personas.

Variable framing Framing that has the ability to cut, zoom, move the camera, or alter the distance or angle of framing.

Whip pan A type of **pan** in which the camera moves so quickly that the image blurs.

Widescreen A frame with an **aspect ratio** wider than the **Academy Ratio**, generally 1.66:1 or wider.

Zoom A cinematography technique (employing a "zoom lens") in which the lens focal length changes continuously during a shot so that objects in the frame are magnified ("zoom in") or reduced ("zoom out").

Bibliography

Aaron, Michele. *Spectatorship: The Power of Looking On*. London: Wallflower, 2007.

Adorno, Theodor. "The Culture Industry Reconsidered." Translated by Anson G. Rabinbach. *New German Critique* 6 (Fall 1975): 12–19.

Agee, James. *Agee on Film*. Vol. 1. New York: Grossett and Dunlap, 1958.

Alden, Dana L., Ashesh Mukherjee, and Wayne D. Hoyer. "The Effects of Incongruity, Surprise and Positive Moderators on Perceived Humor in Television Advertising." *Journal of Advertising* 29, no. 2 (2000): 1–15.

Allen, Richard, and Murray Smith, eds. *Film Theory and Philosophy*. Oxford: Oxford University Press, 1997.

Althusser, Louis. *For Marx*. Translated by Ben Brewster. London: New Left Books, 1979.

Armstrong, Thomas, and Brian Detweiler-Bedell. "Beauty as an Emotion: The Exhilarating Prospect of Mastering a Challenging World." *Review of General Psychology* 12, no. 4 (2008): 305–329.

Austin, B. A., ed. *Current Research in Film: Audiences, Economics, and Law*. Vol. 4. Norwood, NJ: Ablex, 1988.

Austin, B. A. *Immediate Seeing: A Look at Movie Audiences*. Belmont, CA: Wadsworth, 1988.

Axelsson, Östen. "Individual Differences in Preferences to Photographs." *Psychology of Aesthetics, Creativity, and the Arts* 1, no. 2 (2007): 61–72.

Babington, Bruce, and Peter William Evans. *Blue Skies and Silver Linings: Aspects of the Hollywood Musical*. Manchester, UK: Manchester University Press, 1985.

Balio, Tino. *Grand Design: Hollywood as a Modern Business Enterprise, 1930–1939*. Vol. 5. Berkeley: University of California Press, 1995.

Ball, Eustace Hale. *Cinema Plays: How to Write Them*. London: Stanley Paul, 1917.

Barrett, Lisa Feldman. "Are Emotions Natural Kinds?" *Perspectives on Psychological Science* 1, no. 1 (2006): 28–58.

Bazin, Andre. *What Is Cinema?* Vol. 2. Berkeley: University of California Press, 1971.

Beardsley, Monroe C. *Aesthetics, Problems in the Philosophy of Criticism*. Indianapolis: Hackett, 1981.

Beardsley, Monroe C. "In Defense of Aesthetic Value." *Proceedings and Addresses of the American Philosophical Association* 52, no. 6 (August 1979): 723–749.

Begley, Varun. "'One Right Guy to Another': Howard Hawks and Auteur Theory Revisited." *Camera Obscura* 22, no. 64 (2007): 43–75.

Belton, John. *Widescreen Cinema*. Cambridge, MA: Harvard University Press, 1992.

Berliner, Todd, and Philip Furia. "The Sounds of Silence: Songs in Hollywood Films since the 1960s." *Style* 36, no. 1 (2002): 19–35.

Berliner, Todd. *Hollywood Incoherent: Narration in Seventies Cinema*. Austin: University of Texas Press, 2010.

Berlyne, Daniel E. *Aesthetics and Psychobiology*. New York: Appleton-Century-Crofts, 1971.

Berlyne, Daniel E. *Studies in the New Experimental Aesthetics: Steps toward an Objective Psychology of Aesthetic Appreciation*. Washington, DC: Hemisphere, 1974.

Biskind, Peter. *Seeing Is Believing: How Hollywood Taught Us to Stop Worrying and Love the Fifties*. New York: Macmillan, 1983.

Booth, Stephen. *Precious Nonsense: The Gettysburg Address, Ben Jonson's Epitaphs on His Children, and Twelfth Night*. Berkeley: University of California Press, 1998.

Bordwell, David. "Eisenstein's Epistemological Shift." *Screen* 15, no. 4 (Winter 1974–1975): 29–58.

Bordwell, David. *Figures Traced in Light: On Cinematic Staging*. Berkeley: University of California Press, 2005.

Bordwell, David. *Narration in the Fiction Film*. Madison: University of Wisconsin Press, 1985.

Bordwell, David. *On the History of Film Style*. Cambridge, MA: Harvard University Press, 1997.

Bordwell, David. *The Way Hollywood Tells It: Story and Style in Modern Movies*. Berkeley: University of California Press, 2006.

Bordwell, David, and Noël Carroll, eds. *Post-theory: Reconstructing Film Studies*. Madison: University of Wisconsin Press, 2012.

Bordwell, David, Janet Staiger, and Kristin Thompson. *The Classical Hollywood Cinema*. New York: Columbia University Press, 1985.

Bornstein, Robert F. "Exposure and Affect: Overview and Meta-analysis of Research, 1968–1987." *Psychological Bulletin* 106, no. 2 (1989): 265–289.

Bowden, Edward M., Mark Jung-Beeman, Jessica Fleck, and John Kounios. "New Approaches to Demystifying Insight." *Trends in Cognitive Sciences* 9, no. 7 (2005): 322–328.

Braudy, Leo. *The World in a Frame*. Garden City, NY: Anchor Books, 1977.

Brooker, Will. *Star Wars*. New York: Macmillan, 2009.

Bruce, Vicki, Tim Valentine, and Alan Baddeley. "The Basis of the 3/4 View Advantage in Face Recognition." *Applied Cognitive Psychology* 1, no. 2 (1987): 109–120.

Brunette, Peter, ed. *Martin Scorsese: Interviews*. Jackson: University Press of Mississippi, 1999.

Buckland, Warren. *Directed by Steven Spielberg: Poetics of the Contemporary Hollywood Blockbuster*. New York: Continuum Press, 2006.

Buckland, Warren, ed. *Puzzle Films: Complex Storytelling in Contemporary Cinema*. Malden, MA: Wiley-Blackwell, 2009.

Buhle, Paul, and Dave Wagner. *Hide in Plain Sight: The Hollywood Blacklistees in Film and Television, 1950–2002*. New York: Macmillan, 2015.

Burch, Noël. *Theory of Film Practice*. Translated by Helen R. Lane. New York: Praeger, 1973.

Cameron, Ian, ed. *Book of Film Noir*. New York: Continuum, 1993.

Carel, Havi, and Greg Tuck, eds. *New Takes in Film-Philosophy*. Basingstoke, UK: Palgrave Macmillan, 2011.

Carroll, Noël. "Moderate Moralism." *The British Journal of Aesthetics* 36, no. 3 (1996): 223–239.

Carroll, Noël. *Mystifying Movies*. New York: Columbia University Press, 1988.

Carroll, Noël. *Philosophy of Art: A Contemporary Introduction*. New York: Routledge, 2012.

Carroll, Noël. *A Philosophy of Mass Art*. Oxford: Clarendon, 1998.

Carroll, Noël. "The Power of Movies." In *Aesthetics and the Philosophy of Art: The Analytic Tradition*. Edited by Peter Lamarque and Stein Haugom Olsen, 485–497. Malden, MA: Blackwell, 2004.

Chapman, Anthony J., and Hugh C. Foot, eds. *Humour and Laughter: Theory, Research and Applications*. New Brunswick, NJ: Transaction Publishers, 1996.

Chase, William G., and Herbert A. Simon. "Perception in Chess." *Cognitive Psychology* 4, no. 1 (1973): 55–81.

Chatman, Seymour Benjamin. *Story and Discourse: Narrative Structure in Fiction and Film*. Ithaca, NY: Cornell University Press, 1980.

Checkosky, Stephen F., and Dean Whitlock. "Effects of Pattern Goodness on Recognition Time in a Memory Search Task." *Journal of Experimental Psychology* 100, no. 2 (1973): 341–348.

Clagett, Thomas D. *William Friedkin: Films of Aberration, Obsession, and Reality*. Jefferson, NC: McFarland, 1990.

Cook, David A. *Lost Illusions: American Cinema in the Shadow of Watergate and Vietnam, 1970–1979*. Vol. 9. Berkeley: University of California Press, 2002.

Cowgill, Linda J. *Secrets of Screenplay Structure: How to Recognize and Emulate the Structural Frameworks of Great Films.* Los Angeles, CA: Lone Eagle, 1999.

Crim, Brian E. "'A World That Works': Fascism and Media Globalization in *Starship Troopers*." *Film & History: An Interdisciplinary Journal of Film and Television Studies* 39, no. 2 (2009): 17–25.

Crowe, Cameron. *Conversations with Wilder.* New York: Alfred A. Knopf, 1999.

Cundall, Michael K., Jr. "Humor and the Limits of Incongruity." *Creativity Research Journal* 19, nos. 2–3 (2007): 203–211.

Cutting, James E., Kaitlin L. Brunick, Jordan E. Delong, Catalina Iricinschi, and Ayse Candan. "Quicker, Faster, Darker: Changes in Hollywood Film over 75 Years." *I-Perception* 2, no. 6 (2011): 569–576.

Deckers, Lambert, and Robert Thayer Buttram. "Humor as a Response to Incongruities within or between Schemata." *Humor* 3, no. 1 (1990): 53–64.

Dewey, John. *Art as Experience.* Originally published 1934. New York: Putnam, 1980.

Dibattista, Maria. *Fast-Talking Dames.* New Haven, CT: Yale University Press, 2003.

Doane, Mary Ann. *Femmes Fatales: Feminism, Film Theory, Psychoanalysis.* New York: Routledge, 1991.

Dougan, Andy. *Martin Scorsese.* New York: Thunder's Mouth Press, 1998.

Dyer, Richard. *In the Space of a Song: The Uses of Song in Film.* New York: Routledge, 2013.

Dyer, Richard. *Only Entertainment.* New York: Routledge Press, 2002.

Eisenstein, Sergei. *Film Form: Essays in Film Theory.* Edited and translated by Jay Leyda. New York: Harcourt, Brace and World, 1949.

Elsaesser, Thomas, Noel King, and Alexander Horwath. *The Last Great American Picture Show: New Hollywood Cinema in the 1970s.* Amsterdam: Amsterdam University Press, 2004.

Fabe, Marilyn. *Closely Watched Films: An Introduction to the Art of Narrative Film Technique.* Berkeley: University of California Press, 2014.

Fawell, John. *The Hidden Art of Hollywood: In Defense of the Studio Era Film.* Westport, CT: Praeger, 2008.

Fehr, Richard, and Frederick G. Vogel. *Lullabies of Hollywood: Movie Music and the Movie Musical, 1915–1992.* Jefferson, NC: McFarland, 1993.

Field, Syd. *The Screenwriter's Problem Solver: How to Recognize, Identify, and Define Screenwriting Problems.* New York: Dell, 1988.

Fredrickson, B. L. "Psychophysiological Functions of Positive Emotions." In *ISRE '96 Proceedings of the Ninth Conference of the International Society for Research on Emotions.* Edited by N. H. Frijda, 92–95. Toronto: Isre Publications, 1996.

Furia, Philip, and Laurie Patterson. *The Songs of Hollywood.* Oxford: Oxford University Press, 2010.

Gaut, Berys, and Dominic Lopes. *The Routledge Companion to Aesthetics.* New York: Routledge, 2013.

Gehring, Wes D., ed. *Handbook of American Film Genres.* New York: Greenwood, 1988.

Gentry, Ric. "Michael Chapman Captures *Raging Bull* in Black and White." *Millimeter* 9, no. 2 (February 1981): 112.

Goldstein, Jeffrey, and Paul McGee, eds. *The Psychology of Humor: Theoretical Perspectives and Empirical Issues.* New York: Academic Press, 1972.

Gombrich, E. H. *Art and Illusion: A Study in the Psychology of Pictorial Representation.* Princeton, NJ: Princeton University Press, 1969.

Gombrich, E. H. "Style." In *The International Encyclopedia of the Social Sciences.* Vol. 15. Edited by D. L. Sills, 352–363. New York: Macmillan, 1968.

Gombrich, E. H. *The Sense of Order: A Study in the Psychology of Decorative Art.* Ithaca, NY: Cornell University Press, 1979.

Gordon, Andrew. "'Star Wars': A Myth for Our Time." *Literature/Film Quarterly* 6, no. 4 (1978): 314.

Halio, Jay L., Hugh M. Richmond, and Marvin Rosenberg. *Shakespearean Illuminations: Essays in Honor of Marvin Rosenberg.* Newark: University of Delaware Press, 1998.

Harris, Mark. *Pictures at a Revolution: Five Movies and the Birth of the New Hollywood.* New York: Penguin, 2008.

Hekkert, Paul, and Piet C. W. van Wieringen. "The Impact of Level of Expertise on the Evaluation of Original and Altered Versions of Post-impressionistic Paintings." *Acta Psychologica* 94, no. 2 (1996): 117–131.

Herman, David. *Story Logic: Problems and Possibilities of Narrative.* Lincoln: University of Nebraska Press, 2004.

Herman, Lewis. *A Practical Manual of Screen Playwriting*. New York: Meridian, 1963.

Higgins, Scott. *Harnessing the Technicolor Rainbow: Color Design in the 1930s*. Austin: University of Texas Press, 2007.

Hill, John, and Pamela Church Gibson, eds. *The Oxford Guide to Film Studies*. Oxford: Oxford University Press, 1998.

Hillier, Jim, and Peter Wollen, eds. *Howard Hawks: American Artist*. London: British Film Institute, 1996.

Hitt, Jim. *The American West from Fiction (1823–1976) to Film (1906–1986)*. Jefferson, NC: McFarland, 1990.

Hoopes, Roy. *Cain*. Carbondale: Southern Illinois University Press, 1982.

Hoppe, R. A. "Artificial Humor and Uncertainty." *Perceptual and Motor Skills* 42 (1976): 1051–1056.

Humphrey, Diane. "Preferences in Symmetries and Symmetries in Drawings: Asymmetries between Ages and Sexes." *Empirical Studies of the Arts* 15, no. 1 (1997): 41–60.

Hutcheson, Francis. *Philosophical Writings*. London: J. M. Dent, 1994.

Imamoglu, Çagri. "Complexity, Liking and Familiarity: Architecture and Non-architecture Turkish Students' Assessments of Traditional and Modern House Facades." *Journal of Environmental Psychology* 20, no. 1 (2000): 5–16.

Ivanko, Stacey L., and Penny M. Pexman. "Context Incongruity and Irony Processing." *Discourse Processes* 35, no. 3 (2003): 241–279.

Jakesch, Martina, and Helmut Leder. "Finding Meaning in Art: Preferred Levels of Ambiguity in Art Appreciation." *Quarterly Journal of Experimental Psychology* 62, no. 11 (2009): 2105–2112.

Jameson, Fredric. "Reification and Utopia in Mass Culture." *Social Text* 1 (Winter 1979): 130–148.

Johnson, William, ed. *Focus on the Science Fiction Film*. Englewood Cliffs, NJ: Prentice Hall, 1972.

Jones, J. M. "Cognitive Factors in the Appreciation of Humor: A Theoretical and Experimental Analysis," PhD diss., Yale University, New Haven, CT, 1970.

Jung-Beeman, Mark, Edward M. Bowden, Jason Haberman, Jennifer L. Frymiare, Stella Arambel-Liu, Richard Greenblatt, Paul J. Reber, and John Kounios. "Neural Activity When People Solve Verbal Problems with Insight." *PLoS Biology* 2, no. 4 (2004): 500–510.

Kahneman, Daniel, Edward Diener, and Norbert Schwarz, eds. *Well-Being: Foundations of Hedonic Psychology*. New York: Russell Sage Foundation, 1999.

Kant, Immanuel. *Critique of Judgment*. Translated by Werner S. Pluhar. Indianapolis: Hackett, 1987.

Kaplan, Craig A., and Herbert A. Simon. "In Search of Insight." *Cognitive Psychology* 22, no. 3 (1990): 374–419.

Kaplan, E. Ann, ed. *Women in Film Noir*. London: British Film Institute, 1998.

Keating, Patrick. "Emotional Curves and Linear Narratives." *The Velvet Light Trap* 58, no. 1 (2006): 4–15.

Keating, Patrick. *Hollywood Lighting from the Silent Era to Film Noir*. New York: Columbia University Press, 2009.

Kelly, Mary Pat. *Martin Scorsese: A Journey*. New York: Thunder's Mouth Press, 1991.

Kitses, Jim. *Horizons West: Directing the Western from Ford to Clint Eastwood*. London: British Film Institute, 2004.

Klinger, Barbara. "Digressions at the Cinema: Reception and Mass Culture." *Cinema Journal* 28, no. 4 (1989): 3–19.

Klinger, Barbara. *Melodrama and Meaning: History, Culture, and the Films of Douglas Sirk*. Bloomington: Indiana University Press, 1994.

Knoblich, Günther, Stellan Ohlsson, Hilde Haider, and Detlef Rhenius. "Constraint Relaxation and Chunk Decomposition in Insight Problem Solving." *Journal of Experimental Psychology: Learning, Memory, and Cognition* 25, no. 6 (1999): 1534–1555.

Koffka, Kurt. *Principles of Gestalt Psychology*. New York: Routledge, 2013.

Konecni, Vladimir J., and Dianne Sargent-Pollock. "Choice between Melodies Differing in Complexity under Divided-Attention Conditions." *Journal of Experimental Psychology: Human Perception and Performance* 2, no. 3 (1976): 347–356.

Kozloff, Sarah. "Empathy and the Cinema of Engagement: Reevaluating the Politics of Film." *Projections* 7, no. 2 (2013): 1–40.

Lahr, John. "High Marx: Tony Kushner's Socialist Spectacular." *The New Yorker*, May 16, 2011, 130–131.

Lally, Kevin. *Wilder Times: The Life of Billy Wilder*. New York: Henry Holt, 1996.

Lamarque, Peter, and Stein Haugom Olsen, eds. *Aesthetics and the Philosophy of Art: The Analytic Tradition.* Malden, MA: Blackwell, 2004.

Lang, Berel, ed. *The Concept of Style.* Ithaca, NY: Cornell University Press, 1987.

Langlois, Judith H., and Lori A. Roggman. "Attractive Faces Are Only Average." *Psychological Science* 1, no. 2 (1990): 115–121.

Lazarus, Richard S. *Emotion and Adaptation.* New York: Oxford University Press, 1991.

Leder, H., B. Belke, A. Oeberst, and D. Augustin. "A Model of Aesthetic Appreciation and Aesthetic Judgements." *British Journal of Psychology* 95 (2004): 489–508.

Lemon, Lee T., and Marion J. Reis, eds. *Russian Formalist Criticism: Four Essays.* Lincoln: University of Nebraska Press, 1965.

Lev, Peter. *American Films of the 70s: Conflicting Visions.* Austin: University of Texas Press, 2010.

Levinson, Jerrold. *The Oxford Handbook of Aesthetics.* Oxford: Oxford University Press, 2005.

Levinson, Jerrold. *The Pleasures of Aesthetics: Philosophical Essays.* Ithaca, NY: Cornell University Press, 1996.

Lewis, Jon. *American Film: A History.* New York: W. W. Norton, 2007.

Liandrat-Guigues, Suzanne. *Red River.* London: British Film Institute, 2000.

Lichtenstein, A., and L. B. Rosenfeld. "Uses and Misuses of Gratification Research: An Explication of Media Functions." *Communication Research* 10 (1983): 97–109.

Lipton, Peter. *Inference to the Best Explanation.* New York: Routledge, 2003.

Livingston, Paisley, and Carl Plantinga, eds. *The Routledge Companion to Philosophy and Film.* New York: Routledge, 2008.

Locher, Paul, Colin Martindale, and Leonid Dorfman, eds. *New Directions in Aesthetics, Creativity and the Arts.* Amityville, NY: Baywood, 2006.

Lucey, Paul. *Story Sense: Writing Story and Script for Feature Films and Television.* New York: McGraw-Hill, 1996.

Maier, N. R. F. "Reasoning in Humans. II. The Solution of a Problem and Its Appearance in Consciousness." *Journal of Comparative Psychology* 12, no. 2 (1931): 181–194.

Maltby, Richard. *Hollywood Cinema.* 2nd ed. Malden, MA: Wiley-Blackwell, 2003.

Marion, Frances. *How to Write and Sell Film Stories.* New York: Covici Friede, 1937.

Marmorstein, Gary. *Hollywood Rhapsody: Movie Music and Its Makers, 1900 to 1975.* New York: Simon and Schuster, 1997.

Martindale, Colin, and Kathleen Moore. "Priming, Prototypicality, and Preference." *Journal of Experimental Psychology: Human Perception and Performance* 14, no. 4 (1988): 661–670.

Marx, Karl, and Friedrich Engels. *The German Ideology.* Amherst, NY: Prometheus, 1998.

Mason, Oliver J., and Francesca Brady. "The Psychotomimetic Effects of Short-Term Sensory Deprivation." *Journal of Nervous and Mental Disease* 197, no. 10 (2009): 783–785.

Mast, Gerald. *Howard Hawks, Storyteller.* New York: Oxford University Press, 1982.

Mayer, Richard E. *Thinking, Problem Solving, Cognition.* 2nd ed. New York: Worth, 1992.

McBride, Joseph. *Hawks on Hawks.* Berkeley: University of California Press, 1982.

McBride, Joseph, ed. *Focus on Howard Hawks.* Englewood Cliffs, NJ: Prentice Hall, 1972.

McBride, Joseph. *Searching for John Ford: A Life.* New York: St. Martin's, 2001.

McGhee, Paul E. "Children's Appreciation of Humor: A Test of the Cognitive Congruency Principle." *Child Development* 47, no. 2 (1976): 420–426.

McGhee, Paul E., and Jeffrey H. Goldstein, eds. *Handbook of Humor Research.* Vol. 2. New York: Springer-Verlag, 1983.

McWhinnie, Harold J. "A Review of Research on Aesthetic Measure." *Acta Psychologica* 28 (1968): 363–375.

Metcalfe, Janet. "Feeling of Knowing in Memory and Problem Solving." *Journal of Experimental Psychology: Learning, Memory, and Cognition* 12, no. 2 (1986): 288–294.

Metcalfe, Janet, and David Wiebe. "Intuition in Insight and Noninsight Problem Solving." *Memory & Cognition* 15, no. 3 (1987): 238–246.

Metz, Christian. *The Imaginary Signifier: Psychoanalysis and the Cinema.* Bloomington: Indiana University Press, 1982.

Millis, Keith. "Making Meaning Brings Pleasure: The Influence of Titles on Aesthetic Experiences." *Emotion* 1, no. 3 (2001): 320–329.

Möller, Kristian, and Pirjo Karppinen. "Role of Motives and Attributes in Consumer Motion Picture Choice." *Journal of Economic Psychology* 4, no. 3 (1983): 239–262.

Morreall, John, ed. *The Philosophy of Laughter and Humor*. Albany: State University of New York Press, 1987.

Morreall, John. *Taking Laughter Seriously*. Albany: State University of New York Press, 1983.

Mulvey, Laura. *Visual and Other Pleasures*. Bloomington: Indiana University Press, 1989.

Nachbar, John G. *Focus on the Western*. Englewood Cliffs, NJ: Prentice Hall, 1974.

Nannicelli, Ted, and Paul Taberham. *Cognitive Media Theory*. New York: Routledge, 2014.

Naremore, James, ed. *North by Northwest*. New Brunswick, NJ: Rutgers University Press, 1993.

Naremore, James. *More than Night: Film Noir in Its Contexts*. Berkeley: University of California Press, 2008.

Naumburg, Nancy, ed. *We Make the Movies*. New York: W. W. Norton, 1937.

Neale, Stephen. *Genre*. London: British Film Institute, 1980.

Neupert, Richard. *The End: Narration and Closure in the Cinema*. Detroit, MI: Wayne State University Press, 1995.

Nichols, Bill, ed. *Movies and Methods: An Anthology*. Vol. 1. Berkeley: University of California Press, 1976.

Nichols, Bill, ed. *Movies and Methods: An Anthology*. Vol. 2. Berkeley: University of California Press, 1985.

Oring, Elliott. *Engaging Humor*. Urbana: University of Illinois Press, 2003.

Palmer, Frederick. *Author's Photoplay Manual*. Hollywood, CA: Palmer Institute, 1924.

Peirce Edition Project, ed. *The Essential Peirce: Selected Philosophical Writings*. Vol. 2, *1893–1913*. Bloomington: Indiana University Press, 1998.

Perkins, Victor Francis. *Film as Film: Understanding and Judging Movies*. New York: Da Capo Press, 1993.

Plantinga, Carl. *Moving Viewers: American Film and the Spectator's Experience*. Berkeley: University of California Press, 2009.

Plantinga, Carl. "Spectacles of Death: Clint Eastwood and Violence in *Unforgiven*" *Cinema Journal* 37, no. 2 (1998): 65–83.

Powers, Tom. "*His Girl Friday*: Screwball Liberation." *Jump Cut* 17 (1974): 25–28.

Pribram, E. Deidre. "Spectatorship and Subjectivity." In *A Companion to Film Theory*. Edited by Toby Miller and Robert Stam, 146–164. Malden, MA: Wiley-Blackwell, 1999.

Prince, Stephen. *Classical Film Violence: Designing and Regulating Brutality in Hollywood Cinema, 1930–1968*. New Brunswick, NJ: Rutgers University Press, 2003.

Prince, Stephen. *A New Pot of Gold: Hollywood under the Electronic Rainbow, 1980–1989*. Vol. 10. Berkeley: University of California Press, 2000.

Ramachandran, Vilayanur S., and William Hirstein. "The Science of Art: A Neurological Theory of Aesthetic Experience." *Journal of Consciousness Studies* 6, nos. 6–7 (1999): 15–51.

Ray, Robert Beverley. *A Certain Tendency of the Hollywood Cinema, 1930–1980*. Princeton, NJ: Princeton University Press, 1985.

Reber, Rolf. "Reasons for the Preference for Symmetry." *Behavioral and Brain Sciences* 25, no. 3 (2002): 415–416.

Reber, Rolf, Norbert Schwarz, and Piotr Winkielman. "Processing Fluency and Aesthetic Pleasure: Is Beauty in the Perceiver's Processing Experience?" *Personality and Social Psychology Review* 8, no. 4 (2004): 364–382.

Reed, Joseph W. *American Scenarios: The Uses of Film Genre*. Middletown, CT: Wesleyan University Press, 1989.

Rhodes, Gillian, and Tanya Tremewan. "Averageness, Exaggeration, and Facial Attractiveness." *Psychological Science* 7 (1996): 105–110.

Richardson, Brian. *Unlikely Stories: Causality and the Nature of Modern Narrative*. Newark: University of Delaware Press, 1997.

Roberts, Robert C. *Emotions: An Essay in Aid of Moral Psychology*. Cambridge, UK: Cambridge University Press, 2003.

Rodowick, D. N. "An Elegy for Theory." *October* 122 (Fall 2007): 91–109.

Rosen, Philip. *Narrative, Apparatus, Ideology: A Film Theory Reader*. New York: Columbia University Press, 1986.

Rosenbaum, Jonathan. *Movies as Politics*. Berkeley: University of California Press, 1997.

Rosenbaum, Jonathan. "The Solitary Pleasures of *Star Wars*." *Sight and Sound*, October 4, 1977, 208–209.

Russell, P. A. "Preferability, Pleasingness, and Interestingness: Relationships between Evaluative Judgments in Empirical Aesthetics." *Empirical Studies of the Arts* 12, no. 2 (1994): 141–157.

Russell, P. A., and D. A. George. "Relationships between Aesthetic Response Scales Applied to Paintings." *Empirical Studies of the Arts* 8, no. 1 (1990): 15–30.

Russell, P. A., C. D. Gray, and C. D. Grey. "The Heterogeneity of the Preferability Scale in Aesthetic Judgments of Paintings." *Visual Arts Research* 17 (1991): 76–84.

Rutsky, R. L., and Justin Wyatt. "Serious Pleasures: Cinematic Pleasure and the Notion of Fun." *Cinema Journal* 30, no. 1 (1990): 3–19.

Ryan, Marie-Laure. "Cheap Plot Tricks, Plot Holes, and Narrative Design." *Narrative* 17, no.1 (2009): 56–75.

Savile, Anthony. *The Test of Time: An Essay in Philosophical Aesthetics*. Oxford: Clarendon, 1982.

Sayre, Nora. *Running Time: Films of the Cold War*. New York: Dial Press, 1950.

Schaeffer, Neil. *The Art of Laughter*. New York: Columbia University Press, 1981.

Schapiro, Meyer. *Theory and Philosophy of Art: Style, Artist, and Society*. New York: George Braziller, 1994.

Schatz, Thomas. *Boom and Bust: American Cinema in the 1940s*. Vol. 6. Berkeley: University of California Press, 1999.

Schatz, Thomas. *Hollywood Genres*. New York: Random House, 1981.

Schatz, Thomas. "New Hollywood, New Millennium." In *Film Theory and Contemporary Hollywood Movies*. Edited by Warren Buckland, 19–46. New York: Routledge, 2009.

Schickel, Richard, and Billy Wilder. *Double Indemnity*. London: British Film Institute, 1992.

Scorsese, Martin, Ian Christie, and David Thompson. *Scorsese on Scorsese: Revised Edition*. New York: Macmillan, 2003.

Sikov, Ed. *On Sunset Boulevard: The Life and Times of Billy Wilder*. New York: Hyperion, 1998.

Silvia, Paul J. "Artistic Training and Interest in Visual Art: Applying the Appraisal Model of Aesthetic Emotions." *Empirical Studies of the Arts* 24, no. 2 (2006): 139–161.

Silvia, Paul J. "Emotional Responses to Art: From Collation and Arousal to Cognition and Emotion." *Review of General Psychology* 9, no. 4 (2005): 342–357.

Silvia, Paul J. *Exploring the Psychology of Interest*. Oxford: Oxford University Press, 2006.

Silvia, Paul J. "Interest—The Curious Emotion." *Current Directions in Psychological Science* 17, no. 1 (2008): 57–60.

Silvia, Paul J. "Looking Past Pleasure: Anger, Confusion, Disgust, Pride, Surprise, and Other Unusual Aesthetic Emotions." *Psychology of Aesthetics, Creativity, and the Arts* 3, no. 1 (2009): 48–51.

Silvia, Paul J. "What Is Interesting? Exploring the Appraisal Structure of Interest." *Emotion* 5, no. 1 (2005): 89–102.

Silvia, Paul J., and Christopher Berg. "Finding Movies Interesting: How Appraisals and Expertise Influence the Aesthetic Experience of Film." *Empirical Studies of the Arts* 29, no. 1 (2011): 73–88.

Simon, William G., and Louise Spence. "Cowboy Wonderland, History, and Myth: 'It Ain't All That Different than Real Life.'" *Journal of Film and Video* 47, nos. 1–3 (1995): 67–81.

Slotkin, Richard. *Gunfighter Nation: The Myth of the Frontier in Twentieth-Century America*. New York: HarperCollins, 1993.

Smith, J. David, and Robert J. Melara. "Aesthetic Preference and Syntactic Prototypicality in Music: 'Tis the Gift to Be Simple." *Cognition* 34, no. 3 (1990): 279–298.

Smith, Murray. *Engaging Characters: Fiction, Emotion, and the Cinema*. Oxford: Clarendon, 1995.

Smith, Steven M., Thomas B. Ward, and Ronald A. Finke. *The Creative Cognition Approach*. Cambridge, MA: MIT Press, 1995.

Spring, Katherine. *Saying It with Songs: Popular Music and the Coming of Sound to Hollywood Cinema*. Oxford: Oxford University Press, 2013.

Squire, Jason E. *The Movie Business Book*. New York: Simon and Schuster, 2004.

Stam, Robert. *Film Theory: An Introduction*. Malden, MA: Wiley-Blackwell, 2000.

Sternberg, Robert J., and Janet E. Davidson. *The Nature of Insight*. Cambridge, MA: MIT Press, 1995.

Tan, Ed S. *Emotion and the Structure of Narrative Film: Film as an Emotion Machine*. New York: Routledge, 2013.

Thompson, David. "Sweet Unison." *Sight and Sound* 7, no.4 (April 1997): 20–23.

Thompson, Kristin. *Breaking the Glass Armor: Neoformalist Film Analysis*. Princeton, NJ: Princeton University Press, 1988.

Thomson, David. *The Big Sleep*. London: British Film Institute, 1997.

Tompkins, Jane. "Fighting Words: Unlearning to Write the Critical Essay." *The Georgia Review* 42, no. 3 (1988): 585–590.

Triandis, Harry C. "Reflections on Trends in Cross-Cultural Research." *Journal of Cross-Cultural Psychology* 11, no. 1 (1980): 35–58.

Triandis, Harry C., and J. Lonner, eds. *Handbook of Cross-Cultural Psychology*. Vol. 3. Boston: Allyn and Bacon, 1980.

Tsutsui, Ako, and Gentarow Ohmi. "Complexity Scale and Aesthetic Judgments of Color Combinations." *Empirical Studies of the Arts* 29, no. 1 (2011): 1–15.

Turner, Samuel A., Jr., and Paul J. Silvia. "Must Interesting Things Be Pleasant? A Test of Competing Appraisal Structures." *Emotion* 6, no. 4 (2006): 670–674.

Tuska, Jon. *The American West in Film: Critical Approaches to the Western*. Lincoln: University of Nebraska Press, 1988.

Vale, Eugene. *The Technique of Screenplay Writing*. New York: Crown, 1944.

van Mulken, Margot, Rob Le Pair, and Charles Forceville. "The Impact of Perceived Complexity, Deviation and Comprehension on the Appreciation of Visual Metaphor in Advertising across Three European Countries." *Journal of Pragmatics* 42, no. 12 (2010): 3418–3430.

Veselovskii, Aleksandr Nikolaevich, "Istoricheskaia Poetika (A Historical Poetics), Chapter 1, Section 8." Translated by Ian M. Helfant. *New Literary History* 32, no. 2 (Spring 2001): 409–428.

Vogel, Harold L. *Entertainment Industry Economics: A Guide for Financial Analysis*. Cambridge, UK: Cambridge University Press, 2014.

Walker, E. L. *Psychological Complexity and Preference: A Hedgehog Theory of Behavior*. New York: Brooks/Cole, 1980.

Wasko, Janet. *How Hollywood Works*. London: SAGE, 2003.

Wasser, Frederick. *Veni, Vidi, Video: The Hollywood Empire and the VCR*. Austin: University of Texas Press, 2009.

White, Moresby, and Freda Stock. *The Right Way to Write for the Films*. Kingswood, UK: A. G. Elliot, 1948.

Whitfield, T. W., and Philip E. Slatter. "The Effects of Categorization and Prototypicality on Aesthetic Choice in a Furniture Selection Task." *British Journal of Psychology* 70, no. 1 (1979): 65–75.

Whittlesea, Bruce W. A. "Illusions of Familiarity." *Journal of Experimental Psychology: Learning, Memory, and Cognition* 19, no. 6 (1993): 1235–1253.

Whittlesea, Bruce W. A., Larry L. Jacoby, and Krista Girard. "Illusions of Immediate Memory: Evidence of an Attributional Basis for Feelings of Familiarity and Perceptual Quality." *Journal of Memory and Language* 29, no. 6 (1990): 716–732.

Winston, Andrew S., and Gerald C. Cupchik. "The Evaluation of High Art and Popular Art by Naive and Experienced Viewers." *Visual Arts Research* 18, no. 1 (1992): 1–14.

Wohlwill, Joachim F. "Amount of Stimulus Exploration and Preference as Differential Functions of Stimulus Complexity." *Perception & Psychophysics* 4, no. 5 (1968): 307–312.

Wood, Robin. *Hollywood from Vietnam to Reagan . . . and Beyond: A Revised and Expanded Edition of the Classic Text*. New York: Columbia University Press, 2012.

Wood, Robin. *Howard Hawks*. Garden City, NY: Doubleday, 1968.

Wright, Will. *Six Guns and Society: A Structural Study of the Western*. Berkeley: University of California Press, 1977.

Wyatt, Justin. *High Concept: Movies and Marketing in Hollywood*. Austin: University of Texas Press, 2010.

Zajonc, Robert B. "Attitudinal Effects of Mere Exposure." *Journal of Personality and Social Psychology* 9, no. 2 (1968): 1–27.

Zangwill, Nick. *The Metaphysics of Beauty*. Ithaca, NY: Cornell University Press, 2001.

Zito, Stephen. "George Lucas Goes Far Out." *American Film*, April 1977, 8–13.

Zolotow, Maurice. *Billy Wilder in Hollywood*. New York: Limelight, 1996.

Film Index

General Index